Impressionism

PAINTINGS COLLECTED BY
EUROPEAN MUSEUMS

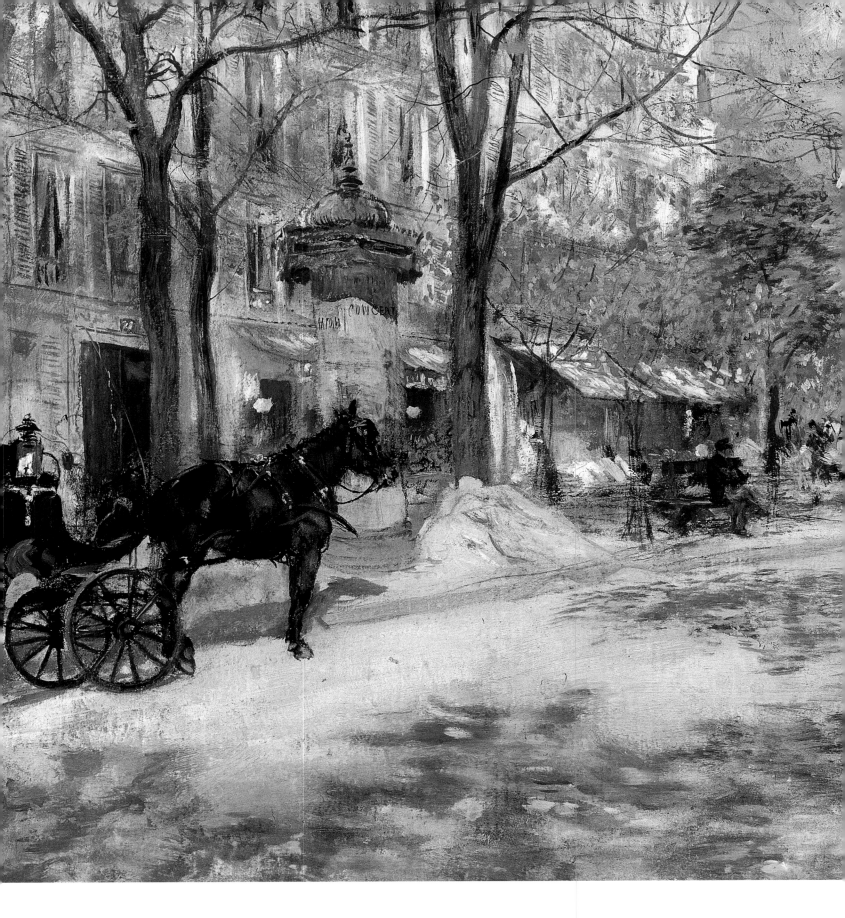

High Museum of Art
Seattle Art Museum
Denver Art Museum

in association with
 Harry N. Abrams, Inc.

Ann Dumas
Curator of the Exhibition

Michael E. Shapiro
Managing Curator of the Exhibition

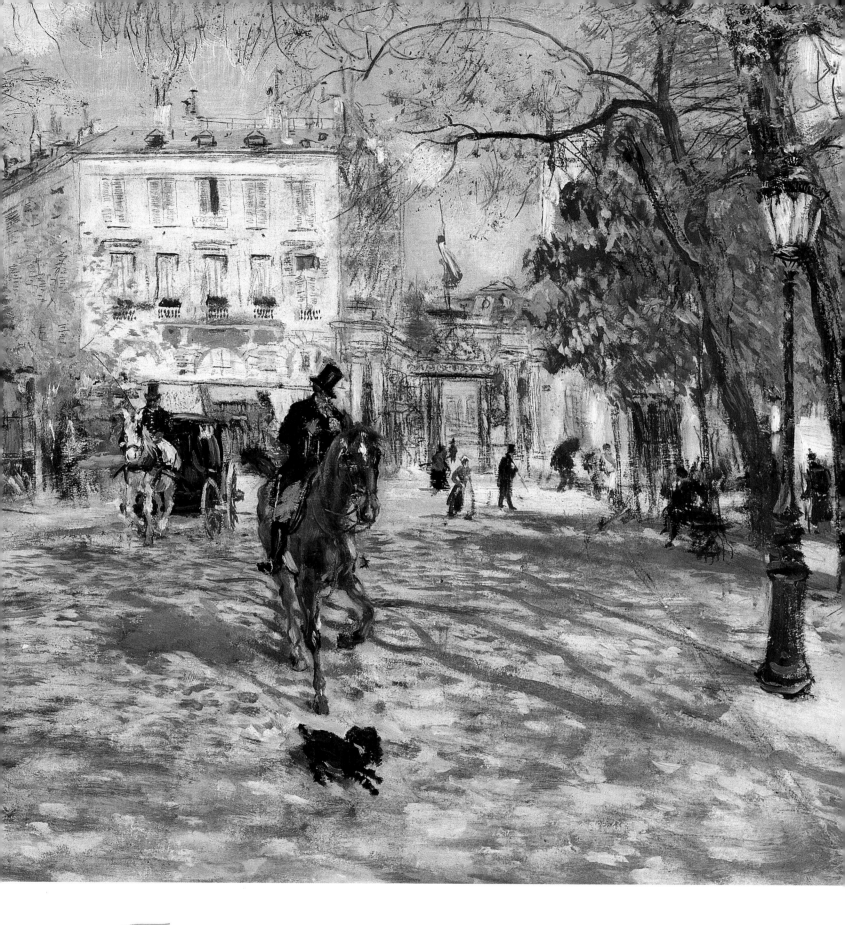

Impressionism

Paintings Collected by European Museums

Impressionism: Paintings Collected by European Museums

is organized by the High Museum of Art, Atlanta, in collaboration with
the Denver Art Museum and the Seattle Art Museum.

In Atlanta, generous support is provided by the Katherine John Murphy Foundation
and The Rich Foundation.
The exhibition is sponsored by Delta Air Lines and NationsBank.

In Seattle, the exhibition is presented by U S WEST.
Generous support is provided by The Boeing Company.

In Denver, the exhibition is presented by U S WEST.
Additional funding is provided by the citizens who support
the Scientific and Cultural Facilities District.

Impressionism: Paintings Collected by European Museums
was on view at the High Museum of Art, Atlanta, from
February 23 to May 16, 1999; at the Seattle Art Museum
from June 12 to August 29, 1999; and at the Denver Art
Museum from October 2 to December 12, 1999.

Distributed in 1999 by Harry N. Abrams, Inc., New York

Harry N. Abrams, Inc.
100 Fifth Avenue
New York, N.Y. 10011
www.abramsbooks.com

Pages 2–3: Jean-François Raffaëlli, *Boulevard in Paris*
(detail), ca. 1888, cat. 48.
Page 6: Alfred Sisley, *A Meadow in Springtime at By* (detail),
1881, cat. 60.
Page 12: Claude Monet, *A Seascape, Shipping by Moonlight*
(detail), ca. 1866 (cat. 30).
Page 28: Edgar Degas, *Before the Performance* (detail),
ca. 1896–98, cat. 17.
Pages 102–103: Gustave Caillebotte, *Le Pont de l'Europe*
(detail), 1876, cat. 5.
Page 248: Alfred Sisley, *The Bridge at Hampton Court*
(detail), 1874 (cat. 58).

FOR THE HIGH MUSEUM OF ART
Kelly Morris, Manager of Publications
Anna Bloomfield, Associate Editor
Melissa Wargo, Assistant Editor

Designed by Susan E. Kelly
Calligraphy by Stan Knight
Proofread by Sherri Schultz
Produced by Marquand Books, Inc., Seattle
Separations by Professional Graphics, Inc.,
 Rockford, Illinois
Printed by CS Graphics Pte., Ltd., Singapore

Library of Congress Cataloging-in-Publication Data

Impressionism : paintings collected by European museums
 / Ann Dumas, curator of the exhibition ; Michael E.
 Shapiro, managing curator of the exhibition.
 p. cm.
 Catalog of an exhibition held at the High Museum
of Art, Atlanta, Ga., Feb. 23–May 16, 1999, the Seattle
Art Museum, June 12–Aug. 29, 1999, and the Denver
Art Museum, Oct. 2–Dec. 12, 1999.
 Includes bibliographical references and index.
 ISBN 0-8109-6383-3 (hard : alk. paper)
 1. Impressionism (Art)—France—Exhibitions.
2. Painting, French—Exhibitions. 3. Art museums—
Europe—Exhibitions. I. Dumas, Ann. II. Shapiro,
Michael Edward. III. High Museum of Art.
IV. Seattle Art Museum. V. Denver Art Museum.
ND547.5.I414485 1999
759.05'4'074758231—dc21 98-45847

Lenders to the Exhibition

Aberdeen Art Gallery and Museums,
Aberdeen, Scotland

Fundación Colección Thyssen-
Bornemisza, Madrid, Spain

Galleria d'Arte Moderna, Florence, Italy

Galleria d'Arte Moderna Ricci Oddi,
Piacenza, Italy

Glasgow Museums: Art Gallery and
Museum, Kelvingrove, Glasgow, Scotland

Göteborgs Konstmuseum, Göteborg,
Sweden

Hamburger Kunsthalle, Hamburg,
Germany

Kunsthalle Bremen, Bremen, Germany

Kunstmuseum, Winterthur, Switzerland

Laing Art Gallery, Newcastle upon Tyne,
England

Musée d'Art et d'Histoire, Geneva,
Switzerland

Musée d'Art moderne et d'Art
contemporain, Liège, Belgium

Musée de Cambrai, Cambrai, France

Musée de Grenoble, Grenoble, France

Musée des Beaux-Arts, Agen, France

Musée des Beaux-Arts, Lyon, France

Musée des Beaux-Arts, Reims, France

Musée des Beaux-Arts, Rennes, France

Musée des Beaux-Arts, Rouen, France

Musée d'Orsay, Paris, France

Musée du Petit Palais, Paris, France

Musée Municipal d'Art et d'Histoire
Marcel Dessal, Dreux, France

Museum Boijmans Van Beuningen,
Rotterdam, The Netherlands

Národní Galerie, Prague, Czech Republic

Nasjonalgalleriet, Oslo, Norway

The National Gallery, London, England

National Gallery of Scotland,
Edinburgh, Scotland

Nationalmuseum, Stockholm, Sweden

Ordrupgaard, Copenhagen, Denmark

Petit Palais, Musée d'Art Moderne,
Geneva, Switzerland

Private collection on extended loan to
the Courtauld Gallery, London, England

Southampton City Art Gallery,
Southampton, England

Staatliche Museen zu Berlin,
Nationalgalerie, Berlin, Germany

Staatsgalerie Stuttgart, Stuttgart, Germany

Szépművészeti Múzeum, Budapest,
Hungary

Tate Gallery, London, England

Van Gogh Museum (Vincent van Gogh
Foundation), Amsterdam,
The Netherlands

The Victoria and Albert Museum,
London, England

Wallraf-Richartz-Museum, Cologne,
Germany

Contents

Acknowledgments

An enterprise of this scope is the result of many substantial individual contributions. Ann Dumas, the Guest Curator of the exhibition, has been a thoughtful, hardworking, and insightful colleague. She has masterfully searched the European continent for this project. Michael E. Shapiro, Managing Curator of the exhibition and Deputy Director of the High, worked closely and effectively with Ann and the key staff members of the participating museums. He particularly worked with Trevor Fairbrother, Deputy Director of Art and the Jon and Mary Shirley Curator of Modern Art of the Seattle Art Museum, and Joan Carpenter Troccoli, Deputy Director of Denver Art Museum. Additional curatorial strength was provided by David A. Brenneman, Frances B. Bunzl Family Curator of European Art, and Phaedra Siebert, Curatorial Assistant in the Department of European Art at the High; Chiyo Ishikawa, Curator of European Painting, Seattle; and Timothy Standring, Project Director and Gates Foundation Curator of Painting and Sculpture, and Marie Adams, Curatorial Assistant, Denver. We would like, in particular, to thank Paul Josefowitz, who helped to make this exhibition possible. Linnea E. Harwell, Exhibition Coordinator, did an excellent job tracking loan negotiations and maintaining lender relations. Joni Haller, graduate intern, was tireless in obtaining the rights and reproductions for the paintings in the exhibition. Additional thanks are extended to the exhibition departments, including Atlanta's Marjorie Harvey, Manager of Exhibitions; Seattle's Zora Hutlova Foy, Manager of Exhibitions and Curatorial Publications, and Michael McCafferty, Exhibition Designer; and Denver's Carol Campbell, Exhibitions Manager, and Jeremy Hillhouse and Lehlan Murray, Exhibition Designers.

Kelly Morris, Manager of Publications at the High, along with Associate Editor Anna Bloomfield and Assistant Editor Melissa Wargo, did the editorial work for the catalogue, which was designed by Susan Kelly of Marquand Books. The book was produced by Marquand Books in Seattle and is distributed by Harry N. Abrams. The book was published with the assistance of Apollo Magazine Limited—London. Ann Grove, Assistant to the Deputy Director and Chief Curator at the High, supervised the assignment of the entries and essays and corresponded with the writers. H. Nichols B. Clark, Eleanor McDonald Storza Chair of Education at the High, initiated and coordinated the educational programs, in tandem with his colleagues in Seattle, Jill Rullkoetter, Kayla Skinner Director of Education and Public Programs, and in Denver, Melora McDermott-Lewis, Project Director and Master Teacher for European and American Art. Anne Morgan, Director of Development and Membership, Susan Brown, Manager of Corporate Support, Keira Ellis, Manager of Foundation and Government Support, and Roanne Katcher, Manager of Membership at the High, worked closely with Maryann Jordan, Deputy Director for External Affairs, and Jill Robinson, Corporate and Foundation Relations Officer, in Seattle, and Cindy Ford, Director of Development, in Denver. Sally Corbett, Manager of Public Relations in Atlanta, and the staff of the Marketing and Public Relations departments developed national materials with Ashley Fosberg, Marketing and Publications Manager, and Linda Williams, Public Relations Manager, in Seattle, and Janet Meredith, Director of Marketing, and Deanna Person, Director of Public Relations, in Denver. Rhonda Matheison, Director of Finance and

Operations, assured the smooth financial workings of our partnership, along with Melissa Calzada, Controller, in Atlanta. They worked effectively with Jeff Eby, Chief Financial Officer, Seattle Art Museum, and Sharon Kermiet, Controller, in Denver. Marcia Meija, Retail Operations Manager at the High, oversaw the creation of beautiful products for each of the three museums to sell. Marie Landis, Manager of Special Events, oversaw the smooth running of the various sponsor and public events at the High Museum. Charles Wilcoxson, Chief of Security at the High, made sure that the exhibition ran smoothly and safely. Heidi Walters, Administrative Assistant to the Director in Seattle, gave needed staff support. Assen and Christine Nicolov worked hard behind the scenes at the Seattle Art Museum to make the exhibition venue there possible. Finally, let us thank the registrars, under the leadership of the High Museum of Art's Frances R. Francis, Registrar, Seattle's Gail Joice, Senior Deputy Director for Museum Services and Registrar, and Torie Stratton, Senior Assistant Registrar, and Denver's Kathleen Plourd, Director of Collections Services, and Lori Iliff, Registrar, who saw to the safe passage of these great and fragile works of art.

To each of the lending institutions that were willing to part with some of their most treasured works of art, we owe a special debt of gratitude. Those institutions and their generous staff members include: Jennifer Melville, Keeper of Fine Art, Aberdeen Art Gallery and Museums, Aberdeen, Scotland; Vivien Hamilton, Curator, Department of Art, Burrell Collection, Glasgow Art Gallery and Museum, Glasgow, Scotland; Dr. John Murdoch, Director, and Helen Braham, Curator and Acting Registrar, Courtauld Institute Galleries, London, England; Tomás Llorens, Chief Curator, Fundación Colección Thyssen-Bornemisza, Madrid, Spain; Dott. Antonio Paolucci, Soprintendente Ministero per i Beni Artistici Storici, Dott. Carlo Sisi, Director, and Dott.ssa. Giovanna Damiani, Vice-Director, Galleria d'Arte Moderna, Florence, Italy; Prof. Stefano Fugazza, Director, Galleria d'Arte Moderna Ricci Oddi, Piacenza, Italy; Dr. Björn Fredlund, Director, and Ingmari Desaix, Curator, Göteborgs Konstmuseum, Göteborg, Sweden; Prof. Dr. Uwe M. Schneede, Director, Dr. Helmut Leppien, Curator, and Dr. Jens Eric Howoldt, Curator, Hamburger Kunsthalle, Hamburg, Germany; Prof. Dr. Wulf Herzogenrath, Director, and Dr. Andreas Kreul, Curator, Kunsthalle Bremen, Bremen, Germany; Dr. Cäsar Menz, Director, Madame Claude Ritschard, Curator, Department of Fine Arts, and Madame Tourki Laïla, Registrar, Musée d'Art et d'Histoire, Geneva, Switzerland; Madame Françoise Magny, Conservateur, Musée de Cambrai, Cambrai, France; Françoise Dumont, Conservateur, Francine Dawans, Conservateur, and Françoise Safin-Crahay, Conservateur, Musée d'Art moderne et d'Art contemporain, Liège, Belgium; Monsieur Henri Loyrette, Director, and Madame Caroline Mathieu, Conservateur en Chef, Musée d'Orsay, Paris, France; Monsieur Serge Lemoine, Conservateur en Chef, Musée de Grenoble, Grenoble, France; Dr. Yannick Lintz, Conservateur, and Dr. Helen Glanville, Restaurateur, Musée des Beaux-Arts, Agen, France; Catherine Delot, Conservateur, Musée des Beaux-Arts, Reims, France; Dr. Laurent Salomé, Director, Musée des Beaux-Arts, Rennes, France; Madame Claude Pétry, Directeur, Musée des Beaux-Arts, Rouen, France; Monsieur Philippe Durey, Conservateur en Chef, Musée des Beaux-Arts, Lyon, France; M. Gilles Chazal, Director, and Isabelle Collet, Assistant Curator, Paintings Department, Musée du Petit Palais, Paris, France; Mlle. Marie Lavandier, Director, Musée Municipal d'Art et d'Histoire Marcel Dessal, Dreux, France; Chris Dercon, Director, and Karel Schampers, Chief Curator, Department of Modern Art, Museum Boijmans Van Beuningen, Rotterdam, The Netherlands; Mr. Gregor, Vice-director, Collection of Contemporary Art, Dr. Olga Uhrová, Curator, Collection of Modern and Contemporary Art, and Martin Zlatohlávek, General Director, Národní Galerie, Prague, Czech Republic; Mr. Tone Skedsmo, Director, Ernst Haverkamp, Senior Curator, Marit Lange, Chief Curator, and Anne-Berit Skang, Senior Curator, Nasjonalgalleriet, Oslo, Norway; Mr. Timothy Clifford, Director, and Michael Clarke, Keeper,

National Gallery of Scotland, Edinburgh, Scotland; Prof. Dr. Peter Klaus Schuster, Director, Dr. Claude Keisch, Curator, and Dr. Angelika Wesenberg, Curator, Staatliche Museen zu Berlin, Nationalgalerie, Berlin, Germany; Mr. Neil MacGregor, Director, Dr. Christopher Brown, Chief Curator, and Mr. Christopher Riopelle, Curator of Nineteenth-Century Paintings, The National Gallery, London, England; Mr. Olle Granath, Director, Görel Cavalli-Björkman, Assoc. Professor, Head of Research, Dr. Torsten Gunnarsson, Head of Collections, and Ms. Lillie Johansson, Loan Registrar, Nationalmuseum, Stockholm, Sweden; Dr. Anne-Birgitte Fonsmark, Director, and Dr. Mikael Wivel, Curator, Ordrupgaard, Copenhagen, Denmark; Prof. Dr. Claude Ghez, Madame Nicole Ghez, Vice President, and Mr. Ofir Scheps, Petit Palais, Musée d'Art Moderne, Geneva, Switzerland; Mr. Godfrey Worsdale, Acting Art Gallery Manager, Mr. Tim Craven, Collections Manager, and Ms. Helen Simpson, Registrar, Southampton City Art Gallery, Southampton, England; Prof. Dr. Christian von Holst, Director, and Dr. Christoph Becker, Curator, Nineteenth-Century Painting and Sculpture, Staatsgalerie Stuttgart, Stuttgart, Germany; Dr. Miklós Mojzer, Director, and Judit Geskó, Curator of Modern Prints and Drawings, Szépművészeti Múzeum, Budapest, Hungary; Mr. Nicholas Serota, Director, Tate Gallery, London, England; Dr. Alan Borg, Director, The Victoria and Albert Museum, London, England; Dr. Rainer Budde, Director, and Barbara Schaefer, Assistant to the Director, Wallraf-Richartz-Museum, Cologne, Germany; John Leighton, Director, Sjraar van Heugten, Conservator, and Aly Noordermeer, Registrar, Van Gogh Museum, Amsterdam, The Netherlands.

Others who gave valuable assistance in the organizing of the exhibition include: Ove Joansson, Cultural Attaché, Embassy of Sweden, Washington, D.C.; Joseph Kruzich, Cultural Attaché, United States Immigration Service, Stockholm, Sweden; Ulrich Schmidt, Deputy Consul General of the Federal Republic of Germany, Atlanta; Jean-Paul Monchau, Consul Général of France, Atlanta; and Cecile Peyronnet, French Cultural Attaché, Atlanta.

The essays for the catalogue were written by Ann Dumas, Görel Cavalli-Björkman, Judit Geskó, Lukas Gloor, Caroline Durand-Ruel Godfroy, Christopher Lloyd, Monique Nonne, and Stefan Pucks. The entries for the works of art were written by Marcia Brennan, David A. Brenneman, Ann Dumas, Stefano Fugazza, Judit Geskó, Ann W. Grove, Joni Haller, Marit Lange, Christopher Lloyd, Jennifer Melville, Mary Morton, Phaedra Siebert, Stefan Pucks, Michael E. Shapiro, Ferenc Tóth, Belinda Thomson, Olga Uhrová, and Gudmund Vigtel, Director Emeritus of the High. The chronology was prepared by Robert McD. Parker.

We are delighted that our museums have joined together to celebrate the journey that our sister institutions in Europe have taken in pursuit of Impressionist masterpieces.

Ned Rifkin
Nancy and Holcombe T. Green, Jr. Director
High Museum of Art

Mimi Gardner Gates
Illsley Ball Nordstrom Director
Seattle Art Museum

Lewis I. Sharp
Director
Denver Art Museum

Directors' Preface

In the 1860s and 1870s, a group of French painters created what was then a shocking new style of painting that eventually came to be known as Impressionism. Monet, Degas, Renoir, Cézanne, and other artists rejected the official Academy standards for both subjects and technique, leaving behind traditional mythological or historical subjects in favor of images of middle-class life in France. The paintings were shocking to the public and often provoked considerable scorn and anger from contemporary critics and writers on art. The sketchlike application of paint was roundly derided. By 1874, these radical young artists had sold few paintings. Degas, Monet, Pissarro, and Renoir took the lead in organizing an exhibition to attain greater visibility for them. Eight Impressionist exhibitions took place between 1874 and 1886. The artists who took part in these exhibitions and the works they displayed define the core of the Impressionist movement.

This exhibition is the first to trace and to celebrate the process by which visionary artists, their dedicated art dealers, those collectors bold enough to buy examples of this new painting, and adventurous museum curators and directors built the Impressionist holdings of European museum collections. Impressionist paintings began entering European museums in the last years of the nineteenth century, and the pace of acquisitions accelerated in the early years of the twentieth. The process of building museum collections continues into our own time, as this exhibition also reveals.

It is fitting that the High Museum of Art, the Seattle Art Museum, and Denver Art Museum—three vibrant regional American museums—should be working together to realize this project. This effort represents the largest Impressionist exhibition to appear in three important regions of the United States: the Southeast, the Pacific Northwest, and the Rocky Mountains. Drawing upon the collections of more than thirty museums in thirteen European countries, this exhibition will allow our audiences to savor important and beautiful Impressionist paintings and enable our museums to contribute to recent scholarship on this subject.

Ned Rifkin
Nancy and Holcombe T. Green, Jr. Director
High Museum of Art

Mimi Gardner Gates
Illsley Ball Nordstrom Director
Seattle Art Museum

Lewis I. Sharp
Director
Denver Art Museum

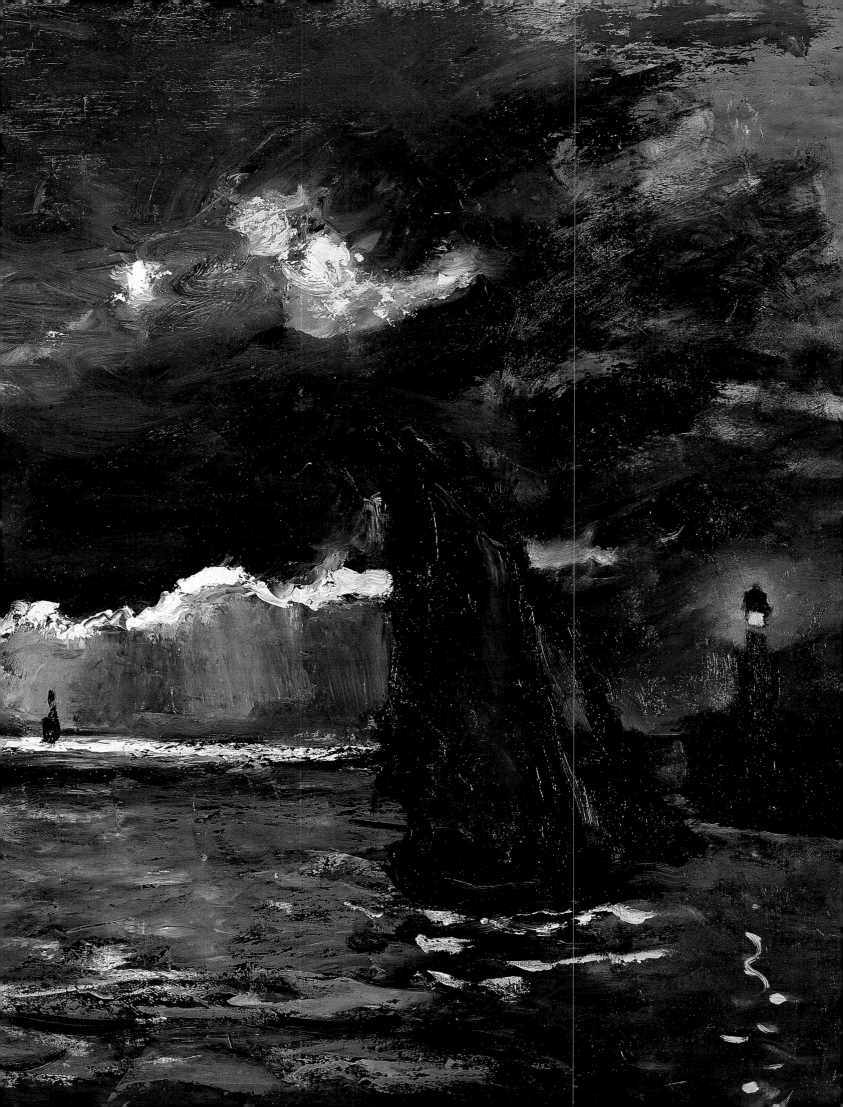

Introduction

ANN DUMAS

I wish to make of Impressionism something solid and durable like the art of the museums.

PAUL CÉZANNE[1]

What could help to ensure the eventual success of these young painters is the fact that their pictures are done in a singularly bright tonal range. A blond light pervades them, and everything is gaiety, clarity, spring festivals, golden evenings, or apple trees in blossom. . . . Their canvases, uncluttered, medium in size, are open in the surface they decorate; they are windows opening on the joyous countryside, on rivers full of pleasure boats stretching into the distance, on a sky which shines with light mists, on the outdoor life, panoramic and charming.

ARMAND SILVESTRE[2]

Writing in 1873, the critic Armand Silvestre identified the qualities that have ensured the unprecedented popularity and success of Impressionist paintings to the present day. There is little question that Impressionist paintings remain among the most widely appreciated works of art ever produced. Known through reproductions in calendars, postcards, posters, and other commercial products, they are now enshrined in the popular imagination the world over. In the last three decades, at least, they have been the subject of numerous books—on the movement as a whole and monographic studies of the individual artists—as well as many international exhibitions. Several of the artists—Cézanne, Degas, Manet, and Monet, for instance—are considered among the greatest who have ever lived.

In the early years of the movement, in the late 1860s and 1870s, when the artists we now call the Impressionists were struggling for recognition, nobody could have predicted the scale of their eventual triumph. In 1874, only a year after Silvestre's encomium, Cézanne, Degas, Guillaumin, Monet, Morisot, Pissarro, Renoir, and Sisley joined forces with a number of now lesser-known artists to exhibit as an independent group in the photographer Nadar's former premises on the boulevard des Capucines in Paris. Their paintings were met with scorn and indignation from the public and a number of critics (fig. 1). And the following year, at the auction of their works that the artists organized at the famous Paris auction house the Hôtel Drouot, the paintings fetched derisory prices. A smaller version of Renoir's *The Box*, 1874 (fig. 2), which had been shown at the first group exhibition the year before, fetched only 110 francs.[3]

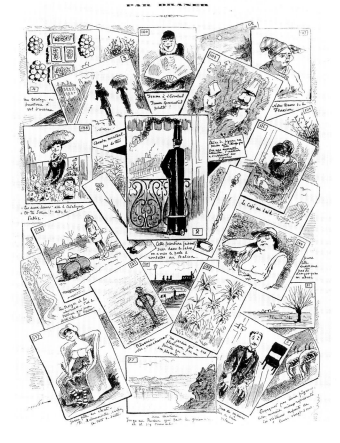

UNE VISITE AUX IMPRESSIONNISTES
PAR DRANER

Fig 1. Caricature of the seventh
Impressionist exhibition.
Draner, "A Visit to the
Impressionists," *Le Charivari,*
9 March 1882.

Rowdy scenes among the hostile public caused such pandemonium in the salesroom that, according to some accounts at least, the police were called.[4]

Although these early initiatives attracted a few supporters among private collectors who had the vision to buy this new and "difficult" art, it would take over twenty years for Impressionism to receive the official sanction of the museums. The bequest by the wealthy Impressionist painter Gustave Caillebotte of paintings bought from his fellow artist friends was not accepted by the French State until 1896, and even then only partially and after almost three years of wrangling with the authorities. When the collection was first shown at the Musée du Luxembourg in January 1897, violent protests erupted in political and artistic circles. But from then on, Impressionist paintings have been slowly transformed from objects of derision to highly valued masterpieces that today command astronomical prices, are eagerly sought by collectors, and occupy pride of place in museum collections.

The acceptance and acquisition of Impressionist paintings by European museums is the subject of this exhibition. We might wonder, perhaps, why the early history of a work of art should interest us today. Why should we care who owned a picture over a hundred years ago, which dealers bought and sold it, or how it came to end up in a particular museum? Although important to the archival work of scholars and cataloguers, and sometimes useful in confirming the authenticity of a work, the lineage of a painting's previous owners has usually been of little interest to a broader audience. Yet buried in the small print headed "Provenance" in a catalogue entry lies the often fascinating story of a painting's "life." This exhibition excavates such dryly recorded facts and brings to life the individual heroes of this important chapter in the history of modern taste: the very first collectors who had the insight to buy Impressionist paintings, albeit for modest prices, providing vital encouragement and, for some of the artists, desperately needed funds that enabled them to continue to work at a crucial stage in their early careers; and visionary museum directors whose daring early purchases drew Impressionism into the arenas of their own national cultures, allowing it to nourish the native artists of their own and future generations. The following essays trace this narrative as it unfolded in different European countries. The catalogue is, however, a survey and does not attempt to be encyclopedic: whereas thirteen countries are represented by the paintings in the exhibition, the essays cover the eight that were the most prominent in collecting Impressionism.

The paintings in the exhibition bear witness to many of the most historic early acquisitions by museums in those countries. Sisley's *September Morning,* ca. 1887 (cat. 61), for example, given to the Musée des Beaux-Arts in the provincial French town of Agen in 1889, enjoys the distinction of being the first Impressionist painting to have been bought directly from the artist by the French State. Monet's *The Port at Argenteuil,* ca. 1872 (cat. 31), now in the Musée d'Orsay, Paris, is one of the paintings from Count Isaac de Camondo's legendary bequest to the French State, accepted in

1896; Renoir's *Woman Playing a Guitar*, 1896–97 (cat. 53), bought in January 1901 by the Musée des Beaux-Arts, Lyon, was the first in a series of bold purchases by that museum. Degas's *The Ballet Scene from Meyerbeer's Opera "Robert le Diable,"* 1876 (cat. 15), became the first painting by him to enter an English museum when it was bequeathed to the Victoria and Albert Museum, London, by the Greek collector Constantine Ionides. The pioneering efforts of Hugo von Tschudi, the great director of the Berlin Nationalgalerie, enriched that institution with a number of outstanding Impressionist works at the beginning of the century, including Manet's *Country House in Rueil*, 1882 (cat. 29), bought in 1906. Almost as enterprising was Jens Thiis, who in the first decade of the century made a number of spectacular purchases for the Nasjonalgalleriet in Oslo, including Gauguin's 1884 portrait of his wife (cat. 21). Monet's *Plum Trees in Blossom*, 1879 (cat. 33), was one of a number of major acquisitions made a little later, in 1912, by Gábor Térey and Simon Meller at the Szépművészeti Múzeum in Budapest. Pissarro's *Farm at Montfoucault*, 1874 (cat. 42), acquired by the Musée d'Art et d'Histoire, Geneva, in 1915, was one of the first Impressionist paintings to enter a Swiss museum. However, there are inevitable omissions to the exhibition. Owing to the fragility of some of the works, the excessive exposure of others, and prior loan commitments, we were unable to borrow any of the pictures acquired by the two great Russian collectors of Impressionism, Ivan Morozov (1871–1921) and Sergei Shchukin (1854–1936), which are now housed in the Hermitage Museum, St. Petersburg, and the Pushkin Museum, Moscow.

The term "Impressionist"—originally coined by a critic who seized on Monet's *Impression, Sunrise*, 1872 (fig. 4, p. 42), as a prime example of the slapdash appearance of the canvases on view at the first Impressionist exhibition[5]—has given rise to a false idea of the homogeneity of the group. Like most artistic "isms," the term fails

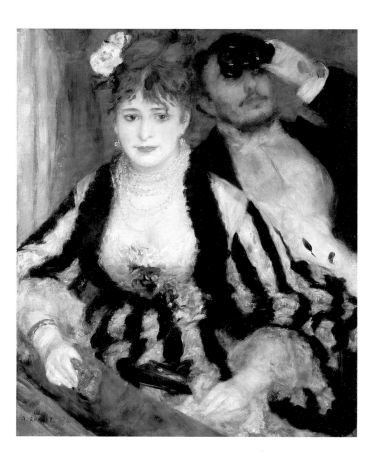

Fig. 2. Renoir, *The Box*, 1874, oil on canvas, 31 × 25 in., Courtauld Institute Galleries, London.

to encompass the complexities and shifts of style of the diverse artists who exhibited under its banner.[6] The artists themselves disagreed about the term, generally preferring the group name "Independents," while Degas always thought of himself as a "Realist." Although in general all the artists in the group shared a commitment to painting contemporary subjects in an informal manner, they were broadly divided into two camps. "Pure" Impressionists, led by Monet and including Pissarro, Sisley, and sometimes Renoir, painted out-of-doors, recording their spontaneous responses to light and atmosphere. An opposing faction, led by Degas and including Caillebotte, Forain, and Raffaëlli, was more interested in urban subjects, draftsmanship, and the human figure. After the third group exhibition in 1877, these different interests—exacerbated by Degas's insistence on inviting a growing number of conservative painters deemed by Monet and other corps members to contradict the original premise of the movement—led to a serious rift that undermined the solidarity of the group.[7] Furthermore, the artists' individual styles evolved in different ways, so that in the 1880s both Monet and Renoir had abandoned the purely outdoor Impressionist style in favor of a more reflective approach to painting, and this applies in different ways to the work of Cézanne, Gauguin, and even Pissarro.

The difficulty of defining Impressionism was an issue that had to be addressed in deciding which artists to represent in this exhibition. With the exception of Manet and van Gogh, all of the artists we have included exhibited in one or more of the eight group exhibitions that were presented between 1874 and 1886. Although Manet remained aloof from the exhibitions, the loose brushwork and high-keyed palette he adopted after his contact with Renoir and Monet in 1874, and which he pursued until his death in 1883, allies him to the Impressionists. Moreover, he is too important to be excluded simply on the grounds that he was not in the group shows. Although van Gogh, as well as Cézanne and Gauguin in their later work, are often considered Post-Impressionist (another unsatisfactory umbrella term) rather than purely Impressionist, we decided to include all three. Cézanne's point of departure was always nature and working from the motif, as was van Gogh's. While we have included Gauguin's work dating from the period when he was working with the Impressionists under the influence of Cézanne and Pissarro, we have excluded the paintings he executed from about 1888, and especially after his departure to Tahiti in 1891, on the grounds that these are more to do with imagination than observation and are a fundamental rejection of the broad tenets of Impressionism. Finally, in addition to the famous names of Impressionism, we have included a number of interesting but now lesser-known figures who exhibited in the group shows, in order to give a more rounded view of Impressionism as it appeared to contemporary viewers. These artists include Bracquemond (cats. 3, 4), Forain (cat. 18), Guillaumin (cats. 25, 26, 27), Raffaëlli (cat. 48), and Zandomeneghi (cats. 67, 68).

As for the chronological span of the exhibition, our primary focus is the earliest museum acquisitions of Impressionist paintings, whether these were made by the institutions themselves or were donations or bequests from the first collectors. However, the time frame varies from country to country, as the essays in this catalogue make clear. Outside of France, the initial and most vigorous collecting of Impressionism occurred not in Europe at all but in the United States, but this would be the subject of another exhibition. In Europe, German collectors and museums were in the vanguard, led by Tschudi, with an active acquisition policy beginning in the late 1890s. Hungary and Scandinavia followed closely behind, acquiring a number of works in the early years of the twentieth century. Despite considerable early

exposure to Impressionism in Britain,[8] serious collecting did not really get under way until the 1920s, when textile magnate Samuel Courtauld deployed his vast resources and enthusiasm in collecting Impressionist pictures for himself and the nation.[9] A few works in the exhibition are later acquisitions, especially those from Swiss collections, where, apart from a few significant early acquisitions (notably in Winterthur, Basel, and Geneva), the most concerted collecting of Impressionism occurred after the Second World War.[10]

The complete accessibility of Impressionism today makes it hard to recapture its early radicalism. Why, we ask, should these enchanting scenes of outdoor hedonism or telling vignettes of contemporary Parisian life have touched such a raw nerve? The clash between hostile critics and a misunderstood avant-garde is now part of the received history of early modernism. It would be misleading, however, to suggest that all the early reviews of the Impressionist exhibitions were harsh and uncomprehending.[11] A number of distinguished critics were early allies, most notably Émile Zola, Théodore Duret, and Jules Castagnary. Castagnary, who had been Courbet's staunch champion, favorably reviewed the first exhibition, referring to Monet's "marvelous impasto effects," Sisley's "distinction," and Renoir's "boldness."[12] But in an era that saw an explosion in the number of newspapers and journals published, the views of journalists and critics covered a wide spectrum, and opinions were sometimes exaggerated for the sake of lively journalism. Albert Wolff, the critic most popular with the Parisian public, in his review of the second Impressionist exhibition in 1876, was one of a number of critics who were outspoken in their scorn for the new art:

> A frightening spectacle of human vanity so far adrift that it verges on sheer lunacy. Try to make M. Pissarro understand that trees are not violet; that the sky is not the color of fresh butter, that the things he paints are not to be seen in any country on earth, and that no intelligent human being could countenance such aberrations. . . . Try to make M. Degas understand reason, tell him that there are in art certain qualities which are called drawing, color, technique and effort, and he will laugh in your face, and tell you that you are a reactionary. Try to explain to M. Renoir that a woman's torso is not a mass of decomposing flesh with those purplish green stains which denote a state of complete putrefaction in a corpse.[13]

On the whole, it was not the subjects of the paintings that gave offense. Although landscape painting had traditionally been considered a lowly form of art at the Salon, it was extremely popular in France by the mid-nineteenth century. Paintings by the Barbizon School, the Impressionists' predecessors in painting scenes of unspectacular nature, were enthusiastically bought by middle-class collectors. Views of contemporary Parisian life were also familiar from magazine illustrations, even if they were less common in the higher art of painting. After all, as early as the 1850s the poet Charles Baudelaire had in his famous essay "The Painter of Modern Life"[14] advocated modern urban life as a subject painters should address. What outraged the public was not so much what the pictures showed but the way they were painted— the seemingly careless execution and the lack of all traditional notions of composition and finish. In their quest to capture their visual impressions with immediacy, the Impressionists developed a synoptic language of loose, rapid brushwork, seemingly crude colors, and "unarranged" compositions in which forms often overlapped and were cropped. Their aim was to replicate the random, unpremeditated way that

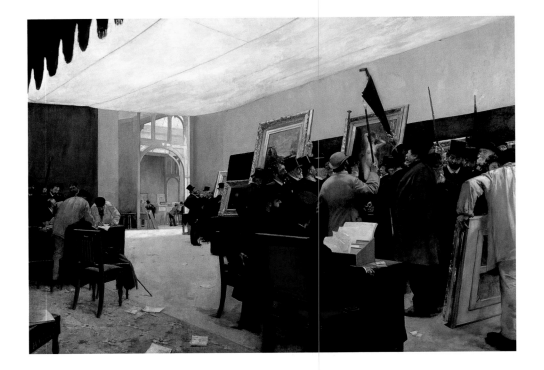

we perceive things in life. But to the public, the idea of exhibiting such "sketches" as finished pictures was incomprehensible. The critic Emile Cardon voiced this reaction when he found the works on exhibit at the first Impressionist exhibition "quite simply the negation of the most elemental rules of drawing and painting. . . . The scribblings of a child have a naiveté and sincerity that make you smile; the debaucheries of this school are nauseating and revolting."[15] "What do we see in the work of these men?" asked Emile Cajart. "Nothing but an insult to the taste and intelligence of the public."[16]

The Impressionists did not set out to be radicals. As Pissarro modestly explained some years later, "I do not believe that art is a matter of progress: it is simply that at the present time we are interested in certain effects that our ancestors were not concerned about."[17] Unlike the more polemical groups of the early twentieth century —the Futurists and the Surrealists, for example—they had no clearly defined artistic program or manifesto. Their aim in forming an independent exhibition group— the Corporation of Artists, Painters, Sculptors, and Engravers (Société Anonyme des Artistes, Peintres, Sculpteurs, et Graveurs) was the workmanlike title they adopted— was pragmatic: they needed an outlet through which to exhibit and sell their work because of their failure to achieve recognition at the official, government-sponsored Salon.

The enormous exhibiting forum called the Salon was the main vehicle through which the nineteenth-century Parisian painter could achieve fame and recognition (fig. 3). The annual exhibitions held in the Palais de l'Industrie in Paris were a dominant feature of French artistic life and attended by vast crowds. Acceptance by the Salon by no means assured critical attention or sales. The paintings were hung very close together in row upon row from floor to ceiling, and only the big names were prominently displayed. Despite their opposition to official Salon art, most of the Impressionists realized that it was the best marketplace available and tried to submit their work. Manet always placed his hopes on the Salon and never exhibited with the Impressionists. In fact, during the 1860s most of the future Impressionists received some recognition at the Salon, although Cézanne was consis-

tently turned down. Pissarro's *L'Hermitage at Pontoise*, 1867 (cat. 40), is typical of the kind of impressive, large-scale composition that some of the future Impressionists were producing at the end of the 1860s with the hope of Salon acceptance.[18] Throughout the 1870s, a period of retrenchment after the Franco-Prussian War, the Salon jury was particularly conservative and unreceptive to modern forms of landscape painting. Nonetheless, when the cohesion of the Impressionist group began to fall apart after the third exhibition in 1877, some of the members returned to the Salon. In 1879, Renoir was the first to defect, followed by Monet in 1880. Disillusioned with the Impressionist exhibitions, Renoir wrote to his dealer Paul Durand-Ruel: "There are in Paris perhaps fifteen *amateurs* capable of appreciating a painting without the Salon. There are 80,000 more who will not buy anything if it has not been in the Salon. . . . I don't want to waste my time resenting the Salon. I don't even want to look as if I do."[19] In the same year, Monet explained to the critic Duret, "It is really unfortunate that the press and the public have taken so little seriously our small exhibitions, preferring instead the official bazaar."[20]

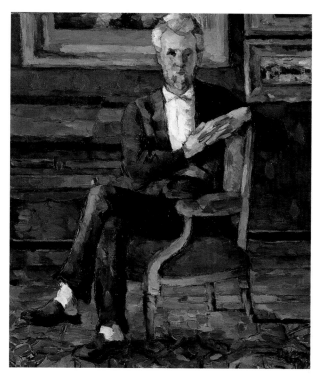

Fig. 4. Cézanne, *Victor Chocquet*, ca. 1877, oil on canvas, 17¾ × 14½ in., Columbus Museum of Art, Ohio.

Although the first independent group exhibitions were a commercial failure, they did attract considerable press coverage that drew visitors and a small group of pioneer collectors. The principal early collectors of Impressionism were a diverse group. Among them were Ernest Hoschedé, a department store owner whose wife later married Monet; the famous operatic baritone Jean-Baptiste Faure; Eugène Murer, a pastry cook and restauranteur; Georges de Bellio, a Rumanian homeopathic doctor; retired customs officer Victor Chocquet (fig. 4), whose passion for the fluid, chromatic paintings of the great Romantic painter Delacroix led him to admire and buy the Impressionists, especially Renoir and Cézanne; Paul Bérard, the diplomat and banker who was Renoir's patron; and François Depeaux, the Rouen merchant who, for a time, supported Sisley.[21]

Other early collectors were the critics and writers who were the first supporters of the Impressionists, most notably Théodore Duret (1838–1927). Independently wealthy from his family's cognac business, he was an enthusiastic and consistent purchaser of Impressionist paintings until financial problems in the business obliged him to sell his collection. The publisher Georges Charpentier (1846–1905) was an important early patron of Renoir in particular and offered the group the offices of his review *La Vie moderne* as an exhibiting venue.

Some of the first collectors were the painters themselves. Foremost was Caillebotte, who not only created some of the icons of Impressionist urban imagery— *Paris Street on a Rainy Day*, 1877 (Art Institute of Chicago) and *Le Pont de l'Europe*, 1876 (cat. 5)—but also used his independent wealth to build up a magnificent collection of sixty-seven paintings by his friends and colleagues. Early on, Caillebotte resolved that his collection should be accepted in its entirety by the Musée du Luxembourg in Paris and later the Louvre. Only thirty-eight were finally accepted, and these now form part of the Musée d'Orsay's great Impressionist collection. Gauguin, who was working as a stockbroker when he began exhibiting with the Impressionists in 1879, also bought paintings by his colleagues, eventually owning

about fifty works, principally by Pissarro, Sisley, Degas, and Cézanne.[22] Gauguin was, in fact, one of the first patrons of Cézanne, acquiring his works around 1879–81, a time when, as a developing artist, Cézanne greatly influenced him.[23] When Gauguin departed for the South Seas, he left his collection in the hands of his wife, Mette (cat. 21), who returned to her native Copenhagen. The sales she was obliged to make from it to fund Gauguin's trips were to have an impact on the Danish taste for Impressionism.[24] Degas, who in the 1890s was to assemble a vast and magnificent collection of earlier nineteenth-century French art, owned a few Impressionist paintings—one painting by Sisley, three by Pissarro, and two by Renoir—that he bought from his friends in the early years of the group enterprise; later he would acquire a number of works by Cézanne and Gauguin. Degas's close friend Henri Rouart, an amateur painter who exhibited with the Impressionists, was a wealthy industrialist and great collector. His collection was distinguished by its Barbizon pictures and significant groups of works by Corot, Daumier, and Millet, but he was also one of the first to buy the works of his Impressionist friends.

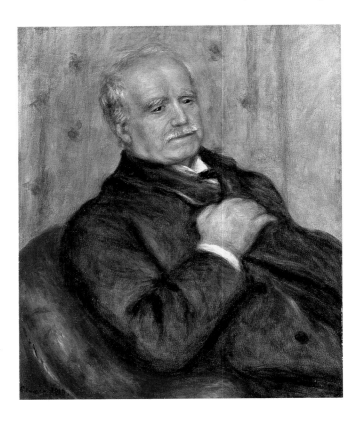

Fig. 5. Renoir, *Paul Durand-Ruel,* 1910, oil on canvas, 25¾ × 21½ in., Durand-Ruel Collection, Paris.

The widening gulf between the Salon and the avant-garde fostered the emergence of a new system of commercial dealers that is the basis of the art market as we know it today. Beside the artists' independently organized exhibitions and the auctions they arranged, the dealers provided the artists with the most important vehicle for selling their work, one that would eventually come to replace the Salon. Preeminent among the dealers was Paul Durand-Ruel (fig. 5), who had an instinctive genius for operating the evolving art market. There is no doubt that he was the single most powerful driving force in ultimately establishing the Impressionists' reputations. Eventually his stock of great contemporary painting was so substantial that his gallery on the rue Laffitte—the street where all the galleries were established by the end of the century—came to be known as "the second Louvre."[25]

A brilliant commercial strategist, Durand-Ruel bought up the work of the "neglected" artists he admired, establishing a virtual monopoly over their work and energetically promoting them. He mounted exhibitions of their work, published albums of reproductions, and built an ever-expanding network of potential clients, pushing up prices by selling works back and forth between himself and collectors. His letters to his artists reveal the extent to which he directed their production, suggesting subjects and advising them on their style, steering them to produce paintings that would be acceptable to a bourgeois clientele.[26] As a result, the kind of works the Impressionists were painting after 1870 were modest in scale, often more carefully finished and less obviously sketchy than those that had attracted adverse reviews from the critics, and, unlike the large works intended to attract attention at the Salon, suitable for the new bourgeois apartments.[27]

In the 1880s, some of the Impressionists began to broaden the range of their subjects, with the market in mind. The advent of the railroads had transformed the possibilities for travel in France in the second half of the nineteenth century, creat-

ing a taste for scenic views of the French landscape among a new group of middle-class patrons who were beginning to savor the pleasures of tourism. Monet in particular started to travel farther afield—away from the established Impressionist sites along the Channel coast, the Seine, and around Paris—in search of more remote, less domesticated scenery of a kind that was popular in landscapes shown at the Salon. His scenes of the wilder cliff scenery on the Channel or the Breton coast exemplify this trend. *The Rocks at Belle-Île* (cat. 36) was specifically a response to Durand-Ruel's advice that he paint a sunny scene because it would have more market appeal.[28]

One of Durand-Ruel's most innovative schemes was the one-man exhibition. When in 1883 he gave Boudin, Monet, Pissarro, Renoir, and Sisley individual shows, it was the first time that monographic exhibitions had been used as a sales policy and, in this respect, Durand-Ruel was a pioneer of modern gallery practices. In 1891 he mounted a long series of solo shows that finally secured the Impressionists' reputations. These strategies, in which dealers are the prime movers in shaping an artist's career, established the origins of the present-day practices of the art world.[29] As the commercial dealer system grew, the authority of the Salon began, gradually, to wane.

In the end, Impressionism could not fail to appeal to a well-to-do bourgeois audience, a class whose sense of its own identity depended on notions of progress and self-advancement. This marked a decisive shift away from an earlier class of aristocratic patrons who favored landscapes based on a shared historical heritage and on the seventeenth-century models of Poussin and Claude, examples of which still lingered on at the Salon. (Flandrin's *Souvenir of Provence,* 1874 [fig. 6], shown in the same year as the first Impressionist exhibition, is an example.) Impressionism, on the other hand, was a new art for a new class that wanted images of the world they inhabited. The subjects of Impressionist paintings are, above all, about middle-class leisure: boating, strolling along rivers, through fields, or on the new boulevards of Paris, the *cafés-concerts* (fig. 7), the racetrack and other forms of urban entertainment, Parisian interiors, and public parks—activities that coincided with their own forms of escape from the modern city.[30] When the informality of its style no longer shocked, Impressionism continued to grow in appeal as an exciting and fashionable

Fig. 6. Flandrin, *Souvenir of Provence,* 1874, oil on canvas, 35⅜ × 45⅝ in., Musée des Beaux-Arts, Dijon.

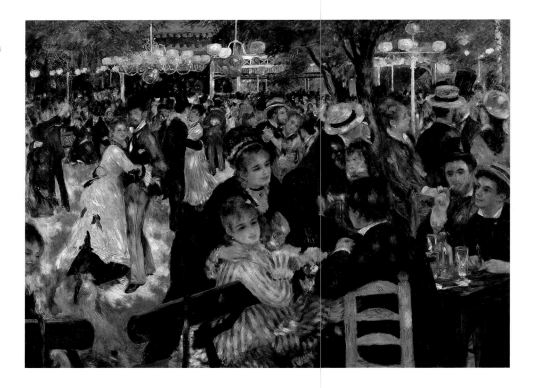

art, attracting new bourgeois patrons who wanted to ensure for themselves a place in the avant-garde. Ironically, the Impressionists' former status as renegades enhanced their appeal to the connoisseurship and speculative skills of the bourgeois collector. Increasingly, Impressionist paintings were favorably reviewed in the press, and illustrations in the pages of such fashionable magazines as *Paris illustré* served to endorse them as both a fashionable purchase and a good investment.

From the 1880s on, Durand-Ruel's clientele was made up of a second wave of collectors quite different from the *amateurs* (or gentleman collectors) who were the first to respond to the work. The millionaire banker Count Isaac de Camondo, the margarine manufacturer Auguste Pellerin, and the historian Étienne Moreau-Nélaton amassed magnificent collections of Impressionist paintings in the 1880s and 1890s. They were partly guided by Durand-Ruel and also helped by new supplies of works that came onto the market with the dispersal in the 1890s of such great earlier collections as Duret's, Faure's, and Chocquet's. The Camondo and Pellerin bequests now form part of the Musée d'Orsay's collection, while Moreau-Nélaton's distinguished group of Impressionist paintings are in the Louvre. While the new collectors differed from the aristocratic patrons of the past in their commitment to modernity, in other ways they wished to emulate them, particularly in the public-spirited ideal of the *amateur* who amassed paintings not merely for his own pleasure but for the national good. This was partly a response to a widespread nationalistic feeling toward the end of the nineteenth century that France's patrimony was being depleted—a "catastrophic diaspora," some called it[31]—by what were viewed as rapacious foreign collectors.

By the end of the century, most collectors of Impressionism were outside of France. Throughout Europe, the growing class of collectors was largely drawn from the newly rich bourgeoisie, who had made their fortunes in banking and in the great industrial enterprises that flourished at the end of the nineteenth century—railways, coal, steel, textiles—for whom acquisition of a collection provided a tangible symbol of social standing. Durand-Ruel unquestionably played a key role

in fostering the international dispersal of Impressionism, staging or contributing to international exhibitions, selling directly to collectors and museum curators throughout Europe, and forming business partnerships with foreign dealers, most notably with Paul Cassirer in Berlin.

During the 1880s, however, Impressionism began to attract the interest of other prominent dealers besides Durand-Ruel. In 1882 Georges Petit opened a sumptuous gallery, which became famed for the lavish private viewings that helped to establish the highest possible prices for his stock. He launched a series of solo exhibitions— the *Expositions Internationales de Peinture*—of the work of Monet, Renoir, Pissarro, and Sisley. Van Gogh's brother Theo was manager of the Montmartre branch of the Boussod and Valadon gallery, where, in the 1880s, he began to deal cautiously in Impressionist paintings. In 1906 the Bernheim-Jeune brothers also opened a major Paris gallery, while a young newcomer from the Île de la Réunion, Ambroise Vollard, began to champion the younger artists, including van Gogh and Gauguin, from his small gallery on the rue Laffitte. In 1895 Vollard gave Cézanne, who had been living more or less as a recluse in his native Aix-en-Provence, his first solo exhibition. A number of galleries in other European centers—Cassirer in Berlin or Alexander Reid in Glasgow, for example—were, as the following essays discuss, crucial in spreading Impressionism throughout Europe.

Gauguin once predicted that the Impressionists would be the "officials" of to-morrow. By the end of the century, almost all of the artists who had participated in the first Impressionist exhibition were successful. Largely owing to the Caillebotte bequest, they all had works displayed in the Musée du Luxembourg, then the museum for living artists. Their inclusion in the 1900 World's Fair cemented their reputations and made them known to international audiences. After 1900, the prices of Impressionist paintings soared, especially when German, Swiss, and Russian collectors entered the market.

Of all the Impressionists, Renoir and Monet became the most wealthy and famous in their lifetimes, living well into the twentieth century to enjoy their success. Degas was more of a recluse, but his paintings were selling well (his *Dancers at the Barre*, The Metropolitan Museum of Art, New York, fetched a record price for a living artist of 478,000 francs at the sale of his friend Henri Rouart's collection in 1912, ofive years before his death). Sisley died poor, and his works only began to fetch high prices a year or so after his death in 1899. Cézanne achieved recognition in his lifetime but died in 1906, long before his works began to sell for the prices attained by the others. The same is true of Pissarro and Gauguin, both of whom died in 1903.

Although, as we have seen, the artists' success had been in great measure secured by Durand-Ruel and other dealers, one must not overlook the role that the painters themselves played in this process. They were not, as the bohemian myth would have it, unsung geniuses whom the world suddenly discovered, but active participants in the creation of their own reputations. Several of the artists came from well-to-do families—Cézanne (at least after his father's death in 1886), Caillebotte, and Morisot—and the need to earn a living from their art was not pressing. It is not surprising, then, that those who came from modest backgrounds—Monet and Renoir in particular—were the most energetic in promoting themselves. Degas's case is unusual: although he came from a prosperous banking family, a reversal in the family fortunes in the 1870s meant that for much of his career he was dependent on his sales for a living.

Because of the felicitous ease of his paintings, Renoir has often been viewed as a sort of "natural" genius, an interpretation that has tended to obscure his skill as a shrewd marketer of his work. His meeting, shortly after the Impressionists' auction in 1875 at the Hôtel Drouot, with the publisher Georges Charpentier and his wife, a celebrated Parisian hostess, marked a turning point in Renoir's fortunes. His 1878 portrait of Madame Charpentier and her children (fig. 2, p. 30) established him as "court painter" to the Parisian bourgeoisie (see cats. 54 and 56). The fact that Renoir painted portraits also allowed him to reach people who were not normally patrons of the Impressionists and sometimes even to convert his models to the new painting. In 1892, the State purchase of Renoir's *Young Girls at a Piano*, 1892 (fig. 9, p. 48), established Renoir's official recognition, and from then on museums and collectors were eager to acquire his work. In 1919, the year of his death, he was awarded the Legion of Honor.

Monet's struggle to establish his reputation ended with the exhibition of 145 of his paintings, shown together with works by Rodin, at the Georges Petit Gallery in 1889. This was followed by the triumphant success that greeted his exhibition of fifteen paintings from his Haystacks series at Durand-Ruel's gallery in Paris in 1891. But, always commercially astute, Monet continued to sell his work privately and play Durand-Ruel off against other dealers such as Bernheim-Jeune. Throughout the 1890s, other series exhibitions were not only a culmination of the Impressionist commitment to the study of light and atmosphere but also a skillful marketing ploy. By 1900 Monet had become one of the world's most celebrated and wealthiest artists,[32] living the life of a country gentleman in his house and splendid garden at Giverny, where he played host to many journalists whose articles helped consolidate his position. His gifts of the large Water Lily paintings to a number of provincial museums in France—Grenoble (fig. 8), Le Havre, Nantes, and Vernon—in the 1920s and the state's decision in 1921 to adapt the rooms of the Orangerie in Paris to permanently house the great Water Lily panels sealed Monet's national reputation.

Although Pissarro was the only one of the Impressionists with work in all eight exhibitions, consistently refusing to show at the Salon, he had never been fully associated with the scandal of the avant-garde. Pissarro had to wait longer than Monet and Renoir before his works were sold and appreciated outside a small group of collectors. In February 1892, Durand-Ruel gave Pissarro his first great retrospective exhibition of over one hundred paintings, which at last canonized the artist. He was then over sixty. But it was not until 1897, with the final acceptance of the Caillebotte bequest, that his work was acquired by the State.

Degas eschewed the self-promotional tactics employed by Monet and Renoir, but, as Richard Kendall has shown, his legendary remoteness was partly cultivated.[33] He quietly created the illusion of an artist who did not exhibit and whose work was scarce. Although Degas more or less retired from active exhibiting after the eighth Impressionist exhibition in 1886, he continued to discreetly promote his own position by intermittently providing carefully selected collectors and dealers with groups of his works. Nevertheless, the full extent and range of his extraordinary output was revealed to a wider public only with the four sales of all the work he had hoarded in his studio, which were held in war-torn Paris in 1918, the year after his death.

Cézanne, in the early years of the Impressionist movement, was certainly the most misunderstood and reviled of the group. Discouraged by his lack of recognition, he had more or less cut himself off in his native Aix-en-Provence, and after 1886 a private income freed him from the need to sell his work, he made little

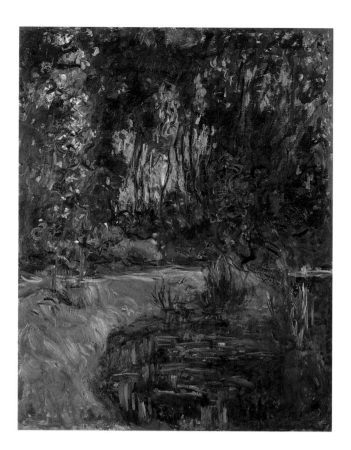

Fig. 8. Monet, *Corner of the Pond at Giverny*, 1917, oil on canvas, 46 × 32½ in., Musée de Grenoble.

attempt to promote himself. His first solo exhibition with the young dealer Vollard in 1895, therefore, caused a sensation and marked the beginning of his commercial success. Before this, he was really appreciated only by fellow artists, especially Gauguin, who once wrote of a painting by Cézanne he owned: "It's the apple of my eye, and except in case of dire necessity, I'll keep it until my last shirt's gone."[34] Cézanne's earlier vilification fueled his newfound cachet, and he became almost a cult figure for the avant-garde. He found influential spokesmen in the artists Émile Bernard and Maurice Denis, who made a pilgrimage to interview the great master of Aix and published his views on art.[35] He was canonized by the great retrospective exhibition of his work in 1907, the year after his death. After 1900 he became the model for the whole avant-garde, from Matisse to the Cubists.

A series of major retrospectives early in the century—Gauguin at the Salon d'Automne in 1903 (the year of his death), Manet at the Salon d'Automne in 1905, and van Gogh at the Indépendants in 1905, for example—conferred historical legitimacy on the Impressionists and heralded the more recent phenomenon of traveling museum exhibitions, which now attract millions of visitors and have enormously expanded the understanding of Impressionism by a wide international audience.

Equally, the whole apparatus of documentary scholarship—in the form of studies of the Impressionist movement as a whole, as well as monographs and catalogues raisonnés of the artists—has greatly enhanced our knowledge and appreciation of Impressionism. Such important contemporaneous studies as Edmond Duranty's *The New Painting* and Théodore Duret's *The Impressionist Painters*, both 1878, were followed by such later key works as Julius Meier-Graefe's *Modern Art*, published in German in 1904 and in English in 1908. The development of art history as an academic discipline since the Second World War has encouraged many new approaches to Impressionism. John Rewald's fundamental study *The History of Impressionism*, published in 1946, remains the point of departure, while more recent studies have explored the social contexts of Impressionism.[36]

This dissemination of information has, of course, contributed to the great rise in the prices paid for Impressionist paintings. Economic factors in the 1980s—such as inflation and an influx of wealthy private and corporate Japanese collectors—pushed the financial value of these works to unprecedented heights.

In terms of the broad public appreciation of Impressionism, it is probably true that its great popularity grew with the advent of the art movements that succeeded it in the early twentieth century. By the early years of this century, Impressionism was no longer avant-garde. It had been overtaken by Fauvism and then Cubism and Expressionism. In comparison with these apparently more "difficult" kinds of painting—Cubism with its more complex intellectual premise and the more discomforting emotional range of Expressionism—Impressionism benefited from its basic empathy with a wide audience.

Toward the end of his life, Cézanne claimed that he wanted to make of

Impressionism "something solid and durable like the art of the museums."[37] This reflected an aspiration shared by several of the other Impressionists—Degas, Renoir, and Manet, in particular—to invest their modern painting with something of the weight and monumentality of the old masters. Today, the Impressionist painters have attained—perhaps some would even say surpassed—the status of the old masters of the past and taken their place in our great museums.

NOTES

1. Maurice Denis, *Cézanne, théories, 1890–1910*, 4th ed. (Paris, 1920). Originally appeared in *L'Occident*, September 1907; cited in *Conversations avec Cézanne*, ed. P. Doran (Paris, 1978), p. 170.

2. Armand Silvestre, introduction to *Galerie Durand-Ruel: Receuil des estampes*, vol. 1 (Paris, 1873).

3. Renoir had sold the original version to the dealer Père Martin for 425 francs, the exact amount he needed to pay his rent; see John Rewald, *The History of Impressionism* (New York, 1973), p. 334.

4. See ibid., p. 354

5. Louis Leroy, "L'Exposition des Impressionistes," *Le Charivari* (25 April 1874); reprinted in Rewald, *Impressionism*, 1973, pp. 318–324.

6. The important exhibition *The New Painting, Impressionism 1874–1886*, exh. cat. (San Francisco, 1986), undertook the fascinating exercise of reconstructing the original eight Impressionist exhibitions and greatly expanded our knowledge of the range of artists who showed in the group and the diversity of paintings they presented.

7. See Joel Isaacson, *The Crisis of Impressionism*, exh. cat. (Ann Arbor, Mich., 1979) and *The New Painting*, 1986, pp. 189–202.

8. See Christopher Lloyd, "Britain and the Impressionists," pp. 65–76.

9. Ibid.; see also John House, *Impressionism for England: Samuel Courtauld as Patron and Collector*, exh. cat. (Courtauld Institute Galleries, London, 1994).

10. See Lukas Gloor, "Switzerland—At the Crossroads of French Impressionism's Reception in Europe," pp. 97–101.

11. *The New Painting*, 1986, and *The New Painting*, ed. Ruth Berson (San Francisco, 1996).

12. Jules Castagnary, "Exposition du boulevard des Capucines: Les Impressionistes," *Le Siècle* (19 April 1874): 3; reprinted in Berson, *The New Painting*, 1996, p. 15.

13. Albert Wolff article in *Le Figaro* (3 April 1876); cited in Rewald, *Impressionism*, 1973, pp. 368–370.

14. Charles Baudelaire, "Le Peintre de la vie moderne," (1863) in *The Painter of Modern Life and Other Essays*, trans. Jonathan Mayne (London, 1965).

15. Emile Cardon, "Avant le Salon: L'Exposition des révoltés," *La Presse* (29 April 1874): 2–3; reprinted in Berson, *The New Painting*, 1996, p. 13.

16. Emile Cajart, "L'Exposition du boulevard des Capucines," *Le Patriote français* (27 April 1874); cited in Berson, *The New Painting*, 1986, p. 109.

17. Pissarro to unknown correspondent, 5 January 1900. Janine Bailly-Herzberg, ed., *Correspondance de Camille Pissarro* (Paris, 1991), p. 64.

18. This may have been the work exhibited in the 1868 Salon, no. 2016, *L'Hermitage*. See Gary Tinterow, *Les Origines de l'Impressionisme*, exh. cat. (Paris, 1994), pp. 444–445, cat. no. 159.

19. Renoir to Durand-Ruel, March 1881. Lionello Venturi, *The Archives of Impressionism*, vol. 1 (Paris, 1939), pp. 120–122.

20. Monet to Duret, 8 March 1880; reprinted in Daniel Wildenstein, *Claude Monet: Biographie et catalogue raisonné*, vol. 1 (Lausanne, 1974), p. 438.

21. See Anne Distel, *Impressionism: The First Collectors* (New York, 1990).

22. See Merete Bodelsen, "Gauguin the Collector," *The Burlington Magazine* 112, no. 810 (September 1970): 590–615.

23. Ibid., p. 601.

24. See Görel Cavalli-Björkman, "The Reception of Impressionism in Scandinavia and Finland," pp. 91–96.

25. According to William Rothenstein; see Richard Kendall, *Degas Beyond Impressionism*, exh. cat. (London, 1996), p. 159.

26. See Venturi, *Archives of Impressionism*, 1939, for Durand-Ruel's letters to artists.

27. See John House, "Framing the Landscapes," in *Landscapes of France*, exh. cat. (London, 1995), p. 26.

28. Monet to Durand-Ruel, 18 October 1886. Wildenstein, *Claude Monet*, vol. 2, 1979, p. 284.

29. See House, *Landscapes of France*, 1995, p. 28.

30. See Robert Herbert, *Impressionism: Art, Leisure and Parisian Society* (New Haven and London, 1988).

31. Robert Jensen, *Marketing Modernism in Fin-de-Siècle Europe* (Princeton, 1994), p. 67.

32. According to Paul Tucker, Monet's income in 1912 was 369,000 francs. A manual laborer earned an average of 1,000 francs a year. See "The Revolution in the Garden: Monet in the Twentieth Century," in *Monet in the Twentieth Century*, exh. cat. (New Haven and London, 1998), p. 17.

33. See Richard Kendall, "Degas and the Market-Place," in *Degas Beyond Impressionism*, 1996, pp. 31–51.

34. Gauguin to Schuffenecker, June 1888. Victor Merthès, ed., *Correspondance de Paul Gauguin: Documents, témoignages*, vol. 1 (Paris, 1984), p.182; cited in *Cézanne*, exh. cat. (Philadelphia, 1996), p. 28.

35. Emile Bernard, "Paul Cézanne," *L'Occident* (July 1904): 17–30; Maurice Denis, "Définition du néo-traditionnisme," *Art et critique* (23 August 1890); reprinted in Denis, *Théories*, 1920, pp. 397–400.

36. Rewald, *The History of Impressionism* (New York, 1946); studies that have emphasized the social dimension are T. J. Clarke, *The Painting of Modern Life: Paris in the Art of Manet and His Followers* (New York, 1985), and Robert Herbert, *Impressionism: Art, Leisure, and Parisian Society* (New Haven and London, 1988).

37. See note 1.

Durand-Ruel's Influence on the Impressionist Collections of European Museums

CAROLINE DURAND-RUEL GODFROY

Paul Durand-Ruel devoted his life and energy to the Impressionists. From 1870 onward, with the help of his sons Joseph and Georges, he bought most of the work they produced—that is to say, thousands of paintings. His clients included almost all the great collectors of the Impressionist artists. He helped them build their collections, some of which are now the pride of the museums that house them. Durand-Ruel also offered museums favorable terms, writing in 1910: "We have always considered museum curators to be very special clients, and we are always willing to sell to them at a very small profit, and sometimes even at cost. That way we hope to create new clients among museum-goers; museums are our best advertisement."[1] The approach was both generous and shrewd. Having a work hung in a museum is of course excellent publicity for an artist, but it is much more difficult for a museum curator to buy a painting he likes than it is for a collector, especially when the painting seems too avant-garde. The curator must win the approval of a committee, while the collector has no one to please but himself.

It is astounding to note that even with favorable terms and Impressionism's increasing success after 1890 (and especially after 1900), of the thousands of works by Cassatt, Manet, Monet, Degas, Cézanne, Pissarro, Sisley, and Renoir to pass through the Durand-Ruel gallery's inventory or storerooms, less than one hundred were purchased directly by museums between 1896 and Durand-Ruel's death in early 1922.

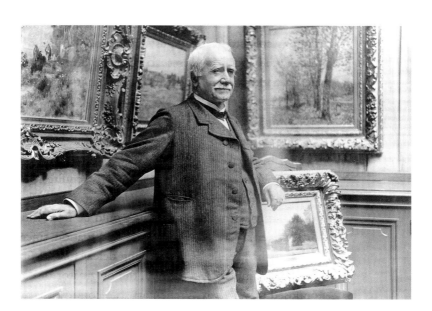

Fig. 1. Paul Durand-Ruel in the rue Laffitte, photographed by Dornac, ca. 1910.

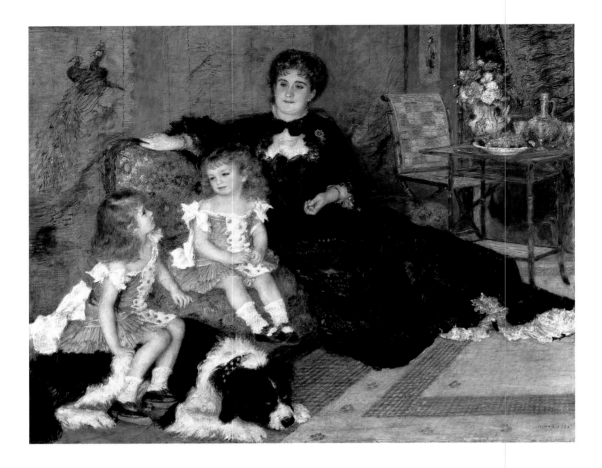

No sales were recorded from 1870 to 1895. American and Canadian museums bought some thirty paintings, and about sixty were sold elsewhere in the world. (The figure does not include paintings recorded as sold to intermediaries representing museums, the exact number of which is difficult to determine.) After 1886, Durand-Ruel no longer had an exclusive arrangement with the Impressionists, and was therefore in competition with other dealers.

The first American museum to buy an Impressionist painting from Durand-Ruel was the Carnegie Museum of Art in Pittsburgh, on 24 January 1899: a Sisley, mistitled *Village on the Banks of the Marne,* which actually depicts the banks of the Loing River at Saint-Mammès.[2] The first museum in Europe was the Berlin Nationalgalerie, through the efforts of its visionary curator Hugo von Tschudi, who bought one of Manet's masterpieces, *In the Conservatory* (fig. 1, p. 54), owned by the famous collector Jean-Baptiste Faure, on 8 August 1896.[3] Faure was asking 25,000 francs, and Tschudi offered 20,000. The deal was struck at 22,000 francs, once the dealer had made the point to Faure that it was perhaps "not a high offer, but the first serious one to come along in a long time."[4]

Durand-Ruel's most fruitful relationships in Europe were with German museums, with the help of Tschudi and the dealer Paul Cassirer, both of whom lived in Berlin. In April 1907 Durand-Ruel wrote to Roger Fry, the curator of New York's Metropolitan Museum, who wanted to acquire for that museum Renoir's superb *Madame Charpentier and Her Children* (fig. 2), which was about to go up for sale: "Your only serious competition would be from museums in Germany, like Berlin's or Dresden's."[5] This was an awkward situation, since the Franco-Prussian War of 1870–71 had resulted in a stinging defeat for the French, and they were deeply resentful. Emperor Wilhelm II, the originator of Pan-Germanism, was staunchly opposed to works by French artists—controversial representatives of an enemy

people, whose works were bought with donations from prominent members of Berlin's largely Jewish bourgeoisie—being given the honor of hanging on the walls of the most important museum in his own capital! As a result, Tschudi and Wilhelm II did not get along at all. Joseph Durand-Ruel reported that Tschudi was able to buy Impressionist paintings only by "digging into his friends' pockets to raise money."[6] Even so, Joseph wrote, Tschudi "[had] more problems than ever with the Emperor and German painters. He cannot even accept a 'new-style' work, as they call our school there, *as a gift*. He has come within an inch of being removed from his post."[7] Cassirer complained that Wilhelm II was exercising his influence in speeches and official acts to constrain "all his friends and all the wealthy within his circle to buy official artwork and sell off French paintings, which are no longer being bought."[8]

In 1908 Wilhelm II finally succeeded in removing Tschudi, who, in spite of everything, had managed to buy one Millet and ten Impressionist paintings from Durand-Ruel between 1896 and 1907: one Degas, four Monets, one Cézanne, one Toulouse-Lautrec, two Manets, and one Renoir. The purchases included wonderful paintings such as Cézanne's *Mill on the Couleuvre at Pontoise* (fig. 3), Sisley's *Early Snows,* and Monet's *Saint-Germain l'Auxerrois, Paris.*[9] Having left Berlin for good, Tschudi died in 1911 as director of the Staatliche Galerien in Munich, after enriching that museum's collections with two masterpieces by Manet from the famous Pellerin collection: *Luncheon in the Studio* and *The Barge* or *Monet Painting in His Studio.*[10] In 1912 Durand-Ruel gave the Munich museum a painting by Renoir, *Head of a Man, Soft Hat (Mr. Bernard)* for the room dedicated to Tschudi's memory.[11]

Paul Cassirer, at first with the help of his cousin Bruno, also played an important role in promoting Impressionism in Germany by encouraging museum curators to buy paintings by Impressionist artists. On the recommendation of art historian Julius Meier-Graefe in September 1898, Durand-Ruel began by sending Cassirer twenty-six works by Degas for an exhibition Cassirer was organizing at his gallery at 35 Victoriastrasse.[12] The two enjoyed such a good relationship that Durand-Ruel wrote to Gustav Pauli, curator of the Kunsthalle Bremen: "It would be better if you reached an agreement with Mr. Paul Cassirer in regard to the paintings you wish

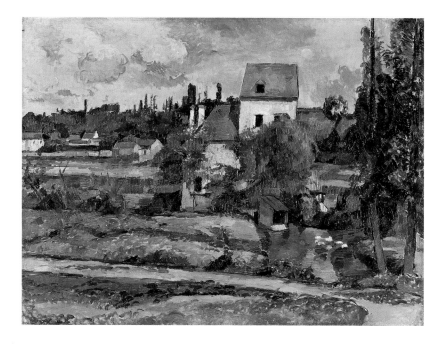

Fig. 3. Cézanne, *Mill on the Couleuvre at Pontoise,* 1881, oil on canvas, 28⅞ × 35⅝ in., Staatliche Museen zu Berlin, Nationalgalerie.

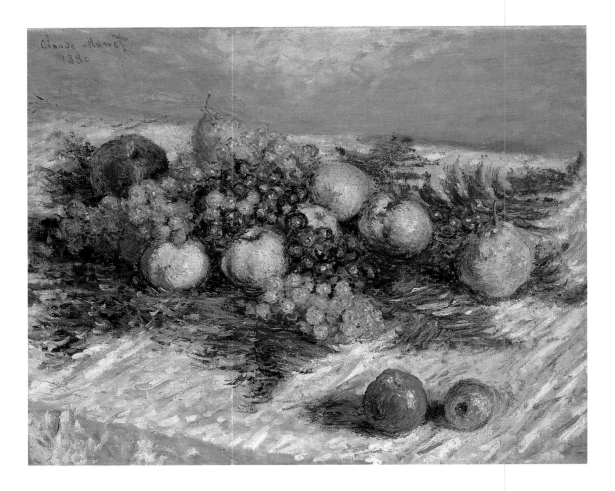

Fig. 4. Monet, *Pears and Grapes,*
1880, oil on canvas, 65 × 81 in.,
Hamburger Kunsthalle.

to hang by Renoir and Pissarro. Mr. Cassirer handles our paintings exclusively for
all Germany."[13] Thus, up through 1914, the Durand-Ruel gallery regularly sent siz-
able consignments of paintings to be offered for sale at Cassirer's gallery or exhibi-
tions held throughout Germany. In exchange, Durand-Ruel agreed to earmark
for Cassirer "10% on sales to German museums, which you have always handled
in particular, and on sales at exhibitions held in Germany by art associations or
museums."[14] In some instances the commission was even higher. In 1914 Durand-
Ruel agreed to "twenty percent of the prices stated on the list of paintings sent for
a show at the Bremen Museum, with the understanding, however, that we will not
cover the ten percent cut usually taken by the Museum. Such commission shall be
deducted from the aforementioned twenty percent."[15] Cassirer does not seem to
have taken a commission on paintings bought by the museums of Dresden, Elber-
feld (the future Wuppertal), and Weimar. Berlin was a special case, because Durand-
Ruel had known Tschudi before meeting Cassirer. Other museums that bought
paintings from Durand-Ruel through Cassirer included the Kunsthalle Bremen
(Renoir's *Madame Chocquet*), the Kunsthalle Mannheim (including Renoir's *Flowers,
Peonies* and Pissarro's *Bridge over the Viosne, Osny*), the Hamburger Kunsthalle
(Manet's *Portrait of Henri Rochefort* [cat. 28], although the museum had already
purchased a Monet, *Pears and Grapes* [fig. 4], in 1896), and the Städelsches Kunst-
institut und Städtische Galerie in Frankfurt.[16]

The Frankfurt museum seems to have had the least difficulty acquiring works
by Impressionist artists. In 1910 it bought superb paintings in rapid succession:
Monet's *The Luncheon,* Renoir's *The Luncheon*—which Joseph Durand-Ruel said
"had been seen in Paris by a few artists and collectors; it created such a stir that I
could have found a buyer immediately, if the painting had been for sale"—and,

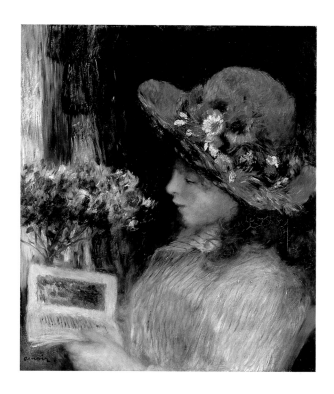

Fig. 5. Renoir, *Girl Reading,*
1886, oil on canvas,
21⅝ × 18⅛ in., Städelsches
Kunstinstitut und Städtische
Galerie, Frankfurt.

rarity of rarities, a painting from Paul Durand-Ruel's own collection, Renoir's *Girl Reading* (fig. 5).[17] The museum did not buy another Renoir from the same collection, *Cup of Tea.*[18] Dr. Fritz Wichert, curator of the Kunsthalle Mannheim, wanted to examine it, but Joseph Durand-Ruel refused, in spite of his strong desire to oblige the curator, giving the following reason: "Although we did agree to part with . . . two of Renoir's most beautiful paintings, one of which was hanging at rue de Rome . . . we cannot give up a third so soon afterward. Everyone would notice it was gone, and it would give the impression that our collection is for sale, which is certainly not the case."[19] Frankfurt's Städelsches Kunstinstitut und Städtische Galerie would soon buy a splendid Degas in 1913, *Orchestra Musicians,* with payments staggered through 1915.[20] Unfortunately the First World War intervened to break off these trusting relationships. When war was declared, Durand-Ruel had ninety-seven works in storage in Germany, and they would never be returned.

On 7 November 1898, Durand-Ruel sold his first painting to a new collector from the fringes of Europe, Sergei Shchukin, an extremely wealthy Muscovite. Although the impressive collection of 280 modern paintings Shchukin assembled during his lifetime cannot be considered a museum, since it was a private collection, Shchukin never made a secret of the fact that he intended the collection for the Russian people. He did not seek to recover it when his property was confiscated by the government. The collection was opened to the public in 1909, and in 1908 one of Shchukin's brothers, Pierre, also a client of Durand-Ruel, had asked to have three paintings he bought delivered to the following address: Shchukin Museum, Moscow, Russia.[21] It also appears that Pierre bought Renoir's *Female Nude, Anna* in 1898, a painting Paul Durand-Ruel considered "nothing short of a masterpiece."[22] Although Pierre Shchukin bought two other Impressionist paintings in addition to the Renoir—Cassatt's *Maternal Care* and Monet's *Landscape at Sainte-Adresse*—his primary interest lay in orientalist painting.[23] Sergei Shchukin, for his part, would purchase fourteen paintings from Durand-Ruel between 1898 and 1904: works by Forain, Monet (including *Pyramids at Port-Coton, Belle-Île* and a *Rouen Cathedral*), Puvis de Chavannes, Degas (including *Dancer at the Photographer's Studio*), and two works by Cézanne, including the extraordinary *Mardi Gras.*[24] He made his last purchase on 26 November 1904, trading a Monet, *The Thames, Waterloo Bridge,* which his wife no longer wanted, for another Monet, *Houses of Parliament, Seagulls.*[25] Sergei Shchukin's growing interest in artists such as Gauguin, van Gogh, Matisse, and Picasso would take him to dealers like Ambroise Vollard, but he was determined to bring his interest in Impressionism to Russia.

England was the country in which Durand-Ruel most desired to see Impressionist painters recognized. The British painter Joseph Mallord William Turner had been a strong influence for the Impressionists, and it was in London that Durand-Ruel had met Monet. The English had also been among the first to see works by the Impressionists in the New Bond Street gallery Durand-Ruel had rented from 1870 to 1875. But in 1904 the English public, "so stuck in a rut and opposed to all new art," persisted in ignoring the Impressionists, and in an effort to "wake them

Fig. 6. View of the central gallery of the Grafton Galleries during the Impressionist exhibition organized by Durand-Ruel in January–February 1905.

up a little" the dealer organized the most important and extraordinary Impressionist exhibition ever.[26] In January and February of 1905, Durand-Ruel presented 315 paintings at the Grafton Galleries, including 196 from his personal collection (fig. 6).

It was at this time that Durand-Ruel began to deal with Hugh Lane, an intrepid Irishman who the dealer would later say "demonstrated extraordinary energy and force of will. Alone and without money or support, he achieved his goals and succeeded in creating a museum for the city of Dublin, which it would never have been able to do without [his] efforts."[27] Of the fifteen paintings Lane bought from Durand-Ruel between 1904 and 1913, eight were painted by Impressionists, including a beautiful work by Morisot, *Summer's Day* (cat. 39).[28] His first purchase, on 11 October 1904, was a Puvis de Chavannes, an artist for whom Durand-Ruel also had a special admiration—*The Beheading of John the Baptist*.[29] That purchase was followed a few months later, on 8 April 1905, by three paintings: Pissarro's *View of Louveciennes* and Monet's *The Thames, Waterloo Bridge, Overcast* and *Snow Effect, Vétheuil 1881*.[30] This last work, which had been shown at the Grafton Galleries exhibition, was so well received by the critics that a number of journalists set up a fund to buy the painting and donate it to the British nation. The dealer held it for them until April 1905, and then sold it to Lane when the fund failed to collect enough money to purchase the painting.[31]

Lane also bought a masterpiece by Renoir, *The Umbrellas,* from Durand-Ruel in 1907.[32] Durand-Ruel did not care much for the work, considering it "not very saleable and full of faults."[33] He would later tell Lane that Renoir had begun "the painting in 1878 . . . and did not finish it until around 1885–86. . . . It is one of the paintings that demanded of him the most painstaking effort and hard work."[34] Lane also enriched his collection by making trades. For example, in 1906 he traded a beautiful Lancret, a Velasquez, and a Tiepolo along with 211,377.05 francs in cash (Durand-Ruel was still dealing in old paintings at that time) for a Puvis de Chavannes, *The Bath (La Toilette),* and two Manets, *Eva Gonzalès* and *Music in the Tuileries Gardens* (fig. 2, p. 66).[35]

Also in 1906, Durand-Ruel exhibited in London the wonderful Manets that

Faure wished to sell. Lane tried in vain to buy *On the Beach at Boulogne* and *The Absinthe Drinker.*[36] The British Museum, for its part, bought nothing, even though Faure offered the museum a twenty-five percent discount on *The Spanish Singer,* and two Seascape watercolors.[37] Thus, London remained the "rebel stronghold" against all Durand-Ruel's efforts.[38]

A number of British colonies proved themselves bolder and more discerning than their mother country. For example, in 1910 the museum of Johannesburg, South Africa, bought seven paintings from Durand-Ruel on Lane's recommendation, including a Monet, a Sisley, and a Pissarro.[39] In 1914 the National Gallery of Ottawa in Canada bought its first Impressionist works, a Monet and a Sisley.[40] Even further afield, in 1905 the museum of Melbourne, Australia, bought a Pissarro that had been shown at the Grafton Galleries exhibition, and in 1913, with the help of the Felton bequest, they purchased a Monet, a Sisley, and a Boudin.[41] These purchases illustrate the interest Impressionism was starting to stir up around the world.

In April 1912, Oskar Reinhart and Arthur Hahnloser of Winterthur bought works by Renoir from Durand-Ruel, marking the start of business relationships with Switzerland that would continue unaffected throughout the war, due to that country's neutrality.[42] With the help of the Galerie Bollag in Zurich and art consultant Charles Montag, with whom Durand-Ruel was in regular contact from then on, the Swiss discovered Impressionism. Collectors also played a crucial role as the founders of a number of museums, including the museum of Winterthur, built in 1916, and as the source of their funding. Thus, the Winterthur museum bought three paintings on 22 December 1916, through the efforts of Hahnloser, including a Renoir, *Flowers in a Vase,* and a Sisley, *Bend in the Loing River.*[43]

Although Durand-Ruel had no regular contact with museums in other European countries, the acquisition of Impressionist works was often helped along by exhibitions of a relatively official nature. For example, it was on the occasion of the 1907 Nemzeti Szalon in Budapest that the Budapest Szépművészeti Múzeum bought three paintings for 60,000 francs: a Daubigny, a Pissarro, and a Sisley.[44] In 1908, however, a shipment of paintings by Renoir, selected by the artist himself, did not meet with the approval of the museum committee, which then made what Durand-Ruel regarded as "ridiculously low offers" on other Impressionist paintings, demonstrating that "the committee members are not well-informed as to the market value of works from the Modern School."[45]

In the spring of 1914, a large exhibition was held in Copenhagen.[46] Durand-Ruel contributed twenty-six paintings, including Manet's *The Execution of Maximilian,* which was bought by Copenhagen's Statens Museum for Kunst for 30,000 francs.[47] The exhibition was extended through 12 July, and all the paintings do not appear to have been shipped back to Paris before war was declared. As a result, in 1917 the Ny Carlsberg Glyptotek would buy another Manet, *The Absinthe Drinker,* for 125,000 francs.[48] Durand-Ruel had asked 135,000 francs, although it was "clear," he wrote, "that after the war, when transportation difficulties ease, we can sell it in the United States for a much higher price than you paid."[49] In like fashion, Durand-Ruel, during a 1920 exhibition in Bilbao, Spain, accepted an offer of 25,000 francs for Cassatt's *Seated Woman Holding a Child,* for which he was asking 35,000 francs, "on the assumption that the acquisition was intended for a museum."[50]

A few countries, such as Holland and Italy, are missing from the list, although Durand-Ruel took advantage of the opportunities presented by exhibitions to send paintings. More strikingly, no Belgian museum showed an interest in Impressionism,

Fig. 7. View of the Durand-
Ruel gallery, 16, rue Laffitte,
during a Renoir exhibition
from 29 November to
18 December 1920.

in spite of the fact that Durand-Ruel had an enthusiastic and influential ally in
Octave Maus, whose La Libre Esthétique group exhibitions were an important cul-
tural event each year.

At the time of Durand-Ruel's death, most European museums had opened
up to Impressionism somewhat, but resistance was still strong, and museum acquisi-
tions did not equal those by collectors. Unfortunately, European museums did not
or could not take advantage of the opportunity they had to buy Impressionist works
on favorable terms from Durand-Ruel, whether the works were considered trou-
bling, too expensive, or, worst of all, uninteresting. In most cases, it was the highly
developed taste and energy of a determined individual that opened up museum
collections to Impressionism, and it is primarily through bequests and donations that
Impressionism has come to be represented in those collections.

NOTES

1. Paul Durand-Ruel to Paul Cassirer, 5 Janu-
ary 1910. Unless otherwise noted, all letters
cited are in the Durand-Ruel archives.

2. *Village au bord de la Marne;* see François
Daulte, *Alfred Sisley: Catalogue raisonné*
(Lausanne, 1959), no. 422.

3. *Dans la Serre;* see Denis Rouart and Daniel
Wildenstein, *Édouard Manet: Catalogue raisonné*
(Lausanne, 1975), no. 289.

4. Paul Durand-Ruel to Jean-Baptiste Faure,
3 August 1896.

5. *Portrait de Madame Charpentier et de ses
enfants,* bought by Durand-Ruel at the
Charpentier sale of 11 April 1907 for the
Metropolitan Museum; see François Daulte,
Auguste Renoir: Catalogue raisonné (Lausanne,
1971), no. 266. Paul Durand-Ruel to Roger
E. Fry, 5 April 1907.

6. Joseph Durand-Ruel to Paul Durand-Ruel,
20 August 1902.

7. Joseph Durand-Ruel to Claude Monet,
25 November 1901.

8. Joseph Durand-Ruel to Paul Durand-Ruel,
20 August 1902.

9. *Le Moulin sur la Couleuvre à Pontoise,* bought
25 October under the title *Landscape (Paysage);*
see Lionello Venturi, *Cézanne: Son art, son
oeuvre* (Paris, 1936), no. 324. *Les Premières
neiges,* bought 25 October 1897; see Daulte,
Sisley, 1959, no. 18. *Saint-Germain l'Auxerrois,
Paris,* bought 22 September 1906; see Daniel
Wildenstein, *Claude Monet: Biographie et cata-
logue raisonné* (Lausanne, 1974), no. 84.

10. *Le Déjeuner dans l'atelier;* Rouart-
Wildenstein, *Manet,* 1975, no. 135. *La Barque
ou Monet peignant dans son atelier;* ibid.,
no. 219.

11. *Tête d'homme, chapeau mou (M. Bernard)* (*Portrait of Monsieur Bernard Wearing a Soft Hat in Profile [Portrait de Monsieur Bernard au chapeau mou de profil]*), donated by Durand-Ruel on 24 January 1912; Daulte, *Renoir,* 1971, no. 342.

12. The show *Ausstellung von Werken von Max Liebermann, H. G. E. Degas und Constantin Meunier* was held from 1 November to 1 December 1898.

13. Paul Durand-Ruel to Kunsthalle Bremen Curator Gustav Pauli, 25 November 1901.

14. Georges Durand-Ruel to Paul Cassirer, 24 February 1913.

15. Joseph Durand-Ruel to Paul Cassirer, 22 January 1914.

16. *Portrait de Madame Chocquet;* Daulte, *Renoir,* 1971, no. 173. *Madame Chocquet Standing (Portrait de Madame Chocquet debout),* bought 23 March 1910. *Fleurs, pivoines,* bought 1 March 1912. *Le Pont sur la Viosne, Osny,* bought 1 March 1912; see Ludovic R. Pissarro and Lionello Venturi, *Camille Pissarro: Son art, son oeuvre* (San Francisco, 1989), no. 300. *Portrait de Henri Rochefort,* bought by Cassirer on 19 December 1907 for the Hamburger Kunsthalle; Rouart-Wildenstein, *Manet,* 1975, no. 366. *Fruits divers,* bought 9 December 1896; Wildenstein, *Monet,* 1974, no. 651.

17. *Le Déjeuner,* bought 23 March 1910; Wildenstein, *Monet,* 1974, no. 132. *Le Déjeuner,* bought 28 June 1910; Daulte, *Renoir,* 1971, no. 288. Joseph Durand-Ruel to Georg Swarzenski, curator of Frankfurt's Städelsches Kunstinstitut und Städtische Galerie, 19 April 1910. *Jeune fille lisant,* bought 28 June 1910; ibid., no. 333.

18. *La Tasse de thé;* Daulte, *Renoir,* 1971, no. 272.

19. Joseph Durand-Ruel to Georg Swarzenski, 15 July 1910.

20. *Musiciens à l'orchestre,* bought 4 January 1913; Paul-André Lemoisne, *Degas et son oeuvre* (Paris, 1954), no. 295.

21. Joseph Durand-Ruel to Mr. Marcerou and Mr. Schreier, 24 July 1908.

22. *Femme nue, Anna,* bought 11 October 1898; Daulte, *Renoir,* 1971, no. 213. Paul Durand-Ruel to Pierre Shchukin, 19 November 1898.

23. *Solicitude maternelle,* bought 17 April 1899; see Adelyn Dohme Breeskin, *Mary Cassatt: A Catalogue Raisonné* (Washington, D.C., 1970), no. 225. *Paysage à Sainte-Adresse;* it has not been possible to identify this painting, for which no photograph is found in the Durand-Ruel archives.

24. *Pyramides de Port-Coton, Belle-Île,* bought 10 November 1898; Wildenstein, *Monet,* 1974, no. 1084. *Cathédrale de Rouen,* bought 22 October 1902 under the title *The Portal of St. Alban's Tower (Le Portail de la tour d'Albane);* ibid., no. 1350. *La Danseuse chez le photographe,* bought 19 November 1902; Lemoisne, *Degas,* 1954, no. 447. *Mardi-Gras,* bought 17 November 1904; Venturi, *Cézanne,* 1936, no. 552.

25. *La Tamise, Waterloo Bridge,* bought 25 November 1904 and returned the next day; Wildenstein, *Monet,* 1974, no. 1565. *Le Parlement, les mouettes,* bought 26 November 1904; ibid., no. 1613.

26. Paul Durand-Ruel to Charles Deschamps, 21 July 1904. *Pictures by Boudin, Cézanne, Degas, Manet, Monet, Morisot, Pissarro, Renoir, Sisley, Exhibited by Messrs. Durand-Ruel and Sons of Paris.*

27. Paul Durand-Ruel to François Thiébault-Sisson, 7 March 1908.

28. *Jour d'été,* bought 12 December 1912 under the title *On the Lake of the Bois de Boulogne;* M.-L. Bataille and Georges Wildenstein, *Berthe Morisot: Catalogue des peintures, pastels et aquarelles* (Paris, 1961), no. 79.

29. *La Décollation de Saint-Jean Baptiste,* bought 11 October 1904.

30. *Printemps à Louveciennes,* bought 8 April 1905; Pissarro-Venturi, *Pissarro,* 1989, no. 85. *La Tamise, Waterloo Bridge, Temps couvert,* bought 8 April 1905; Wildenstein, *Monet,* 1974, no. 1556. *Effet de neige, Vétheuil,* bought 8 April 1905; ibid., no. 511.

31. Georges Durand-Ruel to Frank Rutter, 4 April 1905.

32. *Les Parapluies,* bought 11 November 1907; Daulte, *Renoir,* 1971, no. 298.

33. Paul Durand-Ruel to Durand-Ruel, New York, 9 November 1907.

34. Paul Durand-Ruel to Hugh Lane, 13 November 1907.

35. *Portrait d'Eva Gonzalès* and *La Musique aux Tuileries;* Rouart-Wildenstein, *Manet,* 1975, nos. 154 and no. 51. On 29 May 1906, Hugh Lane traded a Lancret, *Gay Party,* a Velasquez-Mazo, *Portrait of a Woman,* and a Tiepolo, *Virgin and Child Adored by Saint Janvier and a Dominican Monk,* plus a sum of money to Durand-Ruel for a Puvis de Chavannes and the two Manets.

36. *Sur la Plage de Boulogne;* Rouart-Wildenstein, *Manet,* 1975, no. 148, under the title *La Plage de Boulogne. Le Buveur d'absinthe,* later sold by Durand-Ruel to the Ny Carlsberg Glyptotek; ibid., no. 19.

37. *Marine, mer agitée;* ibid., no. 248. *Le Chanteur espagnol,* reduced from 12,000 to 9,000 francs; ibid., no. 32. The second watercolor was probably *Calm Sea (mer calme);* ibid., no. 247. The two seascapes were offered for 3,000 instead of 4,000 francs.

38. Paul Durand-Ruel to Claude Monet, 20 July 1904.

39. On 14 April 1910, Durand-Ruel sold seven paintings to Hugh Lane: two Boudins, one Puvis de Chavannes, one Albert André, Monet's *Spring (Le Printemps,* Wildenstein,

no. 273), Pissarro's *The Forest* (*Le Forêt,* Pissarro-Venturi, no. 91), and Sisley's *Shoreline near Veneux 1883* (*Bords de l'eau à Veneux 1883,* Daulte, no. 410).

40. Monet's *Waterloo Bridge, Sun Shining through Fog* (*Waterloo Bridge, le soleil dans le brouillard,* Wildenstein, no. 1573), and Sisley's *Washers near Champagne* (*Laveuses près de Champagne,* Daulte, no. 466).

41. *Boulevard Montmartre, Overcast Morning, 1887* (*Boulevard Montmartre, matin, temps gris, 1887),* bought 16 March 1905; Pissarro-Venturi, *Pissarro,* 1989, no. 992. Monet's *Foul Weather at Étretat* (*Mauvais temps à Étretat,* Wildenstein, no. 826), Sisley's *Haystacks, Morning Effect, 1891* (*Meules de paille, effet du matin, 1891,* Daulte, no. 772), and Boudin's *The Fort of Le Havre, 1892* (*Le Fort du Havre, 1892);* bought 14 August 1913.

42. Reinhart bought a Renoir, *Landscape (Paysage),* on 13 April 1912, and Hahnloser bought two Renoirs bearing the same title, *Landscape (Paysage),* on 30 April.

43. Renoir's *Vase de fleurs, 1901,* and Sisley's *Tournant, le loing, 1892* (Daulte, no. 811), together with Albert André's *Chrysanthemums in a Vase, 1908* (*Vase de chrysanthèmes, 1908).*

44. Daubigny's *The Outskirts of Villerville* (*Environs de Villerville),* Pissarro's *Le Pont-Neuf*

(Pissarro-Venturi, no. 1211), and Sisley's *Banks of the Loing River, Autumn Effect, 1881* (*Bords du Loing, effet d'automne, 1881,* Daulte, no. 420); bought 2 October 1907.

45. Paul Durand-Ruel to Gábor Térey, curator at the Szépművészeti Múzeum, Budapest, 6 July 1908.

46. *Fransk Materkonst des 19. Jaarhonderts,* held at the Museum of Copenhagen.

47. *L'Éxécution de Maximilien,* bought 27 May 1914 under the title *The Death of Maximilian* (*La Mort de Maximilien);* Rouart-Wildenstein, *Manet,* 1975, no. 125.

48. See note 36.

49. Georges Durand-Ruel to Frederic Poulsen, secretary of the Ny Carlsberg Glyptotek Foundation, 3 February 1917.

50. This exhibition, the exact name and dates of which have been impossible to recover, was organized under the aegis of the French Cultural Commission (Commissariat Général de la Propagande). *Femme assise tenant un enfant dans ses bras,* bought 22 January 1920; Breeskin, *Cassatt,* 1970, no. 178. Joseph Durand-Ruel to the Secretary of the Basque Cultural Commission (*Junta de Cultura Vasca),* 10 January 1920.

The Impressionists and France, 1865–1914
Artists Scorned, Artists Admired

MONIQUE NONNE

The enthusiasm for the Impressionists shown by today's public is undeniable, and the crowds at the exhibitions of their works as well as the sale of reproductions bear witness to their popularity. The sun-filled landscapes, peaceful family scenes, and cityscapes captivate the museum-goer, who wonders why these artists were not readily accepted by their own contemporaries. The public, which tends to measure an artist's genius by the degree of misunderstanding his work engenders during his lifetime, has encouraged the myth of these artists as rebels. While as a group they did meet with some general hostility, by the 1880s the mood had changed, so that during their lifetimes the Impressionist painters attained a certain fame, and even glory.

THE IMPRESSIONISTS BETWEEN THE PAST AND THE FUTURE

For almost twenty years the Impressionists did face problems. In 1865, Renoir, Pissarro, Morisot, Degas, and Monet—almost all of the first group of Impressionists—were accepted by the Paris Salon jury and thus exhibited at the Palais de l'Industrie. Cézanne's works were refused that year, as they would be for many years to come. Cézanne, like his fellow artists, nevertheless continued to try to gain entry to the Salon, since his only thought was to pursue that traditional career which would bring him official recognition. The future Impressionists had all received academic schooling. In fact, beginning in 1862 they made each other's acquaintance in the studios of their teachers, all officially recognized artists. Renoir, Bazille, Monet, and Sisley studied with Gleyre. Pissarro, Cézanne, and Guillaumin were at the Académie Suisse, where Monet also worked.

EXHIBIT, BUT HOW?

During this period, Monet was somewhat successful at the Salon, especially in 1866 with his painting *Camille (The Green Dress)*. He tried to widen his clientele by sending this painting to the provincial Salons organized in imitation of the Parisian model. He first sent *Camille* to Bordeaux and then to Le Havre, where it found a buyer.[1] For Monet the established system seemed to work, which was fortunate since at this time private exhibitions were the rare exception. The Salon, especially the Salon in Paris, was the only possible salesroom for the professional artist. It provided artists with the unique occasion to present their works to the public. In the hope of being admitted to exhibit, painters and sculptors were required to first submit their entries to the jury. Once accepted, being awarded a prize attracted attention and guaranteed the support of the State. Public money went to commissioning works and was increasingly used

Fig. 1. Cover for the catalogue
of the first Impressionist
exhibition, Paris, 1874,
Bibliothèque Nationale de
France, Paris.

to purchase works for museums and administrative buildings. The public, which turned out in large crowds, provided a source of potential collectors. The publicity lavished on the Salon by the flourishing press was of major importance.[2] The accounts of the Salons were closely followed. The Salon entries were described in detail, since the art critics wrote as many as six to ten articles, and sometimes even more, each several columns long.

Despite the legendary severity of the jury, the number of artists exhibiting at the Salon steadily increased, causing traditional structures to overflow. While in 1852 there were a total of 1,757 works exhibited, by 1870 the catalogue contained 5,434 items, including almost 3,000 paintings. With various degrees of success, Bazille, Monet, Renoir, Sisley, Pissarro, and Cézanne all submitted their paintings to the Salon juries. When fortune did not shine on them, they joined in the protests of their fellow artists, requesting the opening of exhibition space for the "*refusés*."[3] In this spirit, Cézanne sent a request dated 19 April 1866 to the Count de Nieuwerkerke, Minister of Fine Arts.[4] The next year, a petition "supported by all the first-rate painters in Paris" was signed by almost three hundred artists, including Cézanne, Manet, Monet, Pissarro, Renoir, and Sisley.[5] More than one artist began to lose patience with the rules and regulations of the Salon. Gradually the idea emerged of creating an association of artists, which would organize unrestricted exhibitions.[6] By 1866 the subject was broached, and the next year some artists began to consider exhibiting outside of the Salon.

Degas, Monet, Pissarro, and Sisley decided not to show their paintings at the Salon of 1872, and at the same time the works of Cézanne and Renoir were rejected.[7] Finally in 1873 an alternative was planned, and in 1874—one month before the opening of the official Salon—an exhibition of the work of thirty artists was inaugurated (fig. 1). These artists were the group who often met together at the Café Guerbois, along with a few other friends. Manet, who was part of this group, refused to exhibit with them. The results were disappointing, but they persevered, organizing three more exhibitions by 1879, for a total of eight by 1886.[8]

The Société Anonyme des Artistes, Peintres, Sculpteurs, et Graveurs, created in order to open a new market for its members' works, was deemed an honorable undertaking, especially by the republican newspapers, even if the works exhibited inspired some rather scathing criticisms. The official Salon continued to be the best and only route to prestige and prosperity, and as disagreements broke out among the society's artist members, several once again tried their luck with the Salon jury.[9] From the very beginning, Manet, whose *Le Bon bock*[10] was a genuine success in 1873, had never considered joining his friends. Many regarded the Impressionist group's undertaking as especially risky. Thus Duret urged Pissarro not to join in: "You have only one more step to take. You must become known to the public and be accepted by all the art dealers and collectors. The only way to do this is through the auctions at the Hôtel Drouot and the major exhibition at the Palais de l'Industrie."[11] By 1876 Cézanne stopped exhibiting with the Impressionists and once again tried in vain to overcome the opposition of the jury. In the Salon of 1879, Renoir exhibited *Madame Charpentier and Her Children (Portrait de Madame Charpentier et de ses enfants,* fig. 2, p. 30).[12] Thanks to the influence exercised by the sitter, the painting was prominently displayed. The praise it received encouraged Renoir to continue

40 NONNE

along the same course. He explained to Durand-Ruel that "in Paris there are only about fifteen collectors who would be capable of appreciating a painter without the Salon. There are about 80,000 who would never dream of buying even a square inch of canvas by a painter who did not show at the Salon. . . . I exhibit at the Salon for commercial reasons. At any rate, it is like some medicines—they may not help but at least they don't do any harm."[13] Renoir's success convinced Monet and Sisley to try their luck the next year. For Sisley, "We still have a long way to go before we can disregard the prestige gained from official exhibitions."[14] However, the results were disappointing. Sisley's works were refused, while Monet's and Renoir's were badly hung.[15] Gradually the Impressionists began to lose interest in the Salon, which, beginning in 1881, was managed by a group of artists joined together to form the Société des Artistes Français. For the Impressionists, the possibilities to exhibit their works in more satisfying conditions began to multiply.

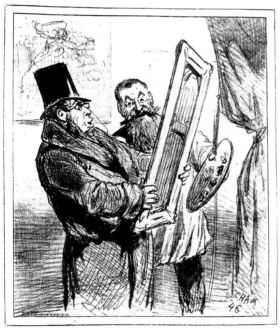

LE PEINTRE IMPRESSIONNISTE.
— Mais ce sont des tons de cadavres ?
— Oui, malheureusement je ne peux pas arriver à l'odeur !

Fig. 2. Bertall [Charles Albert d'Arnoux], *Camille, or the Cavern, by Monet,* "Le Salon de 1866," *Le Journal amusant,* 12 May 1866, Bibliothèque Nationale de France, Paris.

Fig. 3. "But these are the colors of a corpse!" Painter: "Yes, but unfortunately I can't get the smell." Cham, "Le Peintre Impressionniste," *Le Charivari,* 26 April 1877, Bibliothèque Nationale de France, Paris.

EXHIBITING IN ORDER TO ATTRACT THE ATTENTION OF THE PRESS

In the Salons of the 1860s, when they did attract the attention of the critics, the entries of the future Impressionists were not especially controversial. Paul Mantz noted Monet's taste for harmonious colors and his "audacious manner of seeing things."[16] Pissarro was remarked for his "candid [view] of nature."[17] Monet painted with "energy and vitality." His *Camille* was honored by being caricatured, thus providing the young artist with invaluable publicity (fig. 2).[18] Manet alone unleashed the furies in 1865 with *Olympia.*[19] As for Cézanne, even though his work continued to be refused at the Salon, it still inspired derision.[20] Nonetheless, Émile Zola, Cézanne's friend and fellow native of Aix-en-Provence, who began his career as a literary critic for the daily paper *L'Événement,* declared in the issue of 30 April 1866, "I set myself up as the defender of reality."[21] The young artists could also count on Castagnary, who defended the naturalists and Courbet; on Duret, fervent admirer of Pissarro; and also on Ernest Chesneau, partisan of the "modern artists."[22]

After the first group exhibition of the Impressionists in 1874, defending them became more difficult. The public was shocked by the sketchy quality of their works. They suspected that the rapid execution betrayed insufficient training—a lack of "skill and knowledge." Such reproaches had already been aimed at Manet, who was accused of working too quickly. The Impressionists violated the taboo against anything other than a highly finished, irreproachably drawn painting. The viewer, who appreciated skillful modeling and subtle chiaroscuro, had no way of understanding what he was seeing (fig. 3).

Monet's painting *Impression, Sunrise (Impression, soleil levant),*[23] which gave its name to the movement, was the focal point of the scandal (fig. 4). It introduced a universe in which only the sun and the signature were clearly present. Monet painted what was most intangible—the air, the vaporous haze, the glittering water— the masts of the boats were only barely suggested. The visitor, unaccustomed to

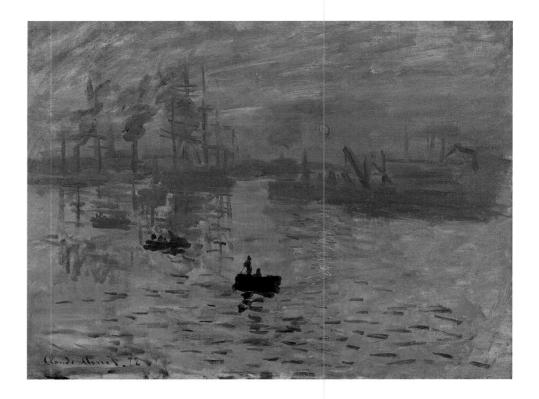

stepping back in order to grasp the whole image, had difficulty reading the painting. Confused, he made fun of what he saw and did not understand, and the press, accustomed to classifying artists by "schools," sought a term to define this new way of painting. Louis Leroy, the facetious critic for *Le Charivari,* took up the title of Monet's painting and spoke of "Impressionism." The word, soon used by the painters themselves, endured for posterity.[24] Elsewhere the press promoted Manet to the "chief of the School of Smudges and Spots,"[25] establishing his relationship to the group despite the fact that he exhibited separately.

The second exhibition, organized by the group in 1876, inspired an even more negative reception (figs. 5, 6). "Five or six maniacs including a woman, a group of unfortunates stricken with the folly of ambition, have gotten together to exhibit their works." Most of the visitors broke into laughter and condemned each and every one of the exhibitors, who "took canvases, paint and brushes and randomly threw together a few colors and signed the result."[26] It was not only the technique that was being questioned. The representation of ordinary, everyday subjects was considered discordant. While Castagnary admired Pissarro's "sober and strong" painting, he condemned his "deplorable partiality for truck market gardens . . . never hesitating to represent some cabbage or other domestic vegetable," a manifestation of the "taste for the vulgar."[27]

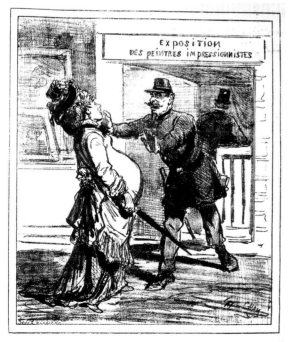

— Madame! cela ne serait pas prudent. Retirez-vous!

Faced with such a thorough lack of understanding, Georges Rivière attempted to explain what his friends were doing. He created a review, *L'Impressionniste,* which appeared every Thursday during the 1877 exhibition (fig. 7). Only four issues were published, and Rivière, assisted by Edmond Renoir, the brother of the artist, wrote almost all the articles. Nevertheless, even if Louis Leroy continued to be amused by

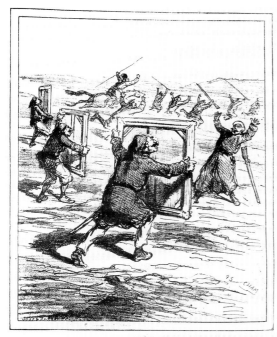

Fig. 6. "The Turks bought several canvases at the Impressionist Exhibition for use in battle." Cham, "Bien féroce!" *Le Charivari,* 28 April 1877, Bibliothèque Nationale de France, Paris.

Fig. 7. *L'Impressionniste, journal d'art,* 21 April 1877, Bibliothèque Nationale de France, Paris.

"this delicious farce called the Impressionist Exhibition," other writers began to think that the hostility was perhaps "the clumsy, somewhat primitive expression of a profound bewilderment."[28] The press sought to characterize the personalities of the artists—their styles. It was admitted that certain artists could have been good painters "if only they would try to paint like everyone else."[29]

In Pau, the provincial newspapers echoed the agitation in Paris.[30] The Pau Society of the Friends of the Arts—whose vice president, Alphonse Cherfils, and secretary, Paul Lafond, were friends of Degas—invited several of these artists that were causing such an uproar in Paris. Exhibiting in 1876 were Degas, Manet, Morisot, Pissarro, and Renoir, as well as Jules Le Coeur, who was a friend of Renoir and Sisley and whose uncle was the curator of the museum.[31] In 1877 the newspapers wrote once again about the presence of "a fair number of canvases belonging to the 'school of intransigents,'" which others described as the "degenerates of realism," while still others praised the works that were exhibited.[32] Amid the almost general hostility, the promoters of this enterprise nevertheless renewed their experiment the next year. Moreover, the Society of Friends purchased for the museum Degas's large canvas *Portraits in a New Orleans Cotton Office* (*Portraits dans un bureau de coton à la Nouvelle-Orléans,* fig. 8). Pissarro and Sisley also found buyers for their works.[33]

EXHIBITING IN ORDER TO SELL

While Manet, Degas, Morisot, Bazille, and Cézanne all enjoyed a certain financial ease, such was not the case for Monet, whose father refused to help him, or for Pissarro, who had a family to support. In the same way, for Renoir, of modest origins, as for Sisley, after the financial ruin and death of his father in 1870, the search for collectors was vitally important, since mutual aid was not enough. Renoir struck up a friendship with the painter Le Coeur and found benevolent patrons within his family.[34] For a certain time, Monet was fortunate enough to count among his clients the shipper Louis-Joachim Gaudibert, who commissioned a portrait of his wife and purchased several other paintings.[35] However, it was above all among the "intrepid

collectors" cited by Duret that the Impressionists were to find lasting support. The description was merited, since a strong character and a great deal of conviction were necessary to publicly purchase paintings that were so denigrated. Most were friends. They were a handful of early advocates: "Men who earlier had already proven their good taste by amassing works by painters like Delacroix, Corot, Courbet today take pleasure in building collections of works by the Impressionists."[36] Among them was the merchant Ernest Hoschedé, who, two months before the group exhibition in 1874, was forced to put his collection up for sale.[37] Collectors hastened to bid, and the prices attained by the "very young" who were facing "public auction for the first time" astonished quite a few.[38] The effects of the auction at Drouot were felt as far away as Pontoise. "It is very surprising that one of my paintings could go for as much as 950 francs, and one man even said that it was astonishing for a simple landscape," Pissarro wrote to Duret.[39] Among the buyers was Dr. Georges de Bellio, who would continue to actively support the group, the dealer Tibulle Hageman, and a collector, Étienne Baudry, a friend of Duret. There is no doubt but that these results reinforced the artists' desire to exhibit as a group.

The names of several collectors who had lent works were mentioned in the catalogue of the 1874 exhibition. Dr. Paul Gachet, a friend from the very beginning, sent a Cézanne and a Guillaumin. Henri Rouart, an industrialist and painter who exhibited with his friends, lent a Degas. Manet can be found as the owner of a canvas by Morisot. The hostile newspapers were amazed that there were buyers for such paintings. "They nevertheless have some rare fanatics, and according to the catalogue M. Faure, the illustrious singer, is the fortunate owner of several canvases exhibited on rue Le Peletier."[40] The journalists were quick to make fun of the famous baritone. "It is true that M. Faure has always liked to attract attention. Buying paintings by Cézanne is as good a way as any other to be conspicuous and to gain a singular publicity."[41]

Despite the support of friends, the first exhibition was a failure. In 1875 Renoir, Monet, and Sisley, joined by Morisot, decided to resort to a public auction at the

famous Hôtel Drouot in order to raise some money.[42] The result was a disaster. Monet was obliged to buy back two canvases that did not even attain 110 francs. There was a great uproar, and the auctioneer, Charles Pillet, "had to call in the police in order to prevent the arguments from degenerating into actual battles."[43] Among the purchasers there were the regulars like Rouart, and Caillebotte—who would soon exhibit with the group—and "new" collectors whose friendship was to prove invaluable—the publisher Charpentier, as well as Chocquet, an office worker.[44] These daring individuals were characterized by their urge to proselytize—not only did they buy but they also tried to convince others to follow them. Chocquet's actions were especially surprising: "He had to be seen during the first years of the Impressionist exhibitions, standing up to the hostile crowds, challenging those who laughed, making them ashamed of their mockery." He dragged the "unwilling art lover in front of the canvases by Renoir, Monet, or Cézanne and did his best to convince the individual to share in his admiration for the reviled painters."[45]

SELLING WITH THE AID OF ART DEALERS

At first, very few dealers were interested in the young generation, but after 1880 they played a crucial role in establishing the structures that provided the means of exhibiting outside of the Salon. Their galleries were concentrated on the right bank of the Seine, in the lively quarter of the "grand boulevards," south of Montmartre. The rue Laffitte especially became "a sort of permanent Salon, an exhibition of painting which lasted all year."[46] These dealers, who were also art suppliers, encouraged the first exhibitions. They included Père Martin, who had sold many of the works of the Barbizon School painters, but beginning in 1867 took an interest in Pissarro. In 1874 he was the provisional manager of the newly formed Société Anonyme, and he lent to the second exhibition, as did Louis Legrand and Louis Latouche. Pissarro bought his art supplies from Latouche, often paying his bills with his paintings. The name of Latouche can also be found on the original founding statutes of the corporation and among its exhibitors. Another, Père Tanguy, met Cézanne through Pissarro in 1872. Right up to his death, he proved a faithful friend of all the avant-garde movements. The private dealer Alphonse Portier was "the intelligent and friendly organizer of the exhibitions of the painters of the new school."[47] Among these devoted individuals there was also Durand-Ruel, who in 1876 showed the group in his galleries. In 1871 in London, Daubigny had introduced him to Monet and Pissarro, who had also gone there seeking refuge during the Commune. The dealer bought one painting from Monet and two from Pissarro. Upon his return to Paris at the end of the hostilities, Durand-Ruel became one of the principal supporters of the group. His dynamism and commercial inventiveness led the way for a new breed of art dealer. It was in his galleries that the merchant Ernest Hoschedé bought his paintings in 1873. Durand-Ruel allowed himself to be converted and in turn converted the collectors of the "realists" like Count Doria. But beyond the traditional role of intermediary, he organized the market with a preference for one-man exhibitions that valorized the production and personality of the individual artist. This changing point of view would be confirmed in the following decades.[48]

THE NEW ERA

Important changes came about in the 1880s. Each of the last four exhibitions of the group marked a reduction in the number of exhibitors drawn from the founding

group of Impressionists. In 1881 the only remaining members of the original team were Degas, Pissarro, and Morisot. The next year, after long negotiations, Durand-Ruel succeeded in convincing Pissarro, Renoir, Morisot, Sisley, Monet, and Caillebotte to continue to exhibit with the group, but this would be the last time. By 1886 everything had changed. Invited by Pissarro, Seurat and Signac exhibited their paintings, and Félix Fénéon invented the expression "neo-Impressionism." Durand-Ruel was still trying to bring together the "old guard" for a group exhibition in 1887. Monet was against the idea, and the project fell apart without anyone especially regretting its demise.[49] The artists and their friends remained in touch and met every month for an "Impressionist dinner" at the Café Riche. Between 1890 and 1894 the participants included Pissarro, Sisley, Renoir, Monet, Caillebotte, the collector de Bellio, and writers and art critics like Gustave Geffroy, Duret, Octave Mirbeau, and sometimes Stéphane Mallarmé.[50] But each developed his career individually and exhibited elsewhere, often with the complicity of friends. Thus Georges Charpentier—who had published Gustave Flaubert, Zola, and the entire naturalist school—prompted by his wife, in order to "better protect and launch their painter friends," founded the periodical *La Vie moderne*.[51] He also rented a space near his office to exhibit the painters he defended in his columns. In June 1879 Renoir, who was a frequent visitor to Madame Charpentier's salon, inaugurated the galleries with a one-man exhibition. Next came Manet in April 1880, Monet in June of the same year, and Sisley one year later.

For his part, in 1883 Durand-Ruel organized a series of important one-man exhibitions for "his" artists: first of all Monet with fifty-six paintings, then Renoir in April, Pissarro in May, and Sisley in June. The financial difficulties faced by the dealer prevented him from continuing. Around 1888 his business in the United States dominated his activity. As a result, the artists were attracted by the sumptuous gallery installed at great expense at 8, rue de Sèze by Georges Petit, who became Durand-Ruel's main competitor. It was in Petit's gallery that the Société Internationale des Beaux-Arts was begun in 1882. Each year it organized an exhibition that invited "the leading [artists] of every nationality . . . in brief an abridged version of all the latest tendencies of today and tomorrow."[52] In 1885 Monet took part in the fourth exhibition. Renoir joined him the next year. In 1887 the Impressionists were an integral part of the fashionable "stable" of artists presented by Petit: Monet, Morisot, Pissarro, Renoir, and Sisley all dispatched their works. Sisley had a one-man show at the end of 1888. On 21 June 1889 Petit opened the exhibition *Monet–Rodin,* in which Monet, for the first time, was given a veritable retrospective of his work. One hundred forty-five paintings were hung on the walls. The event was hailed by the press in spite of the Exposition Universelle, which tended to monopolize everyone's attention. For the Impressionist artists, Petit had become a definite alternative to Durand-Ruel.

Soon there was another arrival on the scene—Theo van Gogh. He bought a canvas by Pissarro in 1884, then one by Sisley. Beginning in 1886 he began to multiply his purchases, exhibiting the Impressionists on the mezzanine of the branch of the Boussod and Valadon gallery at 19, boulevard Montmartre, which he directed. He also organized one-man shows. He showed "ten seascapes of Antibes" by Monet in June 1888 and presented, among others, Degas in January 1888 and Pissarro in September 1889. But Durand-Ruel met the challenge, and during the 1890s no collector could ignore his gallery, since he had accumulated so many canvases by all of these artists, which he willingly exhibited. Reconciled with Monet, he success-

fully showed a series of Haystack paintings in 1891. The canvases were sold for between 3,000 and 4,000 francs in the days right after the opening. The other series, those of the poplar trees, like those of Rouen Cathedral, met with a similar success. Monet became famous. The Impressionists began to be very sought after and were finally enjoying a certain hard-won fame.

THE ATTITUDE OF THE PUBLIC AND OF THE PRESS

The critics were almost unanimous: the works of the Impressionists "were worth going to see."[53] The public was no longer calling them crazy. They were, however, still raising doubts about the possibility of the involvement of the sort of visual impairments symptomatic of hysteria observed by Dr. Charcot. The evolution in taste was obvious at the Salon, where as early as 1879 Georges Lafenestre observed that light colors "could count today numerous adepts, whether they admitted it or not, even among the members of the Institute."[54] Companion of the early, difficult times, Zola had become more distant, but Duranty, author of *The New Painting (La Nouvelle peinture),* remained the most attentive of the earliest admirers.[55] The young generation gathered around J.-K. Huysmans were enthusiastic at first. "The air circulates, the sky is endless," he wrote in reference to Pissarro.[56] Captivated, Mirbeau became extravagant when he spoke of Monet: "He has expressed everything, even the imperceptible, even the inexpressible."[57] But the acceptance was not unanimous, and Mirbeau wrote to Monet that he was obliged to give up the publication of his account of the Salon because of the objections of reader-painters, eighty of whom were subscribers to the review.[58] With the arrival of new artistic tendencies, the vision of the Impressionists was contested by the avant-garde. Fénéon declared that "the sunny days of Impressionism are over," and he devoted his talents to defending the neo-Impressionists.[59] Gauguin's opinion reflected that of the young artists who rehabilitated the role of contemplation and were critical of what they saw as the superficial view of their elders. "They explored the region of the eye, instead of seeking the mysterious center of thought. . . . They are tomorrow's official painters."[60]

THE IMPRESSIONISTS AND THE FRENCH STATE

While the Impressionists were tolerated and even admired in private by numerous representatives of the government, acquisitions of their works with State funds were unabashedly avoided. It was quite late—not until the Salon of 1881—that Manet received a second-class medal for his *Portrait of Pertuiset.* Henceforth he was free to exhibit without first having to win the approval of the jury. A few months later, in December, he became chevalier in the Legion of Honor, thanks to the intervention of Antonin Proust, who had just been appointed minister of fine arts in 1881. The firm belief of Proust and his friends was essential after the artist's death in order to obtain for Manet the honor of the traditional retrospective at the École des Beaux-Arts. This was followed by a sale of his works, where once again the efforts of his friends were felt—"It was a pleasure to watch MM. Hecht, Faure, Caillebotte, de Bellio, Leenhoff, Chabrier, Henri Guérard, Antonin Proust, and Théodore Duret fanning the flames of the bidding. . . . They warmed up the sale, made many purchases, and pushed others to buy." But unfortunately, "the museums were either deaf or blind, as you wish. The Louvre, where fame is consecrated and which for the painters is the temple of Glory, the Louvre, which bought at Courbet's sale, gave no sign of life."[61]

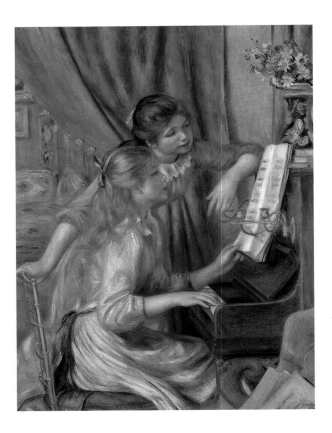

Fig. 9. Renoir, *Young Girls at a Piano*, 1892, oil on canvas, 45¾ × 35½ in., Musée d'Orsay, Paris.

In 1889 Monet started up a subscription among Manet's friends to purchase *Olympia* from his widow in order to offer it to the French nation. Ninety-five donors, among whom figured several Inspectors of Fine Arts like Philippe Burty and Roger Marx, collected the 20,000 francs necessary, but this painting, executed more than twenty-five years earlier, was still considered too scandalous. It was only after great difficulty that on November 2, 1890, *Olympia* was finally hung on the walls of the Musée du Luxembourg, normally reserved for the works of living artists. These works were customarily sent to the Louvre ten years after the artist's death. It was not until February 1907, and after the intervention of Premier Clemenceau, that *Olympia* finally found its place in the Louvre.[62]

The Musée du Luxembourg made almost no effort to acquire works by the Impressionists. By the time its curators took an interest in them, prices had soared out of reach, and they had to depend on the generosity of donations from collectors. In 1888, the State did acquire a landscape by Sisley (cat. 61), but the next year, the work was transferred to Agen.[63] Sisley's bitterness was understandable. "A painting sent to such a place is lost."[64] Because of the intervention of Mallarmé and Marx, the State acquired *Young Girls at a Piano* (*Jeunes filles au piano,* fig. 9) by Renoir, and then in 1894 at the Duret sale, Morisot's *Young Woman Dressed for the Ball* (*Jeune fille en toilette de bal,* cat. 38), again thanks to Mallarmé.[65] These relatively tame canvases did not provoke the sort of scandal that broke out over the bequest made by Caillebotte, who died in 1894. Renoir waged an unstinting battle and finally made enough concessions to have the bequest at least partially accepted. Out of sixty-seven paintings, twenty-nine were excluded. Nevertheless, the Institute was outraged, and the academic painter Gérôme declared, "I must repeat that the State's acceptance of such garbage is the sign of a very great moral decay."[66] But the State did succeed in honoring the Impressionists by including their work in the centenary sections of the Expositions Universelles of 1889 and 1900. This marked their official entry into French art history next to David, Ingres, and Delacroix. The other Fine Arts exhibition, the "Decennial," organized by the Institute and devoted to living artists, paid them no attention whatsoever.

THE STATE SUPPORTS THE IMPRESSIONISTS: THE EXPOSITIONS UNIVERSELLES

For the Exposition Universelle of 1889, Antonin Proust organized—with the aid of the national and departmental museums, as well as numerous private collectors— the "Centennial," which sought "through a small number of rigorously chosen examples, to shed light on the strength and brilliance of French art during our century."[67] Manet was represented with fourteen paintings, and Monet, Pissarro, and Cézanne all exhibited. Renoir had refused to participate. Albert Wolff, forever opposed to the new school, made accusations of favoritism: "Why are some of our greatest living painters not represented? To provide space for a Manet, a Claude Monet, or a Roll."[68] The supporters, such as Albert Aurier, were surprised to see two works by Pissarro in the "old style, and just one Claude Monet, lost in the

rooms of the Palais des Beaux-Arts. There is no Degas, no Gauguin, no Seurat, no Renoir, no Guillaumin!"[69]

The 1900 Exposition Universelle demonstrated a change in attitude. It presented to general admiration "a dazzling room of Impressionists."[70] Roger Marx was responsible for this section. This time he had to convince not only the authorities but also the artists, who were now reticent. "You know as well as we do that we have lived too long outside of all officialdom to cooperate with this; it is not our place."[71] They nevertheless let themselves be persuaded, and finally, around a core of major works by Manet, they were all represented by important works lent by collectors and also by museums. Bazille, Cézanne, Degas, Monet, Morisot, Pissarro, Renoir, and Sisley all exhibited. "In these two marvelous rooms containing the works by Manet and the other Impressionists, the history of the movement writes itself."[72] Some compared these rooms to those occupied by the Caillebotte bequest. "The Impressionist school is generously represented in the Grand Palais, much better than at the Musée du Luxembourg."[73]

Of course there were those who were dissatisfied because of the avant-garde movements that were absent. "They are all of yesterday and today, but there is already a new group which is pushing them, harassing them, and it is a shame that this new group of artists—the neo-Impressionists—were not represented at the Centennial. Why were they excluded?"[74] On the other side, the conservatives remained on the alert, and Gérôme tried to keep President Loubet from entering into the Impressionist room during his visit: "This is the scene of France's dishonor."[75]

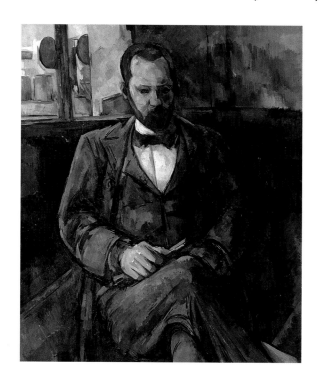

Fig. 10. Cézanne, *Portrait of Ambroise Vollard,* 1899, oil on canvas, 40¼ × 32½ in., Musée du Petit Palais, Paris.

THE NEW ART DEALERS

At the turn of the century, Durand-Ruel had to face the competition of Georges Petit, and after the death of Theo van Gogh he was also confronted with Vollard, who set up shop on the rue Laffitte in 1893 (fig. 10). Following the advice of Pissarro, Vollard met Cézanne, who sent him 150 canvases. In the autumn of 1895, Vollard presented an exhibition of Cézanne, whose work had not been seen for almost twenty years. The public was shocked, but the artists of the young generation, such as Denis and Bernard, had found a mentor. His prices rose, and at the 1899 sale of the collection amassed by Chocquet, one of the first great collectors of the painter from Aix-en-Provence, Cézanne finally seemed to have achieved a certain success. Vollard became Gauguin's dealer and then went on to the new avant-gardes. He became a publisher, and in 1918 he produced a volume of photographs of Renoir's works. Today he is perhaps best known for his activities as Picasso's dealer.

Alexandre Bernheim-Jeune's sons, Josse and Gaston, purchased directly from the artists: Monet, Renoir, Pissarro. But they also focused their attention toward the younger generation, the neo-Impressionists, and then Bonnard, Vuillard, and Matisse, whom they exhibited in their sumptuous gallery. In 1931 they published a luxurious volume, *Renoir's Workshop (L'Atelier de Renoir),* which consecrated the glory of the artist.

Just as in the 1870s, when art dealers supported themselves by selling works

from the Barbizon School in order to exhibit the Impressionists, the new dealers could bank on the sales of the now-established Impressionists in order to exhibit more innovative artists. Paul and Léonce Rosenberg organized retrospectives of Sisley, Boudin, and Guillaumin before showing van Gogh, Cézanne, and Gauguin. They soon became interested in Picasso and the Cubists.

A NEW GENERATION OF COLLECTORS

The collections of Impressionist paintings put together by the earliest art lovers were often dispersed after their death in resounding sales. The surprise came from the prices attained by works of Cézanne, Manet, Monet, and Degas in the sales of the collections of Ernest May in 1890, Emmanuel Chabrier in 1896, Chocquet and Count Doria in 1899, Paul Bérard in 1905, and Rouart and Jean Dollfus in 1912, as well as the three Degas sales in 1918 and 1919.

Many of the collectors who bought at these sales, on the contrary, made sure that their collections would be exhibited in museums. This was true for the banker Isaac de Camondo. When his collection of sixty-two "modern" paintings entered the Louvre in 1911, it brought the work of living artists within its walls, contrary to the custom of this august institution. This collection, which included numerous objects from many different areas and times—Oriental, Medieval, and Renaissance—according to the terms of the bequest had to stay together for a period of fifty years. Today the "modern" works number among the masterpieces in the Musée d'Orsay, as do the canvases donated by the painter and art historian Étienne Moreau-Nélaton, to whom the French museums recently paid homage.[76] Today, also in the collections of the Musée d'Orsay, can be admired the works from the collection of the industrialist Auguste Pellerin, who at one time owned as many as ninety Cézannes. Duret and Vollard made bequests to the city of Paris, and these works are exhibited in the Musée du Petit Palais. Many of the treasures of the Musée Marmottan are due to the generosity of Dr. de Bellio's daughter, Madame Donop de Monchy, as well as that of Michel Monet, the son of the painter. The provincial museums like Lyon, which often bought Impressionist works earlier and in greater number than the State, also benefited from the donations of generous collectors: Depeaux in Rouen, Albert Robin in Dijon, and Henri Vasnier in Reims.[77]

The ultimate proof of the recognition of Impressionism was certainly the opening in 1947 of the Musée des Impressionnistes in the galleries of the Musée du Jeu de Paume and then, in 1974, the celebration in the galleries of the Grand Palais of the centennial of the first Impressionist exhibition.

NOTES

1. Kunsthalle Bremen. *Camille* was purchased for 800 francs in October 1868 by Arsène Houssaye, editor of the magazine *L'Artiste,* after its exhibition in Le Havre. Cited in Dominique Dussol, *Art et bourgeoisie: La Société des Amis des Arts de Bordeaux (1851–1939)* (Toulouse, 1997), pp. 87, 268. At the International Maritime Exhibition of Le Havre, Monet won a gold medal for his entry, no. 858, *Fishing Boats (Bateaux de pêche),* location unknown, and *Camille.*

2. Pierre Vaisse, *La Troisième République et les peintres* (Paris, 1995), p. 353, n. 68. 461,370

people attended in 1859; 463,903 in 1861; 425,706 in 1863; 325,953 in 1864; 496,000 in 1875; and 519,000 in 1876. See also the introduction to the catalogue of the 1877 Salon.

3. Artists whose works were accepted at the Salon: 1859: Pissarro; Manet rejected. 1861: Manet; Pissarro rejected. 1863 *Salon des Refusés:* Pissarro, Manet, and Cézanne. 1864: Morisot, Manet, Pissarro, and Renoir; Cézanne rejected. 1865: Morisot, Degas, Pissarro, Renoir, Sisley, and Monet; Cézanne rejected. 1866: Morisot, Sisley, Degas, Pissarro, and Monet; Cézanne, Manet, and Renoir re-

jected. 1867: None accepted. 1868: Bazille, Monet (one out of two paintings), Degas, Morisot, Pissarro, Renoir, and Sisley; Cézanne rejected. 1869: Bazille, Degas, Manet, Pissarro, and Renoir; Monet, Sisley, and Cézanne rejected. 1870: Bazille, Degas, Manet, Morisot, Pissarro, Renoir, and Sisley; Monet and Cézanne rejected.

4. Cézanne to Nieuwerkerke, Paris, 16 April 1866. Archives des Musées Nationaux, X, Salon of 1866. Isabelle Cahn, chronology in Françoise Cachin et al., *Cézanne,* exh. cat., (Philadelphia, 1996), p. 533.

5. Bazille to his mother, April 1867. *Correspondance* (Montpellier, France, 1992), p. 137. Paris, Archives des Musées Nationaux, X, Salon of 1867.

6. Ibid.

7. Manet, Renoir, Pissarro, Cézanne, and Henri Fantin-Latour signed a new petition demanding exhibition space. The petition was sent to the Ministère de l'Instruction Publique on 25 April 1872, and was denied. Paris, Archives Nationales de France, F21 535.

8. The catalogues of these eight exhibitions have been republished. See *Impressionist Group Exhibitions* (New York, 1981). See also *The New Painting, Impressionism 1874–1886,* exh. cat. (San Francisco, 1986).

9. Works accepted by the Paris Salon: 1872: Manet; Cézanne and Renoir rejected. 1873: Manet and Morisot. 1873 *Salon des Refusés:* Renoir. 1874: Manet. 1876: Cézanne and Manet rejected. 1877: Manet. 1878: Renoir; Cézanne rejected. 1879: Manet and Renoir; Cézanne and Sisley rejected. 1880: Manet, Monet, and Renoir. *Salon of French Artists (Salon des Artistes Français):* 1881: Manet and Renoir. 1882: Manet. 1884: Cézanne rejected. Provincial Salons: 1875 in Pau: Sisley. 1876 in Pau: Degas, Manet, Morisot, Pissarro, and Renoir. 1877 in Pau: Caillebotte, Pissarro, Sisley, and Degas. 1878 in Pau: Degas, Pissarro, Renoir, and Sisley. 1879 in Pau: Sisley. 1880 in Le Havre: Monet. 1881 in Bordeaux: Manet.

10. Philadelphia Museum of Art.

11. Duret to Pissarro, 15 February 1874. Ludovic R. Pissarro and Lionello Venturi, *Camille Pissarro: Son art, son oeuvre,* vol. 1 (Paris, 1939), p. 34.

12. The Metropolitan Museum of Art, New York; no. 2527 in the Salon catalogue.

13. Renoir to Durand-Ruel, Algiers, March 1881. Lionello Venturi, *Les Archives de l'Impressionisme,* vol. 1 (Paris, 1939), p. 115.

14. Sisley to Duret, 14 March 1879. Théodore Duret, "Quelques Lettres de Manet et de Sisley," *La Revue blanche,* vol. 18 (13 March 1899): 436.

15. They wrote to the minister in protest, and Cézanne sent a copy of the letter to Zola for publication in *Le Voltaire,* 10 May 1880. See John Rewald, ed., *Correspondance, Paul Cézanne* (Paris, 1978), p. 191.

16. Cited in Jacques Lethève, *Impressionnistes et symbolistes devant la presse* (Paris, 1959), p. 31.

17. Ibid., p. 34.

18. Bertall, "Le Salon de 1866," *Le Journal amusant,* no. 541 (12 May 1866): 4; André Gill, "Le Salon pour rire," *La Lune* (13 May 1866): 1.

19. Musée d'Orsay, Paris, RF 644.

20 Stock, "Le Salon par Stock," *Album Stock* (20 March 1870). The caption reads: "The March 20 incident at the Palais de l'Industrie, or An anteroom success before the opening of the Salon." The drawing is accompanied by a text: ". . . this year we would like to offer the public two paintings which are forbidden fruit, since they fall into the category of rejected works." Cited in John Rewald, "Un Article inédit sur Paul Cézanne en 1870," *Arts* (21 July 1954): 8.

21. Émile Zola, *Écrits sur l'art* (Paris, 1991), p. 99.

22. Jules Antoine Castagnary supported realism in the Salon criticism that he wrote between 1857 and 1879. This was later published in book form by Georges Charpentier, *Salons (1857–1879)* (Paris, 1892). For Théodore Duret (1838–1927), see Anne Distel, *Les Collectionneurs des Impressionnistes* (Paris, 1989), pp. 57–71, 266. Ernest Chesneau (1833–1890), Inspector of Fine Arts, journalist, and novelist, wrote the preface to the Hoschedé sale catalogue in 1874 and promoted the Impressionists from the beginning.

23. Musée Marmottan, Paris; no. 98 in the catalogue of the Société Anonyme's first exhibition.

24. Louis Leroy, "L'Exposition des Impressionnistes," *Le Charivari* (25 April 1874); cited in *Centenaire de l'Impressionisme,* exh. cat. (Grand Palais, Paris, 1974), pp. 259–260.

25. "L'Ecole des taches," in *Le Bien public* (25 June 1874); cited in Lethève, *Impressionnistes,* 1959, p. 72.

26. Albert Wolff, "Le Calendrier Parisien," *Le Figaro* (3 April 1876): 1.

27. Castagnary, "L'Exposition du Boulevard des Capucines. Les impressionnistes," *Le Siècle* (29 April 1874); cited in *Centenaire,* 1974, pp. 264–265.

28. Leroy (11 April 1877); quoted in Lethève, *Impressionnistes,* 1959, p. 85. Ch. Flor O'Squarr, *Courrier de France,* 6 April 1877; ibid., p. 83.

29. Théodore Duret, *Les Peintres Impressionnistes* (Paris, 1878), p. 7.

30. Marc Le Coeur, "Le Salon annuel de la Société des Amis des Arts de Pau, quartier d'hiver des impressionnistes de 1876 à 1879," *Histoire de l'art,* no. 35–36 (October 1996): 57–70.

31. Charles-Clément Le Coeur (1805–1897), a Parisian architect who retired in Pau. In 1863 he founded the Société des Amis des Arts de Pau, which organized annual exhibitions.

32. André Gorse, *Mémorial des Pyrénées* (20 January 1877), and F. O., *L'Indépendant* (16 February 1877); both cited in Le Coeur, "Le Salon annuel," 1996, p. 60.

33. In 1877 Pissarro sold *June Morning (Matinée de juin),* no. 358 in the catalogue, to a collector for 1,000 francs. Sisley sold *Study of Snow (Effet de neige),* no. 412, for 300 francs.

34. Jules Le Coeur (1832–1882), painter. His brother Charles (1830–1906) was a well-known architect. He, as well as other members of the family, posed for Renoir. It was through Charles Le Coeur that Renoir obtained the commission to decorate the hotel the architect was building in Paris for the Prince Bibesco. Marc Le Coeur, "Charles Le Coeur (1830–1906), architecte et premier amateur de Renoir," *Les Dossiers du Musée d'Orsay,* no. 61 (16 October 1996).

35. Louis-Joachim Gaudibert (1838–1870), a businessman and acquaintance of Eugène Boudin and A. Gautier, showed an interest in Monet's work beginning in 1864.

36. Duret, *Les Peintres,* 1878, p. 9. The collectors he listed include "M. M. D'Auriac, Etienne Baudry, de Bellio, Charpentier, Chocquet, Deudon, Dollfus, Faure, Murer, Rasty."

37. Ernest Hoschedé (1837–1891). See Distel, *Les Collectionneurs,* 1989, pp. 95–107, 267. A first sale was held on 13 January 1874, at the Hôtel Drouot. The official appraiser was Charles Pillet, and the expert was Durand-Ruel. Thirteen paintings by Sisley, Monet, Pissarro, and Degas figured alongside works by Narcisse Diaz de la Peña, Courbet, Corot, and others. Cited in Merete Bodelsen, "Early Impressionist Sales 1874–94 in the light of some unpublished 'procès-verbaux'," *The Burlington Magazine* (June 1968): 331–347.

38. Ernest Chesneau, introduction to the catalogue for the Hoschedé sale.

39. Pissarro to Duret, Pontoise, 1 February 1874. Jeanine Bailly-Herzberg, ed., *Correspondance de Camille Pissarro,* vol. 1 (Paris, 1980), p. 90.

40. Charles Bigot, *Revue politique et littéraire* (8 April 1876); cited in Lethève, *Impressionnistes,* 1959, p. 79. On Jean-Baptiste Faure (1830–1914), see Distel, *Les Collectionneurs,* 1989, pp. 74–93, 267.

41. Emile Cardon, *La Presse* (29 April 1874); cited in Lethève, *Impressionnistes,* 1959, p. 69.

42. 25 March 1875; cited in Bodelsen, "Early Impressionist Sales," 1968.

43. Venturi, *Les Archives,* vol. 2, 1939, p. 201.

44. Victor Chocquet (1821–1891), an employee at the Customs Office, collected paintings by Delacroix, Courbet, Daumier, and others. After the 1875 sale, he became interested in Renoir, Monet, and especially Cézanne. See Anne Distel, *Les Collectionneurs des Impressionnistes* (Düdingen/Guin, Switzerland: La Bibliothèque des Arts, 1989), pp. 125–140; and John Rewald, "Chocquet and Cézanne," *Gazette des Beaux-Arts* (July–August 1969): 33–96.

45. Georges Rivière, *Renoir et ses amis* (Paris, 1921), p. 40.

46. Théophile Gautier, *L'Artiste* (3 January 1858); cited in Jacques Lethève, *La Vie quotidienne des artistes français au XIX siècle* (Paris, 1968), p. 158.

47. Alphonse Portier (1841–1902) sold to collectors like Rouart, Isaac de Camondo, Gallimard, and Depeaux. See Monique Nonne, "Les Marchands de Van Gogh," in *Van Gogh à Paris,* exh. cat. (Musée d'Orsay, 1988), pp. 330–347. La Fare, "Chez les Impressionnistes," *Le Gaulois* (23 February 1882): 1. Portier was a friend of Degas.

48. Harrison C. White and Cynthia A. White, *La Carrière des peintres au XIX siècle: Du système académique au marché des Impressionnistes* (Paris, 1991).

49. John Rewald, *The History of Impressionism* (New York, 1973), p. 553.

50. Ibid., p. 566.

51. M. Robida, *Le Salon Charpentier et les Impressionnistes* (Paris, 1958), p. 66.

52. Jacques-Emile Blanche, *Les Arts plastiques,* French ed. (Paris, 1931); cited in Alain Beausire, "La galerie Georges Petit dans le courant des Sécessions," in *Monet–Rodin, centenaire de l'exposition de 1889,* exh. cat. (Musée Rodin, Paris, 1989), pp. 40–46.

53. Griffon Vert, "Echos de Paris: La ville," *Le Voltaire* (16 April 1879).

54. Georges Lafenestre, *Revue de France,* April 1879; cited in Lethève, *Impressionnistes,* p. 107.

55. Brochure published in 1876. Edmond Duranty (1833–1880) was a novelist and critic and a friend of Degas.

56. J.-K. Huysmans, *L'Exposition des indépendants* (1880); reprinted in Huysmans, *L'Art moderne* (1883), p. 265.

57. *Le Figaro* (10 March 1889); reprinted in the preface to *Monet–Rodin,* 1989, pp. 48–53.

58. Mirbeau to Monet, ca. 1885–86. Octave Mirbeau, "Lettres à Claude Monet," *Cahiers d'aujourd'hui,* no. 9, p. 162.

59. Félix Fénéon, "L'Impressionisme," *L'Emancipation sociale,* Narbonne (3 April 1887), and *Oeuvres plus que complètes,* vol. 1 (Geneva, 1970), p. 68.

60. Paul Gauguin, *Diverses choses (1902–1903);* cited in J. de Rotonchamp, *Paul Gauguin* (Paris, 1925), p. 243.

61. 4–5 February 1884 at the Hôtel Drouot. Duret wrote the preface to the catalogue. See Bodelsen, "Early Impressionist Sales," 1968, p. 341–344. Paul Eudel, "La Vente Manet (2ème journée)," *Le Figaro* (5 February 1884); republished in *L'Hôtel Drouot et la curiosité en 1883–1884* (Paris, 1885), p. 176.

62. Anne Distel, "Il y a cent ans, ils ont donné l'*Olympia*," *Quarante-huit / Quatorze*, no. 4 (1992): 44–50.

63. Archives Nationales de France, F21 2112. Isabelle Cahn, chronology in Mary Anne Stevens, ed., *Alfred Sisley*, exh. cat. (Royal Academy of Arts, London, 1992), pp. 280–281.

64. Sisley to Adolphe Tavernier, 15 May 1893. Ibid., p. 281.

65. Anne Distel, "Les Amateurs de Renoir: Le prince, le prêtre et le pâtissier," in *Renoir*, exh. cat. (Hayward Gallery, London), pp. 28–44. On the sale of Théodore Duret's collection, 19 March 1894, see Bodelsen, "Early Impressionist Sales," 1968, pp. 344–346.

66. Cited in Alfred Leroy, *Histoire de la peinture française* (Paris, 1934), p. 166.

67. Antonin Proust, introduction to *Exposition Universelle Internationale de 1889 à Paris. Beaux-Arts. Exposition centennale de l'art français (1789–1889)* (Lille, 1889), pp. v–vii.

68. Albert Wolff, "L'Exposition centennale au Champ-de-Mars," *Le Figaro* (22 May 1889): 3.

69. G. Albert Aurier, "La Peinture à l'Exposition Universelle de 1900," *La Pléiade* (September 1889): 104.

70. Arsène Alexandre, "Les Beaux-Arts à l'Exposition Universelle de 1900," *Le Figaro* (1 May 1900): 3–5.

71. Monet to Roger Marx, 9 January 1900. *Donations Claude Roger Marx*, exh. cat. (Musée du Louvre, 1980), nos. 78–81, pp. 92–93.

72. Gustave Kahn, "L'Art à l'exposition; la centennale (suite)," *La Plume*, no. 272 (15 August 1900): 506.

73. E. Grosjean-Maupin, "L'Art français (Exposition Centennale de 1900)," *Revue encyclopédique*, no. 381 (22 December 1900): 1040.

74. Gustave Coquiot, "Les Beaux-Arts à l'exposition," *La Plume*, no. 267 (1 June 1900): 334.

75. Cited in J. P. Crespelle, *La Vie quotidienne des impressionnistes du Salon des refusés (1863) à la mort de Manet (1883)* (Paris, 1968), p. 231.

76. *De Corot aux Impressionnistes, donations Moreau-Nélaton*, exh. cat. (Galeries Nationales du Grand Palais, Paris, 1991).

77. On Depeaux, see Gilles Grandjean, "1864–1919, Monet et Rouen," in *Rouen: Les cathédrales de Monet*, exh. cat. (Musée des Beaux-Arts, Rouen, 1994), pp. 22–35. On Robin, see Monique Geiger, "Le Legs du Pr. Robin et les Impressionnistes au Musée des Beaux-Arts de Dijon," *Bulletin de liaison, Association pour le Renouveau du Vieux-Dijon*, no. 21 (1st trimestre 1998): 9–18. On Vasnier, see M. Sartor, introduction to *Musée de Reims, catalogue sommaire de la collection Henri Vasnier* (Reims, 1913).

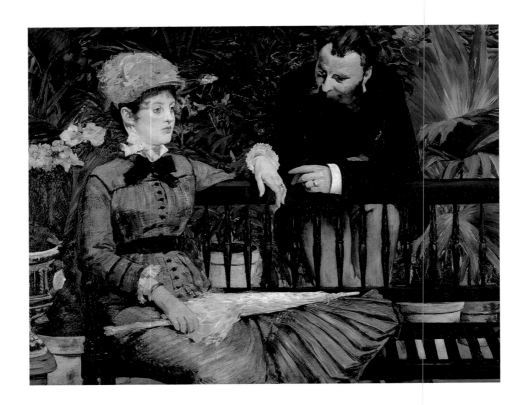

Fig. 1. Manet, *In the
Conservatory,* 1878–79, oil on
canvas, 45¼ × 59⅛ in.,
Staatliche Museen zu Berlin,
Nationalgalerie.

Fig. 2. Degas, *The Conversation,*
ca. 1882, pastel on paper,
25⅝ × 33⅞ in., Staatliche
Museen zu Berlin,
Nationalgalerie.

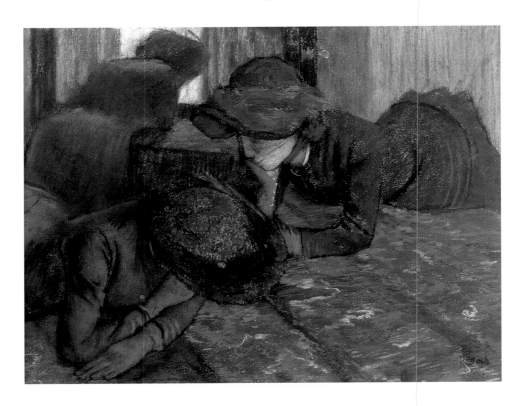

The Archenemy Invades Germany

French Impressionist Pictures in the Museums of the German Empire from 1896 to 1918

STEFAN PUCKS

"Heaven preserve us! Quite unnecessary," wrote Kaiser Wilhelm II in the margin of a report dated 1891 about an exhibition of Manet pictures in Munich.[1] But his protests were in vain—five years later the first paintings by French Impressionists were installed in Berlin's Nationalgalerie.[2] Visitors to the museum, dedicated "to the German people," could see Manet's painting *In the Conservatory* (1878–79, fig. 1), Monet's *View of Vétheuil* (1880), or Degas's *The Conversation* (ca. 1882, fig. 2), and all at a time when the French avant-garde still aroused controversy in Paris.

A quarter of a century after Germany's victorious war against France and the foundation of the German Empire in 1871, the archenemy of the Germans stood in the center of their capital, Berlin. Up to this point, the Germans had managed to fend off the French onslaught. In the summer of 1882, Carl and Felicie Bernstein, a Berlin professor of law and his wife, brought the first Impressionist pictures from Paris to Germany (fig. 3). The following year, the Berlin gallery owner Fritz Gurlitt dared to exhibit some twelve pictures from the Bernsteins' collection, as well as twenty-three Impressionist paintings owned by the Paris art dealer Paul Durand-Ruel. Two paintings by Manet were the most controversial. While critics showed some goodwill to *The Folkestone Boat, Boulogne* (1869, Philadelphia Museum of Art), which belonged to the Bernsteins, they completely tore to pieces *The Railway,* also known as *The Gare Saint-*

Fig. 3. The music room in Carl and Felicie Bernstein's apartment at 23 In den Zelten, Berlin, ca. 1885–90. To the left of the door: Manet, *White Lilies in a Glass Vase* (1882); Sisley, *The Seine at Argenteuil* (1875); Eva Gonzalès, *Child's Head;* and an unidentified picture. To the right: Manet, *The Folkestone Boat, Boulogne* (1869); and Pissarro's *Peasants Working in the Fields, Pontoise* (1881).

Lazare (1872–73, National Gallery of Art, Washington, D.C.), which belonged to Durand-Ruel. The reaction of the Berlin art world was a mixture of derision and outrage. Even artists like Adolph Menzel were unanimous in condemning the Impressionists as an idiotic new fashion from Paris. The Germans believed that Impressionism clearly belonged to the French tradition of superficiality, which appealed only to the senses. They compared it unfavorably to German culture, with its deepness and soul. The Impressionists contradicted their idea of what constituted a painting in every respect, and in this, the German arguments were similar to those of French critics: These paintings were merely incomplete sketches. They dealt with unworthy subject matter and sometimes dealt with it on too large a scale. The colors were unexpected and bright, and the figures were cropped. Worst were the outrageous prices being asked for such horrendous "daubings."

But at the beginning of the 1890s, the time was ripe for an "artistic spring" *(Kunstfrühling)* in Germany. Impressionist pictures appeared more and more often in exhibitions. It became obvious where young German artists like Max Liebermann, Fritz von Uhde, Gotthardt Kuehl, Christian Rohlfs, and Lesser Ury were getting the inspiration for their brighter colors, bolder compositions, and motifs from everyday life. Around 1900, the middle class also rallied under the banner of Impressionism. This revolution of taste was led mostly by Jewish businessmen and bankers. As art collectors, they invested in the future of art. In so doing, they defined their claim to being culturally interested Germans and, at the same time, an international business and banking elite open to new ideas. This challenged the non-Jewish aristocracy, which was still politically dominant, and most of the non-Jewish educated classes, who remained faithful to German art. While there was fear in conservative circles that the cultural identity of Germany could be lost by importing too much foreign art, those with a modern outlook (including several museum directors) regarded the French pictures as a spur to German art.

BERLIN AND MUNICH

The first museum director in Germany to recognize the new French painting was Hugo von Tschudi (1851–1911), an Austrian by birth. In the summer of 1896, just after he became director of the Nationalgalerie in Berlin, Tschudi went with Max

Fig. 4. Max Liebermann in the music room of his apartment at 7 Pariser Platz, Berlin, ca. 1930. Behind him at left are two paintings by Manet, *Portrait of Madame Manet at Bellevue* and *Asparagus* (both from 1880).

Fig. 5. Nationalgalerie, Berlin (1908). Left to right: Manet, *In the Conservatory* (1878–79); Manet, *Country House in Rueil* (1882); Renoir, *In Summer* (1868); Renoir, *Blossoming Chestnut Tree* (1881); Renoir, *Children's Afternoon at Wargemont* (1884); Pissarro, *Country House at L'Hermitage, Pontoise* (1873); and Monet, *View of Vétheuil* (1880). On the top row of the back wall, three pictures by Cézanne: *Jugs, Bottle, Cup, and Fruit* (ca. 1867–69), *Mill on the Couleuvre at Pontoise* (1881), and *Flowers in a Ginger Pot and Fruit* (ca. 1890). Below: Monet, *Houses in Argenteuil* (1873); Degas, *The Conversation* (ca. 1882); and Monet, *Meadow at Bezons* (1874). Three sculptures by Rodin, left to right: *The Age of Bronze* (1875–76), *Jules Dalou* (1883), and *The Thinker* (1899–1900).

Liebermann (1847–1935, fig. 4), one of the first collectors of French Impressionism in Germany, to the gallery of Durand-Ruel. Back in Berlin, Tschudi ordered the first lot of a total of sixteen Impressionist pictures, which he hung in an exhibition room on their own, after taking down the academic, patriotic pictures there (fig. 5). In 1897 there followed landscapes by Sisley, *First Snow at Louveciennes* (1870–71), Pissarro, *Country House at L'Hermitage, Pontoise* (1873), Monet, *Houses in Argenteuil* (1873), and Cézanne's *Mill on the Couleuvre at Pontoise* (1881). This was the start of enthusiasm for Impressionist art in Germany. Tschudi was uncompromising. He put artistic quality before national pride, which brought him into conflict with the conservative circle around Kaiser Wilhelm II. In 1899 the kaiser issued an edict that stymied Tschudi, forcing him to shelve plans for restructuring the museum and requiring the approval of the kaiser for all new acquisitions.

All the French pictures were gifts from the city's rich business and banking elite—notably, the coal magnate Eduard Arnhold and the bankers Robert and Franz von Mendelssohn and Karl Hagen. Arnhold and the von Mendelssohns were among the most noted art collectors of their time, yet they did not give pictures to the Nationalgalerie; rather, they gave money to Tschudi so he could make his own acquisitions. Even in these cases, Tschudi was now forced to ask permission before accepting. The result was that for seven years the Nationalgalerie, the German Empire's main art collection, acquired no more Impressionists. Tschudi's position was systematically undermined, so he jumped at the chance when he was offered the job of director of the Staatliche Galerien in Munich in 1909. But all the promises the Bavarians made to behave better than the Prussians were forgotten in 1910 when Tschudi wanted to accept pictures such as Matisse's *Still Life with Geraniums,* a work he himself had commissioned. Twelve Impressionist pictures that he selected and friendly donors purchased were exhibited in the Neue Pinakothek only after his death in 1911. These works, which became known as the "Tschudi-Spende," included Manet's *Monet Painting in His Studio* and Monet's *The Bridge at Argenteuil,* both from 1874. Also among them was Manet's *Luncheon in the Studio* (1868–69),

by far the most expensive French painting to find its way into a German museum before 1918. It cost around 200,000 marks, and the money was put up by the Starnberg businessman Georg Ernst Schmidt-Reißig. It was an enormous amount when one considers that a worker in 1900 earned an average of 100 marks a month.

Fig. 6. Alfred Lichtwark, director of the Hamburger Kunsthalle, 1899.

HAMBURG

Alfred Lichtwark (1852–1914) in Hamburg was the first museum director to follow Tschudi's example (fig. 6). In 1896 he persuaded the 1870 Art Lovers Society (Verein von Kunstfreunden von 1870) to donate Monet's *Pears and Grapes* (1880, fig. 4, p. 32) to the Hamburger Kunsthalle. Its subject matter and the way it was painted made it a relatively harmless picture, and unlike the acquisitions made by the Berlin Nationalgalerie, it did not cause a great stir in Hamburg. Lichtwark met Tschudi in Berlin in 1883, the year that both, at the latest, saw Impressionist pictures with their own eyes. Although he was well-disposed to the new French painting, Lichtwark preferred German art. In 1904 he wrote to the painter Leopold von Kalckreuth: "Tschudi has devoted the rooms upstairs to his Frenchmen. I would have liked it better if he had put his energies into German nineteenth-century art."[3] It was not until 1907 that Lichtwark acquired more Impressionists: Manet's *Portrait of Henri Rochefort* (cat. 28), followed in 1910 by the same artist's *Faure as Hamlet*. Unlike Tschudi, who was fascinated with the composition and colors of the new art and acquired mostly landscapes and still lifes, Lichtwark was more interested in content, particularly in portraits. He admired Renoir and was able to acquire his large *A Rider in the Bois de Boulogne* for the Kunsthalle in 1912. It was all in the best German tradition: "He [Renoir] is interested not only in the still-life side of the world, but in its soul."[4]

BREMEN

Unlike Lichtwark, who turned down the offer of a picture by Degas in 1898, his colleague and close friend in Bremen, Gustav Pauli (1866–1938), did not hesitate in 1903 when he was offered a Degas pastel drawing, *The Dancer*, as a gift from the publisher and patron Alfred Walter Heymel (1878–1914). Pauli must have known that Degas was considered not only a brilliant painter but also a social critic, "a pitiless observer of those beings who society makes into machines for its pleasure—dance machines, running machines, love machines."[5] The first full-time director of the Kunsthalle Bremen, Pauli came from Dresden where he had worked under the progressive Max Lehrs at the Kupferstichkabinett. The Degas became the foundation of an Impressionist collection that comprised nine pictures by the time Pauli left Bremen in 1914 to become Lichtwark's successor. Like Lichtwark, Pauli prized portraits; of the Impressionist pictures he bought, he spent the most on Monet's *Camille* (50,000 marks) and Manet's *Zacharie Astruc* (20,000 marks). He tried to realize the words of the poet Rainer Maria Rilke, who in his speech at the opening of the Kunsthalle in 1902 said, "Here in this house, some will learn to see for the whole of their life."[6] The painter Carl Vinnen did not learn. With his pamphlet *A Protest by German Artists (Ein Protest deutscher Künstler),* published in 1911, he sought to indict not only Pauli for buying van Gogh's *Poppy Field* (fig. 7), but all progressive museum directors. By that time, the argument was no longer only about French

Fig. 7. Van Gogh, *Poppy Field,* 1889–90, oil on linen, 27⅞ × 35⅞ in., Kunsthalle Bremen.

Impressionism, but also about Post-Impressionism, Fauvism, Cubism, and Expressionism. And, as during the Gurlitt exhibition of 1883, it was about the preservation of German art, an art of "depth, imagination, the feeling of soul," while the achievements of French art since Monet were characterized as "devoted to the superficiality of things."[7] Supporters of the modern—who defended themselves under the title *In the Fight for Art* (*Im Kampf um die Kunst,* Munich, 1911)—emerged for the moment victorious. But resentment against modern art bubbled beneath the surface, and it would erupt after 1933 in the Nazis' anti-modern, backward-looking art policy.

FRANKFURT

Georg Swarzenski (1876–1957) and Fritz Wichert (1878–1951) belonged to the generation of museum directors after Tschudi and Lichtwark. When Swarzenski was appointed director of the Städelsches Kunstinstitut in Frankfurt in 1906, he inherited two Impressionist landscape paintings by Sisley and Monet, which had been acquired by his predecessors, Heinrich Weizsäcker and Ludwig Justi. Swarzenski was just as fascinated by the sensuousness of Impressionist pictures as Tschudi had been, but he proceeded more cautiously. The first pictures he acquired were from the Barbizon School. Between 1910 and 1912, as head of the Städtische Galerie (part of the Städelsches Kunstinstitut), he used his impressive budget of 150,000 marks for buying contemporary art, including five pictures by Renoir, Degas, and Monet. It is worth noting that he was interested solely in genre pictures, like the boldly composed Degas oil painting *Orchestra Musicians,* which cost the handsome sum of 100,000 marks. And to avoid creating a "chamber of horrors," as in Berlin or Hamburg, Swarzenski hung his modern French pictures next to works by German artists.

MANNHEIM

After spending two years as Swarzenski's assistant, Fritz Wichert became head of the new Kunsthalle Mannheim in 1909. He quickly made the museum internationally

Fig. 8. Museum Folkwang Hagen, interior design by Henry van de Velde. At center: Rodin, *The Age of Bronze* (1875–76); at right: Renoir, *Lise* (1867).

renowned by acquiring Manet's huge historical painting *The Execution of Maximilian* (1867), financed by local art lovers who raised 90,000 marks for the picture. Their enthusiasm can be ascribed to the importance Wichert attached to educating his public, just as Lichtwark had done in Hamburg and Karl Ernst Osthaus in Hagen. By 1914, more than 12,000 people had joined the Free League for the Introduction of the Fine Arts to Mannheim (Freier Bund zur Einbürgerung der bildenden Kunst in Mannheim), which Wichert founded in 1911. But in spite of his popularity, a member of the city's Art Commission was intent on making life difficult for him. Not only did the lawyer Theodor Alt protest when the Kunsthalle bought the Manet in 1909 and when it acquired Cézanne's *Smoker* (ca. 1891–92) three years later, but he also wrote a pamphlet in 1911 called *The Devaluation of German Art by the Followers of Impressionism (Die Herabwertung der deutschen Kunst durch die Parteigänger des Impressionismus)*.

ELBERFELD

The fact that the Kunsthalle in Elberfeld (today a part of Wuppertal) is included in this study can be attributed to the tolerance of its director, Friedrich Fries, and the forward-looking attitude of its patrons Julius Schmits and his wife. In 1907 they donated Sisley's *The Canal* (1884), the first of their gifts of modern French paintings, which was followed in 1910 by Monet's *Vétheuil* (1900–1902) and in 1912 by Cézanne's *L'Hermitage at Pontoise* (ca. 1881). The active museum association showed foresight when it donated Picasso's *Two Harlequins* (1905, private collection, Japan) in 1911. It was the first picture by Picasso to find its way into a German art gallery, but it was taken out of the museum in 1937 during the Nazi purge of "degenerate art."[8] Even in 1918, the aesthetics of paintings by Sisley and Monet were little understood, as the warning in the catalogue shows: "Do not stand too close."[9]

HAGEN

Karl Ernst Osthaus (1874–1921) in Hagen was a lot better off than his colleagues elsewhere: he not only was the museum director but also financed acquisitions him-

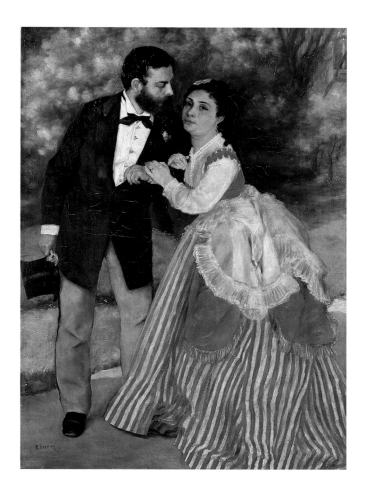

Fig. 9. Renoir, *Mr. and Mrs. Sisley,* ca. 1868, oil on canvas, 42¼ × 30 in., Wallraf-Richartz-Museum, Cologne.

self and was responsible for approving them. In 1902 he opened the Museum Folkwang to acquaint the people of Hagen, a Westphalian industrial town, with European cultural strivings of the time (fig. 8). His efforts were in vain, as he was later forced to admit. The outstanding work in the modern art section of his museum was Renoir's *Lise* (1867). Renoir was the only Impressionist painter Osthaus and his wife Gertrud would accept. They looked to the next generation of French artists and acquired only late examples of Cézanne and Gauguin's work. They bought van Gogh's *The Harvest,* which was the first work by the Dutch artist to be acquired by a German museum.

OTHER CITIES

While all these museums started to acquire Impressionist artists early on—even devoting entire rooms to their work—other towns and cities in the period before 1918 regarded Impressionism as a passing craze. The case of Saxony's cultural capital of Dresden is surprising. Monet's *The Seine at Lavacourt* (1879) was the only Impressionist painting acquired for the Gemäldegalerie by its director, Karl Woermann, who bought it in 1909. In Saxony's other big city, Leipzig, famous for its trade fairs, again only one picture, Pissarro's *La Place du Théâtre Français,* found its way into the Kunsthalle in 1910. Weimar in Thuringia also neglected Impressionist art, for two reasons: first, the taste of Count Harry Kessler (1868–1937), who, apart from French pointillists and the Nabis, accepted only Renoir and Cézanne; second and more importantly, a chronic lack of money in Weimar. When Kessler, with the Belgian craftsman Henry van de Velde, created "New Weimar" in the first years of the twentieth century, he had to rely on a donation from his friend Heymel in 1905 to buy one of Monet's *Rouen Cathedral* paintings to go in the Grand Ducal Museum for Art and Crafts (now Kunstsammlungen, Schloßmuseum), which he had founded two years before. The museum's forerunner, the Permanent Art Exhibition at the Academy, had exhibited paintings by Monet, Pissarro, Sisley, and even Degas between 1890 and 1893, but in vain. Catholic Cologne was particularly conservative. Only in 1909 did Alfred Hagelstange risk acquiring a portrait by Gauguin, *The Woman with a Chignon* (1886), for the Wallraf-Richartz-Museum. In 1912, the year of the legendary "Sonderbund" exhibition in which living artists such as Munch and Picasso were honored with their own exhibition rooms, Hagelstange finally decided to buy Renoir's picture known as *Mr. and Mrs. Sisley* (fig. 9).

All the more gratifying, therefore, are the efforts that were made in German towns less well known as artistic centers. As early as 1901 and 1906, Konrad Lange (1855–1921), art inspector for the painting collection in the Stuttgart Royal Museum for Fine Arts, showed his newly acquired pictures by Pissarro and Monet, *The Gardener* (1899) and *Landscape in Spring* (1887). In Posen (today Poznan in Poland), Ludwig Kaemmerer was lent Monet's *Beach at Pourville* (1882) in 1906 by the local art society for the Kaiser Friedrich Museum. In 1907, a later Monet, *London's Parliament at Sunset* (1900–1901), was acquired by Friedrich Deneken (1857–1927) for the

Kaiser Wilhelm Museum in Krefeld. This museum was opened in 1897 with the express intention of becoming a center for the arts and crafts.

ART CRITICS AND HISTORIANS

Progressive museum directors were publicly supported by art critics and, from behind the scenes, by collectors and dealers. The mouthpiece of Impressionism was the magazine *Kunst und Künstler* (Art and Artist). From 1902 on, it was brought out by Bruno Cassirer (1872–1941), whose publishing company was committed to the Impressionist cause. The first editor was the painter, art critic, and art dealer Emil Heilbut (1861–1921), who had written positively about the work of Manet and Monet as early as 1890. He was related to Hermann Heilbuth, who lived in Hamburg and Copenhagen and collected works by Degas and Monet.[10] From 1906 until it ceased publication in 1933, the magazine was edited by Karl Scheffler (1869–1951). *Das Atelier* (The Studio), edited by Hans Rosenhagen (1858–1943) from 1890 until 1897, and the ambitious and (with its original art supplements) very exclusive *Pan* (1895–1900) were the first magazines devoted to modern art. One of the co-founders of *Pan* was Julius Meier-Graefe (1867–1935), who even today enjoys a reputation beyond the borders of Germany as someone who prepared the way for modern art (fig. 10). He was also an art dealer and ran a gallery in Paris from 1899 to 1903 called La Maison Moderne. He also organized art exhibitions like the 1903 Impressionist retrospective held by the Viennese Secession, the first such exhibition to be held in the German-speaking world. His 1904 book *The History of the Development of Modern Art (Entwicklungsgeschichte der modernen Kunst)* viewed Impressionism and the preeminence of painterliness *(das Malerische)* as not just one tradition but the crucial tradition in painting. The three volumes were translated into English in 1908. With the courage he showed in ignoring the work of the great academic painters and with his subjective use of language, he caught the sensuality of Impressionist pictures and created "the first modern history of modern art."[11] With this apotheosis of Impressionism, Meier-Graefe was different from the popular art historian Richard Muther (1860–1909), who, a decade earlier, had similar success with his three-volume *History of Painting in the Nineteenth Century (Geschichte der Malerei im XIX. Jahrhundert,* Munich, 1893–94). Muther dedicated a thirty-five-page illustrated chapter entitled "Fiat Lux" to the Impressionists.

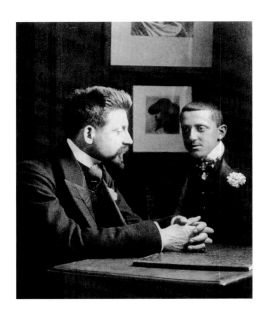

Fig. 10. Julius Meier-Graefe and Alfred Walter Heymel in Darmstadt, 1900.

ART DEALERS

Paul Cassirer (1871–1926), in cooperation with the Paris galleries of Durand-Ruel, Bernheim-Jeune, and the Cézanne dealer Ambroise Vollard, brought Impressionism to Germany (fig. 11). In the Berlin art salon that he opened with his cousin Bruno Cassirer in the autumn of 1898, and in its Hamburg branch (open from 1901 to 1906), he presented the latest foreign art trends to the German public. In 1906–1907 and in 1910, Cassirer brought parts of the great Paris collections belonging to Faure and Pellerin to Germany. These were the collections from which both museums and individuals bought pictures by Manet and Monet, though at exorbitant prices. As secretary of the Berlin Secession movement, founded in 1898 under the presidency of Max Liebermann, Cassirer made sure that French artists were well represented at exhibitions organized by Berlin's opposition artists—with the result that he and

Fig. 11. Paul Cassirer,
ca. 1920.

the so-called "Liebermann Clique" were accused of being too sympathetic to foreigners and of abusing their positions for financial gain. Despite, or perhaps because of, Paul Cassirer's dominance, it is worth also remembering his courageous predecessors and contemporaries. In Berlin, the art dealer Fritz Gurlitt (1854–1893), showed one of Degas's Dancer pastel drawings in 1891. In 1897 Hermann Pächter (1839–1902) arranged a Monet exhibition and sold Manet paintings that he had bought directly from the painter's widow in Paris. Exhibitions of Impressionist works owned by Durand-Ruel were organized in 1897 by the art critic and collector Julius Elias (1861–1927) in the Kaiserhof hotel in Berlin. A similar show was organized two years later by the art dealers Keller and Reiner. In Dresden, Ferdinand Morawe from the gallery Theodor Lichtenberg Nachfolger exhibited five paintings by Pissarro as early as 1895, and four years later, Ludwig Gutbier (1873–1951) exhibited Impressionist pictures in the Kunst Salon Ernst Arnold, a gallery run by his father Adolf. These men were typical of a new breed of gallery owner, prepared to risk financial ruin in order to show contemporary works that were difficult to sell.

CONCLUSION

Despite the opposition, Impressionism enjoyed a golden age during the time of the German Empire. The country was rich, and the wealthy bourgeoisie found in Impressionist art a culture of modernity to set against the conservative but politically powerful aristocracy. The museum directors discussed here came from a generation that had not taken part in the Franco-Prussian War of 1870–71, and so they were less inhibited than their fathers about French art. The sense that everything was in flux, the founding and building of new museums, and the increasing professionalism of art historians all smoothed the way for French Impressionism. The time after 1918 was a time of loss. The major German private collections fell victim to the loss of the First World War, the inflation of 1922–23, and the stock market crash of 1929; the collectors themselves fell to the Nazis after 1933. The acquisitions made by German museums since 1945 cannot bring back these losses, for which the turbulent events of the first half of the century—and Germany herself—are to blame.

NOTES

1. Ludwig Pallat, *Richard Schöne, Generaldirektor der Königlichen Museen zu Berlin* (Berlin, 1959), p. 232.

2. Key to this study on French Impressionists in German museums are two books: Josef Kern, *Impressionismus im Wilhelminischen Deutschland–Studien zur Kunst–und Kulturgeschichte des Kaiserreichs* (Würzburg, 1989); and *Manet bis van Gogh: Hugo von Tschudi und der Kampf um die Moderne,* exh. cat. (Munich, 1996).

3. In a letter dated 31 March 1904. Carl Schellenberg, ed., *Alfred Lichtwark–Briefe an Leopold von Kalckreuth* (Hamburg, 1957), p. 115.

4. Lichtwark, 17 January 1913. Gustav Pauli, ed., *Alfred Lichtwark–Briefe an die Kommission für die Verwaltung der Kunsthalle in Auswahl,* vol. 2 (Hamburg, 1924), p. 491.

5. Richard Muther, *Geschichte der Malerei im XIX. Jahrhundert,* vol. 2 (Munich, 1893), pp. 631, 635. Muther wrote: "Degas, the talented colorist and fabulous draughtsman, is, of all those who belonged to the movement from the very beginning, the most original and bold."

6. *Museum–heute, ein Querschnitt: Zu ihrem einhundertfünfundzwanzigjährigen Bestehen herausgegeben von der Kunsthalle Bremen* (Bremen, 1948), p. 20.

7. Carl Vinnen, *Ein Protest deutscher Künstler* (Jena, 1911), p. 8.

8. Picasso's painting was one of more than 16,000 works of art confiscated from public collections in Germany by the Nazis because they were "degenerate." The campaign was directed against all "decadent art" produced after 1910, which included Expressionism. The works of Impressionist artists were not gathered in the purge.

9. Friedrich Fries, *Saal VII: Die französischen Impressionisten [Städtisches Museum Elberfeld]* (n.d., ca. 1918), nos. 168 and 169.

10. Between 1889 and 1918, Hermann Heilbuth owned three works by Degas, including the pastel drawing *Jacquet* (1878, The Armand Hammer Foundation, Los Angeles), and at least four paintings by Monet, including *The Mill at Orgemont, Snow* (1873, Virginia Museum of Fine Arts, Richmond).

11. Kenworth Moffett, *Meier-Graefe as Art Critic* (Munich, 1973), p. 50.

Britain and the Impressionists

CHRISTOPHER LLOYD

The advent of Impressionism brought out the best and the worst in the British art-going public. The incomprehension and recalcitrance of the majority were matched only by the hesitation and diffidence of a handful of sympathetic critics and dedicated collectors.[1] Although there were many points of contact across the English Channel, the sheer modernity of Impressionism in terms of style and content meant that its acceptance was not easily achieved in a country that had nurtured Pre-Raphaelite painting and continued to admire the output of artists such as W. P. Frith, G. F. Watts, Sir Luke Fildes, and Sir Lawrence Alma-Tadema. Such reluctance was not unknown elsewhere in Europe and to a certain extent even in America, where Impressionism fairly rapidly came to be appreciated intensely.[2] In most countries it was the private collectors who were the pioneers and the official authorities who limped behind, but in Britain even the collectors were slow to recognize Impressionist art. Pissarro posed the question in a letter of 1895, asking "how it was that we were so little understood in a country that had had such fine painters. England is always late and moves in leaps."[3]

Access to Impressionist works in Britain was first granted by the dealer Paul Durand-Ruel, who organized eleven exhibitions in London between 1870 and 1875.[4] These exhibitions were not composed exclusively of Impressionist paintings and were displayed in a relatively obscure gallery (the German Gallery in New Bond Street); nonetheless, works by Manet, Degas, Monet, Pissarro, Sisley, and Renoir were included. The same artists dominated the larger showing organized by Durand-Ruel at Dowdeswell's Galleries in 1883, which included forty-eight works and received considerable attention—both laudatory and condemnatory—from the critics. Durand-Ruel returned to London in 1901 and showed thirty-seven paintings by Monet, Pissarro, Renoir, and Sisley at the Hanover Gallery, but the climax of his activities was the exhibition held at the Grafton Galleries in 1905. This was the largest showing of Impressionist works ever seen in Britain, with 277 paintings (from a total of 315), including ten by Cézanne, who at the time still inspired incredulity and hostility. It was this exhibition that inspired the critic Frank Rutter to launch the French Impressionist Fund to encourage the National Gallery (which until 1917 administered the Tate Gallery as well) to purchase a work by Monet and thus give Impressionism a degree of official respectability. He was unsuccessful, and a work by Boudin was preferred. However, the question of obtaining Impressionist works for the national collection had been publicly raised. Significantly, it was also at the time of this exhibition that Sir Hugh Lane (fig. 1) made his first purchases (among them Manet's *Music in the Tuileries*

Fig. 1. Sargent, *Portrait of Sir Hugh Lane,* 1906, oil on canvas, 29⅛ × 24⅛ in., Hugh Lane Municipal Gallery of Modern Art, Dublin.

Gardens (*La Musique aux Tuileries,* fig. 2), *The Umbrellas (Les Parapluies)* by Renoir, *Beach Scene* by Degas, and *View at Louveciennes [Printemps à Louveciennes]* by Pissarro), thereby establishing himself as the first major collector of Impressionism in Britain. Furthermore, his collection, together with the activities of Samuel Courtauld, came to play a major role in the development of the National Gallery and the Tate Gallery, although this did not occur until the 1920s and 1930s.

The gradual acquisition of Impressionist works by British national institutions is indicative of the protracted debate on the qualities of such paintings. The Victoria and Albert Museum accepted the Constantine Ionides bequest in 1901 and thus acquired *The Ballet Scene from Meyerbeer's Opera "Robert le Diable"* (cat. 15) by Degas. In 1916, the Tate Gallery accepted *Carlo Pellegrini,* a small portrait in mixed media by Degas, and an unfinished work by Gauguin, *Tahitians,* in 1917. The National Gallery, under the directorship of Sir Charles Holmes, made a concerted attempt in wartime conditions to purchase work from the Degas sales held in Paris in 1918. Prompted by the painter and critic Roger Fry and supported by the economist John Maynard Keynes, Holmes acquired some major nineteenth-century French paintings, including *The Execution of Maximilian* by Manet and *A Vase of Flowers* by Gauguin. Yet he could not be persuaded to buy any of the works by Cézanne, and so it was Keynes himself who returned with *Still Life with Apples* for his own collection, where it became an object of some aesthetic consequence for members of the Bloomsbury Group.[5] The representation of Cézanne in a public collection remained a challenge even during the 1920s, so when the sisters Gwendoline and Margaret Davies of Gregynog Hall (Montgomeryshire) offered to lend two important landscapes by the artist —*Mountains, L'Estaque (Montagnes, L'Estaque,* fig. 3) and *Provençal Landscape, under Trees (Paysage provençal, sous-bois),* both acquired in February 1918—to the Tate Gallery in 1921, they were declined, thus triggering a further furious debate in the press. The impetus for the building of a national collection of modern French

Fig. 2. Manet, *Music in the Tuileries Gardens,* 1862, oil on canvas, 30 × 46½ in., National Gallery, London.

Fig. 3. Cézanne, *Mountains, L'Estaque,* 1878–80, oil on canvas, 21 × 28½ in., National Museum of Wales, Cardiff.

paintings in the broadest sense, therefore, came from the private sector and, in consequence, was dependent upon the vision and altruism of individual collectors.

One painting in particular has served as a touchstone for the debate on Impressionism in Britain. This was *The Absinthe Drinker (Dans un café [L'Absinthe],* fig. 4) by Degas, which was first owned by Captain Henry Hill, who lived in Brighton and by 1876 had no less than seven works (six of which were ballet scenes) by this artist in his collection.[6] It can be legitimately claimed that Hill at that time owned the finest collection of work by Degas in Europe.[7] It is not known how Hill obtained *The Absinthe Drinker,* but it was probably directly from Degas. Hill lent the picture to a public exhibition in Brighton in September 1876, where a local reviewer described it as the "perfection of ugliness." Hill sold it on 20 February 1892 at Christie's, where the painting was apparently hissed when it was placed on the stand. It was bought by the young Scottish dealer Alexander Reid, who had worked at the Boussod and Valadon gallery in Paris and had come to know Vincent van Gogh, the brother of his fellow employee, Theo. A collector from Glasgow also attended the Hill sale in London and bought the picture from Reid immediately afterward. This was Arthur Kay, who then lent the painting to the inaugural exhibition at the Grafton Galleries in 1893, entitled *Paintings and Sculpture by British and Foreign Artists of the Present Day. The Absinthe Drinker* was the object of much attention. Some of the general criticism was generous in its praise, but the effusions of D. S. MacColl, later a Keeper of the Tate Gallery, in a review written for *Spectator* (25 February), sparked off a row.[8] MacColl referred to *The Absinthe Drinker* as an "inexhaustible picture, the one that draws you back, and back again." A retort came from J. A. Spender (his pseudonym aptly being "The Philistine") in the *Westminster Gazette* (9 March), who took particular exception to MacColl's words that "the subject, if you like, was repulsive

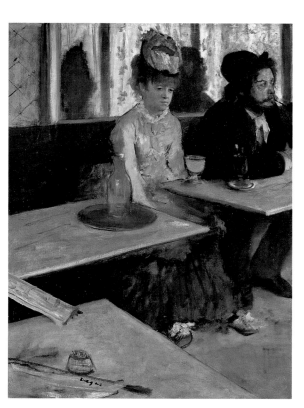

Fig. 4. Degas, *The Absinthe Drinker,* ca. 1875–76, oil on canvas, 36¼ × 26¾ in., Musée d'Orsay, Paris.

as you would have seen it, *before Degas made it his.* If it appears so still, you may make up your mind that the confusion and affliction from which you suffer are incurable." Spender objected that "if you have been taught to think that dignity of subject and the endeavour to portray a thing of beauty are of the essence of art, you will never be induced to consider 'l'Absinthe' a work of art, however 'incurable' your 'affliction and confusion' may be." This clash led to a correspondence lasting for six weeks, with others joining in, including the artist Sir William Blake Richmond, who articulated one of the main objections to the picture, referring to *The Absinthe Drinker* as "a literary performance." He opined that "it is not a painting at all. It is a novelette—a treatise against drink. Everything valuable about it could have been done, and has been done, by Zola. It would be ridiculous not to recognise M. Degas as a very clever man, but curiously enough his cleverness is literary far more than pictorial." For a certain type of critic, the subject matter of *The Absinthe Drinker* proved to be of greater significance than the technical ability or the probity of the artist. Even though he admired the painting as much as MacColl did, Kay sold it shortly after the exhibition to Count Isaac de Camondo, who bequeathed it to the Musée du Louvre with the rest of his distinguished collection in 1911.

The criticism of *The Absinthe Drinker* was a cause célèbre, but it was also a turning point in written comment about Impressionism in Britain. A fair amount of the criticism in the popular press was pure xenophobia. Alfred Thornton, the official historian of the New English Art Club, founded in 1886 by artists in favor of French painting and opposed to the entrenched attitudes of the Royal Academy, asserted that for the average art-lover, French paintings "connoted lubricity, bloodshed and a pursuit of the ugly."[9] The argument eventually settled down to being between the British concern for content and the French search for form. At the same time, there slowly emerged a body of accessible literature devoted to the study of modern French art: Mrs. C. H. Stranahan published *A History of French Painting* in 1889; D. S. MacColl's *Nineteenth Century Art* followed in 1902; Camille Mauclair's *French Impressionists,* translated from the French, in 1903; Wynford Dewhurst's *Impressionist Painting* in 1904; and Julius Meier-Graefe's *Modern Art* was translated from the German in 1908. Dewhurst advanced an argument that was occasionally used to make French Impressionism palatable to the British public, namely that its origins, as regards the treatment of light and color, lay with J. M. W. Turner, John Constable, John Crome, and R. P. Bonington—a view that was challenged by Pissarro, for one.[10] The main problem the British had with Impressionist painting was its sheer novelty, compounded by its seemingly insidious arrival in Britain. The public enjoyed the works of the Barbizon School—a fact readily acknowledged by Durand-Ruel and other dealers—and could even enjoy the style of Boudin, but to move beyond that needed greater courage. Similarly, the professional critics at first lacked the necessary vocabulary to assess or explain this new art, and a period of adjustment ensued during which serious writers tended to be patronizing and popular ones simply rude. The most perceptive of the New Critics—Sir Frederick Wedmore,[11] D. S. MacColl, and R. A. M. Stevenson[12]—attempted to establish a theoretical basis for a style founded on the observation of natural effects transcribed onto the canvas by a startlingly new technique. The prolific writer George Moore and the young painter Lucien Pissarro fall more into the category of witnesses from different generations than critics—the former less reliable, although more wide-ranging, than the latter.

Fig. 5. Edgar Degas and Walter R. Sickert at Dieppe, 1885.

Of greater potency than Moore and the younger Pissarro, however, were J. A. M. Whistler, who wittily promoted himself and his own type of "impressionism" through an endless flow of friendships (with Edwin Edwards, for example), conversations, lectures, controversies, and court cases, and Walter Sickert (fig. 5). Where Whistler perversely remained highly individual, Sickert put his Francophile tendencies to good use in the context of British art. His intimate knowledge of Paris and Dieppe, his meetings with French artists, and his infectious style of writing made Sickert highly influential in allaying British fears about French art. His memoir on Degas in *The Burlington Magazine* of 1917 was the literary counterpart to his knowledge of Impressionist technique and his choice of similar subject matter.[13] The success of these spokesmen ushered in the more far-reaching reviews by Frank Rutter, Charles Marriott, Roger Fry, and Clive Bell, who belonged to the next generation and all of whom made influential contributions.[14] Indeed, it was Fry who organized two epoch-making exhibitions at the Grafton Galleries: *Manet and the Post-Impressionists* (1910), in which Manet, Gauguin, van Gogh, and Cézanne dominated, and the *Second Post-Impressionist Exhibition* (1912), at which Cézanne, Picasso, and Matisse were represented.[15] While Impressionism had been introduced piecemeal and almost by stealth, Post-Impressionism fell like a sledge-hammer, but even though there were protestations, the public was at least more prepared. During the 1870s and 1880s, by contrast, people tended to adhere more readily to the art of those painters whose proclivities they could recognize. Thus Manet could almost be ranked as an old master; Pissarro and Sisley could be fitted into the tradition of landscape painting; and Degas, Renoir, and Gauguin were essentially figure painters. On the other hand, Monet and van Gogh posed problems of technique—notably in aspects of facture and color—whereas every feature of Cézanne's work appeared threatening until championed by Fry, who described the artist in 1910 as "one of the most intensely and profoundly classic artists that even France has produced."[16]

While the critics played a public role in the introduction of Impressionist painting into Britain, collectors acted in a private capacity and in many respects were the unsung heroes.[17] Henry Hill's enthusiasm for early paintings by Degas has already been noted, but, according to Douglas Cooper's research, Sickert, Arthur Studd, Arthur Kay, a certain Mr. J. Burke of London, Mr. and Mrs. Fisher Unwin, Esther Sutro, George Moore, James Staats Forbes, Lord Grimthorpe, and Sir William Eden can also be counted among the early collectors of the French Impressionists and Post-Impressionists. Of these, the Unwins and Esther Sutro are notable for owning works by van Gogh during the 1890s, and Arthur Studd acquired one of the Haystack pictures by Monet as early as 1891 (Wildenstein 1217A). Some of these paintings were bought in France through personal contacts, and it is fascinating to see how zealously Count Isaac de Camondo scooped up works by Degas when they were relinquished by British collectors.[18]

The principal dealers before 1900 were Durand-Ruel and Reid, who was first based in Glasgow but had occasional forays into London. Durand-Ruel also established connections with London dealers such as Agnew, MacLean, and Wallis. Cooper calculated that, up to 1905, British collectors were, or had been, in possession of twenty-five pictures by Degas, six or more by Manet, four by Monet, and

"ten or twenty in all?" by Pissarro, Renoir, Sisley, and van Gogh.[19] It is, of course, difficult to be precise, and Cooper's figures are now only a rough indication that should most probably be revised upward. For example, Samuel Barlow of Stakehill, Lancashire, who made a fortune from his bleach-works, acquired at least four works by Pissarro, five by Fantin-Latour, two by Corot, and one each by Daubigny and Harpignies, as well as several works by local Manchester artists.[20] In many respects, Barlow's selection of artists is characteristic of those collections being formed by enlightened patrons of French art in Britain toward the end of the nineteenth century. There are several other such collectors and personalities from both before and after 1900 still to be fully studied—from the 1920s, for instance, individuals such as Mrs. R. A. Workman, who was enthusiastic about Post-Impressionist art, and more public figures such as Sir Michael Sadler, whose collection included major paintings by Gauguin.

A turning point was reached with the start of the new century. The pattern of collecting had previously been fragmented, but now substantial collections began to be assembled, and a more sophisticated network of dealers and agents began to emerge—for example, Arthur Tooth and the partnership of Reid and Lefevre, both based in London. There was also growing recognition that Impressionism and Post-Impressionism should be represented in the national collections as part of the country's artistic heritage. The collections that were formed after 1900, therefore, not only provided private delectation but also were gathered with one eye on posterity.

After Durand-Ruel's exhibition of 1905, Sir Hugh Lane emerged as "the first serious purchaser of Impressionist pictures in England."[21] An Irishman who lived mostly in England and a dealer by instinct, Lane was briefly director of the National Gallery of Ireland. His collection was originally destined for a projected Gallery of Modern Art in Dublin, which was never built. As a result, Lane offered to lend

Fig. 6. Samuel Courtauld, Courtauld Institute Galleries, London.

thirty-nine pictures to the National Gallery in London in 1913, but the Trustees equivocated. The onset of the First World War, the death of Lane—drowned on the *Lusitania* on 7 May 1915—the generosity of Sir Joseph Duveen in offering to build a new gallery for the display of modern foreign art at the Tate Gallery, and the clarification of the relationship between the National Gallery and the Tate Gallery changed everything. The complications of Lane's will, which was in favor of the National Gallery but reintroduced Dublin in an unsigned codicil, only exacerbated the difficulties, and his paintings were moved from the National Gallery to the Tate in 1917. Since 1924, the Lane pictures have been displayed mainly in the National Gallery, but with a policy of loans to the Hugh Lane Municipal Gallery of Modern Art in Dublin.[22] Nevertheless, the collections formed by Lane and negotiations following his death served as a focus of attention and concentrated the minds of other collectors.

One such collector was the textile manufacturer Samuel Courtauld (fig. 6), who described the display of Lane's pictures at the Tate Gallery in 1917 as an "eye-opener."[23] He subsequently discovered works by Cézanne and Seurat at an exhibition organized by the Burlington Fine Arts Club in 1922. These revelations mark a watershed in the collecting of the Impressionists and Post-Impressionists in Britain. During the 1920s and 1930s, Courtauld, advised principally by the dealer Percy Moore Turner, not only formed his own personal collection but also established a special fund of 50,000 pounds for the purchase of

Fig. 7. Front parlor, Samuel Courtauld's home at Portman Square, London.

Fig. 8. Etruscan Room, Samuel Courtauld's home at Portman Square, London.

similar works for the national collections.[24] The paintings in his personal collection, cleverly obtained before prices began to rise, are remarkable for their consistently high quality. Outstanding are Manet's *Bar at the Folies-Bergère*, Degas's *Woman at a Window*, Monet's *Autumn Effect at Argenteuil*, Renoir's *The Box (La Loge)*, Pissarro's *Lordship Lane Station, Dulwich*, Cézanne's *La Montagne Sainte-Victoire* and *The Card Players*, Seurat's *The Bridge at Courbevoie* and *Young Woman Powdering Herself*, van Gogh's *Peach Blossom in the Crau*, Gauguin's *Nevermore*, and Toulouse-Lautrec's *Jane Avril in the Entrance of the Moulin Rouge*. Whether or not Courtauld was aware of it, the provenances of some of these pictures also reflect the earlier history of Impressionism in Britain.[25] The collection was first hung at Courtauld's house in Portman Square in London, which, after the death of his wife in 1931, became the site of the Institute founded in his name for the study of art history at the University of London (figs. 7, 8).[26]

The Courtauld Fund for the benefit of the national collection was administered by a board of trustees of which Courtauld was the chairman. The considerable strengths of the present holdings of Impressionist and Post-Impressionist painting in London stem from the possibilities created by this munificent gift and also from the skill with which the money was deployed. The fund was used for the most part between 1923 and 1928, when some twenty major paintings were acquired, including *Young Spartans* by Degas, *The Waitress (La Servante de bocks)* by Manet, *The Café-Concert (Le Café-concert la première sortie)* by Renoir, *The Water Lily Pond* by Monet, *Bathers at Asnières (Une Baignade, Asnières,* fig. 9*)* by Seurat, *A Cornfield with Cypresses, The Chair and the Pipe,* and *Sunflowers* by van Gogh, and *Self-Portrait* and *Mountains in Provence* by Cézanne.[27] Courtauld was triumphantly successful in his wide-ranging aims to complement Lane's contribution to the appreciation of modern French painting, to lay the foundations for a more comprehensive display of such paintings, and to promote the study of art.

Fig. 9. Seurat, *Bathers at Asnières,*
1883–84, oil on canvas,
79⅛ × 118⅛ in., National
Gallery, London.

While Courtauld placed the emphasis on London, other collections were being developed elsewhere in Britain. The paintings by Cézanne that Courtauld admired at the Burlington Fine Arts Club in 1922 were owned by the Davies sisters, Gwendoline and Margaret (figs. 10a–b), who in 1920 bought Gregynog Hall, an isolated house in the middle of Wales which they eventually developed into an arts center.[28] Their collection was formed for the most part between 1908 and 1928 with the assistance of Hugh Blaker, a dilettante museum curator, painter, actor, dealer, and critic. The purchasing was done in London and Paris, where the firm of Bernheim-Jeune proved to be influential. The collection comprised some two hundred paintings, nearly half of which were by modern French artists. Contemporary with the Lane collection, the one formed by the Davies sisters was also comparable in terms of its pioneering spirit. *The Parisian (La Parisienne,* fig. 11) by Renoir was acquired in 1913 and was probably the most outstanding Impressionist picture in Britain at that date, certainly in size. The two influential works by Cézanne *(Mountains, L'Estaque* and *Provençal Landscape, Under Trees)* were acquired in 1918, and *Still Life with Théière (Nature morte à la Théière)* was added in 1920. But even before then, the Davies sisters had acquired nine late works by Monet, including one of the series of the facade of Rouen Cathedral, some of the Venice pictures, and three of the Water Lilies *(Nymphéas)* series, which was also well ahead of contemporary taste.

Fig. 10a. Gwendoline Davies,
National Museum of Wales,
Cardiff.

Fig. 10b. Margaret Davies,
National Museum of Wales,
Cardiff.

Fig. 11. Renoir, *The Parisian,* 1874, oil on canvas, 63 × 41½ in., National Museum of Wales, Cardiff.

The Glasgow shipping magnate Sir William Burrell was a different kind of collector, with French paintings forming only a fraction of his total collection, which was particularly strong in medieval and oriental art.[29] Burrell, like Arthur Kay, was part of a singular group of collectors based in Glasgow, well served by dealers such as Alexander Reid, whom Burrell described as having done "more than any other man has ever done to introduce fine pictures to Scotland and to create a love of art."[30] Scottish collectors of paintings enjoyed works by artists of the Barbizon School, as well as those by the Hague School and the Glasgow Boys. As regards the modern French school, Burrell began with Daumier, Monticelli, and Manet, but his real commitment was to Degas: *Woman with Opera Glasses (La Lorgneuse), Jockeys in the Rain,* and *The Private Lesson (La Répétition).* Later, he added landscapes by Pissarro and Sisley, as well as Cézanne's *The Chateau de Médan.* The public impact of Burrell's collection was reduced by the difficulties of deciding how such an extensive and varied collection could be most effectively displayed after his death. Its donation to the city of Glasgow prompted the question as to where an appropriate building could be found. This was not easily solved, and the specially designed building in Pollok Park did not open until 1983. Other notable Scottish collectors of French pictures include William McInnes and David Cargill, who were benefactors of the Glasgow Museum and Art Gallery at Kelvingrove. To these should be added Sir John Richmond, who was senior deputy chairman of an engineering company in Glasgow. Influenced by Reid, he appreciated the work of Pissarro, Monet, Sisley, and Vuillard, although not the Post-Impressionists. Richmond was a benefactor of the Glasgow Museum and Art Gallery, and through his niece, Isabel Traill, also of the National Gallery of Scotland in Edinburgh. The Richmond/ Traill pictures enriched the already strong representation of works by Degas, Monet,

Fig. 12. Pissarro, *Portrait of Lucien Pissarro,* 1883, pastel, 21¾ × 14¾ in., Ashmolean Museum, Oxford.

Sisley, Gauguin, Seurat, van Gogh, and Cézanne in the collection formed by Sir Alexander Maitland.[31]

Finally, mention should be made of one of the most generous gifts of Impressionist art ever made to a museum in Britain. In 1944, Camille Pissarro's son Lucien died in London, where he had spent most of his life since 1883 (fig. 12). In 1892, he had married a young Englishwoman, Esther Bensusan, who, on her husband's death, assumed responsibility for the Pissarro family collection accumulated in Britain. Esther Pissarro's aim was to donate the collection to an institution that was prepared to keep it intact and honor it as a family collection. It seems that no national collection was able to do this, but on the advice of Anthony Blunt, the Pissarro collection was offered to the Ashmolean Museum at Oxford University in 1950. The donation comprised ten paintings by Camille Pissarro, over four hundred of his drawings, and almost a complete set of his prints, in addition to the famous series of letters written to Lucien. As Blunt wrote in a letter at the time of the negotiations (17 November 1949), "no serious student of the Impressionist movement would be able to disregard this collection." Indeed, it is true that for Impressionist and Post-Impressionist scholars, the Ashmolean Museum is today one of the essential points of reference outside France.[32]

This donation to Oxford University occurred almost twenty years after a comprehensive exhibition of French art from 1200 to 1900 was held at the Royal Academy in the winter of 1932, which included major groups of works by Impressionist and Post-Impressionist artists. One reviewer, Tancred Borenius, remarked of the success of the exhibition, "Today the battle is won—triumphantly won . . . May one hope that the promotion of Cézanne to rank, uncontestedly, among the great and prominent glories of French art will serve as a forcible reminder of that necessity of an unprejudiced vision, without which no art can thrive and flourish at any period."[33] It may have taken British collectors and the British public a long time, but it did finally happen, and when it did, it happened with distinction.

NOTES

1. The fundamental study on French Impressionism in Britain remains Douglas Cooper, *The Courtauld Collection: A Catalogue and Introduction* (London, 1954). It should, however, be read in conjunction with the important review by Denys Sutton in *The Burlington Magazine* 96 (September 1954): 292–294. For a general account on collectors of Impressionism, see Anne Distel, *Impressionism: The First Collectors* (New York, 1990), which includes a short chapter on British collectors. Useful biographical summaries of some of the British collectors mentioned below can be found in Dianne Sachko Macleod, *Art and the Victorian Middle Class* (Cambridge, 1996).

2. For America, see John Rewald, *Cézanne and America: Dealers, Collectors, Artists and Critics 1891–1921* (London, 1989). Gary Tinterow, "The Havemeyer Pictures," in *Splendid Legacy: The Havemeyer Collection,* exh. cat. (The Met-

ropolitan Museum of Art, New York, 1993), pp. 24–53. For some preliminary remarks on Mrs. Potter Palmer's activities as a collector in Chicago, see Richard Brettell, "Monet's Haystacks Reconsidered," *The Art Institute of Chicago Museum Studies 11* (fall 1984): 5–21.

3. John Rewald, ed., *Camille Pissarro: Letters to His Son Lucien,* 4th ed. (London, 1980). For the French text, see Janine Bailly-Herzberg, ed., *Correspondance de Camille Pissarro: Tome 4 1895–1898* (Paris, 1989), no. 1174, pp. 118–119.

4. For a complete list of these, see Kate Flint, ed., "Impressionist Works Exhibited in London, 1870–1905," appendix to *Impressionists in England: The Critical Reception* (London and Boston, 1984), pp. 356–375.

5. On the National Gallery and the Degas sale, see Ann Dumas, *Degas as a Collector,* exh. cat. (National Gallery, London, 1996), pp. 6–7;

and for the effect of Cézanne's still life on the Bloomsbury Group, see Frances Spalding, *Roger Fry: Art and Life* (London and New York, 1980), pp. 219–221. On arriving back in Britain from Paris, Keynes left the picture beneath a hedge in the Sussex countryside for Duncan Grant to collect. It is now on loan to the Fitzwilliam Museum, Cambridge.

6. The reception of this picture is described in detail by Ronald Pickvance, *"L'Absinthe* in England,*"* *Apollo* 77 (May 1963): 395–398, on which what follows below is based.

7. On Hill's mixed collection of Victorian and French paintings (some 400 in all), see Ronald Pickvance, "Henry Hill: An Untypical Victorian Collector," *Apollo* 76 (December 1962): 789–791. Hill (1812–1892) began to collect during the 1860s, but bought most of his pictures during the 1870s.

8. Douglas Sutherland MacColl (1859–1948) was an artist who made a reputation as a critic for *Spectator* (1890–1896) and *Saturday Review* (1896–1906 and 1921–30). He was keeper of the Tate Gallery (1906–11) and then of the Wallace Collection (1911–24).

9. Alfred Thornton, *Fifty Years of the New English Art Club 1886–1935* (privately printed, 1935), p. 6; quoted in Cooper, *Courtauld Collection,* 1954, p. 42. On the relationship between English and French painting during this period, see the excellent essay by Kenneth McConkey, "Impressionism in Britain," in Kenneth McConkey, ed., *Impressionism in Britain,* exh. cat. (Barbican Art Gallery, London, 1995), pp. 11–85.

10. For Pissarro's reaction, see Rewald, *Letters to His Son Lucien,* 1980, pp. 355–356 (8 May 1903). The French text is given in Bailly-Herzberg, *Correspondance . . . Tome 5,* 1989, no. 2016, to which should be added no. 1962, pp. 282–283; and less well known, Pissarro's views quoted in an anonymous review in *Artist* (1 June 1892), quoted in Flint, "Impressionist Works," 1984, no. 35, pp. 105–107. Dewhurst was an English artist who studied in Paris during the early 1890s (McConkey, "Impressionism in Britain," 1995, nos. 56–59). His 1904 book on Impressionism is the first in English to contain a reference to Cézanne.

11. Frederick Wedmore (1844–1921) was the chief critic for the *Evening Standard* newspaper for thirty years. His article "The Impressionists" in the *Fortnightly Review,* January 1883, is described by Flint, "Impressionist Works," 1984, no. 12, pp. 46–55, as "the first important piece devoted entirely to the Impressionists to be published in English."

12. R. A. M. Stevenson (1847–1900) was an artist who trained in Antwerp and Paris. He was the art critic for *Saturday Review* (1883–89) before becoming professor of fine arts at University College, Liverpool (1889–93), after which he became the art critic for *Pall Mall Gazette* until 1899. His book, *The Art of Velasquez* (London, 1895), was critical in linking Impressionism to more traditional painting associated with the old masters. A revised and enlarged edition of *Velasquez* was published in 1899.

13. The memoir on Degas is reprinted in Walter Sickert, *A Free House! or the Artist as Craftsman Being the Writings of Walter Richard Sickert* (London, 1947), pp. 144–154.

14. On the criticism of the younger generation, see Elizabeth Prettejohn, "Modern Foreign Paintings and the National Art Collections: Anthology of British Texts, 1905–32," in John House, *Impressionism for England: Samuel Courtauld as Patron and Collector,* exh. cat. (Courtauld Institute Galleries, London, 1994), pp. 225–252.

15. For the exhibitions of 1910 and 1912, see J. B. Bullen, ed., *Post-Impressionists in England: The Critical Reception* (London and New York, 1988).

16. Quoted in Cooper, *Courtauld Collection,* 1954, p. 54. The article by Fry was published in *The Burlington Magazine* 18 (February 1911): 293. Fry's statement has been pursued by Richard Verdi, among others, on such occasions as *Cézanne and Poussin: The Classical Vision of Landscape,* exh. cat. (London, 1990).

17. The groundwork on this topic was undertaken by Cooper, *Courtauld Collection,* 1954, pp. 60–76.

18. Apart from *The Absinthe Drinker* (ca. 1875–76) and *The Dance Class (La Classe de danse,* ca. 1875–76), which belonged to Henry Hill, Camondo also acquired *The Pedicure (Le Pédicure),* which had been owned by J. Burke, who had acquired it from Durand-Ruel in 1898, and *The Lobby of the Opéra on rue Le Peletier (Le Foyer de la danse à l'Opéra de la rue Le Peletier)* of 1872, which had belonged to Louis Huth in London from 1872 until 1888 (also acquired from Durand-Ruel). By this purchase, Huth became "the first English collector to own a work by Degas," and when it was included in the Glasgow International Exhibition of 1888, it was the first Degas to be seen in Scotland. Ronald Pickvance, "Degas's Dancers: 1872–6," *The Burlington Magazine* 105 (June 1963): 257, is most instructive about Degas's works in Britain.

19. Cooper, *Courtauld Collection,* 1954, p. 66.

20. On Barlow, see Cecil Gould, "An Early Buyer of French Impressionists in England," *The Burlington Magazine* 108 (March 1966): 141–142.

21. Cooper, *Courtauld Collection,* 1954, p. 66. A biography of Lane was published by Thomas Bodkin, *Hugh Lane and His Pictures* (Dublin, 1932), but there is a more recent account by Barbara Dawson, "Hugh Lane and the Origins of the Collection," in *Images and Insights,* exh. cat. (Hugh Lane Municipal Gallery of Modern Art, Dublin, 1993), pp. 13–31.

22. A new arrangement for the display of the Lane pictures in London and Dublin was

agreed upon in 1993 and published in *The National Gallery Report* (London, 1994), pp. 62–63. I am grateful to David Carter (archivist, National Gallery) for clarification. It should be noted that there is now also a formal exchange of nineteenth- and early-twentieth-century French pictures between the National Gallery and the Tate Gallery in order to rationalize the holdings of both galleries.

23. Anthony Blunt, "Samuel Courtauld as Collector and Benefactor," in Cooper, *Courtauld Collection,* 1954, pp. 3–4.

24. For the evolution of the Courtauld collection and the use of the Courtauld Fund, see House, *Impressionism for England,* 1994, pp. 9–33, which is an important contribution based on new research and therefore updating Cooper. Other essays in House, by Andrew Stephenson and John Murdoch, deal with related aspects of Courtauld as a collector. Percy Moore Turner was an eminent dealer who owned a gallery in Paris (Galerie Shirley in 1906) and was then connected with the Galerie Barbazanges. Returning to Britain after 1914, he subsequently opened the Independent Gallery in 1920–21. He is a key figure in the appreciation of Impressionist and Post-Impressionist art in Britain during the 1920s, about whom little is as yet known.

25. Most of the provenances of the pictures catalogued by Cooper, and again by House, are outstanding and underline the role played by Percy Moore Turner. From early British collections of Impressionist and Post-Impressionist art, Courtauld's personal collection included Degas, *Woman at a Window,* once owned by Sickert; Degas, *Two Dancers on the Stage,* once owned by Captain Henry Hill; Gauguin's *Nevermore,* previously owned by the composer Frederick Delius; and Picasso, *Child with a Pigeon,* once owned by Mrs. R. A. Workman.

26. Dennis Farr, "Samuel Courtauld as a Collector and Founder of the Courtauld Institute," in *Impressionism and Post-Impressionist Masterpieces: The Courtauld Collection,* exh. cat. (New Haven and London, 1987), pp. 8–13.

27. A full list has been compiled by Elizabeth Prettejohn, "Checklist of Samuel Courtauld's Acquisitions of Modern French Paintings," in House, *Impressionism for England,* 1994, pp. 221–224.

28. John Imgamells, *The Davies Collection of French Art* (Cardiff, 1967).

29. Richard Marks, *Burrell: A Portrait of a Collector: Sir William Burrell 1861–1958* (Glasgow, 1983).

30. Ibid., p. 62.

31. See Colin Thompson, *Pictures for Scotland: The National Gallery of Scotland and Its Collection: A Study of the Changing Attitude to Painting Since the 1820s* (Edinburgh, 1972); and Hugh Brigstocke, *French and Scottish Paintings: The Richmond-Traill Collection* (Edinburgh, 1980). On a general basis, the memoirs of T. J. Honeyman, *Art and Audacity* (London, 1971), are instructive in an informal way about collectors in Scotland.

32. Anne Thorold, "The Pissarro Collection in the Ashmolean Museum, Oxford," *The Burlington Magazine* 120 (October 1978): 642–645. A good idea of the range of material may also be gleaned from Anne Thorold and Kristen Erickson, *Camille Pissarro and His Family: The Pissarro Collection in the Ashmolean Museum* (Ashmolean Museum, Oxford, 1993).

33. Quoted in House, *Impressionism for England,* 1994, p. 21. The article by Borenius was published in *Studio* (February 1932): 77–78.

Collecting for the Nation and Not Only for the Nation: Impressionism in Hungary, 1907–1918

JUDIT GESKÓ

There are people who allegedly do not understand Cézanne and Gauguin because their painting is too new to them. They understand the old masters, allegedly. Well, neither Cézanne nor Gauguin is new. Both are very old—they could safely be displayed in a gallery of early painters. Real painting . . . in its essence, is one and absolute and pure. . . . In the end, it is silly to have labels: primitive, modern, new. There is no time in art, there are no ages, no distances. There is only art which—if true—is always one, whether it is modern or not.

LAJOS FÜLEP, 1907[1]

The end of the nineteenth century and the first two decades of the twentieth were a great period in Hungarian culture. Anyone who visited Budapest around 1896 must have been astonished by the frantic construction boom. East of the Danube intersecting the city, broad avenues and sweeping circular roads were laid out, lined with hundreds of huge tenement buildings. Scores of public buildings were built; the Parliament was under construction, as was the Szépművészeti Múzeum (Museum of Fine Arts) and the Műcsarnok (Exhibition Hall). The Museum of Applied Arts had just been completed. New churches, cafés, banks, theaters, and factories appeared.

Hungary was celebrating its 1,000th anniversary in 1896. Official art marched onto the stage with great pageantry, aligned with the self-adulatory view of history adopted by feudal Hungary. The institutions of Hungarian culture and art became more connected to the rest of Europe. Economic changes, contemporary transportation, telecommunication, and the press removed barriers to the spread of ideas and artistic trends. The first specimens of secessionist art appeared. Led by artists returned from Munich, the Nagybánya colony[2] introduced elements of plein-air painting and Impressionism into Hungarian art for the first time, challenging the traditional academic practice with a new language of visual art suitable for a modern society.

IDEAS AROUND A CAFÉ TABLE

At the turn of the century, the Abbázia café on Andrássy Avenue was the main meeting place for Hungarian artists. Exponents of the academic trends, followers of Nagybánya, and devotees of other progressive currents all gathered there. When new exhibitions in the Műcsarnok were being discussed, the gatherings were especially large.[3] The conflict between adherents of the academic branch of the Society of Hungarian Artists—who won state prizes and received commissions, and whose

Fig. 1. József Rippl-Rónai, *Elek Petrovics and Simon Meller,* 1910, oil on cardboard, 32⅞ × 40⅞ in., private collection, Hungary.

Fig. 2. *Portrait of Gábor Térey,* director of the Old Masters Gallery in the Szépművészeti Múzeum, Budapest, reproduction from the review *Színházi Életí* (Life in the Theater), 1926.

work was purchased—and the Hungarian Impressionists so sharpened after the first successes of the Nagybánya artists that the innovators transferred their headquarters to another café along the avenue, the Café Japan.[4]

The nonartists who frequented the Café Japan were supporters of all kinds of art patronage. At that time, centralized State subvention for art still prevailed in Hungary, in a system set up after the 1867 Compromise with the Habsburg Empire designed to promote national art. New forms based on free competition and bourgeois patronage were evolving parallel to the system of official subsidy.

The figures who set the tone at this café were the aging plein-air artist Pál Szinyei Merse (1845–1920), the art nouveau architect Ödön Lechner (1845–1914), and the painter József Rippl-Rónai (1861–1927), who returned to Hungary in 1902 after associating with the Nabis in Paris. Their presence attracted a large number of artists, museum people, and collectors. Legend has it that MIÉNK (an acronym meaning "ours" in Hungarian, standing for the Circle of Hungarian Impressionists and Naturalists) was organized around this table in 1907. This is where the decisive impetus was initiated for the erection of a new National Salon (Nemzeti Szalon) building to house exhibitions of nonacademic artists. And here it was decided that Elek Petrovics (1873–1945) (fig. 1)[5] should be the director of the Szépművészeti Múzeum instead of Gábor Térey (1864–1927) (fig. 2).[6] The collector Pál Majovszky (1871–1935), a junior official and later head of the Art Department of the Ministry of Religion and Public Education, also belonged to the company and managed to put the decision through.

As Simon Meller (1875–1949), then a young museum curator, recalled, all the major collectors of the period—Marczell de Nêmes, Ferenc Hatvany, Pál Majovszky —frequented the artists' table at the Café Japan, which functioned as a "free school" at that time.[7] The purchases of Adolf Kohner were also influenced by his friends who belonged to the circle, and he set out to acquire as representative a selection as

Fig. 3. Szépművészeti Múzeum, Budapest, ca. 1930s.

possible of French art produced in the last thirty or forty years of the nineteenth century.[8] Meller had access to every collection, followed the latest art historical literature with unflagging attention, and visited auctions in Paris, Berlin, Dresden, and Vienna. As a spider spins its web, he connected the material of the Budapest collections with invisible threads. His advice to collectors was guided by the hope that part of the purchases might eventually end up in the Szépművészeti Múzeum. He was careful to see that each collection reflected the history of nineteenth-century French art, that all periods of an artist were represented, and that important watercolors, pastels, and drawings related to the paintings also found their way to the Szépművészeti Múzeum or the collection of Pál Majovszky, which was being developed from its very first years (1906–10) for the benefit of the museum.[9]

THE IMPRESSIONIST COLLECTION OF SZÉPMŰVÉSZETI MÚZEUM, BUDAPEST

Curatorial collecting

The opening of the Szépművészeti Múzeum (fig. 3) in 1906 was soon followed by dissatisfaction over the weakness of the modern collections.

> The National Salon got together a roomful of pictures from the cream of impressionist art. Those who are represented, except for the impressive pictures by Daubigny and Boudin (which are closer to the old masters), are actually the French impressionists, the one-time revolutionaries of the Café Guerbois, who ignited the revolution of impressionism from this tiny Montmartre café with the help of Manet and Zola. These masters hang in all the museums abroad, and a few months ago they found their way into the Louvre in their native land. Has anyone ever seen one of them in the Museum of Fine Arts?![10]

Between 1907 and 1913, six exhibitions held in Budapest included Impressionist paintings (figs. 4a–b).[11] The Szépművészeti Múzeum bought works in Budapest, in 1907 and 1913. The purchases in 1907—Boudin's *Panoramic View of Portieux* (cat. 1),

Fig. 4a. Title page of the exhibition catalogue for the May 1907 Nemzeti Szalon (National Salon), *Spring Exhibition, Gauguin, Cézanne.*

Fig. 4b. Title page of the exhibition catalogue for the December 1907 Nemzeti Szalon (National Salon), *Exhibition of Great Modern French Artists.*

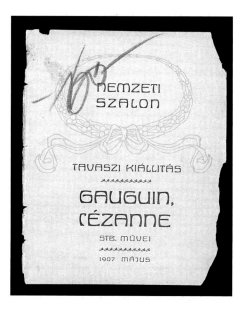

Gauguin's *Garden under Snow* (shown at the fifth Impressionist exhibition in Paris in 1880), and Pissarro's Post-Impressionist masterpiece *Le Pont-Neuf* (cat. 47)[12]—were the foundation of the nineteenth-century French collection.[13] In a letter dated 20 August 1907, Simon Meller wrote Durand-Ruel concerning the Pissarro, as well as a Daubigny and a Sisley, seeking to settle on a price:

> Sir, I have the honor to inform you that our Minister has consented to acquire the following three pictures for the Musée des Beaux-Arts of Budapest: Daubigny: *Environs de Villet,* Sisley: *Aux bords du Loing,* Pissarro: *Le Pont-Neuf,* which were shown at the Nemzeti Szalon exposition. / At this time we are authorized to offer you the sum of 60,000 francs for the three paintings. / We know that the price of these three masters has risen in the last few years sharply; nevertheless, we hope that you will agree to part with the said pictures for the sum offered, since this is virtually the first step to found a French section in our modern gallery, and if this year our means are constrained, we hope that in the future we will have more to spend and that we will gradually fill up the considerable gap in our collection of nineteenth-century painting."[14]

Both Gábor Térey, the director of the gallery, and Simon Meller, the curator of prints and drawings, were enthusiastic about modern French art, and they collaborated effectively in collecting it. Meller and Térey bought Monet's *Plum Trees in Blossom* (cat. 33) from Vienna's Galerie Arnot in 1912, and they purchased Gauguin's *Black Pigs* and Toulouse-Lautrec's *The Women* at a 1913 exhibition entitled *Great Nineteenth-Century French Masters* at the Ernst Museum in Budapest.[15] The letter to the minister of culture in which they applied for the refund of the buying price of the Monet reveals a consistent museum-building scheme.[16]

When Elek Petrovics was appointed to the post of general director in 1914, the passionate campaign of the Petrovics-Meller duo for the development of the new collection became well known all over Europe. At the Stern auction in Berlin in 1916, Meller made purchases on behalf of Petrovics.[17] The extensive correspondence with Paul Cassirer reveals that the collector of drawings Pál Majovszky was

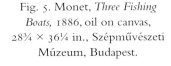

Fig. 5. Monet, *Three Fishing Boats,* 1886, oil on canvas, 28¾ × 36¼ in., Szépművészeti Múzeum, Budapest.

also represented by the Szépművészeti Múzeum at this auction. The museum paid the Cassirer gallery 35,000 German marks for Monet's *Entrance of the Port at Trouville.*[18] Monet's *Three Fishing Boats* (fig. 5) went to the Herzog collection in 1912, and was bought for the modern collection for 1 million pengö by the Ministry of Religion and Public Education in 1945.[19] A great opportunity to extend the French collection with a masterpiece came in 1916. The architect and art dealer Kurt Walter Bachstitz, who had long been in contact with the museum, offered Manet's *Portrait of Baudelaire's Mistress* (fig. 6), a radically innovative portrait of Baudelaire's

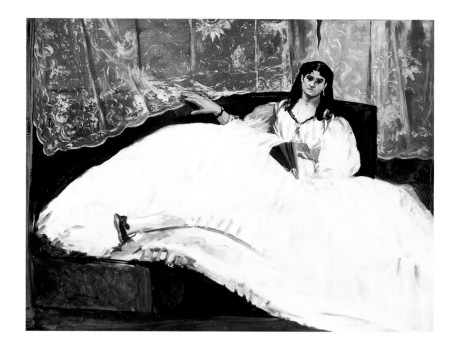

Fig. 6. Manet, *Portrait of Baudelaire's Mistress*, 1862, oil on canvas, 35⅜ × 44½ in., Szépművészeti Múzeum, Budapest.

lover, Jeanne Duval.[20] The justification written to the minister of religion and public education is carefully phrased:

> The artist painted it in 1862 when, having alloyed the influences he had got from the old masters, primarily Velasquez and Goya, he produced the first masterpieces of his peculiarly singular art. . . . Even when depicting a man of today, he reflects some of the old masters' monumental seriousness; despite the deficiencies in the proportions and the drawing of some details, his magnificent painterly qualities reveal themselves again with elementary force; the coloring reflects his extraordinary elegance and especially, his daring and sweeping personality revealed in the whole conception of the work.[21]

The Manet was the only major purchase during the First World War.

Ferenc Hatvany's generous donations were of special significance. He gave the museum Cézanne's *The Cupboard* in 1917 and Pissarro's early landscape *La Varenne de St. Hilaire, Seen from Champigny* in 1918.[22] Hatvany bought the picture from Paul Cassirer, who described Pissarro's painting as "from the artist's early period, from the 1860s, painted obviously under Corot's influence but showing distinct signs of the Impressionist approach; therefore, this transitional quality makes it particularly illuminating in terms of art history."[23]

In the interwar years, no Impressionist picture was acquired by the Szépművészeti Múzeum. In 1945, the museum bought Renoir's *Portrait of a Girl (Portrait of Julie Manet)*, painted in 1892, from István Herzog.[24] The purchase was the epilogue to the long and fruitful connection between Hungarian private collections and the Szépművészeti Múzeum. It took decades for the situation to change.

PRIVATE COLLECTIONS

The major collectors in the first two decades of this century were all born between 1865 and 1881 and raised under the same formative influences. Most of the collectors were wealthy cosmopolitans or aristocrats-turned-bourgeois who had broken with the past. A study of the major taxpayers of Budapest reveals their rapid and powerful enrichment, especially sweeping between 1906 and 1914. One result was

that aristocrats were squeezed out as the number of rich middle-class citizens acquiring the rank of nobleman or baron steadily increased. The new bourgeois elite of Budapest came from the wealthy Jewry raised to noble rank.[25]

The *fin de siècle* came to Hungary belatedly, but with a volcanic eruption. A typical example is the career of Marczell de Nêmes (1866–1930), a coal salesman of humble origin. The coal-trading firm he worked for from the age of twenty represented the copper dealer Goldschmidt of Frankfurt. Nêmes acquired his first collection of prints through Goldschmidt. He strengthened his financial status when he realized that sooner or later the import of Prussian coal would be cut off, so he set out to develop coal mining in Hungary. He compiled his first collection on the money of Baron Herzog, through monetary speculation. Toward the end of his life, he bought, sold, and traded art passionately.

The Deutsches (Hatvany-Deutsch), a family of grain merchants, founded the enormous sugar factory at Hatvan in 1889. They also had important steam mills, paper mills, and banking interests. The generation of Hatvanys active around 1910 included practitioners and patrons of literature and the arts.[26] The Herzog family was ennobled in 1886. Raised to baronial rank in 1904, Péter Herzog, originally a corn and wool merchant, founded a company to import raw material for the government monopoly of the tobacco industry, and he himself grew tobacco on large plantations in Macedonia. He established the Herzog Mór Lipót and Co. banking firm in his son's name. One of the largest art collections of the city was developed by Mór Herzog.

An aristocratic collector

Gyula Andrássy the younger (1860–1929), whose father had been prime minister after the Austro-Hungarian Compromise (1871–1879), studied law, joined the diplomatic corps, and served in Constantinople and Berlin. When he returned, he held a number of offices, including minister of domestic affairs from 1906 to 1910. He also was named the president of the Nemzeti Szalon, founded in 1894. Both his grandfather and father had collected art, and Gyula continued the family tradition. When his brother Tivadar (1857–1905), a painter who greatly admired the Barbizon School, died, part of his collection went to Gyula Andrássy the younger. He placed the nineteenth-century Austrian, German, and French pictures in his palace in Esterházy Street in Buda and the rest in the family's castle in Tiszadob.[27] The modern Hungarian collections were housed in the same north Hungarian castle.[28] The two Andrássy sons were especially drawn to the great landscapists of the last century, notably Turner and the Barbizon artists.[29] Next to landscapes by Díaz de la Pena, Rousseau, Dupré, Daubigny, and Millet, as well as works by Corot, Courbet, and Bastien-Lepage, there hung a small Monet landscape from 1872–73: "a faint green hillside, with two ladies in white, and small round spots of trees and houses in the background. Combined with a coloristic differentiation refined to the extreme, a decorative stylization appears: the rhythmic effect of a single line creating the landscape and the dark patches lined up above it."[30]

The connoisseur

After Count Andrássy, Adolf Kohner (1865–1934, fig. 7) was the first Hungarian to collect nineteenth-century French art systematically.[31] Kohner made his purchases mainly at Bernheim-Jeune in Paris and later, after the outbreak of the First World War, at Galerie Miethke in Vienna. His collection presented the development of

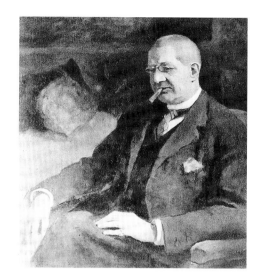

Fig. 7. Ida F. Kohner, *Portrait of Adolf Kohner,* reproduction from the review *Magyar Művészet,* 1929.

nearly a hundred years of French art, from romanticism to Post-Impressionism. When his collection was auctioned off after his death in 1934, together with a part of the Andrássy collection, the catalogue remarked: "Since his most active adulthood coincided with the years of the triumphal march of French Impressionism, the backbone of his picture collection is constituted by the works of these French masters and their predecessors."[32]

Kohner found himself the subject of nationwide attention at an early age when he bought Pál Szinyei Merse's *Lark,* the masterpiece of the ingenious Hungarian plein-air painter. Kohner was a regular buyer at the Kunsthalle but his collection was substantially enlarged only after 1900, when the Kohner palace was completed in a new neighborhood of Budapest, on a street off Andrássy Avenue. In the rooms of aristo-cratic splendor, along with masterpieces of nineteenth-century French romanticism, realism, and Impressionism, wrote Kálmán Pogány, "the superb works of the so-called Post-Impressionist painters were already present around 1906, at a time when . . . the top supervisers of our public collections had not even heard the names of most of these masters. . . . What a number of young Hungarian artists of a progressive trend were encouraged by the fact that French masters of similar bent have found admission and understanding at such an elegant place."[33] Kohner also collected small bronzes, gems, ceramics, and excellent German and English paintings; a virtual history of the last half-century of Hungarian painting was represented on his walls (fig. 8).[34] During a visit, Simon Meller exclaimed with a sigh, "But from the rich rooms filled with arts we long to go back into the little yellow room where the paintings of the new French school are hanging."[35]

The Kohner collection was the first major collection of modern art in Hun-gary.[36] Goya's *Hanging,* Daumier's *Singers,* Courbet's landscape *The Sea at Étretat,* Puvis de Chavannes's *The Magdalene,* Manet's *Lady with Parasol,* Fantin-Latour's *Flower-piece,* Sisley's *Old House,* Monticelli's *Garden Scene,* Carrière's *Breakfast,* Mori-sot's *Portrait of Madame Heude,* Renoir's *The Parisian,* and Cézanne's *The Black Clock* (from Zola's former collection) were complemented later by Gauguin's *The Appeal* and a flower study, Raffaëlli's *The Notre-Dame in Winter,* Maillol's study of a woman's

Fig. 8. The yellow room in the home of Adolf Kohner, Budapest. On the wall: Gauguin, *The Appeal* (1902).

head, van Gogh's *Olive Grove, Saint-Rémy,* Matisse's colorful still life with flowers, and Toulouse-Lautrec's *Seated Woman with Parasol.*[37] Kohner was quick to show his collection to visitors and to lend works to exhibitions, notably the *International Impressionist Exhibition* at Művészház (House of Artists) in 1910 (fig. 9).[38] After the exhibition he purchased Monet's *Thaw* at Galerie Miethke and Pissarro's *The Dam at Pontoise* from Durand-Ruel.[39] When he was forced to sell his collection in 1934, one of the most famous pieces was *Dancers,* a pastel by Degas.

The art of collecting

Marczell de Nêmes (fig. 10) was known as a collector of Cézanne and El Greco, for at the beginning of this century he had six pictures by the Aix master and twelve by El Greco.[40] He had a passion for art, in which his master was József Rippl-Rónai. During his stay in Munich (1918–30) his best friend was Simon Meller, who was teaching at the university at that time.[41] He showed his first collection in Budapest, Munich, and Dusseldorf between 1910 and 1912, then was forced to auction it off at Galerie Manzi-Joyant in Paris in 1913 (fig. 11).[42] Hugo von Tschudi, who was reviled in Berlin for his modern French purchases, described Nêmes as "the paragon of a collector who is not led by art historical considerations, who does not aim at completeness or hanker after rarities, but whose relationship to art is utterly personal, whose talent, taste, and temper are expressed by his collecting activity."[43]

After the 1913 auction Nêmes made only occasional efforts to buy Impressionist works, realizing that he would never achieve the quality of the earlier collection.[44] This later collection included such notable works as Cassatt's *In the Box;* Cézanne's *The Table, Still Life with Fruit Bowl, Apples and Biscuits, Man with Red Vest, Bathers in Plein Air,* and *The Maria Mansion;* Degas's *The Ballerinas* and *Three Dancers;* Gauguin's *Still Life with Profile of Laval* and *Te Far Hymenée, the House of Songs;* Manet's *The*

Fig. 9. B. Kádár and T. Hirschmann, poster of the *International Impressionist Exhibition* at Művészház (House of Artists), 1910.

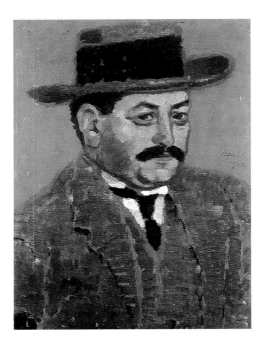

Fig. 10. József Rippl-Rónai, *Marczell de Nêmes,* 1912, oil on cardboard, 25 × 17⅜ in., Museum Rippl-Rónai, Kaposvár, Hungary.

Fig. 11. Title page of the sale catalogue *Collection Marczell de Nêmes,* Galerie Manzi-Joyant, 18 June 1913.

Negress, Study for Olympia, *Rue Mosnier Decked with Flags, Portrait of Clemenceau,* and *Peaches;* Monet's *Girl Sitting on Bench* and *Boats on the Beach at Étretat;* Morisot's *Women Gathering Flowers;* Renoir's *Nude Study, Flowers, Portrait of a Girl, Landscape, The Henriot Family,* and *Dancing at the Moulin de la Galette;* Sisley's *Landscape at Sèvres;* and van Gogh's *Still Life* and *Landscape.*[45]

The amateur

Hór Herzog (1869–1934) was left an immense fortune upon the death of his father, the tobacco baron Péter Herzog. While Herzog's main interest appears to have been his racing stable, he became a business partner of Nêmes and the two often traveled together.[46] Herzog's collecting activity assumed a definite trend when he redeemed or bought Nêmes's pictures at the 1913 Paris auction. He acquired, among other items, Manet's *The Negress* and *Rue Mosnier Decked with Flags,* Renoir's *The Henriot Family,* Cézanne's *Apples and Biscuits* and *Bathers in Plein Air,* Gauguin's *Still Life with Profile of Laval* and *Te Far Hymenée, the House of Songs,* and a fine set of Nêmes's Spanish pictures, including works by El Greco, Zurbaran, and Goya. The collection was to be extended over the years by Herzog's own purchases. The walls of his palace were adorned with three Monet pictures, and he bought Sisley's *By the Seine* and Degas's pastel *Dancing Ballerinas* from Alex Rosenberg *père*'s Paris collection.[47] He continued to buy from Nêmes, and several noted pieces in his old collection came from the Amsterdam auction of Nêmes's pictures in 1928.

The artist collector

In 1912, Berlin's Cassirer gallery and Bernheim-Jeune in Paris showed the works of Ferenc Hatvany (1881–1958). His contacts with the best European galleries can be retraced to 1907. He studied at the artists colony of Nagybánya and the Julien Academy. As a painter, he was drawn to the tradition of Ingres and Chassérieu, but he admired and collected Impressionism. When studying in Paris, he began collecting, buying Pissarro's *L'Hermitage at Pontoise* in 1905.[48] At the 1908 auction of the collection of Paul Alfred Chérany, he purchased twelve pictures. Like others of his generation of collectors, Hatvany was building his collection systematically.[49] Hatvany bought Manet's *Suicide* at Cassirer's in 1910.[50] The picture possibly went from Bernheim-Jeune to Berlin, then sojourned in Hungary until the outbreak of the Second World War; it was exhibited in the Ernst Museum in 1940 (fig. 12). Manet's pastel *Méry Laurent with a Pug* arrived in Budapest in 1913 via the galleries of three dealers, Bernheim-Jeune, Durant-Ruel, and Cassirer.[51] Other Impressionist works collected by Hatvany included three Renoirs and Degas's pastel *After the Bath.*[52]

In 1915, Hatvany bought the Lónyai palace in the Castle district for his collection. In the war years, he bought Manet's *Bar at the Folies-Bergère* from Cassirer, who set the price at 60,000 marks.[53] Hatvany had only half that amount, but he longed for the picture. He immediately realized its significance, although he must have read Meier-Graefe's damning criticism. In his letter to the art historian Ervin Ybl, he wrote that he had given a few tens of thousands of marks as well as a Cézanne and a Renoir for the picture. According to Antal Géber,

> As time passed, he was less and less delighted by the picture. He found it a bit too hard. After the war, as soon as he could, he traveled to Paris and visited Bernheim-Jeune. He was glad to see him and asked what he had bought lately. As Hatvany mentioned *Le Bar,* Bernheim asked infuriated

Fig. 12. Interior of the exhibition *French Art from Hungarian Private Collections,* Ernst Museum, Budapest, 1940. At center: Manet, *Suicide* (1877).

where he had got it. The picture was his, he had been searching all over, he had given it to Cassirer on commission. . . . Hatvany sold the picture as soon as he could.[54]

In the vast and rapid expansion of wealth in the first two decades of this century, the newly rich middle class in Budapest was attracted to the art of the present and the future. In Hungary, this meant Impressionism and Post-Impressionism. In a 1910 lecture, the great Hungarian poet Mihály Babits called the Impressionist movement a revolution of art that set the goal of doing away with outdated mannerisms. He said:

> This kind of modern art is like a metropolitan Venus, and we who love her in this distant province pay homage to her like the medieval knights paid homage to an oriental princess. But for an evening she will alight among us, fascinated as we are by her beauty newly washed by the sea from which she had arisen. She is the soul of modern man and the sea, the soul of the French people that wanted and dared to be the first modern people in our dry continent.[55]

1. Lajos Fülep, "Cézanne és Gauguin," *A Hét* (12 May 1907), p. 319. From early in his career, the art theorist Lajos Fülep (1885–1970) investigated the spiritual and intellectual changes underlying the emergence of modern art, and the role Hungarian art played in world culture. Fülep was a member of the *Vasárnapi Kör* [Sunday Circle] (1915–22/26) led by the philosopher György Lukács (1885–1971), which included such art historians of Hungarian origin as Charles de Tolnay, Johannes Wilde, Arnold Hauser, and Frederick Antal.

2. See Géza Csorba and György Szücs, ed., *The Art of Nagybánya: Centennial Exhibition in Commemoration of the Artists' Colony in Nagybánya,* exh. cat. (Hungarian National Gallery, Budapest, 1996). Today Nagybánya is Baia Mare in Romania.

3. The Kunsthalle, for a long time the only exhibiting institution of Budapest, was completed in 1896.

4. The first recorded occurrence of the word "Impressionist" in Hungary was in 1895 and "Impressionism" in 1904. See *A Magyar Nyelv Történeti-Etimológiai Szótára* [The Historical-Etymological Dictionary of the Hungarian Language] (Budapest, 1970), II, p. 207.

5. An aesthete and lawyer of unimpeachable character, Petrovics became director of the Szépművészeti Múzeum in 1914 and general director in 1921. At the University of Law, he was a student of Ágost Pulszky, the son of the greatest figure of nineteenth-century Hungarian museology, Ferenc Pulszky. See Ian Jenkins, *Archaeologists and Aesthetes* (London, 1992), pp. 57, 70–71. Many turn-of-the-century bourgeois radical sociologists, politicians, and thinkers had been pupils of Ágost Pulszky.

6. Térey was employed by the National Picture Gallery from 1896 and directed the Old Masters Gallery of the Szépművészeti Múzeum between 1904 and 1926. A pupil of Jacob Burckhardt, professor at Freiburg University, he was unjustly implicated in connection with the appraisal of the Marczell de Nêmes collection.

7. See Ernő Marosi, ed., *Die ungarische Kunstgeschichte und die Wiener Schule, 1846–1930,* exh. cat. (Collegium Hungaricum, Wien, 1983), pp. 70–71.

8. This taste was a synthesis of everything from the Barbizon School to Post-Impressionism, which makes it difficult to distinguish between the collection of Impressionist and Post-Impressionist works.

9. Judit Geskó, "Die Entstehung von Pál Majovszkys Sammlung französischer Zeichnungen des 19. Jahrhunderts. Ein Konservativer für die Modernen," in Judit Geskó and Josef Helfenstein, ed., *"Zeichnen ist Sehen,"* *Meisterwerke von Ingres bis Cézanne aus dem Museum der Bildenden Künste Budapest und aus schweizer Sammlungen,* exh. cat. (Kunstmuseum Bern-Hamburger Kunsthalle, Stuttgart, 1996), pp. 10–20.

10. György Bölöni, "Francia impresszionisták" [French impressionists], *Népszava* (15 June 1907), quoted in *Képek között: Bölöni György művei* [Among pictures: The works of György Bölöni] (Budapest, 1967), p. 56.

11. *Tavaszi kiállítás, Gauguin, Cézanne* [Spring exhibition, Gauguin, Cézanne], exh. cat. (Nemzeti Szalon, Budapest, May 1907); *Modern Francia Nagymesterek Tárlata* [Exhibition of Great Modern French Artists], exh. cat. (Nemzeti Szalon, Budapest, December 1907); *Kalauz a Művészház Nemzetközi Impresszionista Kiállításához* [Guide to the International Impressionist Exhibition of Művészház], exh. cat. (Muvészház, Budapest, April–May 1910); *Francia Impresszionisták (Manet és Herman Lipót gyűjteményes kiállítása)* [French impressionists (Manet and Lipót Herman's collected works)], exh. cat. (Ernst Museum VI, Budapest, 1913); *Dr. Sonnenfeld Zsigmond Gyujteménye* [The collection of Dr. Zsigmond Sonnenfeld], exh. cat. (Ernst Museum VII, Budapest, 1913); *A XIX. Század Nagy Francia Mesterei* [The Great 19th-Century French Masters], exh. cat. (Ernst Museum XI, Budapest, 1913). For lists of the exhibited works, see Donald E. Gordon, *Modern Art Exhibitions 1900–1916* (Munich, 1974).

12. *Panorama de Portrieux,* 1874; see Robert Schmit, *Eugène Boudin, 1824–1898* (Paris, 1973), no. 958. *Jardin sous la neige,* 1879; see Georges Wildenstein, *Gauguin I, Catalogue* (Paris, 1964), no. 27. *Le Pont-Neuf, 2e série,* 1902; see Ludovic R. Pissarro and Lionello Venturi, *Camille Pissarro: Son art, son oeuvre* (Paris, 1939), no. 1211.

13. The collections that laid the foundations for the Szépművészeti Múzeum—the Esterházy, the Pyrker, and other art treasures—came into being in the first third of the nineteenth century and represented the history of painting up to the end of the eighteenth. See Andor Pigler, *Katalog der Galerie Alter Meister I–II* (Budapest, 1967); and László Mrávik, ed., *Pulszky Károly in memoriam,* exh. cat. (Szépművészeti Múzeum, Budapest, 1988).

14. Szépművészeti Múzeum Archives, 1907/1257. It is not clear to which member of the Durand-Ruel family the letter was addressed. Sisley's *Bords du Loing, effet d'automne, 1881,* was later exchanged; see n. 20; and François Daulte, *Alfred Sisley: Catalogue raisonné de l'oeuvre peint* (Lausanne, 1959), no. 420.

15. *Les pruniers en fleurs à Vétheuil,* 1879; see Daniel Wildenstein, *Claude Monet: Biographie et catalogue raisonné I* (Lausanne, Paris, 1974), no. 520. *Les Pourceaux noirs,* 1891; see

G. Wildenstein, *Gauguin I,* 1964, no. 446. *Ces Dames au réfectoires,* 1893; see M. G. Dortu, *Toulouse-Lautrec et son oeuvre: Catalogue des peintures, aquarelles, monotypes, reliure, vitrail, céramiques, dessins* (New York, 1971), no. P.499.

16. The letter was signed by Gábor Térey, but the autograph reveals that it was drafted by Simon Meller: "To the Minister. It is the main defect of our modern picture collection that the leading masters of 19th century French painting are almost completely missing from it. This is the more painful, for in the 19th century it was French art that took the lead, providing the impetus and showing the way for the course of development. And if the task of the old collection is to introduce the development of previous centuries to us, then the modern collection, which is its natural continuation, can only fulfill its function when it provides an overview of recent development. . . . Monet's *Apple Trees in Blossom* [the picture's title for decades] appears highly suited to the enlargement of our collection. Monet, the spearhead of French Impressionism, is missing from our collection; the mentioned picture is from the heyday of the master, from 1879, and is an excellent representative of his art." Szépművészeti Múzeum Archives, 1912/725.

17. *Sammlung Julius Stern, Berlin,* exh. cat. (Galerie Paul Cassirer, Berlin, 19–21 May 1916).

18. *L'Entrée du port de Trouville,* 1870, was exhibited at the fourth Impressionist show in Paris, under no. 147; see D. Wildenstein, *Monet I,* 1974, no. 154. The invoice was dated 7 June 1916 (Berlin, 1916, lot. 69). Szépművészeti Múzeum Archives, 1916/458, 551, 593.

19. *Trois bateaux de pêche,* 1885; see D. Wildenstein, *Claude Monet: Biographie et catalogue raisonné II* (Lausanne, Paris, 1979), no. 1029.

20. *Portrait de la maîtresse de Baudelaire couchée,* 1862; see Denis Rouart and Daniel Wildenstein, *Édouard Manet: Catalogue raisonné I* (Lausanne, Paris, 1975), no. 48. The picture was bought for 106,000 korona, plus Sisley's *Banks of the Loing River, Autumn Effect,* which had been bought for the museum in 1907. In justification, Petrovics wrote: "I suggested that the latter picture could be involved in the transaction because it fell below the standards we must set to us when trying to compile the French collection of the 19th century." (Szépművészeti Múzeum Archives, 1916/1084).

21. In Elek Petrovics's hand, Szépművészeti Múzeum Archives, 1916/1084. Petrovics and Meller almost always laid emphasis on the continuity between modern art and the work of the old masters.

22. *Le Buffet,* 1877–79, until 1913 in the Nêmes collection; see John Rewald, Walter Feilchenfeldt, and Jayne Warman, *The Paintings of Paul Cézanne: A Catalogue Raisonné I–II* (New York, London, 1996), no. 338. *La Varenne de Saint-Hilaire, vue de Champigny,* ca. 1863; see Pissarro-Venturi, *Pissarro,* 1939, no. 31.

23. Paul Cassirer to Elek Petrovics, 19 October 1918 (Szépművészeti Múzeum Archives, 1918/808), and telegram dated 30 October 1918 (1918/1105).

24. Ferenc Tóth's attribution, formerly *Portrait de jeune fille,* 1892; see *Französische Kunst des 19. Jahrhunderts aus dem Museum der Bildenden Künste Budapest,* exh. cat. (Kunsthalle Bremen, Bremen, 1989), no. 14.

25. See John Lukacs, chapter 5, in *Budapest 1900: A Historical Portrait of a City* (New York, 1988); as well as László Mrávik, "Collections et collectionneurs en Hongrie," in Emmanuel Starcky and László Beke, eds., *Modernité hongroise et peinture européenne,* exh. cat. (Musée des Beaux-Arts de Dijon, 1995), pp. 63–67.

26. Lajos Hatvany was a writer and aesthete (1880–1961), the patron of the periodical *Nyugat.* His younger brother Ferenc (1881–1958) was a successful painter both in Paris and Berlin, and an art collector. It is indicative of his social rank that he married the daughter of a prime minister. On the relationship between the Hatvany family and Paul Cassirer, see Georg Brühl, *Die Cassirers: Streiter für den Impressionismus* (Leipzig, 1991), pp. 205–208.

27. Its famous dining room was designed for Tivadar Andrássy by József Rippl-Rónai; see Mária Bernáth, ed., *Rippl-Rónai's Collected Works,* exh. cat. (Hungarian National Gallery, Budapest, 1998), pp. 464–473.

28. György Gombosi, "Andrássy Gyula gróf gyűjteménye. II. Régi mesterek képei a tiszadobi kastélyban. III. Modern festők" [The collection of Count Gyula Andrássy. II. Pictures of the old masters in the Tiszadob castle. III. Modern painters], *Magyar Művészet III* (1927), pp. 431–452.

29. Some of the pictures were on display at the Nemzeti Szalon in 1904. *Művészettörténeti Kiállítás. I. A XVIII. század angol mesterei. II. A francia barbizoni iskola mesterei* [Exhibition of Art History. I. English masters of the eighteenth century. II. Masters of the French Barbizon School], exh. cat. (Nemzeti Szalon, 1904).

30. Gombosi, "Andrássy Gyula," 1927, p. 444. The painting was *Dans la prairie près d'Argenteuil;* see D. Wildenstein, *Monet I,* 1974, no. 275. Its present location is unknown.

31. His father, Károly Kohner, who died in 1894, also collected artworks, especially seventeenth-century Dutch paintings and rugs, as well as Austrian art. Adolf was one of the founders of the Szolnok artists colony and at one time was the president of the Society of Hungarian Artists, established in 1861. The Kohner family wealth was based on trade in raw materials, especially feathers. See Károly Vörös, *Budapest legnagyobb*

adófizetői 1873–1917 [Budapest's largest tax-payers 1873–1917] (Budapest, 1979).

32. *Ernst Múzeum Aukciói. XLVIII/a. Kohner Adolf gyűjteménye* [Ernst Museum Auctions. XLVIII/a. Adolf Kohner's collection] (Budapest, 1934), pp. 3–6. The preface was by Elek Petrovics, the director of the Szépművészeti Múzeum, and the introductory essay was by Kálmán Pogány, who had been removed from the museum for political reasons in 1919.

33. Ibid., p. 4.

34. Elek Petrovics, "Báró Kohner Adolf gyűjteménye. I. Képek" [The collection of Baron Adolf Kohner. I. Pictures], *Magyar Művészet V* (1929), pp. 301–321.

35. Simon Meller, "Kohner Adolf művészeti gyűjteménye" [Adolf Kohner's art collection], *Vasárnapi Ujság,* vol. 58, no. 18 (11 April 1911), pp. 353–354, photo of the interior on p. 363.

36. Hugo Haberfeld, "Peintures françaises de la collection Adolf Kohner," *Der Cicerone 1* (August 1911): 579–589.

37. Puvis de Chavannes, *La Madeleine,* 1897, Szépművészeti Múzeum, Budapest, Inv. 389 B., purchase from Baron Kohner, 1930. Manet, *La Femme à l'ombrelle,* 1872; Rouart-Wildenstein, *Manet I,* 1975, no. 182. Morisot, *Portrait de Mme Heude,* 1870; M.-L. Bataille and Georges Wildenstein, *Berthe Morisot: Catalogue des peintures, pastels et aquarelles* (Paris, 1961), no. 21. Renoir, *La Parisienne,* 1877; Elda Fezzi, *L'opera completa di Renoir nel periodo impressionista 1869–1883* (Milan, 1972), no. 294. Cézanne, *La Pendule noire,* 1867–69; Rewald-Feilchenfeldt-Warman, *Cézanne I–II,* 1996, no. 136. Gauguin, *L'Appel,* 1902; G. Wildenstein, *Gauguin I,* 1964, no. 612. Gauguin, *Fleurs dans une coupe,* 1901; G. Wildenstein, *Gauguin I,* 1964, no. 695. Kohner bought Van Gogh's *Olive Grove, Saint-Rémy* from Galerie Miethke in Vienna; see Imre Soós, "Van Gogh képek Magyarországon" [Van Gogh pictures in Hungary], *Művészet barátai* (September–October 1995), pp. 16–19; J.-B. de la Faille, *The Works of Vincent van Gogh: His Paintings and Drawings* (Amsterdam, 1970), no. 715. Toulouse-Lautrec, *Femme assise de face, et tenant une ombrelle,* 1889; Dortu, *Toulouse-Lautrec,* 1971, no. P.341.

38. *Nemzetközi Impresszionista Kiállítás* [International Impressionist Exhibition], exh. cat. (Művészház, Budapest, April–May 1910).

39. Monet, *Le Dégel,* 1873; D. Wildenstein, *Monet I,* 1974, no. 255. Pissarro, *Le Barrage de Pontoise,* 1872; Pissarro-Venturi, *Pissarro,* 1939, no. 157.

40. For works by Cézanne, see Rewald-Feilchenfeldt-Warman, *Cézanne I–II,* 1996, nos. 338 (today at the Szépművészeti Múzeum, Budapest), 419, 431, 658, 748, 792.

41. A commissar during the communist Republic of Soviets in Hungary in 1919, Simon Meller was appointed professor by the philosopher György Lukács. The counter-revolutionary and right-wing political course forced him into retirement in 1923. From 1924 he taught at the University of Munich. Nêmes moved to Munich after the First World War.

42. *Catalogue des tableaux modernes: Oeuvres capitales de Mary Cassatt, Cézanne, Courbet, Corot, Degas, Gauguin, Van Gogh, Manet, Claude Monet, Berthe Morisot, Renoir, composant la collection de M. Marczell de Nêmes de Budapest,* Galerie Manzi-Joyant (Paris, 18 June 1913).

43. Hugo von Tschudi and August L. Mayer, *Katalog der aus der Sammlung des Kgl.Rates Marczell von Nêmes—Budapest ausgestellten Gemälde,* exh. cat. (Alte Pinakothek, Munich, 1911). Tschudi (1851–1911) was the director of Munich's Staatliche Galerien at that time. See also Ernst Múzeum Aukciói, XLIX. III, *Nemes Marcell festményei* [The paintings of Marczell de Nêmes] (lot. 147–182); and Elek Petrovics, "Nemes Marcell," *Magyar Művészet VI* (1930), t. 561.

44. Simon Meller, "Marcell von Nemes," in *Zeitschrift für bildende Kunst,* 1931–21 (65/2), p. 26.

45. Cassatt, *Dans la Loge;* Manzi-Joyant, Paris, 1913, no. 84. Cézanne, *Le Buffet, Nature morte au compotier, Pommes et biscuits, Le Garçon au gilet rouge, Baigneurs en plein air, La Maison Maria sur la route du Château Noir;* Rewald-Feilchenfeldt-Warman, *Cézanne I–II,* 1996, nos. 338, 418, 431, 658, 748, 792. Degas, *Les Ballerines, Trois danseuses;* Manzi-Joyant, Paris, 1913, nos. 103, 104. Gauguin, *Nature morte au profil de Laval, Tè Far Hymenée, la maison des chants;* G. Wildenstein, *Gauguin I,* 1964, nos. 207, 477. Manet, *La Négresse, étude pour L'Olympia, La rue Mosnier aux drapeaux, Portrait de Clemenceau à la tribune, Pêches;* Rouart-Wildenstein, *Manet I,* 1973, nos. 68, 270, 329, 362. Nêmes also owned Rouart-Wildenstein, *Manet I,* 1975, nos. 236, 301. Monet, *Femme assise sur un banc, Bateaux sur la plage à Étretat;* D. Wildenstein, *Monet I,* 1974, nos. 343, 1024. Morisot, *Dames cueillant des fleurs;* Bataille-Wildenstein, *Morisot,* 1961, no. 80. Renoir, *Étude de nu, Fleurs, Portrait de femme;* Manzi-Joyant, Paris, 1913, nos. 115, 117, 118; and *Paysage, La Famille Henriot, Le Moulin de la Galette;* Fezzi, *Renoir,* 1972, nos. 606, 211, 247. Sisley, *Paysage à Sèvres;* Daulte, *Sisley,* 1959, no. 288. Van Gogh, *Nature morte, Paysage;* de la Faille, *Van Gogh,* 1970, nos. 604, 815.

46. Antal Géber, *Magyar műgyűjtők* [Hungarian Collectors] (Budapest, 1970), p. 279. According to Nêmes's niece, "Had it not been for Uncle Marcell, Mór would still be caring for his horses and reading the postmen's almanac."

47. *Au Jardin, la famille de l'artiste, Le Repos dans le jardin,* and *Trois bateaux de pêche;* D. Wildenstein, *Monet I,* 1974, G. Wildenstein, *Monet II,* 1979, nos. 386, 408, 1029. See Ludwig Baldass, "Herzog báró gyűjteménye" [Collection of Baron Herzog], *Magyar Művészet III* (1927),

pp. 203–204. He also owned Gauguin's *Les Pêcheurs à la ligne,* 1888; G. Wildenstein, *Gauguin I,* 1964, no. 252, present location unknown. See László Mrávik, "Et in Arcadia Ego (Magyarországi eredetű műkincsek a Szovjetunióban-illegálisan)," in *Új Művészet II/*10–11 (October–November 1991), pp. 8–9.

48. *La "Maison Rouge" à L'Hermitage, Pontoise,* 1876; Pissarro-Venturi, *Pissarro,* 1939, no. 347.

49. Eugène Gerlötei, "L'ancienne collection François de Hatvany," *Gazette des Beaux-Arts LXVII* (1966), pp. 357–374.

50. *Le Suicidé,* 1877; Rouart-Wildenstein, *Manet I,* 1975, no. 258. See István Genthon, "Báró Hatvany Ferenc képgyűjteménye" [Collection of Baron Ferenc Hatvany], *Magyar Művészet XI* (1935), pp. 4–24.

51. *Méry Laurent au carlin,* 1882; Rouart-Wildenstein, *Manet I,* 1975, no. 76.

52. Renoir, *Femme lisant,* 1873, *Le Conversation,* 1879; Fezzi, *Renoir,* 1972, nos. 109, 335, and *Portrait de femme;* Manzi-Joyant, Paris, 1913, no. 118. For the Degas pastel, see sale cat. (Paris, 1918) no. 155. The pastel was bought by Nêmes in Paris, and by Hatvany at Nêmes's auction (no. 97) in Munich in 1931.

53. *Le Bar aux Folies-Bergère,* 1881–82; Rouart-Wildenstein, *Manet I,* 1975, no. 388.

54. Géber, *Magyar műgyűjtők,* 1970, pp. 265–266.

55. Mihály Babits, "Modern impresszionisták" [Modern impressionists], *Babits Mihály Muvei: Esszék, tanulmányok* [The works of Mihály Babits: Essays, studies] (Budapest, 1978), p. 181.

Several colleagues helped the writing of this study by sending photos, books, and copies. I would like to thank Orsolya Karsay (National Széchenyi Library, Budapest), Christian Lenz (Neue Pinakothek, Munich), Helmut R. Leppien (Hamburger Kunsthalle), Katalin Bakos, László Mrávik, and Eszter Békeffy (Hungarian National Gallery), Andor Nagyajtai (Szépművészeti Múzeum Library), Nicholas Penny (National Gallery, London), Ronald Pickvance (Briar Hill College), Annamária Vígh (Budapest Historical Museum, Kiscell), and Juliet Wilson-Bareau (London).

The Reception of Impressionism in Scandinavia and Finland

GÖREL CAVALLI-BJÖRKMAN

Impressionism came late to Scandinavia. The exhibition of French paintings in Copenhagen in 1888 showed a few works by Manet, Monet, and Sisley, and the big *Art and Industry* exhibition in Stockholm in 1897 showed works by Monet, Pisarro, and Gauguin. The public, the collectors, and the museum curators seem to have felt uncomfortable, and not one of those works was acquired by a Scandinavian museum or collector.[1] The *Frie Udstilling* in Copenhagen in 1893 was an exceptional event: no fewer than fifty-one works by Gauguin and twenty-three paintings, five drawings, and one lithograph by van Gogh were exhibited. It is not surprising that Gauguin was well represented in Denmark since his wife was Danish and twenty-four of the objects belonged to the family or other Danish owners. Today, twelve works by Gauguin and three by van Gogh still remain in public collections in Scandinavia and Finland.[2] Ny Carlsberg Glyptotek owns six pictures by Gauguin and Ordrupgaard owns one. Two Gauguin paintings belong to Nationalmuseum, Stockholm, and one to Nasjonalgalleriet, Oslo, which also owns one drawing by van Gogh. The Ny Carlsberg Glyptotek, Copenhagen, and Atheneum in Taidemuseo, Helsinki, each own one van Gogh.

In 1903 Carl Jacobsen, the brewer, founder, and first director of the Ny Carlsberg Glyptotek in Copenhagen, wrote to his son Helge: "Manet is a famous French painter, the inventor of Impressionism. There are some pictures by him in the Luxembourg that are highly appreciated by the fireworshippers of Impressionism. To me they are only ugly, mannered and affected."[3] The leaders of fashion were still paying homage to the art that prevailed at the Salon in Paris. In 1884 Pontus Fürstenberg in Göteborg, the great collector and promoter of contemporary Swedish art, had acquired the highly academic *Summer* by the French artist Raphaël Collin as a centerpiece of his collection, and in 1887 he donated a sum of money making it possible for the Göteborgs Konstmuseum to acquire *Scandinavian Artists' Lunch at Café Ledoyen, Paris* by Collin's Swedish protegé Hugo Birger, also an academic painter (fig. 1).

The first Scandinavian collector to concentrate in French (and primarily Impressionist) art was the Danish councillor of state Wilhelm Hansen (1868–1936), who came from the humbler end of the bourgeoisie. Since early youth he had shown an interest in art. At the age of only twenty-four, he bought his first picture—a small study by a Danish "Golden Age" painter. Hansen quickly made a career in the insurance business, and during his frequent professional stays in Paris he visited museums and exhibitions. His interest in French art grew and he decided to create a collection of "at most twelve paintings by each of the leading French artists . . . from Corot to Cézanne." As early as 1902, at an auction viewing, Hansen made a list of artists later

Fig. 1. Hugo Birger, *Scandinavian Artists' Lunch at Café Ledoyen, Paris,* 1886, oil on canvas, 72¼ × 103 in., Göteborgs Konstmuseum.

to be included in his collection. In 1916 he made his first acquisition: five pictures by Sisley, Pissarro, Monet, and Renoir. A period of massive acquisition followed. He bought entire collections *en bloc*— Georges Viau's and Flersheim's, for example. He participated in the sale of the Degas estate, acquired important works from the Alphonse Kann collection, and negotiated (although without success) with Auguste Pellerin for the purchase of that extraordinary collection, which included seventy paintings by Cézanne. In 1918 Hansen opened his estate and museum, Ordrupgaard, on the northern outskirts of Copenhagen, a few meters from the Royal Deer Park, where the French collection had its own gallery. The collection, by then probably the most substantial gathering of French art outside Paris, was open once a week to the general public (fig. 2).

Within a few years, however, the good times were over. When the bank Landmandsbanken crashed in 1922, Hansen got into a serious financial situation and was forced to sell a part of his French collection. His first move was to offer it to the Danish State at a price far below its value, as he was eager to keep it in the country. His proposal was turned down, however, and his only alternative was to offer the paintings to foreign collectors. Oskar Reinhart from Winterthur in Switzerland,

Fig. 2. Wilhelm Hansen in his home, Ordrupgaard, Copenhagen, 1918.

Dr. Albert Barnes of Philadelphia, and the Japanese industrialist Kojiro Matsukata divided the spoils. Wilhelm Hansen did not give up his ambitions, and as soon as he had settled his debts, he began buying again. This time he collected more fastidously, acquiring few but important works, such as Renoir's study for *Dancing at the Moulin de la Galette,* Degas's study for the large painting *The Bellelli Family* (Musée d'Orsay), and Pissarro's *Plum Trees in Blossom, Eragny* from 1894.[5]

Before Hansen entered into negotiations with his foreign buyers in 1922, the director of the Ny Carlsberg Glyptotek, Helge Jacobsen, managed to acquire a number of the most important paintings in the collection. Jacobsen, who in 1915 had succeeded his father as director of the Glyptotek, immediately demonstrated his interest in Impressionism by acquiring Manet's *The Absinthe Drinker,* three pictures by Sisley, and one by Monet. Jacobsen acquired no fewer than nineteen works from Hansen, including important paintings by Degas, Manet, and Renoir. In the same year, 1922, an exchange took place between the Royal Museum of Fine Arts and the Glyptotek: the Glyptotek received all the Royal Museum's Impressionist and Post-Impressionist pictures in return for a group of old masters. Through generous donations from the Ny Carlsberg Foundation, the Glyptotek has since succeeded in enlarging its collections substantially, and its holdings of Impressionist and Post-Impressionist art are the most important in Scandinavia.

Fig. 3. Manet, *Young Boy Peeling a Pear*, ca. 1869, oil on canvas, 34¼ × 27⅞ in., Nationalmuseum, Stockholm.

The first Impressionist painting to enter the Nationalmuseum, Stockholm, was Manet's *Young Boy Peeling a Pear* (fig. 3), an 1896 gift from the Swedish portrait painter Anders Zorn. As mentioned above, Impressionist paintings were exhibited in Stockholm the following year, 1897, but it was not until 1913 that two paintings by Degas and one by Sisley were acquired by the Nationalmuseum. They were a gift from the Friends of the Nationalmuseum, founded in 1911 by Crown Prince Gustaf Adolf. Axel Gauffin, a young assistant curator and close friend of the crown prince, had taken the initiative, which was far from appreciated by the curator of the department or the elderly director of the museum.

In 1915 a new director was appointed, the painter Richard Bergh, who served for a short and dynamic period until 1919. The museum was run-down, the victim of an old-fashioned structure. Bergh reorganized the whole museum and launched a new policy. He saw to it that works by younger generations of Swedish painters became properly represented, he collaborated with collectors and dealers, he traveled to Berlin and Paris looking for paintings to acquire, and he worked with patrons willing to make donations to the museum. Within a few years, important works by Manet, Monet, Pissarro, Renoir, Cézanne, and Gauguin were acquired. In 1926 the collection was further enlarged with works by Monet, Renoir, and Cézanne, bought from the magnificent collection of Klas Fåhræus. During the decades that followed, however, there were no important acquisitions of Impressionist paintings.

In Stockholm, three outstanding collectors of contemporary art were active during the 1910s to the 1930s: Prince Eugen, the king's youngest brother, himself a painter; Ernest Thiel, a banker; and Klas Fåhræus, a gentleman of independent means, author, and art critic. Prince Eugen collected mainly works of his own generation of Swedish artists, but he also owned a small number of French nineteenth-century paintings, although none of exceptional interest. He initiated the participation of Monet, Pissarro, and Gauguin in the 1897 Stockholm exhibition, but he never acquired Impressionist paintings for himself.

In 1900, when he was just over forty, Ernest Thiel relinquished his position as director of a bank to devote time to a wide range of cultural activities. He was particularly interested in two pursuits: the creation of Thielska Galleriet (the Thiel Art Gallery, built in 1904) and the support of research related to the philosopher Friedrich Nietzsche. Thiel's collection consisted mostly of works by contemporary Swedish artists, as well as twelve important paintings by Munch, the largest collection of that master outside Norway. Thiel also brought together a small group of French and Impressionist paintings. Besides two pictures by Daumier, he owned *Wheatfield and Poppies* by van Gogh, acquired in 1905 in Berlin[6]; a watercolor *Study from Tahiti* (1891–93)[7] and *The Flight* (1902)[8] by Gauguin; and a *Ballet Scene* (1886) by Toulouse-Lautrec.[9] In 1922, financial problems forced Thiel to sell the van Gogh and Gauguin's *The Flight* (both now in the Národní Galerie, Prague). In 1924, the Thielska Galleriet was purchased by the Swedish State, and from 1926 it has been open to the public as a museum.

The most important collector of international art was Klas Fåhræus. In 1911 he built his home in Lidingön, close to Stockholm, with an impressive gallery. His

Fig. 4. Carl Larsson, *Interior of the Fürstenberg Gallery,* 1885, oil on canvas, 30¾ × 22¼ in., Göteborgs Konstmuseum.

collection was mainly Swedish art but also contained an exquisite selection of works by Courbet, Monet, Renoir, Gauguin, van Gogh, and Cézanne.[10] In 1926 financial straits forced Fåhræus to sell his home and the entire collection. The Swedish paintings stayed in the country, while the French pictures were sold abroad, with the exception of four important paintings by Courbet, Renoir, Monet, and Cézanne, which the Friends of the Nationalmuseum acquired for the museum.

In 1906 the Konstmuseum in Göteborg—Sweden's second-biggest city, dominated by wealthy shipowners and businessmen—got a new, young, and enthusiastic director. Axel L. Romdahl was a scholar, and he combined his work as director with a chair in the history of art at the University of Göteborg. As a scholar, he specialized in Pieter Breughel the Elder, while as a museum director he cooperated closely with the artists in the city, making important acquisitions of contemporary art.

Göteborg had a long tradition of private patronage of the arts. The most important collector was Pontus Fürstenberg, who supported many of Sweden's progressive artists in the 1880s and the early 1890s, although he never demonstrated interest in the Impressionists (fig. 4). He died in 1902, bequeathing his entire collection to the Göteborgs Konstmuseum. Another important Göteborg art collector was Conrad Pinaeus, who belonged to a younger generation and concentrated on works from this century.

Romdahl was no specialist in Impressionist art, but in 1917 he bought three important paintings: *Girl in Spanish Jacket* by Renoir, *Olive Grove, Saint-Rémy* by van Gogh, and *The Hunting Party* by Bonnard. Moreover, he managed to persuade

Fig. 5. Monet, *Rainy Weather,* 1886, oil on canvas, 23⅞ × 29¾ in., Nasjonalgalleriet, Oslo.

several Göteborg collectors to part with some of their most important Impressionist paintings. Gustaf Werner presented the museum with Monet's *Village Street, Vétheuil* in 1923, Gauguin's *Still Life (Nature morte)* in 1930, and Cézanne's *Avenue* in 1931, and the Mannheimer family donated Renoir's *Garden* in 1935.

A central role in the acquisition history of Scandinavian collections was played by the Norwegian painter, art expert, and author Walther Halvorsen (1887–1972). In 1913 he moved to Paris, and in 1916, 1918, 1928, 1931, and 1938 he arranged important exhibitions of French art in Oslo, Stockholm, Göteborg, and Copenhagen. Halvorsen acted as an agent and intermediary between French dealers and Scandinavian museum curators and collectors, and he proved extremely useful. He knew the collections of the Scandinavian museums well, and he knew what they needed. When he found something exceptional, he sought to secure the work and to see that it found what he thought was its proper place. He even went so far as to donate some works himself.

In Norway one man dominated the scene: Jens Thiis (1870–1942). A specialist in Italian Renaissance art and modern French painting, he became director of the Nasjonalgalleriet in Oslo in 1908, a position he held until 1941.[11] He was a close friend of the two dominating Norwegian artists of his time, Edvard Munch and Gustaf Vigeland, and was a great connoisseur and a persuasive author on art. In 1890 the museum had acquired *Rainy Weather* (1886) by Monet, the first Impressionist painting to enter a Scandinavian museum (fig. 5). In 1907 the museum bought from a private Norwegian collector two paintings by Gauguin from his stay in Denmark during 1884–85, *Portrait of Mette Gauguin, the Artist's Wife* (cat. 21) and *Basket with Flowers.* After Thiis became director, a large number of important Impressionist paintings found their way into the museum within a short period of time. His first choices were a self-portrait by van Gogh and a still life by Cézanne, both acquired in Paris in 1910. Then the museum acquired three more pictures by Cézanne, four paintings by Gauguin, three by Manet, two by Degas, another by Monet, two by Guillaumin, and two by Renoir. By 1919, the character of the collection had been established and the period of intense buying came to an end. Occasional acquisitions were made later, including a Morisot in 1929, a Manet in 1948, and a Degas in 1952.

Ateneum, the Finnish National Gallery in Helsinki, was a museum of modest means. Founded in 1863, its organization was bureaucratic and the collections consisted almost completely of Finnish art and, to a minor extent, Scandinavian art. The museum held no other examples of modern European art, and it is therefore astonishing that in 1903, a painting by van Gogh, *Street in Auvers-sur-Oise* (fig. 6), was bought. We do not know who took the initiative, as the circumstances of its acquisition are not known. In 1907 Gauguin's *Landscape with Pig and Horse* entered the collection, and in 1911 the museum made the acquisition, initiated by the painter Magnus Enckell, of a painting by Cézanne, *The Viaduct of L'Estaque,* at an exhibition arranged by Roger Fry at Grafton Galleries in London. On the initiative of Jens Thiis, a late Gauguin, *Landscape from Tahiti* (1892), was bought from a private Norwegian collection in 1913.[12] At this point it proved impossible to continue buying works by the Impressionists. The prices were already prohibitive for the Finnish museum, and the director and his advisors decided to start collecting works by a younger generation of French artists.

The systematic acquisition of Impressionist paintings came to an early end in Scandinavia. Most Scandinavian museums formed their collections of Impressionist

Fig. 6. Van Gogh, *Street in Auvers-sur-Oise,* ca. 1890, oil on canvas, 38¾ × 36¼ in., Ateneum/The Antell Collections, Helsinki.

art in the decade between 1914 and 1924, with the Ny Carlsberg Glyptotek as the sole exception.[13] Occasional donations, bequests, and a few purchases have added works to the collections—the Nationalmuseum, Stockholm, received an interesting Cézanne picture, a *Portrait of Mme Cézanne,* in 1970, and the Göteborgs Konstmuseum acquired a Monet Water Lilies in 1995. In general, the taste and the ambition of the years around 1920 are still mirrored in the collections.

NOTES

1. The initiative to exhibit works by Monet, Pissarro, and Gauguin in Stockholm was taken by Prince Eugen, son of the king, who was himself a painter and collector. He did not, however, acquire any of them for his own collection, and as member of the board of the Nationalmuseum, he preferred to promote the acquisition of works by Hans Thoma and Jean-François Raffaëlli. Per Bjurström, *Nationalmuseum 1792–1992* (Stockholm, 1992), pp. 156–157.

2. Haavard Rostrup undertook a serious study of and provided a basis for reconstructing the list of works by Gauguin exhibited in the show in his paper "Nye oplysninger om Gauguin og hans forhold till Danmark" [New information on Gauguin and his relation to Denmark], in *Meddelelser fra Ny Carlsberg Glyptotek* (1956), pp. 59–85, republished in translation in the *Gazette des Beaux-Arts* (1958). For full documentation, see the exhibition catalogue by Merete Bodelsen, *Gauguin og van Gogh i Köbenhavn i 1893/Gauguin and van Gogh in Copenhagen in 1893* (Ordrupgaard, Copenhagen, 1984). Kirsten Olesen contributed the introduction to van Gogh and the catalogue entries for van Gogh's work.

3. Jens Peter Munch, *Catalogue French Impressionism Ny Carlsberg Glyptotek* (Copenhagen, 1993), p. 7.

4. See Karl Madsen, *Katalog over Wilhelm Hansen's Samlinger/Fransk Malerkunst/Ordrupgaard* (Copenhagen, 1918).

5. Haavard Rostrup, *Histoire du Musée d'Ordrupgaard/1918–1978* (Copenhagen, 1981); Haavard Rostrup, *Catalogue of the Works of Art in the Ordrupgaard Collection* (Copenhagen, 1966).

6. Brita Linde, *Ernest Thiel och hans konstgalleri* (Stockholm, 1969), pp. 93 and 105.

7. Ulf Linde, *Thielska Galleriet* (Stockholm, 1979), p. 49, no. 111.

8. Linde, *Ernest Thiel,* 1969, p. 99.

9. Ibid., p. 102.

10. Johnny Roosval, "Om herr Klas Fåhræus konstsamling" [The Art Collection of Klas Fåhræus], *Konst och konstnärer* 9 (Stockholm, 1913), pp. 97–105.

11. Harry Fett, "Jens Thiis," *Kunst og Kultur* (Oslo, 1942) and *Ord och Bild* (Stockholm, 1942), pp. 549–558.

12. Aune Lindström, *Konstmuseet i Ateneum 1863–1963* (Helsingfors, 1963), pp. 63–64.

13. Of the forty-four pictures catalogued in Jens Peter Munk, *Catalogue/French Impressionism/Ny Carlsberg Glyptotek* (Copenhagen, 1993), twenty-one were acquired after 1941.

Switzerland—At the Crossroads of French Impressionism's Reception in Europe

LUKAS GLOOR

The international recognition of French Impressionism as the most important move-ment in late nineteenth-century European art was well under way when the first paintings by Impressionists reached Switzerland in 1908.[1] By then, it had become clear that large parts of recent art history were being rewritten. In Germany, the notion of a modernist art movement based on French origins quickly gained widespread accep-tance—at least among those who weren't antagonized by seeing their heroes, like Arnold Böcklin, ending up as mere "cases" in a modernist pictorial pathology.[2] Begin-ning in 1908, when the first exhibition of Impressionist paintings took place in the Zurich *Künstlerhaus,* the reception of Impressionism proceeded at a fast pace in private collections as well as in exhibitions held at major museums (fig. 1). However, while the exhibition schedules of these museums quickly came to include international art, the permanent collections of their Art Associations remained focused on Swiss art well into the twentieth century. Swiss museums entered the stage as large-scale collectors of Impressionist paintings only after the Second World War.

On a smaller scale, however, significant steps were taken earlier on. In 1912, a group of artists in Basel volunteered to raise the funds necessary to buy a painting by Pissarro, *Village near Pontoise,* which was being exhibited in a small show organized

Fig. 1. Cuno Amiet, *The Two Little Girls* (copy after van Gogh), 1907, oil on canvas, 20⅛ × 18⅛ in., private collection. The van Gogh, the first to be shown in Switzerland in 1907, was purchased by Richard Kissling, a collector in Zurich, who lent it to Amiet, one of the leading artists of Swiss modernism before the First World War.

Fig. 2. Ernst Würtenberger, *The Board of Directors of the Winterthur Art Association,* 1915, oil on canvas, 59⅛ × 72⅞ in., Kunstmuseum, Winterthur.

by the Cassirer gallery from Berlin at the Basel Kunsthalle. This exhibition was the second in Switzerland to focus exclusively on Impressionism as an art movement, and it included works recognized by now as the era's "classics," as acknowledged by a critic in a local Basel newspaper on the occasion.[3] At that point, Basel was still the wealthiest town in Switzerland, as well as the only one to maintain two different institutions dedicated to the fine arts: the Kunsthalle gave exposure to contemporary art, and the Kunstmuseum contained Europe's oldest art collection owned by a municipality. It was significant that a few of Basel's younger artists suggested that Pissarro's *Village near Pontoise* should enter the museum's collection immediately after its arrival at the Kunsthalle. It tells much about the acceptance that Impressionism had achieved that in addition to individual donors, the city's government also agreed to contribute toward the purchase, and the first Impressionist painting to enter a Swiss museum hung close to the many paintings by Arnold Böcklin assembled in his native city.[4]

In 1916, a new building for the Kunstmuseum was opened in Winterthur, near Zurich (fig. 2). In October of the same year, an *Exhibition of French Painting* opened, containing 196 works by Impressionists and their followers, particularly the Nabis (fig. 3).[5] What was perhaps most striking about the exhibition was the fact that one-quarter of the paintings exhibited were lent by local collectors. This was due in large part to the efforts of Carl Montag, a young painter from Winterthur who had settled in Paris in 1904 and started to win his friends and acquaintances back home to the cause of Impressionist painting. With the support of leading art dealers in Paris, Montag turned the 1916 exhibition into an important show, to which Swiss audiences responded enthusiastically. A quarter of the paintings in the show were sold, mostly to new collectors, and the exhibition firmly established Winterthur's reputation as the headquarters for French painting in Switzerland for decades to come.

The event left its imprint on the Winterthur Kunstmuseum as well. Quite a few paintings were given to the museum throughout the 1920s and 1930s, either as long-term loans or as gifts by such private collectors as the Reinhart, Hahnloser, and Bühler families. Other paintings came to the museum through an Association

of Friends of the Museum who contributed toward their acquisition. In the years before the Second World War, the Winterthur Kunstmuseum became the only place in Switzerland where an important group of French paintings could be viewed in public. The museum also prefigured the way in which other Swiss institutions would assemble their own collections of Impressionist paintings by attracting individual donations or entire private collections.

In 1947, the Basel Kunstmuseum again led the way by receiving the bulk of Rudolf Staehelin's collection, which had been assembled in the years following the First World War. The forty paintings by major Impressionists, including masterworks by van Gogh and Gauguin, were the core of the museum's nineteenth-century collection for many years. They were championed by its director, Georg Schmidt, who had been foremost among Swiss critics to introduce his audience to the history of modernism as based upon the Impressionist revolution in art.[6] However, the collection remained the property of the family and, having been stripped of some of its most important components over the years, has recently been removed from the Basel museum entirely. This leaves a gap that—at today's rates in the art market—no European museum can hope to fill again.

Fig. 3. Félix Vallotton, *Josse and Gaston Bernheim-Jeune in Their Office at rue Richepance,* 1901, oil on canvas, 31½ × 29½ in., private collection. Swiss-born Félix Vallotton, who was a member of the Nabis, married into the Bernheim-Jeune family and arranged for his brother Paul to become head of a Swiss branch of the famous Paris gallery.

The pattern of Impressionist works being first assembled by private collectors and later donated to a local museum was repeated at other Swiss institutions. Soleure, a town about the size of Winterthur, also counted a few families who had started to build collections of modernist paintings shortly after 1900. Two such examples are the collections of Josef Müller and his sister Gertrud Dübi-Müller, which focused on international currents of modernism and their roots in Impressionism.[7] The two collections entered the Soleure Kunstmuseum in 1977 and 1980, allowing the museum to display works by Degas, Cézanne, and van Gogh, along with those by younger French painters such as Matisse and Léger.

When the Kunstmuseum Bern opened a new wing in 1936, the Bernese government donated a picture by Bonnard to the collection—a gesture widely interpreted as a statement in favor of transcending the collection's hitherto strictly local examples. Subsequently, two large donations formed the nucleus of a French department in the museum: one made by Justin K. Thannhauser, whose father had been the founder of Munich's most radiant modern art gallery before the First World War, and one made by Hans R. Hahnloser, son of the Winterthur family who had been among the first to collect French paintings in Switzerland.[8]

The Kunstmuseum in Zurich was in a position to take advantage of that city's great economic growth, which accelerated after 1945, and it has become the country's biggest and most important art center. The first Impressionist paintings entered the museum in 1920, including an important van Gogh bequeathed by Hans Schuler, who had bought the painting at the first van Gogh show in Zurich in 1908. This early beginning, however, did not mark a trend, and the museum's catalogue of 1958 still lists only a few examples of Impressionists, such as Monet, Renoir, and Manet, whose *Escape of Henri Rochefort* had been given to the collection three years before. Particular emphasis was given to the work of Monet, as the museum had secured a pair of the master's Water Lilies *(Nymphéas)* in 1952, partly with the help of their Friends Association. Throughout the 1970s and 1980s, however,

Fig. 4. René Auberjonois, *The French Painters: Pissarro Introducing a Young Artist to Cézanne,* 1941, oil on canvas, 28⅜ × 23¼ in., The Coninx Foundation, Zurich.

Fig. 5. Alexandre Blanchet, *Portrait of Oskar Reinhart,* 1943, oil on canvas, 24½ × 25¼ in., Museum am Stadtgarten, Winterthur.

donations by individuals made Zurich's collection of Impressionists Switzerland's most important.[9]

In the German-speaking part of Switzerland, the reception of Impressionism closely followed the patterns established by critics, collectors, and museum directors in Germany. Indeed, while Impressionist paintings were welcomed in all the important museums in Germany, the enthusiasm that greeted the same paintings in French museums remained lukewarm for years. A similar attitude was to be found in French-speaking Switzerland, although Geneva was not without an important tradition in the fine arts. Throughout the nineteenth century, Geneva maintained the only School of Fine Arts in Switzerland, and it had been home to an important artists' community. The city's Musée d'Art et d'Histoire proudly owned a few paintings by Corot, among which *Reclining Nude,* acquired by the city government in 1857, held widespread fame. When paintings by Impressionists were exhibited for the first time in Geneva in 1915, a work by Pissarro, *Farm at Montfoucault* (cat. 42), was purchased by the Société Auxiliaire du Musée. It remained, however, an isolated witness for the art of Impressionism for some time, and many visitors to Switzerland in the 1920s and 1930s found the finest collections of French painting exclusively in the country's German-speaking part. The same was not true for the artists in the French-speaking communities. For painters such as René Auberjonois, reverence for the likes of Cézanne was almost a matter of faith in the 1920s and 1930s (fig. 4).[10] In recent decades, the influx of foreign collectors who settled on the shores of Lake Geneva has brought a new stimulus from which both Geneva and Lausanne have subsequently seen their collections enhanced.[11]

Donations to museums were not the only way by which Impressionist paintings were collected in Switzerland. Some private collectors preferred to keep their collections together and transform them into museums of their own. The most prominent, Oskar Reinhart, was a member of a wealthy merchant family in Winterthur who had contributed substantially to the building of the new Winterthur Kunstmuseum in 1916 (fig. 5). In 1928, Reinhart abandoned his career in the family's firm and dedicated himself to building the country's finest collection of nineteenth-century paintings. Today, his collection can be seen as a prime witness for the vision that revised the history of painting under the supremacy of color and its painterly expression. Apart from his collection of Impressionism, Reinhart also assembled the most important collection of nineteenth-century German paintings to be found outside Germany.[12] He donated this latter collection to the city of Winterthur, which keeps it in the Museum am Stadtgarten. Reinhart gave his Impressionist collection, housed at his estate in Winterthur, Am Römerholz, to the Swiss Confederation, which opened it to the public in 1970.[13]

A smaller collection was assembled by Emil G. Bührle in Zurich during the years immediately following the Second World War. After Bührle's death in 1956, his collection was turned into a foundation and made accessible to the public, as was the collection of the Hahnloser family in Winterthur, which was permanently

installed in the family home, the Flora, in 1995. Another private Swiss collection of Impressionism, that of Sidney and Jenny Brown-Sulzer, has been on view at the Browns' estate of Langmatt in Baden, a small town near Zurich, since 1990.[14] Sidney and Jenny Brown-Sulzer bought the first painting by Cézanne to enter a Swiss collection in 1908—the crucial year in which the reception of Impressionism in Switzerland began, first in the country's exhibition halls, then in its private collections, later in its museums, and finally in its private collections-turned-museums.

NOTES

1. The most recent account of the reception of Impressionism in Switzerland can be found in Dorothy Kosinsky, Joachim Pissarro, and Mary Anne Stevens, *From Manet to Gauguin: Masterpieces from Swiss Private Collections,* exh. cat. (Royal Academy of Arts, London, 1995), whose extensive bibliography provides thorough information on Swiss private collections, as well as on general aspects of art exhibitions, art criticism, and museums in twentieth-century Switzerland. For information on Swiss art institutions—both public and private—in the second half of the nineteenth century, see *Von Anker bis Zünd: Die Kunst im jungen Bundesstaat, 1848–1900,* exh. cat. (Kunsthaus, Zurich, 1998). Additional information can be found in Institut Suisse pour l'Étude de l'Art (Swiss Institute for Art Research), ed., *L'Art de collectionner: Collections d'art en Suisse depuis 1848* (Zurich, 1998), with an extensive bibliography.

2. Reference is made to Julius Meier-Graefe's notorious pamphlet *Der Fall Böcklin,* published in 1905. The most thorough discussion to date about the making of the structures—intellectual as well as institutional—which then served to promulgate modernism in the fine arts is Robert Jensen, *Marketing Modernism in Fin-de-Siècle Europe* (Princeton, 1994), where particular emphasis is given to Meier-Graefe's writings.

3. Lukas Gloor, *Von Böcklin zu Cézanne, die Rezeption des französischen Impressionismus in der deutschen Schweiz* (Berne, Frankfurt am Main, New York, 1986), pp. 176–178.

4. Christian Geelhaar, *Kunstmuseum Basel: The History of the Paintings Collection and a Selection of 250 Masterworks* (Zurich, Basel, 1992).

5. *Das gloriose Jahrzehnt: Französische Kunst 1910–1920 aus Winterthurer Besitz,* exh. cat. (Kunstmuseum, Winterthur, 1991).

6. Georg Schmidt, *Schriften aus 22 Jahren Museumstätigkeit* (Basel, 1964).

7. *Kunstmuseum Solothurn, Dübi-Müller-Stiftung, Josef Müller-Stiftung* (Soleure, 1981).

8. Hans Christoph v. Tavel, *Kunstmuseum Bern,* English ed. (Zurich, 1991).

9. Christian Klemm, *Kunsthaus Zürich,* English ed. (Zurich, 1992).

10. Oskar Bätschmann, "René Auberjonois: une quête impossible," in *René Auberjonois,* exh. cat. (Musée Cantonal des Beaux-Arts, Lausanne, 1994), pp. 57–73.

11. Claude Lapaire, *Musée d'Art et d'Histoire Geneva,* English ed. (Zurich, 1991).

12. Peter Wegman, ed., *From Caspar David Friedrich to Ferdinand Hodler: Masterpieces from the Oskar Reinhart Foundation, Winterthur,* exh. cat. (Frankfurt am Main, 1993).

13. Matthias Frehner and Christina Frehner-Bühler, *The Oskar Reinhart Collection "Römerholz"* (Zurich, 1994).

14. Urs Raussmüller and Christel Saurer, ed., *Luxe, calme et volupté, regards sur le post-impressionnisme: Collectionneurs à Winterthur et Baden au début du XXe siècle,* exh. cat. (Casino Luxembourg, with full English translation, Schaffhouse, 1994).

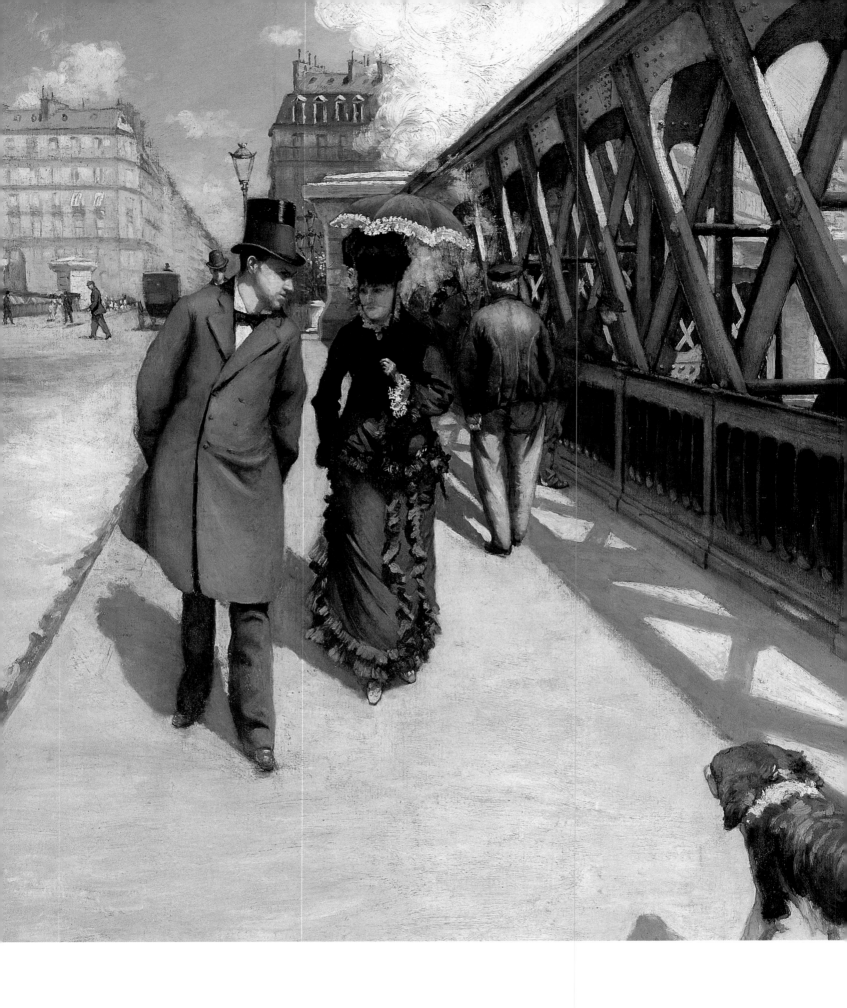

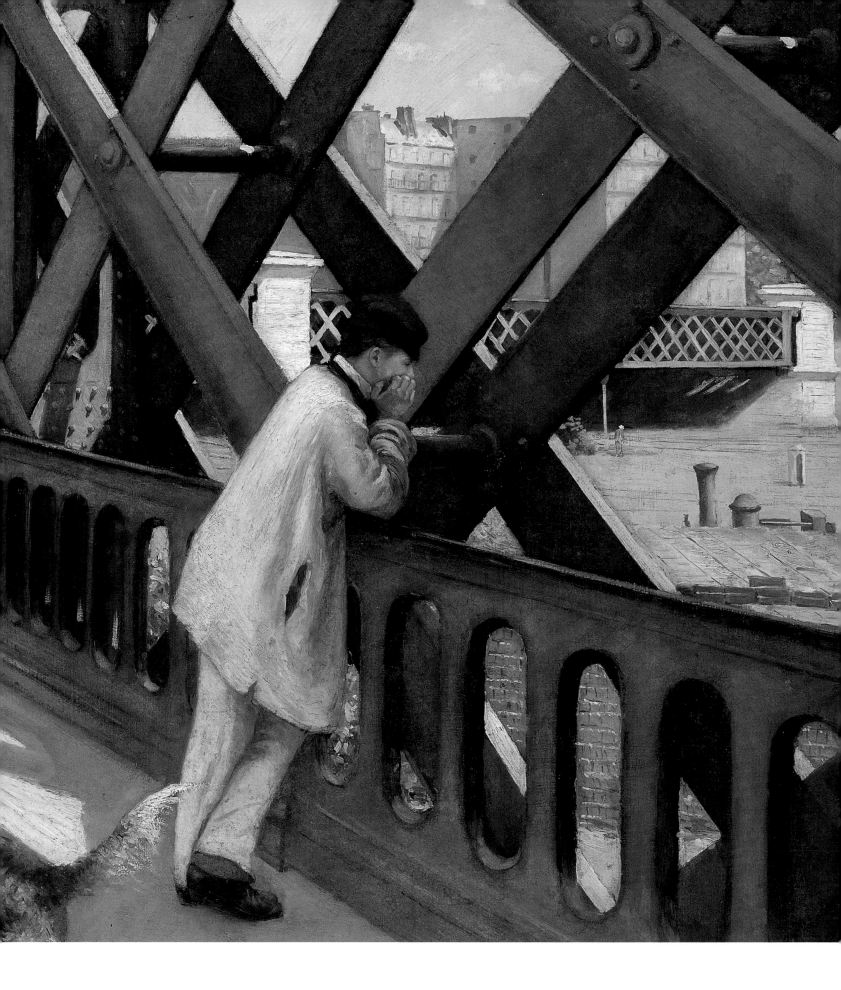

Catalogue

I.

Panoramic View of Portrieux, 1874

Oil on canvas
21½ × 34⅞ inches (54.6 × 88.6 cm)
Szépművészeti Múzeum, Budapest

Eugène Boudin

The complexity of Boudin's seaside landscape is typical of the painter. The depth of the composition is reminiscent of the Barbizon masters, particularly Millet. On the right, tiny houses of the town can be seen, with toylike windmills in the background, harnessed horses waiting, people coming and going. The foreground is striking in its sketchiness. The composition is held together not by meticulous realism but by the optical unity of the objects. The white cart horses, the red cap of the figure on the left, and the white bonnets of the women on the right show that even within the framework of realism Boudin wished to take a fresh view of a familiar sight. In his technique of tiny broken brushstrokes and evocation of atmospheres, Boudin was a forerunner of Impressionism. As Charles Baudelaire noted: "These wonderful studies so quickly and faithfully sketched from waves and clouds still carry the date, hour, and wind direction written in their margins; for example: 8 October, at noon, wind from the northwest. If you ever had the leisure time to get to know these meteorological beauties, you could verify from your memory the exact observations of M. Boudin."[1]

The picture was painted in 1874, the year of the first Impressionist exhibition, but was not displayed there. Boudin showed two other landscapes instead. *Panoramic View of Portrieux* was included in an exhibition at Hôtel Drouot in 1877 and at the auction of the Bascle collection in 1883.[2] The picture was purchased by the Szépművészeti Múzeum in 1907, one year after its opening, when Gábor Térey, curator of the Old Masters Gallery, and Simon Meller, head of the collection of prints and drawings, launched their campaign for the creation of a modern French collection.

The museum and the ministry cooperated with the leaders of the Nemzeti Szalon (National Salon) in seeking to break down Hungarian conservative resistance to modern art. Boudin's *Panoramic View of Portrieux* was first noticed by Térey in Galerie Le Peletier in Paris. Alberto Caro sent the picture to Budapest. At the same time, the Durand-Ruel gallery had another Boudin taken to the Hungarian capital, and the two pictures were shown at the 1907 exhibition of the Nemzeti Szalon.[3] Upon the order of museum director Ernő Kammerer, one was selected and the museum paid 6,000 francs to Galerie Le Peletier. The gallery was prepared to reduce the asking price of 8,000 francs, as Caro wrote in his letter of 3 June 1907 to Térey: "I have just received your kind letter of 31 May. To reenter into a relationship with you and your country, for which I have great sympathy, I will make a sacrifice to send Boudin's masterpiece to you."[4]

Judit Geskó

Eugène Boudin

The year before this painting was executed, Boudin's wife died. The couple had no children, and Marie-Anne had been Boudin's constant companion and best friend. From that time on, he found great consolation in his work, producing paintings at a prodigious pace and "only returning home to eat and sleep."[1] Even as late as 1890, when Boudin was concentrating on the river valleys of Saint-Arnoult and Sainte-Valéry-sur-Somme, the influence of his early masters Corot and Daubigny was still present. Indeed, in the lower-key palette and more subdued mood of his late paintings, Boudin seems more in their debt than he was some twenty years earlier when painting his now-famous beach scenes of the fashionable resort of Trouville, in which the rich, attired in dramatically colored and shaped crinolines and bonnets, parade on the front. Here the subject is not people but the enormous gray presence of sky and water. Most of the canvas is devoted to this expansive overcast sky, which, in its size and overall tonality, recalls the work of the Hague School artists and their French Barbizon contemporaries, including Corot and Daubigny. Like those Dutch and French artists, Boudin's only recognition of a human presence is in the addition of working people, whose station in life can be clearly established from their simple attire. The seemingly simple subject is no more than a view of the village and its river (the artist is looking upriver at half tide). A series of subtle, broad arcs leads the eye into the picture gradually, creating a grand effect. Boudin animates his gentle vision with vigorous brushwork and touches of bright color, such as the red on the stern of one of the sailing vessels and the larger mass of white laundry bleaching on the green to the left. Boudin seemed never to tire of painting his native Picardy. Again and again he studied the same views but, with every change of wind and every new pattern taken up by the clouds, they presented him with new subjects, and his paintings are always fresh and spontaneous. They are weather reports but also profound studies of nature and life.

The early history of this painting is not known. It was acquired by the Aberdeen Art Gallery in 1936, with income from the Webster bequest from Lockett Thomson, who had taken over running Barbizon House in Henrietta Street, London, after the death of his former partner, Scottish art dealer D. Croal Thomson, in 1930. The purchase was complicated: an apparently inferior work by Boudin, *Pont de Deauville,* which belonged to the Aberdeen Art Gallery, was given in partial payment for this work and for another, *The Student* by John Opie R.A., which was purchased at the same time. The purchase was negotiated by Harry Townend, who was curator of the Aberdeen Art Gallery from 1914 to 1939. Townend built up a significant holding of works by Impressionist artists and their precursors, including Courbet, Monet, Sisley, and Pissarro.

Jennifer Melville

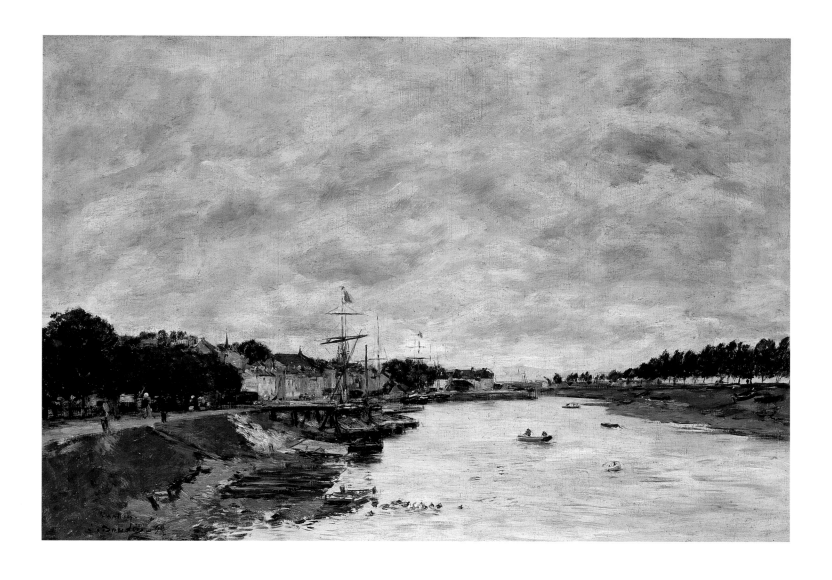

2.

Sainte-Valéry-sur-Somme, 1890

Oil on canvas

18¼ × 25½ inches (46.4 × 64.8 cm)

Aberdeen Art Gallery and Museums

Marie Bracquemond

Two women and a straw-hatted man are seated on an outdoor terrace during a warm summer day. The veiled woman on the left engages the viewer with the direct gaze of her soft brown eyes and slightly raised eyebrows. Her white gloved hands rest atop a closed parasol, and her left thumb and index finger hold a pair of glasses. In the center of the composition is a bearded and mustachioed man wearing a brown suit. His gaze looks past the woman in pink, and he has placed his arm around the third figure while holding a lit cigarette. The woman on the right is entirely dressed in white, including the white rose pinned to her bodice. She is seen in profile, lost in her thoughts. Behind the threesome are the feathery leaves of trees and several small houses.

Marie Bracquemond was born Marie Quiveron in Brittany in 1840. Eventually her family moved to the outskirts of Paris, where she began to study painting. While copying a painting by Rembrandt in the Louvre around 1867, she met Félix Bracquemond, a gifted but curmudgeonly engraver. They wed in 1869 and had one son, Pierre, just a year later. Félix Bracquemond's taste ran towards the conservative images of Bonvin and Ribot, while his wife preferred Alfred Stevens's paintings of fashionably dressed women. In the late 1870s, Marie became drawn to the light-filled work of Monet and Renoir.

By 1871, the family moved to the rue Brancas in Sèvres, a rural suburb of Paris. The reason for the move was Pierre's health and the better air outside the city. It was on the terrace of their house that this painting appears to be set. Although the identity of the man in the painting has been previously identified as the painter Fantin-Latour, that identification has been called into question and appears unlikely. We do know that Marie's sister Louise Quiveron posed for *both* of the female subjects in the painting. Marie and Louise were quite close, and Louise lived with the Bracquemond family in Sèvres. One wonders if the subject of the painting reflects the Bracquemonds' domestic situation. Are we, in a sense, looking at Bracquemond the engraver at the center of the household maintained by the two Quiveron sisters?

On the Terrace at Sèvres was included, along with *Portrait (The Lady in White)*, ca. 1880 (cat. 4), in the fifth Impressionist exhibition that same year, marking the second of Marie's three appearances in that epochal series of shows. With her increasing connections to the Impressionists, her painting style became looser. Though her husband had exhibited with the Impressionists, he preferred a more traditional painting style and railed against the stylistic change that *On the Terrace at Sèvres* represents. Because of her husband's objections, Marie exhibited only one more time with the Impressionists, in their last exhibition in 1886, shortly before she stopped painting altogether around 1890.

As a result, in part, of the brevity of her career, the work of Marie Braquemond has been little known and not very well documented. This painting was included in an exhibition of Marie's work at the Paris gallery of Bernheim-Jeune in 1919, and it reappeared at another exhibition of her work, also at Bernheim-Jeune, in 1962. The painting was subsequently acquired by Oscar Ghez, the founder of the Petit Palais, in Paris on 10 March 1970 and became part of the collection of the Petit Palais.

Michael E. Shapiro

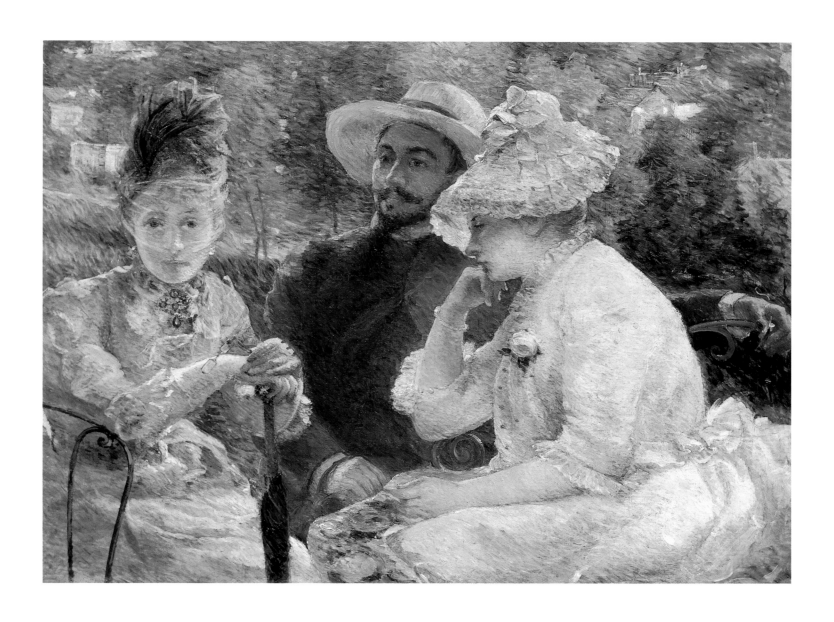

3.

On the Terrace at Sèvres, 1880

Oil on canvas
34⅝ × 45¼ inches (87.9 × 114.9 cm)
Petit Palais, Musée d'Art Moderne, Geneva

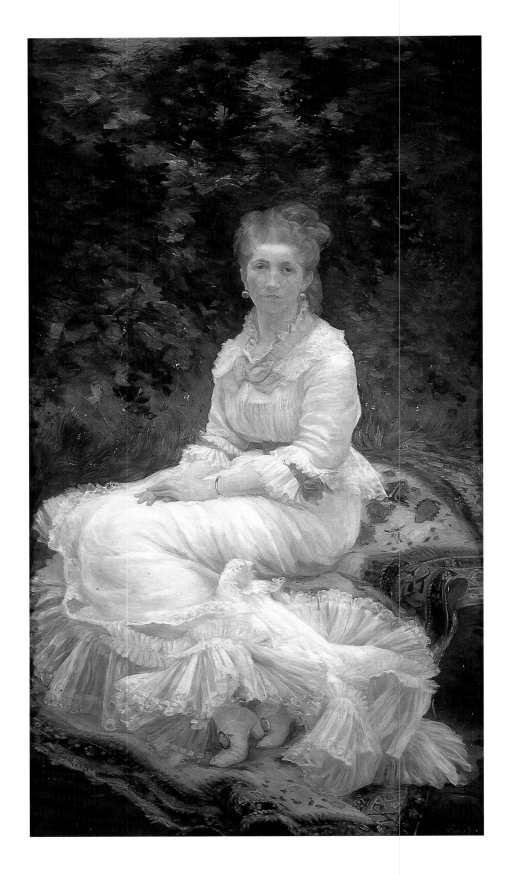

4.

Portrait (The Lady in White), ca. 1880
Oil on canvas
71½ × 41⅜ inches (181.6 × 105.1 cm)
Musée de Cambrai

Marie Bracquemond

The subject of this portrait is the artist's sister Louise Quiveron, gracefully attired in a white, gauzy gown, its ruffled hem lifted to reveal a pair of dainty, fashionable boots. Despite the outdoor setting, the model's rather formal pose is augmented by the Oriental rug on which Louise is seated. *Portrait (The Lady in White)* was painted at a transitional moment in Bracquemond's career. The draftsmanship, the careful placing of the figure to create a spiraling form, the tonal coloring, and the fact that the finished picture was clearly not painted on the spot show an adherence to an academic manner—as a young artist, Bracquemond had been advised by the elderly Ingres. However, the challenge of capturing the effect of shifting sunlight, especially on white, indicates her response to Impressionism, a new direction in her work that occurred around 1880 when she was particularly influenced by Renoir. The subject of a charmingly dressed woman posed in an outdoor setting is clearly indebted to such works as Renoir's *The Swing* and *Dancing at the Moulin de la Galette* (fig. 7, p. 22), both from 1876. Like Renoir, Bracquemond had also worked as a porcelain painter: the graceful, sinuous silhouette of the figure in *The Lady in White* can be linked to some drawings of female figures representing the arts that Bracquemond had produced for a wide ceramic tile panel for the de Haviland porcelain factory at Auteuil in 1878 (present location unknown).[1]

Although the critic Gustave Geffroy described Marie Bracquemond as "one of the three great ladies of Impressionism," she had remained the least known of the three women who exhibited with the Impressionists (the other two were Cassatt (cats. 7, 8) and Morisot (cats. 38, 39).[2] Naturally self-effacing, Bracquemond was eclipsed by her husband, the famous engraver Félix Bracquemond, apparently an overbearing personality who strongly objected to the loose technique and outdoor painting practiced by the Impressionists, and so discouraged his wife's ambition that she more or less gave up painting around 1890. Louise, who lived with the couple at their villa at Sèvres just outside of Paris, is supposed to have been irritated by Marie's submissiveness to her husband but nevertheless was her constant supporter and chief model.

Bracquemond seems to have had a special attachment to this painting. She kept it until the end of her life, and it can be seen in the background of a delightfully informal watercolor of her living room in the house at Sèvres, *Interior of a Salon,* ca. 1890 (Musée du Louvre, Cabinet des Dessins, Paris). Together with *On the Terrace at Sèvres* (cat. 3), it was included in the fifth Impressionist exhibition in 1880, titled *Portrait.* Both works were exhibited again in the retrospective exhibition of Bracquemond's work held at the Bernheim-Jeune gallery in Paris in 1919, three years after the artist's death.

Marie Bracquemond received little exposure in her lifetime, and very few of her paintings are today in public collections. However, *The Lady in White* was bought from the Bernheim-Jeune exhibition by the French state and entered the Musée du Luxembourg in 1919. In 1929 the painting was transferred to the Musée de Cambrai.

Ann Dumas

Gustave Caillebotte

Gustave Caillebotte's *Le Pont de l'Europe* was exhibited at the third Impressionist exhibition in April 1877, along with two other large city scenes, *Paris Street on a Rainy Day* (Art Institute of Chicago) and *The House-Painters* (private collection). Together, the subject matter of these works—everyday activities on the boulevards of Paris—marked the artist as what Charles Baudelaire would have described as a "painter of modern life." In *Le Pont de l'Europe,* Caillebotte presents us with a wide-angle view of a sidewalk on one of the technological marvels of Paris. Built between 1865 and 1868 at the convergence of six major boulevards, the bridge straddled the tracks of one of the city's major train stations, the Gare St.-Lazare. Caillebotte may have chosen the site because he lived nearby. In this painting, Caillebotte also documented several of the modern inhabitants of Paris. On the right, an artisan rests on the bridge's handrail and, to the left, the artist depicted one of the archetypal denizens of modern city life, the "man of the crowd" or *flâneur* (the detached observer of urban life), who strides past a fashionably dressed woman strolling with a parasol. Scholars have noted that the carefully constructed exchange of glances between these characters suggests that Caillebotte intended this painting to be seen not only as a visual document but also as a social allegory.[1]

Le Pont de l'Europe is an ambitious painting that required extensive preparation. Caillebotte made meticulous perspective studies as well as preliminary drawings of each of the various individuals depicted in this scene. The result is a carefully rendered and complex composition. Émile Zola, the great realist writer and early supporter of the Impressionists, was so taken by the "beautiful truth" *(belle vérité)* he discerned in the works Caillebotte exhibited in 1877 that he wrote, "When his talent becomes a little more broken in, M. Caillebotte will certainly be one of the boldest of the group."[2]

In the fifty years or so immediately following his death in 1894, Caillebotte was best known for the magnificent collection of Impressionist pictures that he bequeathed to the French State. His own paintings suffered from decades of neglect, only beginning to attract public recognition in the 1950s as a result of a rethinking of Impressionism and the greater availability of pictures that had remained in the hands of the artist's descendants. How *Le Pont de l'Europe* entered the collection of the Petit Palais in Geneva is typical of the way in which Caillebotte's paintings have come into public view. The painting was initially given by the artist to Eugène Lamy, who then bequeathed it to his daughter. In 1956, it appeared for sale in the Charpentier gallery in Paris, from which it was acquired by the perceptive Swiss collector Oscar Ghez. In 1968, the Ghez collection opened in Geneva under the title of the Petit Palais, where *Le Pont de l'Europe* has since become one of the museum's major attractions.

David A. Brenneman

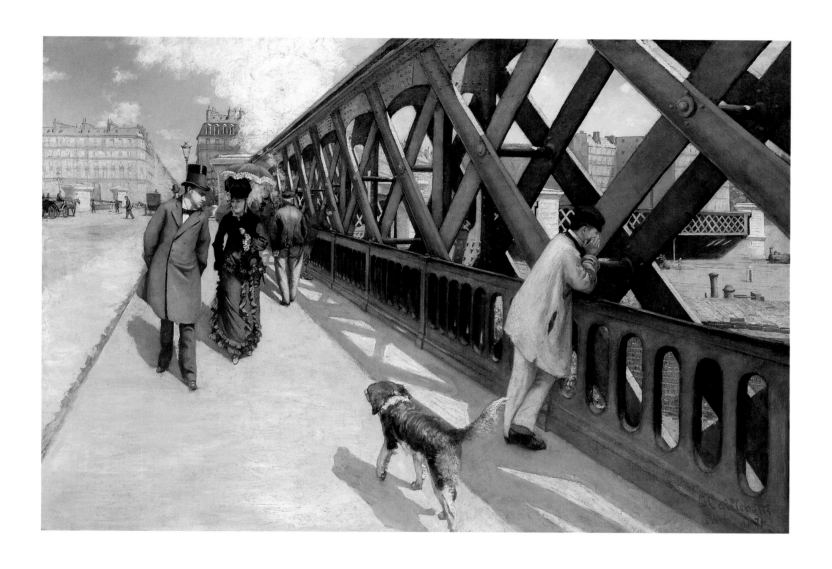

5.

Le Pont de l'Europe, 1876

Oil on canvas
49¼ × 71 inches (125.1 × 180.3 cm)
Petit Palais, Musée d'Art Moderne, Geneva

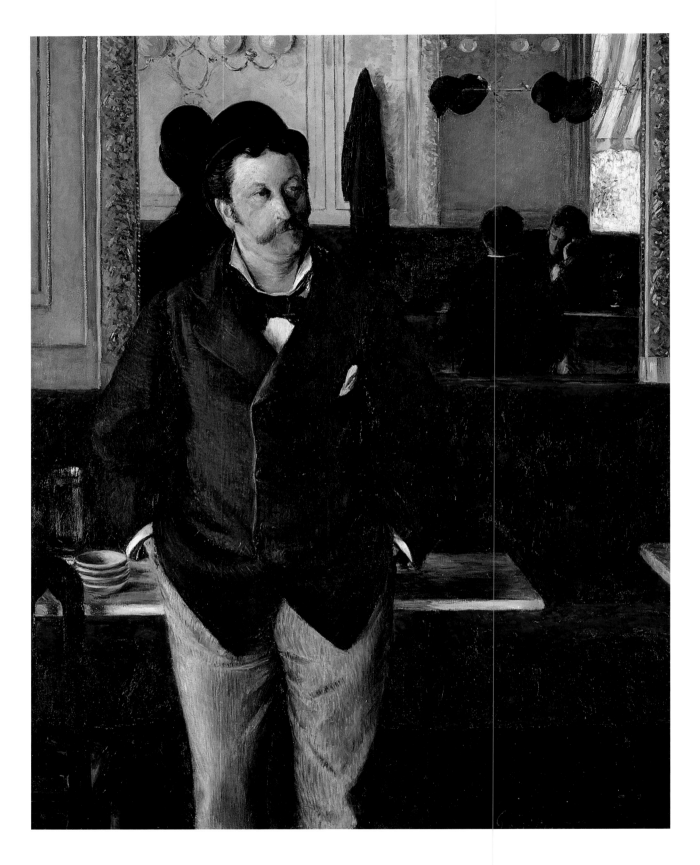

6.

In a Café, 1880
Oil on canvas
61 × 45 inches (154.9 × 114.3 cm)
Musée des Beaux-Arts, Rouen

Gustave Caillebotte

An anonymous man, lost in thought, leans against a marble table in front of a large, gilt-framed mirror in which we can see reflected the interior of a typically French nineteenth-century café with its red plush banquettes, mirrors, and globe lamps. To the right, strong sunlight filters through a window below an orange-and-white-striped awning. But within, a mood of ennui prevails: the café is empty save for two seated figures absorbed in a desultory game of cards. The foreground figure embodies the Baudelairian concept of the *flâneur*—the detached observer of modern urban life, absorbed in what he sees while always retaining his anonymity.

The painting displays the strong structural articulation that distinguishes Caillebotte's work around the end of the 1870s and early 1880s, as is evident in his major compositions of Paris street scenes painted at this time—for example, *Paris Street on a Rainy Day*, 1877 (Art Institute of Chicago), and *Le Pont de l'Europe*, 1876 (cat. 5). Here, the coat hanging on the far wall defines the central axis of the composition and provides the key for a rhythmic grid of verticals and horizontals formed by the mirror frame and wall paneling, the banquette and the marble table. Caillebotte creates an amusing visual pun with the bowler hats: the central figure's hat is reflected in the mirror behind him and echoed in the card players' hats hanging on the wall above them. The palette of burgundy and black enlivened by turquoise-blue, white, and gold is rich yet subdued and underscores the introspective tenor of the work as a whole.

Together with several other works in this exhibition, *In a Café* was shown at the fifth Impressionist exhibition. It seems more than likely that it was seen there by Manet and played a major role in the genesis of his great café painting, *Bar at the Folies-Bergère*, 1882 (Courtauld Institute Galleries, London), in which a prominent foreground figure is similarly reflected in a large mirror. It also attracted the notice of the critic J.-K. Huysmans, who admired Caillebotte for the honesty of his realism.[1]

Caillebotte was a central figure in the history of Impressionism, not only as a painter but also as one of the first important patrons of his friends' work.[2] He also was an organizer of their group exhibitions, a role that proved particularly trying in 1880, 1881, and 1882, the years of the fifth, sixth, and seventh exhibitions, when dissension in the group and the admission of new and lesser talents led to a loss of solidarity and focus. In the end, Caillebotte lost heart as he saw his beliefs increasingly compromised. After 1882 he retreated from Paris and settled at his home at Petit-Genevilliers, to the west of the city. Although he continued to support his friends, most of Caillebotte's collecting was done before 1880.[3] After Caillebotte's death in February 1894 at the age of forty-five, Renoir wrote to inform the director of the Fine Arts Administration of Caillebotte's bequest of "a collection of sixty works, approximately, by Messrs. Degas, Cézanne, Manet, Monet, Renoir, Pissarro, Sisley, Millet."[4] This remarkable bequest (now part of the collections of the Musée d'Orsay, Paris) was finally accepted in February 1896 and installed in the Musée du Luxembourg in January 1897, when it became the first major group of Impressionist paintings to enter a French museum.

Ann Dumas

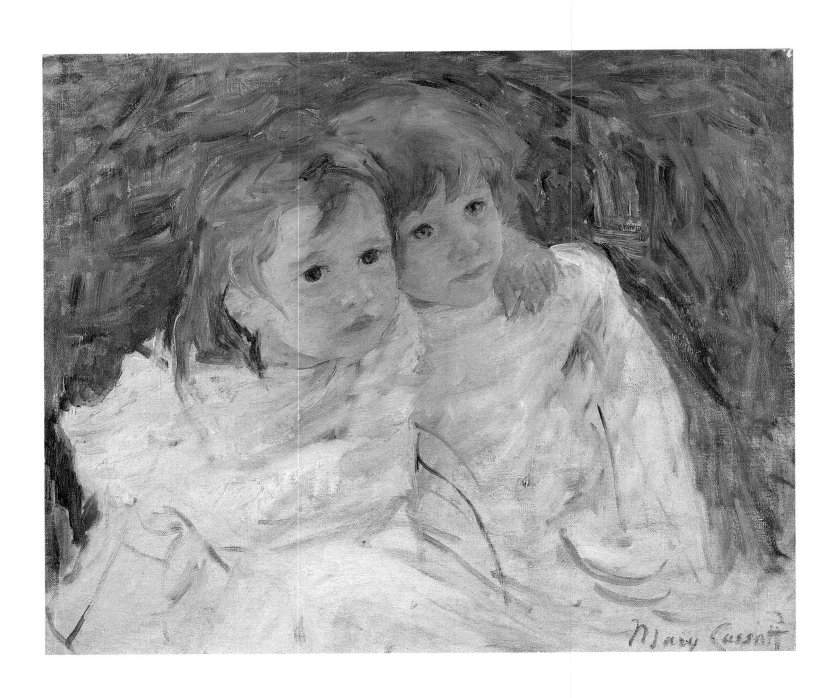

7.

The Sisters, ca. 1885

Oil on canvas
18¼ × 21¾ inches (46.4 × 55.2 cm)
Glasgow Museums: Art Gallery and
Museum, Kelvingrove

Mary Cassatt's greatest artistic gifts found expression in her intimate and sensitive depictions of mothers and children. It was a genre for which she seemed perfectly suited:

> Woman alone is capable of painting childhood. There is a particular feeling which a man does not know how to render; unless he is singularly sensitive and delicate, his fingers are too big not to leave clumsy and brutal marks; only the woman can pose the child, dress it, pin it, without pricking it.[1]

Though childless herself, Cassatt seems to have had an innate knowledge and understanding of children. Here the childlike qualities of the girls are reinforced by the high viewpoint that Cassatt, a visitor in their nursery, naturally adopts. The two girls look up trustingly toward someone—perhaps their mother—who maintains their attention while Cassatt captures their boisterous beauty and lively expressions. They hug each other, the older girl to the left putting a protective arm around the shoulder of her sibling. Cassatt's treatment has been described as both fresh and frank.[2] That frankness is assisted by the simplicity of the composition. Her interest in Japanese prints had led her to develop firmer outlines and, as here, a flattened, somewhat two-dimensional space. She uses long, curving brushstrokes to define the figures, only sketching in their white dresses, but filling in the simple background with vibrant greens and blues.

Mary Cassatt

In such intimate scenes, Cassatt's interest lay in the character of her sitters rather than in decorative detail. These girls are not neatly posed or elaborately coiffured; they are neither demure nor particularly feminine. Yet the spontaneity of Cassatt's portrayal of these two young girls reveals their very essence.

The Sisters belonged to Ambroise Vollard and was subsequently in an unknown private collection in France. In 1953 it was purchased from the dealers Roland, Browse and Delbanco, London, and presented to the Glasgow Art Gallery and Museums by trustees of the Hamilton bequest. James Hamilton, who died in 1877, had directed that his collection of paintings, and also a sizable sum of money, should pass to the Glasgow Art Gallery upon the death of the longest lived of his sisters, Elizabeth and Christina. The bequest did not come into effect for almost twenty-five years, just in time for the opening of Glasgow's new Art Gallery at Kelvingrove in 1901. The terms of the bequest were broad, allowing for the acquisition of works that would fill gaps in the collections. One obvious gap in the holdings—that of French nineteenth-century painting—was filled using the bequest, most actively after the appointment of Dr. T. J. Honeyman as director in 1938. In consultation with the trustees, Honeyman selected many fine examples of French art, including works by Delacroix, Monet, Sisley, Signac, Gauguin, and this work by Cassatt.

Jennifer Melville

Two Mothers and Their Children in a Boat is one of the most important canvases Mary Cassatt painted near the end of her career. A few years later she was obliged to abandon her work due to failing eyesight. The setting can be identified as the trout pond in the park of the Château de Beaufresne. Cassatt bought this seventeenth-century manor house in the Oise, north of Paris, entirely with the proceeds of her work, which were particularly substantial after a successful show in 1893 at the Durand-Ruel gallery. In later life she spent much of her time there.

Mary Cassatt

By 1910 Cassatt's considerable reputation was firmly linked to themes of maternity, and this was what was expected of her by her sizable international clientele. Cassatt varied the poses and settings, increasingly favoring outdoor scenes. She had explored the subject earlier, notably in a striking composition of a family being rowed, *The Boating Party* (1893–94, National Gallery of Art, Washington, D.C.). Here, however, we look down from close range on a moored punt. The composition makes an interesting comparison with *Summer's Day* (cat. 39) by Morisot, a work Cassatt may have seen around 1909–10 in Durand-Ruel's stock.

Cassatt's forceful drawing forms the imperceptible underpinning of the composition, while her brushwork shows considerable freedom, and her color is applied boldly and in broad areas. The patch of lilac blue beneath the dangling feet of the child on the left marks a startling accent, offsetting the predominantly warm flesh tones of the naked children and the gold of the woman's robe. This more decorative technique is typical of her later work and comparable to the technical bravura of other artists of the day, notably her compatriot John Singer Sargent.

The identity of the models is not known; it is possible they were local women and their offspring, whom Cassatt often asked to pose, finding them natural and gracefully maternal sitters. They are dressed in flowing robes by Paquin, which Cassatt would have bought at the couturier's sales, according to her biographer Frederick A. Sweet.[3]

The Paquin robes would have appealed to the first owner of this painting, James Stillman (1850–1918), who in addition to collecting art also collected examples of ladies' haute couture. President and later chairman of the board of the National City Bank of New York, he became a close friend of Cassatt's when he moved to Paris in 1909, occupying a grand residence overlooking the Parc Monceau. He allowed her to advise him—as she did the Havemeyers—on buying art. She steered him away from the safe and somewhat sentimental realism to which he naturally gravitated, toward works by old masters such as Gainsborough, Rembrandt, Titian, and Ingres, as well as toward the Impressionists. Durand-Ruel bought *Two Mothers and Their Children* from the artist on 27 September 1910 for 7,000 francs, and he sold it to Stillman on 12 November 1910, together with three other of her works.[4] At his death, Stillman's Cassatt collection numbered about twenty, most of which were donated anonymously to different American museums by his son, Dr. Ernest G. Stillman. In 1922 several entered The Metropolitan Museum of Art in New York. The following year, the Musée du Petit Palais in Paris, which had tried unsuccessfully to buy Cassatt's *Lady at the Tea Table* (1883–85, The Metropolitan Museum of Art, New York) in 1914, received this important donation, a fitting tribute to the American artist's longstanding residence in the French capital.

Belinda Thomson

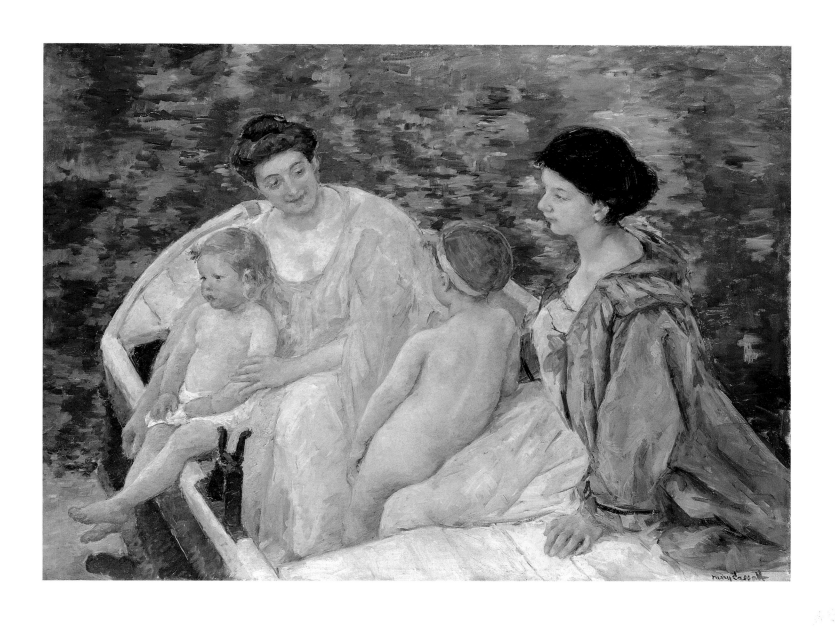

8.

Two Mothers and Their Children in a Boat, 1910

Oil on canvas

39 × 50¾ inches (99.1 × 128.9 cm)

Musée du Petit Palais, Paris

Paul Cézanne

Cézanne, unlike his Impressionist colleagues, usually chose timeless subjects for his work. This picture, which depicts a scene from everyday working life, is unusual for him. At the Quai de Bercy to the east of Paris, the bed of the river Seine is being dredged. A floating crane is at work on the water, and two men are digging on the riverbank, while near them stand a wheelbarrow and a cart pulled by two horses. Dramatic clouds hang over the low-lying horizon, where a bridge elegantly crosses the Seine.

Guillaumin (cats. 25–27) painted an almost identical picture between 1873 and 1875. It is painted from exactly the same angle and is almost the same size. It is also in the Hamburger Kunsthalle, having been acquired in 1983. As the German art historian Hans Platte convincingly argued, Cézanne used Guillaumin's picture—one of his typical dock scenes—as the basis for his own painting: "Cézanne has basically simplified everything: the cloud formation, the big house in the background behind the bridge, the form of the crane and the cart and the appearance of the yellow house on the left."[1] Cézanne's work is more abstract, and he omits a man with a wheelbarrow seen in the background of Guillaumin's picture.

In 1872 Cézanne copied *View at Louveciennes* by Pissarro, who taught him about plein-air painting. In *The Seine at Bercy,* completed five years later, Cézanne tried out his new "constructive stroke" technique, seeking to overcome the loose composition typical of many Impressionist pictures. "Through the application of regular, often square brushstrokes and occasional impasto, his copy gained a tighter structure and a completely different texture, most noticeable in the clouded sky."[2] Perhaps this explains why he chose a subject matter that he normally refused to paint. As he said in 1902: "Unfortunately, what we call progress is nothing other than the invasion of bipeds, who won't stop until they have transformed the whole thing into odious quays with gas lamp standards and—even worse—electric light."[3]

The first private collector to own the painting was the politician Baron Denys Cochin (1851–1922). He first met Cézanne in 1898 while out riding, and though he disturbed the painter at his easel, he was one of the few admirers whom Cézanne treated with friendship.[4] Cochin's art collection (which included up to eight paintings by Monet and seven by Manet, including the monumental *Execution of Maximilian* from 1867, today in the Kunsthalle in Mannheim) was auctioned in Paris at Georges Petit's on 26 March 1919. But by that time *The Seine at Bercy* had already been sold through Paul Cassirer to the landowner Freiherr Victor von Mutzenbecher, then sold again to the banker Theodor Behrens (1857–1921) in Hamburg. Unlike Mutzenbecher, Behrens was making a name for himself as a modern art collector. On his estate at Waldenau near Hamburg, he collected "especially Frenchmen from the Impressionist school: Manet, Monet, Pissarro, Degas, Cézanne etc."[5] After his death in 1921, his collection was lent to the Hamburger Kunsthalle. Three years later, the Kunsthalle's director, Gustav Pauli, managed to acquire the picture, although in that same year there was a public outcry over the high price he paid for Manet's *Nana* (1877), which was also part of the Behrens collection.

Stefan Pucks

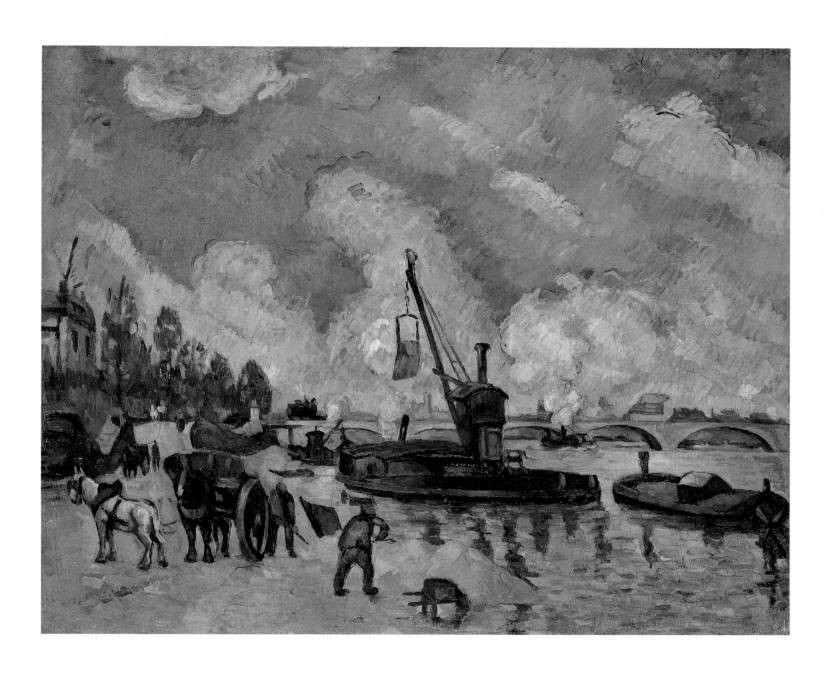

9.

The Seine at Bercy, after Guillaumin, 1876–78

Oil on canvas
23½ × 28½ inches (59.7 × 72.4 cm)
Hamburger Kunsthalle

10.

Farm in Normandy:
The Enclosure, ca. 1882

Oil on canvas
19½ × 25¾ inches (49.5 × 65.4 cm)
Private collection on extended loan to
the Courtauld Gallery, London

Paul Cézanne

Despite the modest subject, Cézanne has succeeded in imposing on his composition a powerful sense of architectural form. The strong, black, vertical tree trunks and the overarching branches convey the feeling of an enclosed sanctuary of green and cool on a hot summer's afternoon. The painting's emphatic armature is softened by the foliage, a drift of green varied with blue shadows and yellow, glancing sunlight and applied with a repeated, parallel stroke—often called "the constructive stroke"—that Cézanne used to give density and organization to his compositions, especially in the late 1870s and early 1880s.

Cézanne's family's money freed him from the necessity of selling his work, and as a result he often left paintings in an unfinished, experimental state. In this painting, the slender young tree trunks to the right, overpainted with strokes of green, are evidence of his continual process of erasure and revision. This unconcealed experimentation shocked Cézanne's first viewers but strikes a chord with his admirers today.

This is one of four similar orchard views that were most likely painted on the farm at Hattenville in Normandy belonging to Victor Chocquet (1821–1891), Cézanne's first important patron. Chocquet, a modestly paid official in the customs service, was a passionate collector of the work of Delacroix and the Impressionists. He was particularly keen on Renoir but his greatest enthusiasm was reserved for Cézanne, whose work he began to collect in 1875 when Renoir took him to Père Tanguy's artists' materials shop, one of the few places in Paris where it was possible to see Cézanne's paintings at this date. At one time, Chocquet owned fifty paintings by Cézanne, years before his work was generally understood or appreciated.[1] Thirty were included in the spectacular sale of Chocquet's collection held in July 1899 at the Hôtel Drouot following his widow's death. As the critic and defender of the Impressionists Théodore Duret noted in the introduction to the sale catalogue, Chocquet's sale established the market value of Cézanne, although the prices were much less than those attained by works of Manet, Monet, and Renoir.[2]

In 1937 *Farm in Normandy: The Enclosure* was bought for 2,500 pounds by the great British collector of Impressionism Samuel Courtauld. Courtauld played a crucial role in the acceptance of "modern" French painting in Britain not only through his personal collecting but, perhaps more importantly, through a substantial gift of 50,000 pounds made to the Tate Gallery in 1923 specifically to establish a fund for the acquisition of Impressionist and Post-Impressionist paintings. In England, Cézanne proved initially to be the most unacceptable of the modern artists to public taste.[3] Courtauld bought his first Cézanne in 1923, *Still Life with Plaster Cupid,* ca. 1884 (Courtauld Institute Galleries, London), but it was not until 1934 that a painting by Cézanne entered the National Gallery, *La Montagne Sainte-Victoire,* ca. 1887 (Courtauld Institute Galleries, London), a long-term loan from Courtauld's private collection. On that occasion he wrote to Kenneth Clarke, the director of the National Gallery: "For my part, I am pleased to help in getting official recognition for Cézanne in England."[4]

Ann Dumas

II.

Bathers in Front of a Tent, 1883–85

Oil on canvas
25 × 31⅞ inches (63.5 × 81 cm)
Staatsgalerie Stuttgart

Paul Cézanne

Cézanne was fascinated by the theme of bathing, and he dealt with the subject in more than two hundred oil paintings, watercolors, drawings, and lithographs. On the back of a letter of 20 June 1859 to his friend Émile Zola, he drew a naive picture of bathers as a reminder of the happy days of their youth. Forty-five years later, Émile Bernard took a photograph of the old painter in front of his easel, on which stood his painting *Bathers* (now in the Barnes Foundation, Merion, Pennsylvania). While his colleague Renoir emphasized the sensual pleasures of bathing in his paintings of young girls with peach-colored skin, the loner from Aix-en-Provence was not interested in copying such joyful scenes from life. Cézanne's crude, faceless women are drawn from his imagination, taken from other artists or from drawings he made when he was at the Académie Suisse in Paris. In *Bathers in Front of a Tent,* completed between 1883 and 1885, the three women in the foreground form a triangle. One is standing, a figure of "tempted, temptress Athena," while the second is sitting and undressing, and the third is crouching.[1] The triangle is repeated in the giant, pyramid-shaped white cloth, which has been thrown over two branches of a tree to shelter the women. While such a tent is unique in Cézanne's work, a big white cloth represents for him the sphere of "eternal femininity," the other sex, which is both attractive and dangerous. To the right of the tent a woman is taking off her shirt, while another on the far right is getting into the water. A splash of color on the far side of the pool reveals a sixth bather.

Through the art dealers Ambroise Vollard in Paris and Heinrich Thannhauser (1859–1934) in Munich, *Bathers in Front of a Tent* found its way into the hands of Scandinavian private collectors. In 1913 it belonged to the Swedish collector and writer Klas Valter Fåhræus (1863–1944) in Lidingön near Stockholm. Fåhræus had lived in the Nordic artists colony in Grez-sur-Loing, southeast of Paris, in 1886, and owned not only works by the Swedish painters Ernst Josephson, Carl Larsson, and Anders Zorn, but also a noteworthy collection of East Asian art, as well as paintings by van Gogh, Renoir, and another by Cézanne.[2] The painter and art critic Walther Halvorsen (1887–1972) from Oslo, who studied at the Matisse School in Paris in 1909–10, acquired the work and added it to his three other paintings and watercolors by Cézanne.[3] Halvorsen also owned two paintings by Manet, including *Portrait of Clemenceau* from 1880. In the 1950s, the Oslo shipowner Ragnar Moltzau (1901–1982) acquired Cézanne's *Bathers in Front of a Tent.* Together with other works in his extensive collection, which ranged from the Impressionists and Edvard Munch to the informal painting of the École de Paris, the picture was acquired by the Staatsgalerie Stuttgart in 1959.[4]

Stefan Pucks

Paul Cézanne

Cézanne makes ordinary objects unfamiliar, and then he does the same to the perspective. The table, a simple wooden board on trestles, is shown parallel to the picture on the right, while at the same time it appears to have been pulled back from the wall and so becomes narrower to the left. The bright blue wall is nothing more than a flat surface that is bisected by a diagonal—rather than a straight—ochre strip. In this picture, one of more than 170 still lifes Cézanne painted, he demonstrates his idea of art as a harmony "parallel to nature."[1] The subject of this painting is not pears but art. It is all about the complementary colors of red and green, the elements used in the construction of the picture, such as the dominant diagonals, and the "optique," the manner of seeing the painting in many different ways, a technique often used by Cézanne. Familiar objects in a still life were well suited to create this sense of the unfamiliar: "The painter should devote himself totally to the study of nature and try to make pictures which teach us something," wrote Cézanne in 1904.[2]

In November 1900, the Berlin gallery owner Paul Cassirer (1871–1926), then still in partnership with his cousin Bruno Cassirer (1872–1941), exhibited pictures by Cézanne for the first time in Germany. Paul's older brother, Dr. Hugo Cassirer (1869–1920), a Berlin cable manufacturer, was one of the customers who helped support him in the difficult early days. From 1908 onward, Hugo and his wife Charlotte bought French Impressionist paintings from Paul Cassirer and amassed a collection that included a four-season cycle by Pissarro, three pictures by Renoir, and "two pictures each of the highest quality" by Manet, Monet, and Cézanne, including *Still Life with Pears*.[3] When the Nazis seized power in 1933, Hugo Cassirer's widow managed to get the famous collection—which included seven paintings by Cézanne—out of the country with the help of the director of the Galerie Cassirer, Walter Feilchenfeldt. Through her son Stefan Cassirer, an art dealer in Copenhagen, the Cézanne picture came into the ownership of Marianne Feilchenfeldt, who ran the gallery in Zurich after her husband died in 1953. The Wallraf-Richartz-Museum in Cologne bought Cézanne's *Still Life with Pears* from her in 1965, as well as his *In the Meadow at Bellevue* (1885–87) with the help of Rhineland art lovers, Cologne businesses, and the Westdeutscher Rundfunk.

Stefan Pucks

12.

Still Life with Pears, ca. 1885

Oil on canvas
15 × 18⅛ inches (38.1 × 46 cm)
Wallraf-Richartz-Museum, Cologne

Edgar Degas

Although it is dated 1862, Degas extensively reworked this painting twenty years later, prior to selling it to the dealer Durand-Ruel in February 1883. X-ray examination has revealed that he redefined the horses and riders—rendering facial features with greater specificity than before—and added the central hill and the smoking chimneys to the right.[1]

In its earlier form, this was probably one of Degas's first paintings of horse racing, a subject that would later become one of his principal themes. The colors of the jockeys' silken outfits (pale blue, pale yellow, buff, greens, oranges, russet-reds, and pinks), picked up in the tiny, indistinct figures of the waiting spectators in the distance, glow against the soft, gray light of a moist Normandy landscape, while the interlocking frieze of horses and riders, their bodies tensed for the start of the race, forms a dense group against the open, gently rolling hills punctuated by the vertical chimneys. Almost certainly, this work was painted during one of Degas's regular visits to his friends the Valpincons' estate, Ménil-Hubert, at Argentan in Normandy. In a notebook entry written around 1862, the artist remarked how appealing he found the gentle, damp countryside in this area of northwestern France and how it reminded him of the scenery of England.[2]

Not only the landscape but also the long-established tradition of English equestrian painting must have influenced Degas as he developed his own very original approach to the subject. But the knot of overlapping jockeys and the dramatic cropping of the rider in red to the right, which suggest a randomly observed view (though, in fact, Degas's compositions were the result of the most calculated orchestration), are evidence of how far Degas had moved from conventional formulas of horse-race compositions.

The painting was acquired by Durand-Ruel on 14 February 1883 for 5,000 francs.[3] It changed hands many times in a short period: deposited with Fritz Gurlitt, Berlin, September 1883–January 1884; deposited with M. Cotinaud, Paris, June 1884; Hector Brame, Paris; deposited with Durand-Ruel, Paris, June 1889; purchased by Durand-Ruel, Paris, August 1889; and deposited with Manzi, August 1889, who purchased it the next day. Finally it was acquired in April 1894 by the banker and great collector Count Isaac de Camondo. In addition to collecting paintings, tapestries, medieval and Renaissance sculptures, and Japanese prints, Camondo was a major collector of nineteenth-century painting. At the time of his death he owned works by Cézanne, van Gogh, Manet, Monet, and Sisley, as well as nineteen works by Degas. In 1908 Camondo presented his entire collection to the French State, stipulating that it was to be kept together at the Louvre for fifty years after his death, in a suite of adjoining rooms bearing his name; he donated 100,000 francs for this purpose. The collection was transferred to the Musée du Jeu de Paume in 1947, and to the Musée d'Orsay in 1986.

Ann Dumas

13.

The Gentlemen's Race: Before the Start,
1862, reworked ca. 1882

Oil on canvas
19 × 24¼ inches (48.3 × 61.5 cm)
Musée d'Orsay, Paris, bequest of
Count Isaac de Camondo, 1911

14.

Woman and Dog, ca. 1875

Oil on canvas
15½ × 18¾ inches (39.4 × 47.6 cm)
Nasjonalgalleriet, Oslo

Woman and Dog is not one of Degas's most spectacular pictures, but the motif, composition, color, and brushwork are characteristic of his work. Modest in scale and devoid of drama, it nevertheless admits us to this artist's idiosyncratic pictorial world. Degas sought to capture on his canvas a fleeting sensory impression, defined by the

Edgar Degas

prevailing influence of light on colors. His fascination with figures in motion sets him apart from other Impressionists. In his refined compositions and with his assured drawing he manages to give the momentary a validity far beyond that instant. In *Woman and Dog*, his color divisionism is not as elaborate as it was to become later; dating this picture to the mid-1870s, therefore, seems reasonable.[1]

In this picture of a woman in a straw hat, seen from the unusual viewpoint of semi-profile from behind, we confront an important aspect of Degas's highly personal art. The painter does not offer a complete image of the world but only a fragment of a much more comprehensive reality. We see the woman and her dog, but we do not know what they are looking at. The untraditionally cut-off composition, while typical of Degas, is probably a study for a larger composition, perhaps a steeplechase picture. Though the figures partly dissolve in a play of light and shade, the principal forms are nevertheless depicted with emphasized contours, which was not common among the Impressionists.

Along with Renoir's *Bathing Woman* (cat. 51), *Woman and Dog* was shown in the exhibition *French Art* held at the Nasjonalgalleriet in 1914. The pictures had previously been exhibited in Copenhagen, where both were illustrated in the catalogue. From Oslo, parts of the exhibition traveled on to Stockholm. There the Degas was described as belonging to Ambroise Vollard.

In all, twelve paintings from the collections of Vollard and Levesque in Paris were transferred from the Copenhagen exhibition to Oslo in the summer of 1914. Besides a few pieces of sculpture, graphic works, reproductions, and photographs, forty-eight paintings were shown. Twenty came from Norwegian and Swedish private collections, but sixteen belonged to the Nasjonalgalleriet, which had purchased its first painting by a French Impressionist as early as 1890: Monet's *Rain, Étretat* (1886), the first painting by Monet to be bought for any public collection.

The paintings belonging to Vollard and Levesque were for sale, and were not returned to their owners when the exhibition closed because of the outbreak of the First World War. Sending them by sea would have been risky, and that is presumably why the pictures continued to hang in Oslo for several years. In the end, six of the paintings were incorporated into the Nasjonalgalleriet's collections, five of them as a result of Tryggve Sagen's generous financial donation of 1916.[2] At this time, Sagen (1891–1952) was a young man of twenty-five who had been extraordinarily successful in shipping. He was a considerable collector of modern French art, and many important works now in private and public collections throughout the world were at some stage owned by him. In addition to Renoir's *Bathing Woman* and Degas's *Woman and Dog*, Cézanne's *View from Jas Bouffan*, Gauguin's *Still Life with Basket and Fruit*, and Courbet's *Jura Landscape* were bought with funds donated by Sagen.

Woman and Dog is listed in the Nasjonalgalleriet's records as having entered the collections in 1918, and must therefore have been bought after the Stockholm show.[3] It was the last of the paintings purchased with the funds donated by Sagen.

Marit Lange

Edgar Degas

Degas was an avid operagoer and attended several performances of *Robert le Diable (Robert the Devil)*. Meyerbeer's romantic opera was first performed in Paris on 21 November 1831 and remained a favorite with Paris audiences until the end of the century.[1] The scene Degas has depicted here is the celebrated nuns' ballet, in which the spirits of nuns who have broken their vows hope to lure the hero, Robert, to damnation by performing a wild dance in a ruined, moonlit cloister. The first idea for the subject appears in some preliminary, on-the-spot notebook jottings that Degas made in the early 1870s.[2] Five larger drawings of nuns (The Victoria and Albert Museum, London) executed in the fluid oil medium known as *essence* (oil paint diluted with turpentine) relate to an earlier, vertical canvas of the same subject painted in 1871 and now in the Metropolitan Museum of Art, New York.

This is the last of a group of daringly modern paintings of the early 1870s in which Degas breaks with the convention of presenting the stage head-on, choosing instead what looks like a random view that crops both the stage and the darkened orchestra pit and auditorium, creating an extraordinarily immediate sense that the viewer is actually seated in the front row of the theater looking across the orchestra and up to the stage. The other paintings are *The Orchestra of the Opéra,* ca. 1870 (Musée d'Orsay, Paris) and *Orchestra Musicians,* 1874–76 (Städelsches Kunstinstitut und Städtische Galerie, Frankfurt).

Degas was fascinated by artificial lighting. Here, he explores the striking contrast between the gauzy, gaslit dancers on stage and the foreground figures caught in the vivid glow of the musicians' desk lamps. Some of these are, in effect, portraits of Degas's opera-loving friends: the bearded man in the right foreground is Viscount Ludovic Lepic (1839–1889), an amateur painter and engraver who showed at the first and second Impressionist exhibition; the third figure on the left is the bassoonist Désiré Dihau; and on the extreme left is the Impressionist collector Albert Hecht (1842–1889), whom Degas has amusingly captured as his attention momentarily strays from the performance to the attractive occupant of a box.[3]

The painting was commissioned by the famous operatic baritone and great early collector of Impressionism, Jean-Baptiste Faure (1830–1914), who between 1870 and 1880 was the most important collector of Degas's work.[4] However, the friendship between artist and patron was undermined by Degas's failure to fulfill a commission in 1874 for four paintings.[5] Two of the pictures, including the present work, were finished in 1876, but the rest of the commission was not completed until 1887 (and then only when Faure threatened to sue). Faure sold the painting to Durand-Ruel in February 1881 for 3,000 francs, who in turn sold it in June of that year for 6,000 francs to the British collector of Greek origin, Constantine Ionides (1833–1900), whose family had made a fortune in textiles.[6] Between 1874 and 1884, Ionides built up an eclectic collection that included ancient gems, Italian Renaissance painting, and contemporary British art. He also developed a passion for French nineteenth-century painting and bought works by Delacroix, Millet, Courbet, Fantin-Latour, and the present work by Degas.[7] He bequeathed his entire collection to the Victoria and Albert Museum in 1900 on the condition that it should always be kept together. *The Ballet Scene from Meyerbeer's Opera "Robert le Diable"* thus became the first painting by Degas to enter an English museum. It is interesting to note that a work by Degas was refused by the National Gallery, London, even as a gift, as late as 1905.[8]

Ann Dumas

15.

The Ballet Scene from Meyerbeer's Opera
"Robert le Diable," 1876

Oil on canvas
30⅛ × 32 inches (76.5 × 81.3 cm)
The Victoria and Albert Museum, London

16.

Portrait of Lorenzo Pagans, 1882
Oil on canvas
23¼ × 19¼ inches (59.1 × 48.9 cm)
Národní Galerie, Prague

Edgar Degas

Degas's 1882 portrait of Lorenzo Pagans (1838–1883) portrays a casual moment in the life of a long-standing family friend. Pagans was a singer and musician born in Spain in 1838. He moved to Paris at twenty-one, where he became a successful teacher and performer, prompting a vogue for Spanish music. He befriended members of the Parisian artistic circles of the day, including Alexandre Dumas *fils* and the Degas family.

The Degas family's enthusiasm for music, along with the private weekly soirées that Pagans often attended, is well known. This portrait is the fourth and last of Pagans (not counting his likeness in the background of *The Orchestra of the Opéra* in the Musée d'Orsay), and is the only instance in which Degas painted the musician alone. The first three works are double portraits with the artist's father, Auguste, who died in 1872. The earliest of the paintings, from 1869, is a convincing portrayal of two subjects completely absorbed in their activities: Pagans in the quiet performance of his song, and M. Degas in a music-induced reverie. The next two portraits are less personal and more self-conscious as compositions. In the final double portrait, painted after Auguste's death, the elder Degas appears as a slurred memory in the background, and Pagans poses patiently, reading a book.

In this painting, Degas turned his attention to Pagans himself. We are close to him, as if in familiar conversation, an impression that is supported by the close cropping and warm tones of the work. The musician is in midsentence, and once again in his own reverie. This time, however, it not music that he is caught up in but his own thoughts, as Degas has captured a remarkably candid moment in his model. This painting stands out in the body of Degas's work as a highly finished oil portrait, made at a time when the artist produced increasingly experimental and loosely finished pastels.

After the artist's death, this work was retained by his brother René and then sold to a French collector in 1927. By 1970 the painting had found its way to California, but returned to Europe and was acquired by the Národní Galerie in Prague in 1977. The collection of nineteenth- and twentieth-century French art at the Národní Galerie was founded in 1923 with the intention of assembling art by Delacroix, the Barbizon School, the Impressionists, Cézanne, Gauguin, van Gogh, Picasso, Braque, and other French painters. The focus of the collection was a purchase by the Czechoslovak state that included forty paintings and sculptures shown at the exhibition *19th and 20th Century French Art,* organized in Prague by the SVU Mánes artists' association under the auspices of the President of the Republic, T. G. Masaryk. The collection also received works through purchases made directly from Paris collections and galleries in 1923. Other works were later purchased and added to the collection, Degas's painting and his sculpture *Large Arabesque* among them. The collection was a deposit of the Modern Gallery, which is part of what is today the Národní Galerie in Prague.

Phaedra Siebert and Olga Uhrová

Edgar Degas

Degas developed this composition from an earlier pastel (Lemoisne no. 1262) and indeed this oil painting resembles a pastel, particularly in the way Degas has smudged the oil on the orange tutus of the two dancers to the right, which appear almost out of focus. The brutal application of paint, which had characterized much of his earlier work, is replaced here by a more delicate treatment, with edges between colors and forms merging, giving the composition an overall sense of pattern and a strongly two-dimensional quality.

Degas had painted dancers preparing to perform for many years. In earlier paintings he shows their boredom and fatigue, their tired limbs and weary expressions. Twenty years later the dancers are expressionless—blank puppets with features not defined sufficiently to reveal any emotion. Their faces are either turned away from the viewer or painted flat brown and completely blank. The effect of alienation is increased by the way that the dancers are distanced from the viewer by the large space (far greater here than in the preparatory pastel), which is almost filled by a disconcertingly large and ominous shadow.

The scene before which the ballerinas prepare appears to be a wooded landscape. The "trees" cut across them at daring angles. To the left, a dancer is truncated by the edge of the canvas. What had been a yellow skirt in the pastel sketch has been filled in with white but retains its yellow edges, so that the result is a ghostly apparition rather than any suggestion of a physical presence. Colors made eerie by the play of gaslight, pools of dark shadow, and ambiguous forms combine to create a work in which mood and mystery are the subject far more than ballet or even ballerinas.

This painting was included in the first sale of Degas's collection, which took place on 1 May 1918. It was acquired by J. Seligmann, Paris, who sold it in New York on 27 January 1921 to Captain Edward Molyneaux, Paris. Lord David Eccles of London owned it subsequently, then Arthur Tooth & Sons, from whom it was bought by Sir Alexander Maitland Q.C. in 1947. Maitland (1877–1965) was a Scottish lawyer, whose wife Rosalind seems to have been the driving force behind the couple's collecting. By gifts in 1958 and 1960 and a bequest in 1965, the Maitlands gave their collection of paintings, sculpture, and prints to the National Gallery of Scotland. This included works by Monet, Matisse, Cézanne, van Gogh, and Gauguin, and this painting by Degas, which was donated by Sir Alexander in memory of his wife in 1960. The Maitlands bought many of their paintings in consultation with National Gallery staff, since they had decided to bequeath their entire collection to the museum. In turn, the staff acquired works that would complement the Maitlands' bequest. Thus paintings by El Greco, Chardin, Goya, Daumier, and Corot were added to the collections, and in time the National Gallery came to furnish its walls with the paintings of the most important precursors of modern art.[1]

Jennifer Melville

17.

Before the Performance,
ca. 1896–98

Oil on paper laid on canvas
18¾ × 24¾ inches (47.6 × 62.9 cm)
National Gallery of Scotland, Edinburgh

18.

The Fisherman, 1884

Oil on canvas

37¼ × 39⅜ inches (94.6 × 100 cm)

Southampton City Art Gallery

Jean-Louis Forain

In the fading light of evening, a fisherman and his dog sit on a plank jutting out over a river. On the far bank we can make out a few buildings that are almost engulfed in the gray-mauve twilight. The lone figure introduces a touch of melancholy to this evocative study in mood and atmosphere. Forain explores the subtle gradation of light—from the high white clouds and last traces of daylight that deepen to a violet sky tinged with the glow of sunset in the west and reflected in the water below. The bold diagonal of the plank imposes a powerful design on the composition and reflects the enthusiasm for Japanese prints that Forain shared with many of his contemporaries. Indeed, the composition and the emotive light recall the work of Whistler.

Forain's original training was academic. Like his friend and mentor Degas, his art was based on draughtmanship and line, and he is known as much as a printmaker and illustrator as a painter, especially for his mordantly satirical caricatures. At Degas's invitation, he exhibited with the Impressionists in some of their group exhibitions. He shared Degas's love of urban imagery and often depicted backstage scenes at the Opéra and *café-concerts.* Later he turned to powerful narrative subjects that included religious and courtroom scenes. Outdoor subjects are rather rarer in Forain's work, but the present picture and a few other landscapes—*The Race-Track,* 1884–85 (Springfield Museum of Art, Massachusetts), for example—show how he adopted a lighter palette in response to the Impressionists' influence.

The picture was owned for a time by the famous Philadelphia collector Dr. Albert C. Barnes. It subsequently passed into the collection of the American Impressionist painter William Merritt Chase (1849–1916), whose luminous landscapes, especially those painted on Long Island, bear some relationship to Forain's painting. After Chase's sale in 1912, the picture was acquired by the dealer Durand-Ruel. It was bought by the Southampton City Art Gallery in 1936 with funds left by a former city councilor, Robert Chipperfield (1879–1911), an enlightened and philanthropic man who noted in his will that although Southampton was well provided with venues for music, it lacked facilities for the visual arts. Consequently, his bequest provided for the building of an art gallery and art school as well as an endowment for buying works of art, on condition that this be done in consultation with the National Gallery, London.[1]

Ann Dumas

Paul Gauguin

Between 1879 and 1881, while he was still a prosperous stockbroker, Gauguin managed to amass a collection of Impressionist paintings that included works by Manet, Degas, Renoir, Cézanne, and Pissarro.[1] Of all the artists in his collection, it was Cézanne whose works Gauguin particularly valued. He once told his friend Émile Schuffenecker that he considered a Cézanne still life the gem of his collection, and that he would part with it only in the direst of circumstances.[2] Gauguin is known to have owned at least five paintings by Cézanne.[3]

Gauguin first met Cézanne during the summer of 1881, while painting alongside Pissarro at Pontoise. At the time, Gauguin had expressed a strong interest in Cézanne's theories of art, particularly regarding questions of formal exaggeration and the expression of sensation in painting.[4] In fact, Gauguin's interest was so avid that Cézanne was led to express concerns about Gauguin's having appropriated his theories.[5]

Gauguin painted *Still Life with Oranges* during the first two months of 1882, while he was still a broker on the Paris Stock Exchange and essentially a Sunday painter. Cézanne's influence is evident in Gauguin's choice and treatment of subject matter. The motif is typically Cézannean: a bowl piled high with pieces of fruit that balance precariously—if not impossibly—atop one another, with the oranges clustering densely along the right-hand side of the composition. An open knife hangs flat against the foreground tabletop, further complicating the spatial ambiguities already suggested by the discontinuous line of the table itself and the asymmetrical silhouette of the fruit bowl, which is more densely modeled along its left-hand side. While the painting's subject matter and spatial distortions are Cézannean, Gauguin's paint-handling and the chromatic disposition of the work itself suggest the influence of another Impressionist artist, Renoir.[6] Traces of Renoir's presence are visible in the loose, "basket weave" character of the brushwork and in Gauguin's use of vivid, contrasting tones of orange, green, and red to model the oranges.[7] In short, this work can be seen as a complex triangulation in which Gauguin negotiates the influences of Cézanne and Renoir at what is still a formative moment in the development of his own painting.

Still Life with Oranges is one of thirteen works that Gauguin exhibited at the seventh Impressionist exhibition of 1882.[8] Gauguin had been participating in the Impressionist shows, as both an exhibitor and a lender, since 1879. The painting first entered the collection of the ceramist Ernest Chaplet, an artist whom Gauguin had met in the spring of 1886 and at whose studio Gauguin created his own ceramics. Following Chaplet's death in 1909, the painting was bequeathed to the Musée du Luxembourg. In 1929 *Still Life with Oranges* became part of the collection of the Musée du Jeu de Paume. Since 1955, the work has been housed at the Musée des Beaux-Arts, Rennes.[9]

Marcia Brennan

19.

Still Life with Oranges, 1882

Oil on canvas
13 × 18 inches (33 × 45.7 cm)
Musée des Beaux-Arts, Rennes

20.

Figure on a Road (Rouen), 1884

Oil on canvas
28¾ × 36¼ inches (73 × 92.1 cm)
Fundación Colección
Thyssen–Bornemisza, Madrid

Paul Gauguin

Paul Gauguin started his painting career relatively late in life, picking up his first paintbrush in his early twenties. At first, Gauguin was an amateur, painting on weekends while employed as a stockbroker during the week. Only at the age of thirty-five did he quit his job to become a professional artist. Due in part to his late start, Gauguin escaped the kind of traditional academic art education that encumbered his fellow avant-garde artists, and initiated his painting practice in the most radical contemporary style: Impressionism.

Figure on a Road (Rouen) displays Gauguin's immersion in the Impressionist style. It was Pissarro who, in the 1870s, introduced him to the other Impressionists and gave him his first serious training in painting. The year after he quit his job, Gauguin moved his family to Rouen to take advantage of the lower cost of living and the proximity of his teacher and mentor (Pissarro had installed his family in Rouen several months earlier).

Figure on a Road shows Gauguin working through Pissarro's lessons: the regular, interwoven strokes creating a unified, textured surface, the close palette of green, yellow, and beige with a touch of bright blue in the sky, and the strong perspectival plunge from the right to the center of the canvas, where the composition is anchored by the strong vertical of the trees intersecting the cluster of buildings. Clearly, Gauguin had mastered the Impressionist technique, and he would soon move on to the less naturalistic works of his Pont-Aven and Tahiti periods, in which imagination and memory play a greater role. *Figure on a Road* hints at Gauguin's aesthetic future in the presence of the lone figure and the sense of emptiness suggested in the work. The Impressionist emphasis on the empirical, on the immediate representation of external nature, offered few expressive opportunities to Gauguin's intense and turbulent inner life. In 1886, he participated in the last Impressionist exhibition, joining the new generation of artists who would take the lessons of Impressionism in new directions.

This work was purchased by Baron Hans Heinrich Thyssen-Bornemisza from Sotheby's, New York, on 11 November 1987 (lot no. 13). The painting came to Spain from Switzerland in 1988 on a long-term loan basis, and was purchased in 1993 by the Spanish government and installed in the newly remodeled Palacio Villahermosa in Madrid along with the rest of the Thyssen-Bornemisza collection. Prior to the baron's purchase of *Figure on a Road,* it belonged to the Stephen Hahn Gallery in New York, and before that to the Galerie Brame and Lorenceau in Paris.

Mary Morton

21.

Portrait of Mette Gauguin, the Artist's Wife, 1884
Oil on canvas
25⅝ × 21¼ inches (65.1 × 54 cm)
Nasjonalgalleriet, Oslo

Paul Gauguin

Gauguin here portrays his wife, Danish-born Mette Gad (1850–1920), in an elegant, pink, low-necked evening outfit. Around her neck she has a deep blue velvet ribbon with a sparkling jewel—an intriguing detail to set off her bare skin. She holds a half-open fan painted with a colorful motif, presumably by her husband. He was, as were the other Impressionists, greatly inspired by Japanese art and, like Pissarro and Degas before him, he produced many fan paintings. The picture can be described as a genre painting, between a scene from life and a portrait. The brushwork, with short, emphatic strokes, is characteristic of Gauguin during this period, and different from the Synthetistic style he was to develop later with the Nabis at Pont-Aven and Le Pouldu in Brittany. The sculptural conception of form was soon to be abandoned in favor of clearly outlined flat areas, and the broken colors would be replaced by strong local colors. At the beginning of the 1880s, his style was close to that of his friend Pissarro, and at the same time he was much influenced by Cézanne's "pure" painting.

The portrait is signed and dated 1884, and was painted in Rouen that spring. Gauguin's work as a stockbroker had ended in the autumn of 1883, and in order to live more cheaply the family moved to Rouen in January 1884. He failed to find a permanent job there, and he sold nothing; the family became so short of money that Mette went home to Copenhagen that summer, taking two of their five children with her. Gauguin followed, but the stay in Denmark was no success; the faltering marriage was nearing its end. A few months before Gauguin painted this portrait, Mette had given birth to their youngest son, Pola, who would become a painter and writer (1883–1961). Yet in this picture we encounter not a worn-out mother of five with financial worries and a shaky marriage, but an elegant woman.

Portrait of Mette Gauguin, the Artist's Wife and *Basket with Flowers,* the latter also shown at the Autumn Exhibition of 1884,[1] were both purchased by the Nasjonalgalleriet in 1907 from Mette's sister, Pauline Horst. They had belonged to Pauline's late husband Herman Thaulow, with whom Gauguin had had a business relationship. In order to support himself and his family Gauguin had, before leaving France, become an agent for a French textile company, Dillies & Cie, to sell tarpaulin in Denmark. Thaulow offered to act as subagent for the Norwegian market, but the entire venture was a financial disaster.[2] Whether Thaulow kept the pictures as payment for his work, or whether he bought them from the artist or from Mette, is unclear.

When the paintings were offered to the Nasjonalgalleriet in the late autumn of 1907, the annual purchase grant had been exhausted. However, the board found a solution: it sought permission from the Ministry of Church and Education to use money earmarked for the purchase of Scandinavian art to buy works by Gauguin, since he had a Danish wife. For once, the Ministry behaved in an exceptionally unbureaucratic manner and gave its consent.

Marit Lange

Paul Gauguin

Although Gauguin later downplayed the Impressionist origin of his early painting career, he participated in the fourth through the eighth Impressionist exhibitions.[1] By 1886, however, he became disillusioned by negative reviews that compared his work unfavorably with that of such neo-Impressionist pointillist painters as Seurat.

Gauguin left Paris for Pont-Aven in Brittany, seeking serenity in a place unspoiled by modern civilization, a place where he could live inexpensively and develop his painting technique. Here he began to move away from Impressionism, encouraged by the enthusiastic response to his work from fellow artists visiting the area. "I am respected," he wrote his wife, "and everyone here clamors for my advice."[2] *The Breton Shepherdess* exemplifies this important transitional phase for Gauguin, both in terms of technique and subject.

The Breton Shepherdess is one of five pictures of Breton peasants dating from Gauguin's 1886 stay in Pont-Aven. As evident in this painting, Gauguin continued to work in an Impressionist manner, applying his paint in separate strokes of individual hues. He prided himself on this technique, declaring to his friend Henri Delavallée that he used only pure color, blending it as little as possible.[3] Yet *The Breton Shepherdess* also reveals his growing interest in what would later be termed "Synthetism," a concept he continually discussed during this period. Synthetism was the expression of a subject's essence through simplification and use of enduring forms, an approach that superceded Impressionism's overriding concerns with complex light effects.[4]

Gauguin found in the peasants of Pont-Aven a subject well suited to this endeavor. Their traditional clothing and ancient Celtic customs provided the sense of permanence he sought. [5] He viewed them as part of the Breton landscape— an extension of the natural world. In this painting, Gauguin suggested the female figure's rustic or primitive nature by echoing her silhouette with that of a cow.[6] His inclination toward simplification is evident in the nearly flat forms of the shepherdess's costume and sheep. Gauguin made numerous preparatory studies for these figures, which suggests that he executed the final work in his studio rather than *en plein air.*[7]

An inscription in Gauguin's sketchbook indicates that he sold *The Breton Shepherdess* in 1888 to fellow Pont-Aven painter Léon Fauché for 150 francs.[8] The following year he and Fauché participated in *L'Exposition de Peintures du Groupe Impressioniste et Synthétiste*. This exhibition of largely unknown painters was presented as an alternative to the official art exhibition of the Exposition Universelle, which included works by several artists from the disbanded Impressionist group. The *Impressioniste et Synthétiste* exhibition heralded Gauguin's official break with Seurat, Pissarro (his former mentor), and other leading neo-Impressionists of the day.[9] Further evidence of the importance of *The Breton Shepherdess* as a transitional work in Gauguin's oeuvre is its subsequent place in Gustave Fayet's collection. Fayet, a collector and museum curator who avidly supported the Post-Impressionist painters, owned several major canvases and ceramics by Gauguin, including a jardiniere bearing the image of a seated shepherdess much like the figure in the painting. In 1902 Fayet attempted to organize a retrospective of Gauguin's work, but it never came to fruition.[10] He was, however, the largest lender to the artist's 1906 Paris exhibition at the Salon d'Automne. Fayet sold *The Breton Shepherdess* anonymously at auction on 16 May 1908. It later resurfaced in 1945 when it was bequeathed by a Mrs. Fulford to the National Art Collections Fund, which in turn presented it to Laing Art Gallery at Newcastle upon Tyne.

Joni Haller

22.

The Breton Shepherdess, 1886

Oil on canvas
23¾ × 28⅞ inches (60.3 × 73.3 cm)
Laing Art Gallery,
Newcastle upon Tyne

23.

Seascape, 1886

Oil on canvas

28 × 36¼ inches (71.1 × 92.1 cm)

Göteborgs Konstmuseum

Paul Gauguin

In late June 1886, Gauguin left Paris for Pont-Aven in Brittany, where he remained well into the autumn. Pont-Aven was already a well-established artists' center, a place where Gauguin could immerse himself in the "primitive" character of the Breton countryside, surrounded by picturesque rocky coasts and the culture of the Breton peasants.[1] Gauguin stayed at the Pension Gloanec, an inn located just a few kilometers from the sea. It was there that he painted *Seascape,* a work that exemplifies his exploration of Impressionist motifs and pictorial techniques. While the influences of Cézanne and Renoir are apparent in *Still Life with Oranges* (cat. 19), *Seascape* reflects Gauguin's knowledge of Monet's coastal scenes, particularly his depictions of Fécamp (cat. 35) and Étretat on the north coast.[2] In such canvases Monet creates what Gauguin would later achieve in a less dramatic form in *Seascape*—a dialogue between the oppositions of swirling water, curving rock, and sky. By September 1886, Monet was painting the rocky cliffs of Belle-Île, an island approximately eight miles off the Quiberon peninsula (cat. 36). Meanwhile, Gauguin was working just to the west at Pont-Aven. While it is unclear whether Gauguin had specific knowledge of Monet's nearby activities, it does seem likely that Monet's penchant for traveling to remote locations would have encouraged Gauguin to explore regions outside of Paris.

The Impressionist-inspired canvases that Gauguin produced at Pont-Aven were of considerable interest to the other artists working there. Among them was the painter Henri Delavallée, who later recalled that Gauguin used sable brushes to achieve maximum tonal intensity in his works, and that the artist "painted with small strokes . . . he applied his colors as frankly as possible; but, most important, he striped."[3] Gauguin's technique of painterly "striping"—of presenting visibly animated, juxtaposed brushmarks—is evident in *Seascape.* In this work Gauguin establishes a traditional landscape composition with a central horizon line, anchored at the right by a rocky, wedge-like cliff to create a support for his dynamic range of brushwork. The diversity of Gauguin's mark-making is seen in the swirling brushstrokes of the foreground waves, the accretion of marks that constitute the rock formation, and the dense, "striped" zone of the sea. In this manner, Gauguin drew on the formal possibilities of Impressionist paint-handling to synthesize his own observations from nature and transpose them into pictorial form.

Seascape is one of three works by Gauguin now represented in the Gotëborgs Konstmuseum. Each painting in the museum's collection exemplifies a different phase in Gauguin's artistic development, with *Seascape* dating from the artist's Impressionist period. This painting was first exhibited in Göteborg in 1918, at the *Exhibition of French Art* organized by the Swenska-Fransk Konstgalleriet of Stockholm, which had received the painting from the Galerie Druet in Paris. The work was then purchased from the exhibition by the shipowner Werner Lundquist (1868–1943), a generous donor to the museum of works by Delacroix, Corot, Courbet, Pissarro, and Sisley. Lundquist gave this painting to the Göteborgs Konstmuseum in 1918, where it has remained for the past eighty years.[4]

Marcia Brennan

Eva Gonzalès

In nineteenth-century Paris, women who sought serious training as painters had limited options. Training in design and the decorative arts had been available to women since 1803, with the opening of the École Gratuite de Dessin pour les Jeunes Filles. Although these schools (there were eventually as many as twenty in Paris) were attended by many young middle-class women, the aim of these institutions was to provide lower-class women with a means to employ themselves. Concentrated instruction in the fine arts was not offered. However, women of means could obtain fine arts training in a privately run atelier.

As the daughter of a successful writer, Eva Gonzalès grew up among the intellectual elite of the day. In 1866, she entered Charles Chaplin's studio, an atelier so popular that he was able to hold classes attended exclusively by women. His studio was one of the few places where women were permitted to study from nude models. Chaplin was a well-established painter at the Salon, and worked in the highly finished style espoused by the École des Beaux-Arts. By 1869 Gonzalès had been introduced to Manet by Alfred Stevens, a fellow painter and family friend. Manet was reluctant to take on pupils and accepted only two during his career—Gonzalès and Berthe Morisot.

Gonzalès used her sister Jeanne as a model for *Morning Awakening*. A sleeping or awakening woman was a common subject in painting during this period. Gonzalès has presented her subject as self-absorbed and modest, whereas many contemporary male artists routinely produced images that were overtly erotic and confrontational. In this work we see the student employing the lessons she learned from both of her masters, Chaplin and Manet. Evidence of her academic training can be seen in the bedside table and in the smooth modeling of Jeanne's face. Manet's influence is evident in the painterly rendering of the bedclothes that envelop the model in shades of white. Gonzalès worked the surface just enough to create an impression of the materials she portrayed, allowing the canvas to show through in places. Manet's influence also appears in the painting's somber palette, which is broken only by the freshness of Jeanne's face and the purple burst of violets by the bed.

Upon Gonzalès's death, only a few days after the birth of her son Jean-Raymond, the works in her studio remained with her husband Henri Guérard, a respected printmaker. Jean-Raymond inherited most of his mother's work, including this painting. It remained in French private collections until the Kunsthalle Bremen purchased it in 1960.

Phaedra Siebert

24.

Morning Awakening, 1877–78

Oil on canvas

32 × 39⅜ inches (81.3 × 100 cm)

Kunsthalle Bremen

25.

Snow at Ivry, 1873

Oil on canvas
20½ × 28¾ inches (52.1 × 73 cm)
Petit Palais, Musée d'Art Moderne, Geneva

Jean-Baptiste Armand Guillaumin

Guillaumin, a founding member of the Impressionist group, painted *Snow at Ivry* when he was only thirty-two years old, struggling to earn his living working for the streets department of the city of Paris. In 1872, the year before this work was painted, Pissarro noted that his friend Guillaumin "works at painting in the daytime and at his ditch-digging in the evening, what courage!"[1] Since his job made only limited travel possible, Guillaumin focused his attention on the city and suburbs of Paris. His views of the riverbanks of Paris, with their boats, barges, and laborers, are among the artist's best-known subjects.

Of the three paintings Guillaumin submitted to the first Impressionist exhibition of 1874, one was a scene entitled *Sunset at Ivry*.[2] Ivry is an industrial suburb located just over a mile outside Paris on the left bank of the Seine. Guillaumin painted at least three related views of the forge at Ivry during the winter of 1873, including *Snow at Ivry*.[3] Scholars have posited a link between such Impressionist depictions of industrial and commercial subject matter and the period of rebuilding that France was experiencing following the Franco-Prussian War.[4] Pissarro himself painted a number of factory scenes of Pontoise during 1873. In addition to its typically Impressionist subject matter, *Snow at Ivry* features a traditional landscape composition in which design is subordinated to the sense of perspective established by the low, virtually unbroken horizon line. Yet despite its more conventional features, *Snow at Ivry* is notable for its chromatic subtlety. In this work Guillaumin presents an expressive range of salmon tones in the sky and the reflected snow. These colors seem to be intensified by their adjacency to the complementary shades of blue and gray in the water and the clouds. In this manner, the snow scene at Ivry facilitates a study in tonal delicacy and intensity not unlike Monet's more famous and dramatically abstracted "Impression" of the sunrise, the work that earned the Impressionists their name.

The early provenance of this painting is unknown. In 1971 Georges Serret and Dominique Fabiani listed the work as belonging to the Aquavella Collection in New York.[5] The Petit Palais in Geneva acquired the painting from Christie's, London, and by 1992 the museum had displayed it as part of a monographic exhibition on Guillaumin.[6] The Petit Palais owns many fine examples of the artist's work, canvases spanning nearly three decades and representing Guillaumin's development in both his Impressionist and Post-Impressionist phases.

Marcia Brennan

Jean-Baptiste Armand Guillaumin

Although Impressionism is often associated with scenes of leisure, Guillaumin concentrated almost exclusively on the working life of the river Seine at the eastern edge of Paris. He was attracted to industrial motifs, barges loading and unloading their cargo (particularly wine, which was warehoused at Bercy), and sand hoppers dredging the river, such as the one at the center of *Quai de Bercy,* a procedure that forms the subject of a number of Guillaumin's paintings and pastels. He interprets the scene in terms of color: the sand's vibrant note of yellow, with complementary purple shadows, contrasts sharply with the dark green clumps of summer trees and the green accents in the sky.

Guillaumin exhibited with the Impressionists from the outset (although *Quai de Bercy* appears not to have been shown in 1886), and his various friendships and allegiances give a fascinating insight into the group's development.[1] Early on, he was closest to Cézanne and Pissarro, whom he had first met in the 1860s, sharing with them the harshest rebuffs of the critics and the slow and painful road to success. Although critics complained about Guillaumin's clumsy paint-handling and crude color sense, it was these very "faults" that endeared him to later adherents to the group, notably Gauguin (who bought a number of his paintings around 1880) and Paul Signac, whose early work from 1883 to 1885 is similar to Guillaumin's.[2] The van Gogh brothers also admired his work—Theo handled a few Guillaumins in the late 1880s but had certain reservations: "He does not strive much for new effects in his coloration. He contents himself with what he has found, and one always finds the same pink, orange and blue-violet spots, but his stroke is vigorous and his view of nature is certainly broad."[3] Vincent stressed the positive side of this assessment and hugely admired Guillaumin's refusal to compromise and his ability to work steadily, despite the considerable financial hardships he had to face.

Quai de Bercy was bought by Paris collector Maurice Leclanché, probably in the late 1880s or 1890s, when he was buying Monets and Sisleys. He had been an acquaintance and colleague of Gauguin's in the 1870s when they both worked for the stockbrokers Bertin, which may explain the adventurous nature of his picture buying. In 1895, when living at 114, boulevard Malesherbes, Leclanché was listed alongside Degas as one of the rare buyers at Gauguin's disastrous auction sale, where he acquired one of the artist's most important figure pieces, *Aha oe Feii? (What! Are You Jealous?)* (1892, Pushkin Museum of Fine Arts, Moscow), though for only 500 francs, a deflation from the 800 francs that was the minimum price Gauguin wanted when he sent it off from Tahiti.[4] Leclanché sold this to the Russian magnate Sergei Shchukin in 1908. Leclanché and his wife built up a notable and representative Impressionist collection which, after his widow's death, was dispersed at auction on 6 November 1924 at the Hôtel Drouot.[5] There *Quai de Bercy* was bought, possibly in person, by Wilhelm Hansen of Copenhagen. Hansen's buying of French art for his collection at Ordrupgaard (see cat. 63) had been briefly halted in 1922 when the banking firm in his business consortium was declared bankrupt. But by 1924, having sold a major part of the collection to the Ny Carlsberg Glyptotek to clear his debts, Hansen had resumed his discriminating collecting with renewed energy.[6] This is one of nine Guillaumins in the Ordrupgaard collection.

Belinda Thomson

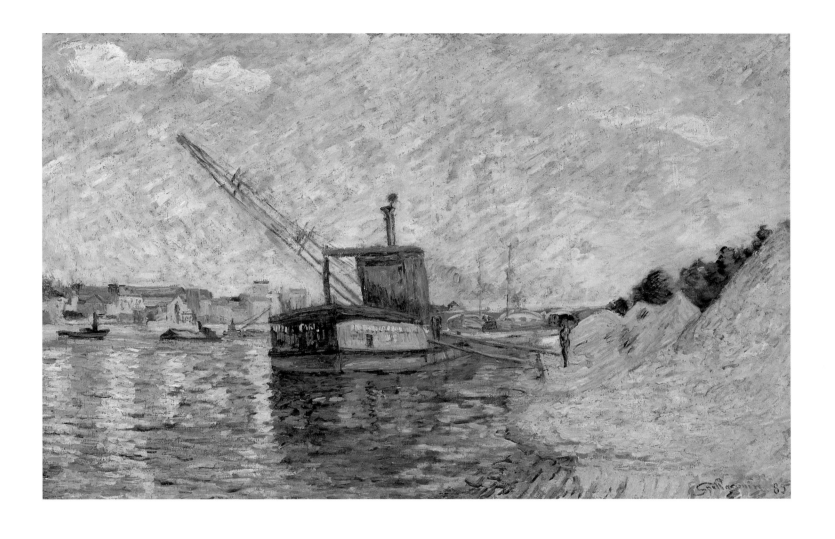

26.

Quai de Bercy, 1885

Oil on canvas
23⅝ × 36¼ inches (60 × 92.1 cm)
Ordrupgaard, Copenhagen

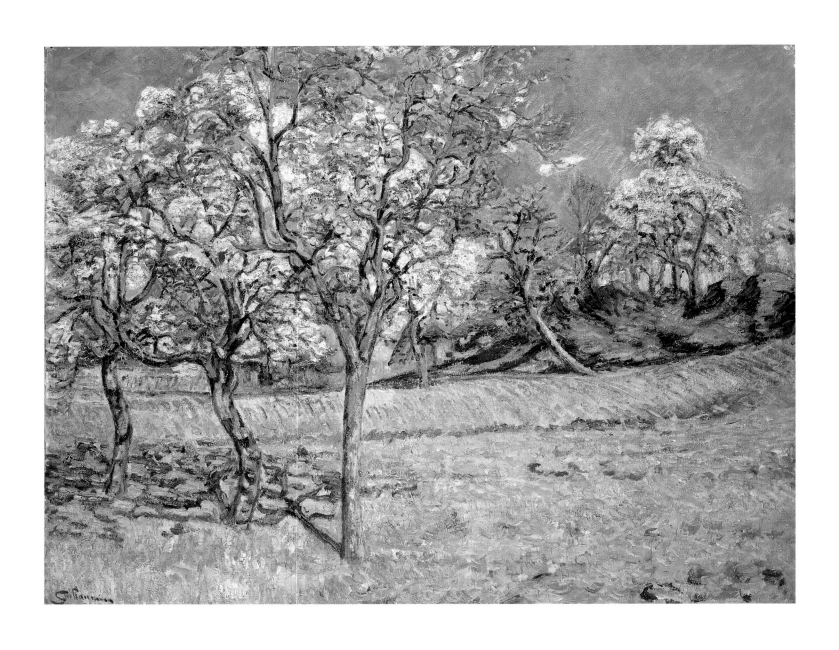

27.

Apple Trees at Damiette, 1893

Oil on canvas

29 × 36⅝ inches (73.7 × 93 cm)

Aberdeen Art Gallery and Museums

Jean-Baptiste Armand Guillaumin

Guillaumin visited Damiette, a small hamlet to the west of Paris, almost every year between 1882 and 1891. Of the twenty-one paintings that he exhibited in the eighth Impressionist exhibition of 1886, at least eight were views of Damiette. *Apple Trees at Damiette* was painted two years after Guillaumin had won a substantial sum of money in the national lottery and was able to take up painting full time. His winnings allowed him to travel to paint, and he began to journey further afield, particularly to the ocean at Saint-Palais-sur-Mer and to the Mediterranean at Agay. The birth of his third child, Marguerite, may have meant that he preferred to stay close to Paris during the spring of 1893.

The landscapes of Guillaumin were among the most provocative of Impressionist paintings. His exotic colors led some critics—either genuinely or jokingly—to assume that he was depicting the Moroccan town of Damietta rather than northern France.[1] In spite of the jibes, Damiette remained a favorite subject, and Guillaumin's treatment became more exaggerated and his colors more fiery as the years progressed.

The bright colors, energetic brushstrokes, and rhythmic flow of the trees and grass all recall the work of van Gogh, who from 1887 until his death in 1890 was a close friend of Guillaumin. This strong sense of movement carries across the entire composition from upper right to lower left, and it is accentuated by the distorted trunks of the apple trees, which curve in a similar direction. The shadows created by the largest tree, painted in acid green and vivid lilac, form an intricate, lacy design across the ground, increasing the overall effect of a layered pattern. The asymmetrical composition suggests the influence of Japanese art, which affected many European artists at this time. Guillaumin is known to have admired Japanese art—indeed, the hall of his Parisian home was decorated with Japanese wall hangings. Guillaumin's work was admired in Japan, and in the 1880s, Tadama Hayashi imported no fewer than fifty of his paintings.[2]

The provenance of this work for the first sixty years of its existence is not known. It was exhibited at the Galerie Rousso, rue de Seine, Paris, in 1950, where it was acquired by the Redfern Gallery, London. One year later the curator of the Aberdeen Art Gallery, Charles Carter, chose to buy it instead of *The Tugboat at Samois,* 1901, by Paul Signac, which, at 750 pounds, was more than twice as expensive as the Guillaumin. In 1951 the chairmanship of the Aberdeen Art Gallery had passed from the banker Sir Thomas Jaffrey to a local councilor, Baillie James A. Mackie. As a result, the curator was given far more autonomy in his selection of works of art, and soon Carter's incisive taste made itself felt in terms of acquisitions. This daring work by Guillaumin, which with its sinuous line and exaggerated color might seem more Post-Impressionist than Impressionist, was typical of Carter's adventurous spirit, and complemented both earlier Impressionist paintings and the collection of early twentieth-century British paintings that he was adding to the collection at the same time.

Jennifer Melville

Édouard Manet

Henri Rochefort was known in France in the 1870s for his written protests against Napoleon III. He was an active member of the Commune, a group formed in opposition to the provisional national assembly elected after Napoleon III abdicated the throne. When the provisional assembly's troops finally overpowered the Communards in 1873, Rochefort was one of about 7,500 deported to a prison colony in New Caledonia, east of Australia. He was not imprisoned for long, however, and in 1874 he escaped to the United States on an Australian ship. From there he returned to Europe but was unable to enter France until 1879, when amnesty for the Communards was proclaimed. Upon Rochefort's return to Paris, Manet met him through Marcellin Desboutin, a fellow artist and a relative of Rochefort.

For the Salon of 1881, Manet set out to create a seascape depicting Rochefort's romanticized escape from captivity. The idea of creating a sensation at the Salon by depicting an event from recent history was not new. Gericault set the precedent in 1819 with *The Raft of the Medusa,* when he made painstaking efforts to recreate a pivotal scene from a recent tragedy and political scandal. Manet himself had done the same in 1864 with *The Battle of the Alabama and the Kearsarge,* his recreation of a Civil War battle off the coast of France—just a year after his *Déjeuner sur l'herbe* had caused an uproar in the Salon of 1863.

Although Rochefort's return to Paris did revive interest in his escape six years before, it did not provoke the sensation Manet was hoping for. Rochefort's account of his escape differed from the accounts of others who accompanied him, and Manet worried that the discrepancies of the account, rather than the event itself, would attract the greater notice. Rather than risk a misfire, Manet chose to submit this portrait of Rochefort instead. Except for the treatment of the face and the sketched-in left fingers of the sitter, the painting is tame and traditional. The subject did bring Manet a certain degree of notoriety; a member of the jury wrote to Manet airing his misgivings about the artist's choice of subject.[1] The portrait, with Rochefort's wild shock of hair and impatient eyes, was an easy target for caricaturists. Manet received a second-class medal for the work.

Manet sold this work along with four others to Jean-Baptiste Faure the year after it was painted. When Faure was seven years old, his father died and he became his family's sole supporter, first as a choirboy and then in the chorus at the Italian Opéra. Eventually, he became a famous baritone at the Paris Opéra. Faure was one of the first collectors to prove that speculation on young artistic talent could be profitable. When he sold his first collection in 1873—mostly Barbizon paintings—the sale brought in nearly half a million francs. Paul Durand-Ruel was the expert appraiser at that auction. Faure also acquired his first works by Manet in 1873, and became one of the most important collectors of his work. In 1907 Durand-Ruel bought the work, and that same year used Paul Cassirer, Durand-Ruel's representative in Berlin, to sell it to the Hamburger Kunsthalle.

Phaedra Siebert

28.

Portrait of Henri Rochefort, 1881

Oil on canvas

32½ × 26¼ inches (81.6 × 66.7 cm)

Hamburger Kunsthalle

Édouard Manet

Manet's *Country House in Rueil,* painted in the summer of 1882, is a happy picture as well as a sad one. An unseen treetop casts a large shadow over the sun-drenched front of the house, just as the destiny of the fatally ill painter also overshadows this painting. Manet was to die a few months later on 30 April 1883. In July 1882, the painter went to convalesce at Rueil, a town just outside Paris, and spent three months in the house of André Labiche. Unable to move beyond his immediate surroundings, Manet painted still lifes and views of the house.[1] In this painting, the long house dominates the background, leaving no room for the sky. On the narrow stage in the front left-hand corner is a bed of large-leafed plants with red flowers that leads us down a path toward the middle of the picture, where the viewer finds a tree hiding the porticoed front door of the house. Past the open window one's eye finally comes to rest on the white park bench in front of the house. What looks like a typical Impressionist scene with a shimmering atmosphere of light, air, and color is in reality a highly artificial painting by Manet the intellectual. In it he balances garden and house, nature and civilization. The upright tree trunk and the ledge that runs like a belt around the house are both straight lines that do not quite meet in the middle of the picture. Dark is contrasted with light, the red flowers with the green of the plant leaves, the ochre of the house's facade with the bluish window ledges. The main actor is the tree; only part of it is there, but it also conceals the heart of the picture. Manet borrowed the idea of such a tree from Japanese art, perhaps from one of the *Thirty-Six Views of Fuji* (1823–32) by Katsushika Hokusai. Trees placed so centrally in pictures, writes Angelika Wesenberg, became "a short while later the main motif of Japanesery in West European painting. We come across it, for example, in Monet, van Gogh and Hodler."[2]

In May 1903, Hugo von Tschudi chose a similar picture by Manet, *A Corner in the Garden at Bellevue,* 1880 (today in the Bührle Collection, Zurich), for the Berlin Nationalgalerie. But in 1904, Eduard Arnhold, who had advanced 30,000 marks for the purchase of the picture, demanded it for his own collection by paying the remaining sum of 5,900 marks.[3] As a result, Tschudi bought *Country House in Rueil* for 50,000 marks through Paul Cassirer from Durand-Ruel in May 1905. His application to accept the painting for the Nationalgalerie was approved in December 1906. The money for it was donated by the Berlin banker Karl Hagen, who also gave the Nationalgalerie the money to buy a painting by Renoir, *Children's Afternoon at Wargemont* (1884), and, with the banker Karl Steinbart, also paid for two pictures by Monet, *Saint-Germain l'Auxerrois, Paris* (1867) and *Meadow at Bezons* (1874). Unlike Arnhold, Hagen was an unknown art collector, and his gifts to the Nationalgalerie in 1906 and 1907 were probably connected to his conversion to Christianity around 1905. On his baptism, the banker, who had been called Levy, adopted the name Hagen, as his brother Louis (actually Ludwig), an influential banker in Cologne, had done before him.[4]

Stefan Pucks

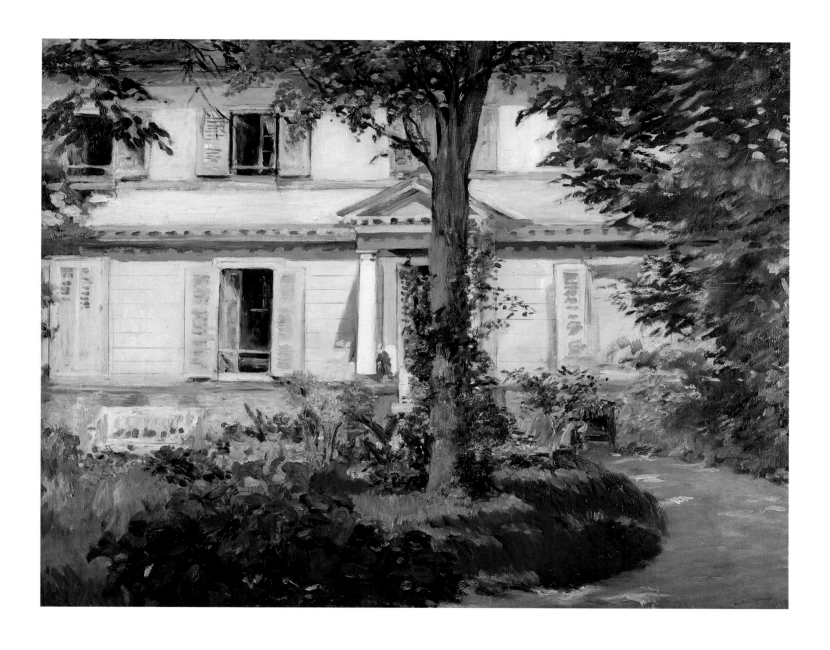

29.

Country House in Rueil, 1882

Oil on canvas
28¼ × 36¼ inches (71.8 × 92.1 cm)
Staatliche Museen zu Berlin, Nationalgalerie

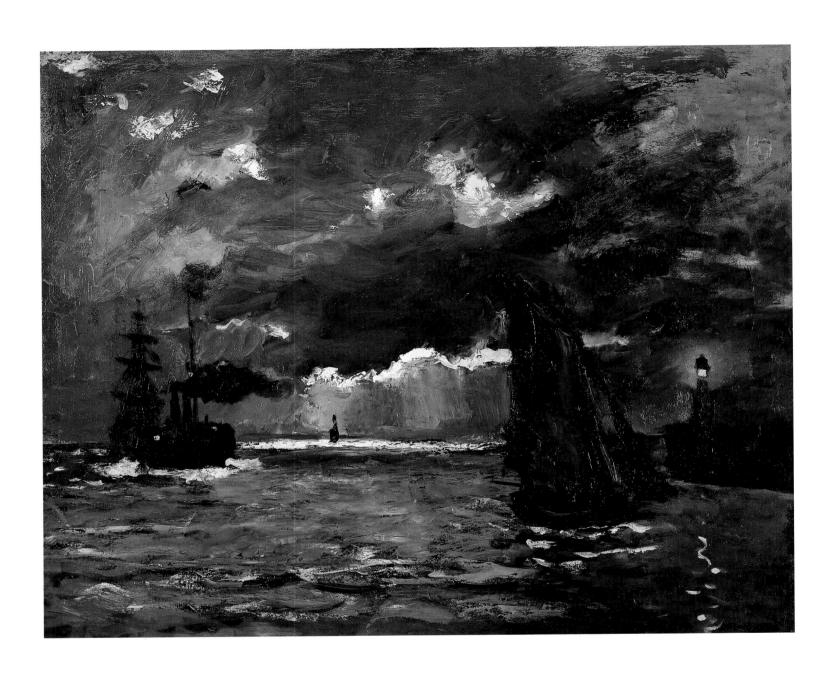

30.

A Seascape, Shipping by Moonlight, ca. 1866

Oil on canvas

23⅝ × 29 inches (60 × 73.7 cm)

National Gallery of Scotland, Edinburgh

Claude Monet

Though born in Paris, Monet was brought up in Le Havre and knew the Normandy coast well. He returned there throughout his life to paint its harbors and cliffs. In spite of the inscription on the stretcher, *Marine tempet/Port du Havre effet de nuit,* Wildenstein states that the view is from Honfleur, in which case Monet must have been looking east across the Seine estuary toward Le Havre.[1] Monet painted the same scene—though looking west—one year earlier (The Norton Simon Foundation, Pasadena, California), and painted the boats alone, helpless in dangerous waves, in *Marine—The Green Wave* in 1865 (The Metropolitan Museum of Art, New York), works that were acclaimed by contemporary critics and earned him a reputation as a marine painter.[2]

Monet rarely painted night scenes, but his treatment here is masterful and apparently spontaneous. The moon is not visible, but its garish light seeps dramatically through dense black clouds, illuminating their lower edges and hitting the turbulent sea below. The boat in the foreground is leaving port. Perched precariously at the bow end on the edge of the hull, a small boy seems oblivious to the danger ahead. He looks back at the viewer and laughs in excitement. In complete contrast, an older figure, sheltering from the elements under a large sou'wester, controls the vessel and seems more conscious of their potential predicament.

The dramatic scene is picked out by Monet with thick impasto. Bold white highlights define the shafts of intense moonlight and the light cast from the lighthouse. Dabs of vivid green on the steamboat to the left and in the foreground give eerie color and depth to the nocturnal scene.

Acquired in 1980 by the National Gallery of Scotland from Christie's, London, *A Seascape, Shipping by Moonlight* had been one of the first Impressionist paintings to come to Scotland. Originally it was thought to have been bought in Paris in the 1890s by a Paisley shipowner, William Robertson—a belief maintained by Robertson's family and repeated by Wildenstein.[3] However, research after its acquisition by the National Gallery established that it had once belonged to a Lanarkshire ironmaster, D. McCorkindale, whose sale in Glasgow in 1903 included this work. Since Robertson owned the painting after 1903, it is now thought that he must have acquired the work at the McCorkindale sale or shortly thereafter. That two Scots wished to own this painting at such an early date, when only two other paintings by Monet were in Scotland, can be explained partly by the subject matter, which had been a favorite one with Scottish artists such as William Quiller Orchardson and William McTaggart for many years. The painting's close affinities with the work of both Dutch and earlier French artists may also have been in mind. The work of the Hague School and Dutch seventeenth-century painters of marine subjects, such as Aert van der Neer, a specialist in nocturnal scenes, were in many collections throughout Scotland at this date. Monet's somber palette, broad handling, and vigorous naturalism clearly show his debt to Courbet and his Dutch friend J. B. Jongkind, who was painting such scenes throughout the 1850s.

Jennifer Melville

Claude Monet

Monet's wish to become a painter was supported financially by his aunt, enabling him to study at the Académie Suisse in Paris and at Charles Gleyre's atelier, where he met a number of his future Impressionist colleagues. Monet received valuable advice from his fellow Normandy painter Boudin, who specialized in beach and harbor scenes around Le Havre and often worked in the open air. In his still life and figure work of the later 1860s, Monet followed the lead of Manet. For the rendering of landscape, however, Monet admired the limpid tonalities of Corot as well as the more robust realism of Courbet, but he quickly established his own vigorous personal manner using bold, abbreviated touches—the style that came to be known as Impressionism.

In 1867, Monet's model and mistress Camille Doncieux gave birth to a son, an event that caused a rift with his father. Monet and Doncieux married in 1870 and, since he had a family to support, landscape subjects became Monet's bread and butter. After working in a number of landscape settings—the forest of Fontainebleau, Le Havre, London during the Franco-Prussian War, and Holland immediately afterward—in 1871 Monet settled in Argenteuil, a small town on the Seine to the west of Paris.

Argenteuil proved the ideal site for Monet, offering him a wealth of motifs. It allowed him to combine his interest in water, boats, and bridges on the one hand and in the fashionable population inseparable from modern leisure on the other. In *The Port at Argenteuil* he depicts the widest stretch of the river, the popular yacht basin much patronized by Parisians. Although the calm and balanced composition recalls an earlier view of the same subject by Boudin, *The Seine at Argenteuil*, 1869 (Paul Mellon Collection, Upperville, Virginia), Monet presents a more animated scene that has been carried to a relatively high degree of finish.[1] His viewpoint incorporates leisurely figures strolling along the promenade under the lengthening shade of trees. A number of houseboats, functioning as bathing places, are moored alongside. Beyond these are the sails of two small yachts, making the most of the lively breeze indicated by the scudding clouds and the drifting smoke of the steamboat. Closing off the horizon are the arches of Argenteuil's road bridge, which had been recently rebuilt after its destruction during the Franco-Prussian War.

The first owner of this highly accomplished, luminous painting was the chic portraitist Ernest-Ange Duez (1843–1896). Living at a smart address in the avenue de la Grande Armée, Duez, with Léon Lhermitte and Alfred Roll, was one of a group of artists, slightly younger than Monet and the Impressionists, who enjoyed the support of the dealer Durand-Ruel. It is not known exactly when Duez bought the painting, but he was clearly buying in the 1870s. In 1879 he was one of the private collectors who lent a Monet to the fourth Impressionist exhibition—in that instance, another early boating subject, *Entrance to the Port of Trouville*, 1870 (Szépművészeti Múzeum, Budapest). *The Port at Argenteuil* was subsequently acquired, presumably at Duez's death in 1896, by Edmond Decap, a notable collector of Impressionist painting from Rouen. At Decap's sale in April 1901, the painting went for the sum of 16,500 francs to the wealthy banker Count Isaac de Camondo (1851–1911).[2] By this date, such a sum for a Monet of this quality was about standard, reflecting the steady rise in Monet's prices during the 1890s.[3]

Belinda Thomson

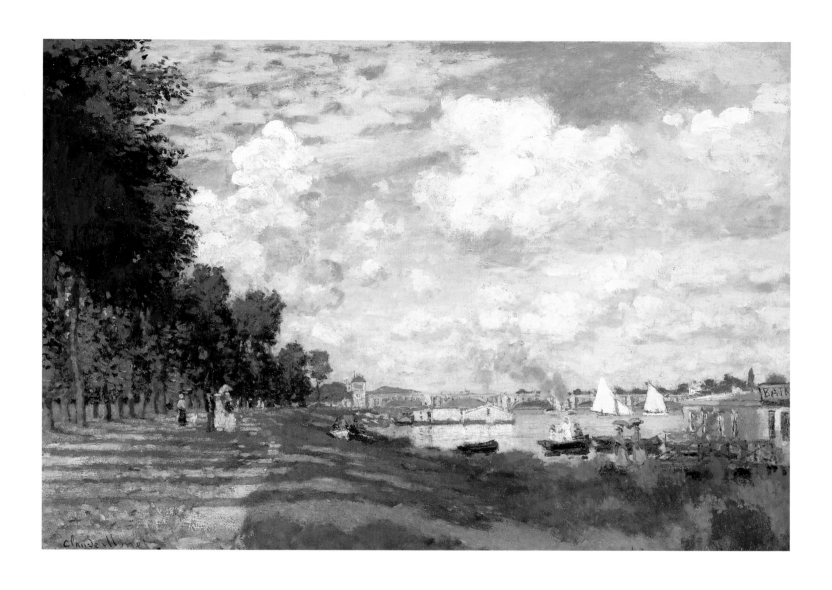

31.

The Port at Argenteuil, ca. 1872

Oil on canvas
23⅝ × 31¾ inches (60 × 80.6 cm)
Musée d'Orsay, Paris;
bequest of Count Isaac de Camondo, 1911

Claude Monet

In January 1874, Monet left his colleagues in Paris to sort out the final administrative details of their first group exhibition—due to open in the spring—and made a painting excursion to his hometown of Le Havre. It was here that Monet's father had elected to establish himself in the chandlery business, and Monet had grown up in an atmosphere where shipping and sea trade were an economic reality. Le Havre itself had prospered as a result of its increasing importance as a port: by the second half of the nineteenth century, it handled a quarter of France's entire foreign trade.[1]

During his visit, Monet stayed at the Hôtel de l'Amirauté, on the Grand Quai overlooking the outer harbor. Three of the paintings from the trip represent, roughly speaking, the view he would have had from his hotel. *Le Bassin du Commerce, Le Havre,* however, depicts the innermost, and probably most protected of the complex system of harbors at Le Havre, surrounded by buildings on all sides. The choice of composition and motif, looking toward the town center, recalls some of his views of London and looks forward to paintings done a few weeks later in Amsterdam. Beyond the bulk and rigging of the commercial shipping at the quayside, we see the dome of the municipal theater. The painting's small, almost square dimensions and cool, blue-grey tonality make it a calm, contained work, very different from his larger, bustling, rain-soaked view of *Fishing Boats Leaving the Port of Le Havre,* 1874 (Los Angeles County Museum of Art). Monet sent the latter in April to the first Impressionist exhibition, together with his more misty view of the same harbor painted the previous year, to which he gave the famous title *Impression, Sunrise. Le Bassin du Commerce* was not shown.

Interestingly, on 24 March 1875, Monet placed *Le Bassin du Commerce* in an auction sale at the Hôtel Drouot. This was a one-time attempt by several Impressionist artists—Monet, Morisot, Renoir, and Sisley—to reach a broader public without going through the immense effort of organizing another exhibition.[2] It was a severe blow when the prices reached only half the levels attained at the Hoschedé sale the previous year. *Le Bassin du Commerce* was sold for 200 francs to Rouart. He acquired another Monet, two Morisots, and a Renoir for equally low prices. Henri Rouart (1833–1912), a close friend of Degas, ran a successful engineering and refrigeration company, Mignon et Rouart. He painted in his spare time and participated in most of the Impressionist exhibitions. At his somewhat austere home, 34, rue de Lisbonne, Rouart built up a sizable collection in which he hung Impressionist paintings and works by earlier masters, notably Corot, in the company of Greek and Egyptian sculptures and other curiosities. Although the collection was not dispersed until after his death, he decided to part with this Monet at an earlier date. Its next owner, Eugène Dumont (1845–1906), a well-to-do Liégeois living in Paris, donated it to his native city in 1900. Along with the Monet, which was the first Impressionist painting to enter the Liège collection, Dumont's donation of thirty-nine pictures comprised works by Corot, Desboutin, and Raffaëlli, as well as lesser-known artists such as Bergeret, Gabriel, Achenbach, and Ranvier.[3]

Belinda Thomson

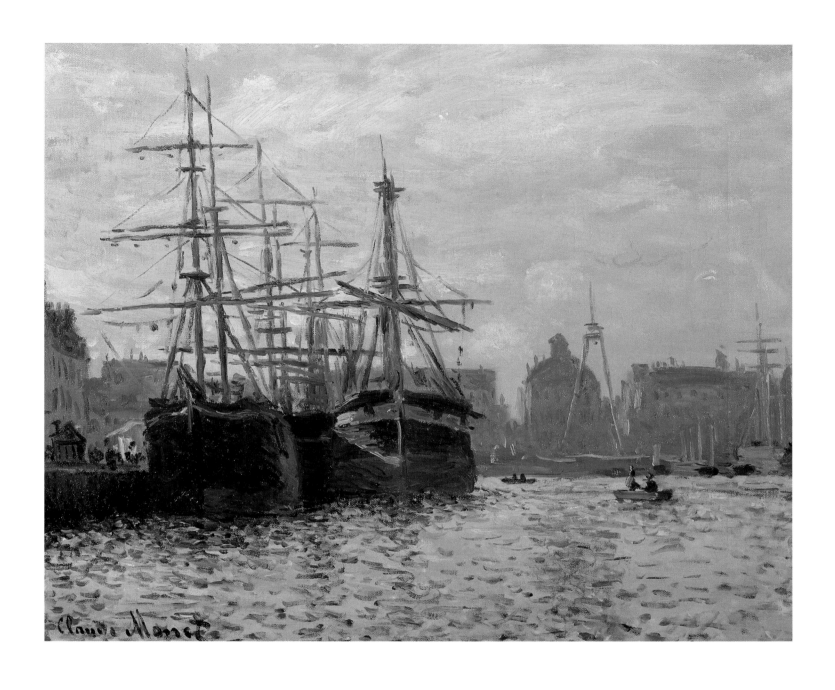

32.

Le Bassin du Commerce, Le Havre, 1874

Oil on canvas
14½ × 17¾ inches (36.8 × 45.1 cm)
Musée d'Art moderne et d'Art contemporain, Liège

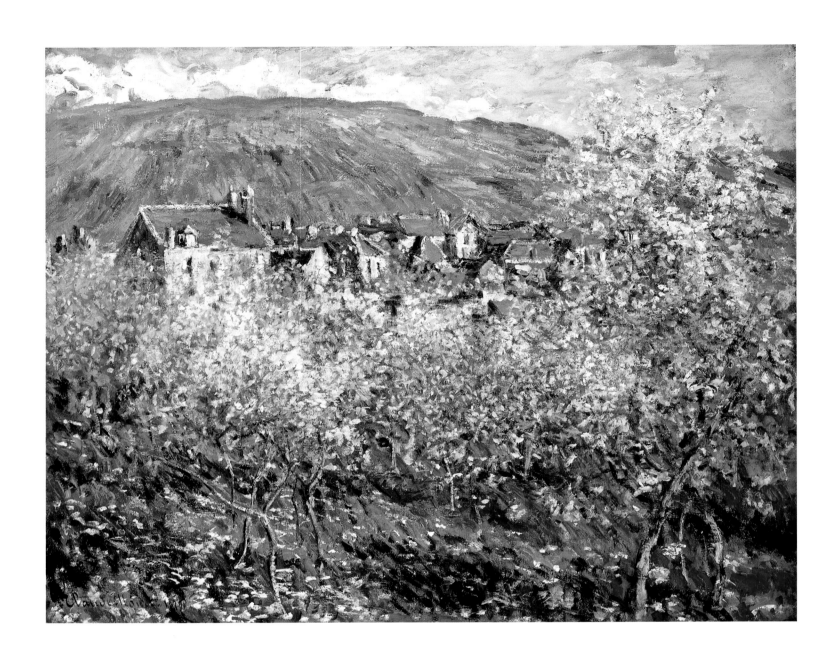

33.

Plum Trees in Blossom, 1879

Oil on canvas
25⅜ × 31⅞ inches (64.5 × 81 cm)
Szépművészeti Múzeum, Budapest

Claude Monet

Monet moved from Argenteuil to Vétheuil in the summer of 1878. His stay of three and a half years was a tragic period for the artist. His wife's constant ill health took all their money for medicine and doctors until her death in September 1879. Monet overcame a deep professional crisis and personal difficulties, and his stay in Vétheuil became a key period in his artistic development: it consummated the experiments he had begun in Argenteuil to make atmospheric light phenomena perceptible.

Before moving to Vétheuil, Monet had already earned a reputation as a painter of city life. In this small town on the Seine, he was drawn to the quiet rural landscape, with its subtle shades of light and color. He painted several views of the orchards and the town seen from the river. Monet painted *Plum Trees in Blossom* near his house in the spring of 1879. Through the foliage, some of Vétheuil can be seen, with Mount Chenay in the background. Compared to his earlier paintings, the presence of man has been reduced to a minimum, and the anecdotal details are missing. Nothing of his personal trials can be sensed in the paintings; the serenity of his Vétheuil pictures is in striking contrast to his unhappy family circumstances. Everything trembles in the pictures, coming to life from dots of paint. It is an excellent example of optic color blending, of decomposing natural colors into their constituents, which are united again in the viewer's eye into an atmospheric image of space.

The details of the picture reveal Monet's profound deliberation, belying the Impressionists' legendary spontaneity. The final composition followed many preliminary studies. In those years, Monet began painting groups of pictures of the same site that recorded shifts in color and mood at different times of day. He also experimented with changing the format, size, and viewpoint. There are variants of the Budapest picture painted from the same vantage point. One similar composition, slightly larger, features two blurred female figures in the clearing among the trees in the foreground. In another study, the trees on the left appear independently.[1]

The Budapest picture was possibly first shown to the public in Monet's first solo show in the gallery of the periodical *La Vie moderne* in 1880.[2] The exhibition included eighteen pictures, most of them landscapes made in Vétheuil, and marked a turning point in Monet's life and career, with renewed interest of critics and collectors.[3]

The first owner of *Plum Trees in Blossom* was the margarine manufacturer Auguste Pellerin of Paris, who built up an outstanding collection of Impressionist paintings, especially Cézanne. In 1898, the picture came into the possession of Galerie Bernheim-Jeune, one of the period's most significant modern art dealers. Franz Goerg, a collector from Reims, bought it in 1899 and auctioned it off in 1910, when Paul Durand-Ruel, the principal art dealer and patron of the Impressionists, bought it.[4] Monet had met Durand-Ruel in London, and later the noted dealer regularly purchased and exhibited his works. In 1898, Monet had established regular business contacts with the German art dealer Paul Cassirer, who undertook to exhibit his works annually. In 1912, the picture went to Cassirer, whose gallery in Vienna was a central promoter of modern art. The Szépművészeti Múseum in Budapest purchased the picture in 1912, after a period of stagnation in their acquisitions following the opening of the museum building in 1906.

Ferenc Tóth

Claude Monet

Monet frequently painted wintry scenes, enjoying the coloristic challenge they presented. *Hoarfrost, near Vétheuil* dates from the winter of 1879–80, when France underwent a record spell of severe cold and the river Seine at Vétheuil froze over completely. In this virtually featureless white and pale blue scene, relieved by a few touches of ochre to indicate vegetation, the rowboat, marooned in a field of ice, is the only dark accent. It is this detail that allows us to orient ourselves to the idea that the distant row of trees marks the far bank of the frozen river. Monet tackled the same view in three separate paintings. During the thaw that followed, Monet made the most of the extraordinary motif offered by the floating ice floes.

Only three months before, in September 1879, Monet's wife Camille had died of cancer. His decision to submerge himself in work was a natural reaction to his loss. Nature's transformation into frozen beauty may even have seemed an apt reflection of his mood. Moreover, the desperation of his circumstances seems to have sharpened his desire to make his name at this time. In the spring of 1880, Monet followed Renoir's lead and, instead of exhibiting with the Impressionists, submitted two works to the Salon, his first such compromise since the Impressionist group had formed. This action angered Degas and Pissarro, who wanted the group to adhere to strict independent principles. Monet's justification was his anxiety over his family situation, which was complicated but not without solace: Alice Hoschedé would take over much of the burden of bringing up his children, and they would eventually marry in 1892. Moreover, he had loyal supporters such as Caillebotte and de Bellio.

Monet included *Hoarfrost* in his first one-man exhibition, held in June 1880 at the offices of *La Vie moderne,* conveniently located on the boulevard des Italiens. The publisher of this new journal, Georges Charpentier, had recently become an avid patron of both Renoir and Monet. For publicity purposes, he persuaded Monet to give an interview to Émile Taboureux. The article portrayed Monet as the painter without a studio, the archetypal *plein-airist.*[1]

Hoarfrost was acquired at or soon after this exhibition by Gustave Caillebotte, a fellow painter and a man of inherited wealth. Caillebotte had joined the Impressionists at their second exhibition in 1876, with a powerful group of paintings whose novelty of subject, composition, and viewpoint attracted considerable attention. As a collector he did much to help the Impressionists—Monet in particular had reason to be grateful for his generous financial advances at this difficult phase of his life—but he bought their work with an acute eye for quality, never out of sentimentality. In 1876, while still laying the foundations of his important and representative collection, Caillebotte drew up a will leaving his pictures to the State, with the proviso that it would require a certain time, possibly twenty years or more, to take effect, "until the public may, I do not say understand, but admit this painting."[2] Of the sixteen Monets offered to the French State from Caillebotte's estate following his death in 1894, *Hoarfrost* was one of the eight selected by the Musée du Luxembourg's curator, Léonce Bénédite. The collection went on display on 9 February 1897.

Belinda Thomson

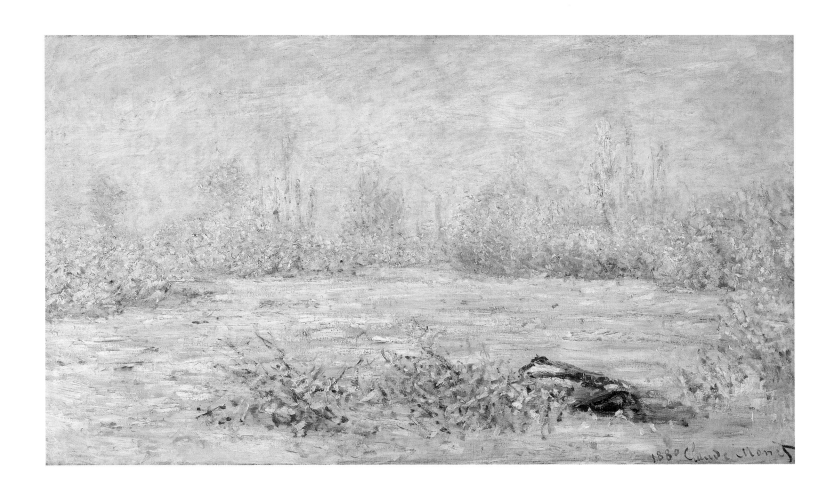

34.

Hoarfrost, near Vétheuil, 1880

Oil on canvas
24 × 39⅜ inches (61 × 100 cm)
Musée d'Orsay, Paris;
bequest of Gustave Caillebotte, 1894

Claude Monet

Splendidly vibrant after recent cleaning, this is an early example of Monet's sequence of cliff paintings of Grainval, just to the south of Fécamp on the Normandy coast. From 9 March to 10 April 1881, Monet had been studying the different effects the spring weather gave to the chalk cliffs between Le Havre and Dieppe and delighting in their anthropomorphic shapes.[1] Here he has chosen a viewpoint where the far cliff, to the east of Fécamp, juts out from behind the principal shapes. In other works of the series, a human presence is suggested by boats, buildings, or paths, but here no trace of human life is allowed to reduce the immensity and monumentality of the cliffs. By taking a different viewpoint from some of his other paintings (moving slightly to the right), Monet abandons all such indications. The cliffs in the foreground now block much of Cap Fagnet and obscure completely the church of Notre-Dame du Salut, which flanks the harbor of Fécamp. In so doing, Monet increases the viewer's sense of vertigo when viewing the painting.

The composition is severely simple, the canvas divided to the left by the horizon and to the right by three consecutive cliffs, which together form a strong diagonal. This asymmetrical composition is redolent of Monet's interest in Japanese prints, which had transformed his art and his depiction of the French landscape. Monet's distinctive and apparently rapid treatment of sea and sky, with choppy waves and scudding clouds, gives a very real sense of the breezy spring day. Vibrant blue, green, and yellow give joyous color to this magnificent scene, and in this daring modernity it is possible to see how far Monet has come since his traditional interpretations of the Normandy coast of fifteen years earlier.

In June 1881, Paul Durand-Ruel bought from Monet twenty-two canvases that were the product of Monet's recent trip to the coast of Normandy.[2] It seems likely that one of those paintings was *The Cliff at Fécamp*. It subsequently came into the possession of Sir James Murray, an Aberdeen livestock dealer, who was also chairman of the Aberdeen Art Gallery. Murray had a rich and varied collection of late nineteenth- and early twentieth-century French, Dutch, and British painting, much of which he sold at Christie's, London, in April 1927. The sale included this painting as well as Degas's *Two Dancers* (Courtauld Institute Galleries, London) and Daumier's *The Railway Carriage* (National Gallery of Art, Ottawa). Nine of the 103 pictures were purchased by the Aberdeen Art Gallery. Following the sale, Murray intimated his wish to assist the gallery in acquiring eight more, one of which was *The Cliff at Fécamp*. The purchase price was about 1,522 pounds, half of which was paid by Murray, who had intended that through gifts and such assistance much of his collection should come into the possession of his home city. Murray had bought the painting only a year earlier, and perhaps already had in mind that he would donate it to the Art Gallery.

Jennifer Melville

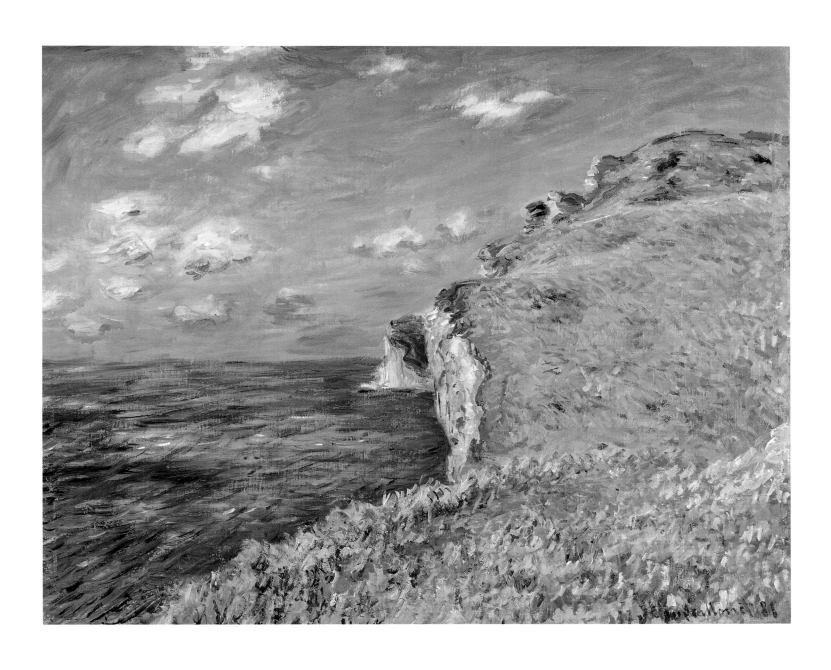

35.

The Cliff at Fécamp, 1881

Oil on canvas
25⅝ × 32 inches (64.5 × 81 cm)
Aberdeen Art Gallery and Museums

Claude Monet

Monet always had a passion for the sea. Throughout his life he returned to paint the cliffs and harbors along the English Channel in Normandy, but when he arrived on the little island of Belle-Île off the south coast of Brittany in September 1886, he was thrilled by the more dramatic Atlantic coast, finding it "sinister, diabolical and superb."[1] He had planned a short stay of about ten days, but found himself so exhilarated by the remoteness and grandeur of this extraordinary place that he established himself in the tiny fishing hamlet of Kervilahouen and produced almost forty paintings over the next two and a half months.

In many of these canvases Monet depicts the rocks lashed by the ocean in wild, stormy weather, but the Reims painting—and two others of the same scene, *Port-Domois,* 1886 (Yale University Art Gallery), and *Port-Domois at Belle-Île,* 1886 (private collection)—show the seared and jagged rocks enclosing deep, silent inlets of blue-green water bathed in a serene sunlight that does not detract from the majesty of the site.[2] In the Reims painting, the entire canvas is threaded through with strokes of gold, blue, russet, green, and mauve, weaving rocks and water into a harmonious whole.

Most of the paintings begun outdoors at Belle-Île were completed in the controlled environment of Monet's studio at Giverny, allowing a meditative approach to his subject that is characteristic of the direction his work was taking in the mid-1880s. The critic Gustave Geffroy, who watched Monet working at Belle-Île and became a devoted supporter, left an account of how the artist worked: "Quickly, he covers his canvas with the dominant values, studying their gradations, contrasting [and] harmonizing them. This procedure gives the paintings their unity. Look at these thin bands of clouds, these limpid, gloomy effects, these fading suns, these copper horizons, the violet, green and blue seas, all these states so far from a singularly defined nature, and you will see mornings dawn before you, middays brighten, and nights fall."[3] In this revealing passage, Geffroy conveys how the Belle-Île paintings anticipate Monet's more developed serial views of the next decade, recording the same subject—Rouen Cathedral or the Haystacks, for instance—at different times of day.

The Rocks at Belle-Île is probably one of the two paintings from the Belle-Île group that Durand-Ruel purchased from Monet in 1887. In 1902, the painting was bought by the collector Henri Vasnier. Born in Paris in 1832, Vasnier had moved at the age of twenty-three to Reims, where he took a job as a clerk in the famous champagne firm Veuve Pommery et Cie, eventually rising to become a director and amassing a considerable fortune. Like many late nineteenth-century collectors, Vasnier had a taste for landscapes by the Barbizon School, but he acquired a few outstanding Impressionist paintings. Clearly, he was drawn to Monet's more rugged scenes, for in addition to *The Rocks at Belle-Île,* he bought *The Ravine of the Creuse,* 1889, also now in the Musée des Beaux-Arts, Reims.[4] Vasnier built a special building to house his collection, complete with splendid, glass-roofed galleries. He played an important role in the artistic life of Reims, helping to establish the Musée des Beaux-Arts in its current premises in 1891. Following his death in 1907, his entire collection was bequeathed to the museum, together with the sum of 100,000 francs to pay for its installation.[5]

Ann Dumas

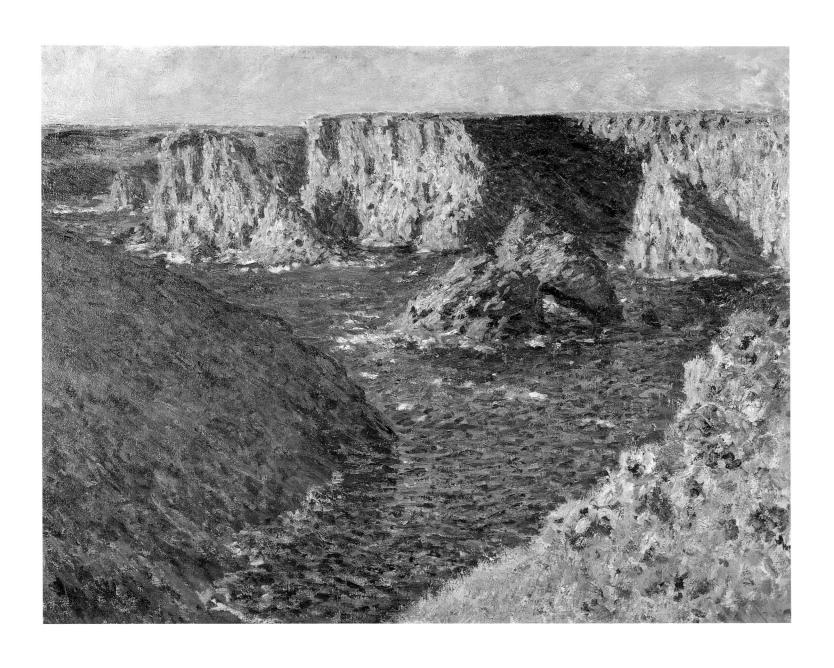

36.

The Rocks at Belle-Île, 1886

Oil on canvas
25¾ × 32 inches (65.4 × 81.3 cm)
Musée des Beaux-Arts, Reims

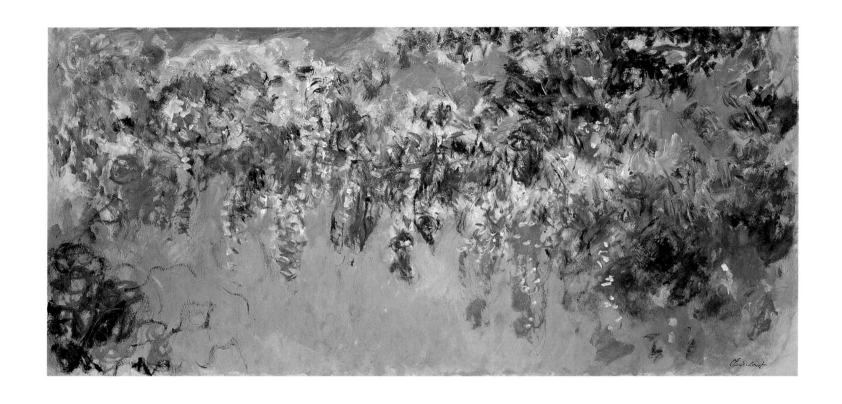

37.

Wisteria, ca. 1919–20

Oil on canvas
39⅜ × 78¾ inches (100 × 200 cm)
Musée Municipal d'Art et d'Histoire
Marcel Dessal, Dreux

Claude Monet

In his forties and well established as an artist, Monet desired a working environment that was removed from the clutter and din of Paris, but not too far removed to hear the latest news from the capital of the art world. In 1883, he and his companion Alice Hoschedé, whom he married in 1892, rented a pink house on an eight-acre plot of land in Giverny, a provincial town outside of Paris. The artist eventually bought the house and garden, and stayed in Giverny until his death in 1926.

Monet was an avid gardener, and he meticulously reworked and added to the garden over time. In 1893, Monet was granted permission to create a pond by diverting the Epte River near his property. He planted the pond with water lilies, installed a Japanese footbridge nearby, and surrounded the pond with weeping willow trees and wisteria. In the works created at Giverny, a mature Monet continued to work in the same vein as he had in previous decades, producing series of landscape paintings of the same subject in order to fully catalogue the effects of light and atmosphere.

In *Wisteria,* he moves beyond his earlier series by composing his landscape of a smaller area painted in closer proximity and translating it into expanses of earth, water, and sky. In this larger-than-life work, Monet seems to solve a problem he first encountered in 1865 when he attempted to paint a monumental canvas called *Déjeuner sur l'herbe* (the largest sketch, in the Pushkin Museum, is over eight feet tall). With *Déjeuner,* Monet experienced difficulties working on a large scale. Unfinished details in the preparatory sketches, which Monet's vigorous brushwork produced and which could be extrapolated by the viewer from a smaller format, dissolve into illegibility when enlarged.[1] In these late Giverny works, however, Monet solves his dilemma by concentrating solely on these problematic areas. He takes what would have been a detail in an earlier, moderately sized work as the subject of a huge canvas. He magnifies his subjects so that they appear to be slightly out of focus, and one must stand away from the canvas to see clearly. This allowed Monet to use the excited brushstrokes he was most comfortable with and to create a coherent image as well.

The monumental paintings created during and just after the First World War seem to have been Monet's way to combat the feelings of apprehension and helplessness that came with the war.[2] In 1918, Monet wrote to his friend, Premier Georges Clemenceau, that he wanted to donate two water-garden panels to the State to celebrate the end of the war. However, the plan grew to include a permanent installation of twelve panels. Originally, plans called for the *Weeping Willows* and *Water Lilies* to be housed on the grounds of the Hôtel Biron, the home and studio of the late sculptor Auguste Rodin. The present work is one of eight paintings of wisteria, apparently intended as overdoors for the installation. However, this plan, which called for the construction of a new building, proved to be prohibitively expensive. Instead, the government chose to use an existing structure, the Orangerie, in the Tuileries Gardens. The Orangerie installation allowed for twenty-two panels total, but did not call for any of the Wisteria paintings to be used. Monet did not live to see the installation completed; the Orangerie opened in May 1927, five months after the artist's death. Michel Monet retained the present painting of wisteria after his father's death. In 1964, he donated it to the museum in Dreux to commemorate the passing of his wife.

Phaedra Siebert

Berthe Morisot

As an upper-middle-class young woman living in Paris at the end of the nineteenth century, Morisot found that the range of subjects available to her as an artist was more restricted than to her male colleagues in the Impressionist group. She shared their interest in contemporary life, but as she was not free to seek out her material in the streets, cafés, or theaters of Paris, her modernity was often expressed in paintings of fashionably dressed young women from her own circle. Morisot frequently used models for her paintings, and it is possible that here, rather than recording an actual event, she posed this unidentified young woman in a costume and setting that evoked the opulent atmosphere of a ball. Dressed in a beautiful white gown, the bodice decorated with flowers, the model poses in front of a background of lush foliage and white blooms that suggest the exoticism of a hothouse rather than an outdoor setting. This indoor garden appears in other Morisot paintings, indicating perhaps that the Morisot home was the setting for this work.

Young Woman Dressed for the Ball was exhibited at the fifth Impressionist exhibition in 1880, probably together with her *Summer's Day* (cat. 39) and Bracquemond's *On the Terrace at Sèvres* (cat. 3) and *Portrait (The Lady in White)* (cat. 4). Morisot shares Bracquemond's interest in the effect of light on white fabric, except that in the present work it is not sunshine but the glow of artificial light that provides the key to the color harmonies. The painting is a study in whites that range from bluish tones in the bodice of the dress and gloves, rich creamy-whites broken with green tints in the flowers on the dress and those in the background, and soft, pearly tones in the skin. As in her contemporary *Summer's Day*, Morisot's touch is remarkably mobile and free throughout. The influence of her brother-in-law and mentor Manet is felt in the broad and vigorous brushwork in the foliage background; lighter, more delicate accents are used in the fabric and decoration of the dress and the translucent highlights of the flesh.

The painting was bought at the fifth Impressionist exhibition by Giuseppe de Nittis (1846–1884). Like Zandomeneghi (cats. 67, 68), he was an Italian painter living in Paris who was friendly with the Impressionist group; he exhibited in their first exhibition in 1874. The impact of Impressionism on his work, however, was short-lived. Instead, he became a successful painter of high society and used his substantial earnings to support his Impressionist friends by buying their works.

After de Nittis's death, the painting passed into the collection of the journalist, critic, collector, and champion of the Impressionists, Théodore Duret (1838–1927).[1] Duret's family fortune from the cognac business enabled him to collect art, and he proved to be a most generous and discerning patron of the Impressionists, not only buying their works but also using his influence to help them find other collectors. In 1894, serious business losses forced him to sell most of his collection, including the present work.[2] The poet Stéphane Mallarmé was instrumental in persuading the State to buy the painting from Duret's sale for the sum of 4,500 francs for the Musée du Luxembourg in Paris, the museum for contemporary art at the time. It thus became one of the first Impressionist paintings to enter a French museum. It was transferred to the Louvre in 1929, to the Musée du Jeu de Paume in 1947, and to the Musée d'Orsay in 1986.

Ann Dumas

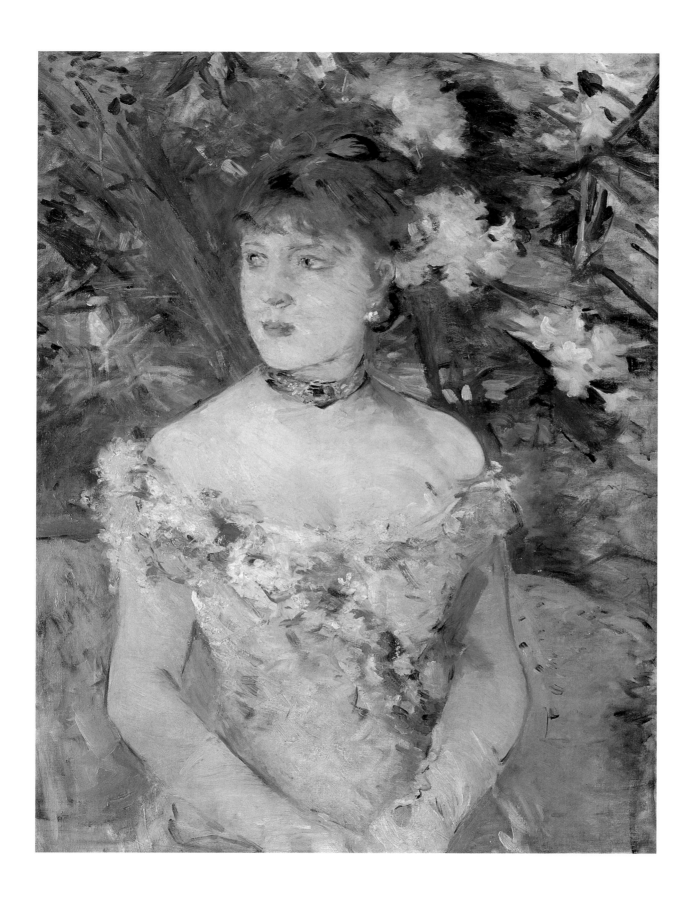

38.

Young Woman Dressed for the Ball, 1879

Oil on canvas
28 × 21¼ inches (71.1 × 54 cm)
Musée d'Orsay, Paris

Berthe Morisot

Summer's Day depicts two elegant young women seated in a boat in the Bois de Boulogne, the fashionable park to the west of Paris near the suburb of Passy, where Morisot lived. The sitters have not been identified and are probably models who posed for the painting. Inspired by her brother-in-law Manet, Morisot was always bold and experimental in her technique. This picture exemplifies the vigorous, zigzagging brushwork with which she would animate the whole surface of a canvas, weaving figures and background together in a continuous, luminous texture that brilliantly renders the effect of sunlight and water. This is probably the painting that was exhibited at the fifth Impressionist exhibition in 1880 with the title *The Lake in the Bois de Boulogne,* together with *In the Bois de Boulogne* (Nationalmuseum, Stockholm), in which the same models appear. Morisot's works in this exhibition attracted both favorable and unfavorable attention from the critics. Some viewed the spontaneity and looseness of her style as an indication of laziness. "Why, with her talent, does she not take the trouble to finish?" complained one reviewer,[1] while others responded to the appeal of the translucent compositions. Arthur d'Echerac was "utterly seduced and charmed by Mlle Morisot's talent. I have seen nothing more delicate in painting," he declared, noting that her works "have been painted with extraordinarily subtle tones."[2]

This work belonged to Sir Hugh Lane, a pioneer collector of modern art in Ireland in the early years of the twentieth century. A successful art dealer, Lane used his wealth to build up an impressive collection of old masters as well as nineteenth-century French paintings. The latter consisted mostly of works by Corot and the Barbizon School, but also included eight Impressionist pictures, most of which he bought from the Paris dealer Durand-Ruel. He paid 25,000 francs for *Summer's Day* in 1912. In addition to the Morisot, he acquired Monet's *Lavacourt under Snow* (1878–81) and Pissarro's *View at Louveciennes* (1869–70) in 1905, Manet's *Music in the Tuileries Gardens* (1862) and *Eva Gonzalès* (1870) in 1906, Renoir's *The Umbrellas* (1881–86) in 1907, and Degas's *Beach Scene* (1868–77) in 1912. All are now in the collection of the National Gallery.

A public-spirited collector, Lane carried out his intention to make a collection that would enrich the cultural life in his native Dublin when he founded a municipal gallery of modern art in Dublin in 1908. However, when the authorities turned down his offer to commission a new building to house his collection, he offered thirty-nine of his pictures to the National Gallery, London, in 1913. But the Gallery agreed to exhibit only fifteen of the works, not including the Morisot. "The National Gallery is—and should remain—a great Temple of Art," declared Lord Redesdale, one of the Gallery's trustees, who would not tolerate "an exhibition of the works of the modern French art-rebels in the sacred precincts of Trafalgar Square."[3] After Lane drowned when the *Lusitania* was torpedoed in 1915, the unclear terms of his bequest led to a dispute between the National Gallery and the Hugh Lane Municipal Gallery of Modern Art in Dublin that was not resolved until 1959, when it was agreed that the paintings should be rotated between the two institutions.

Ann Dumas

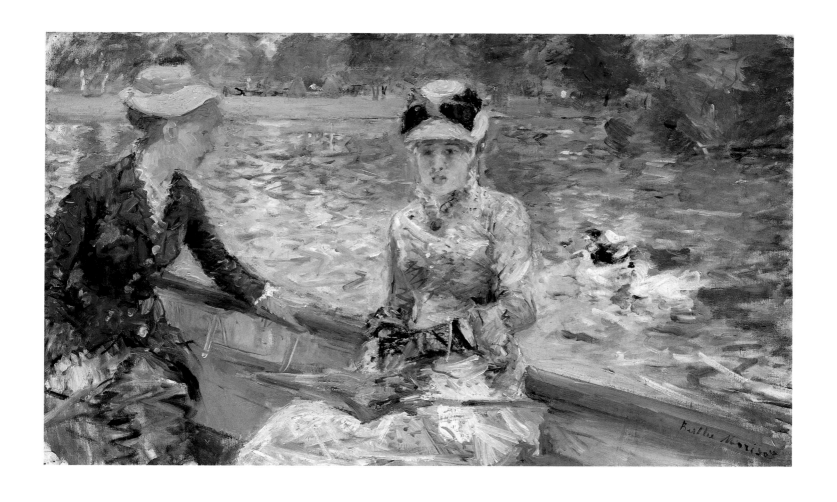

39.

Summer's Day, ca. 1879

Oil on canvas
18 × 29⅝ inches (45.7 × 75.2 cm)
The National Gallery, London

Camille Pissarro

Pontoise is a medieval town some twenty miles northwest of Paris. Of considerable importance in the early history of France, mainly for of its strategic position, by the mid-nineteenth century the town showed a marked dependency upon the rapid development of Paris. The traditional rural economy of the town was based on granaries, mills, and market gardens, but to these activities were now added minor industries such as distilleries and tanneries. Located on the river Oise, the town also benefited from being a barge port, but the arrival of the railway in 1863–64 marked a dramatic upturn in its fortunes.[1]

Pissarro lived in Pontoise at intervals over several years, beginning in 1866–68, when he resided in the area known as L'Hermitage in the northeast part of the town.[2] Dominated by steep hillsides, L'Hermitage was notable for its market gardens. Pissarro subjected the area to close scrutiny in a series of large landscapes that he submitted for exhibition at the Salon. As a group these constitute one of the most powerful and significant exercises in landscape painting of the period.[3]

L'Hermitage at Pontoise has sometimes been identified as the work entitled simply *L'Hermitage* in the Salon of 1868 (no. 2016). The scale of the painting attests to Pissarro's early confidence, but even more important are the formal qualities expressed not only in the spatial relationships between the natural terrain and the buildings, but also in the range of the brushwork, including the use of the palette knife.[4] The successful rendering in an even light of the houses in the middle distance, with the almost abstract treatment of walls and roofs, helps to link the flat foreground to the rising background and towering sky. The critic Émile Zola praised Pissarro's work extensively in his criticism of the Salon of 1868:

> The originality is here profoundly human. It is not derived from a certain facility of hand or from a falsification of nature. It stems from the temperament of the painter himself and comprises a feeling for truth resulting from an inner conviction. Never before have paintings appeared to me to possess such an overwhelming dignity. One can almost hear the inner voices of the earth and sense the trees burgeoning. The boldness of the horizons, the disdain of any show, the complete lack of cheap tricks, involve the whole with an indescribable feeling of epic grandeur.[5]

Pissarro's broad treatment of the subject owes a great deal to Daubigny, but the influence of Corot is also apparent in the compositional balance and the tonal nuances, as well as that of Courbet in the handling of the paint surface. More importantly, it is apparent that these views of L'Hermitage by Pissarro exercised a powerful influence on Cézanne, a link possibly being provided by Zola. When intermittently working with Cézanne during the mid- and late 1870s, Pissarro looked again at these motifs. Cézanne then in his own work began to observe landscapes with a comparable degree of objectivity and to exercise a similar deliberation in his brushstrokes.[6]

The picture was first owned by Ambroise Vollard, who became Cézanne's main dealer. It passed into the collection of Sir Alfred Chester Beatty (1875–1968), a millionaire mining engineer who was born in New York but lived mostly in Britain before retiring to Ireland. He was a prodigious art collector with varied interests.[7] At an uncertain date, the painting came into the possession of Fritz and Peter Nathan, who sold it in 1961 to the Wallraf-Richartz-Museum.

Christopher Lloyd

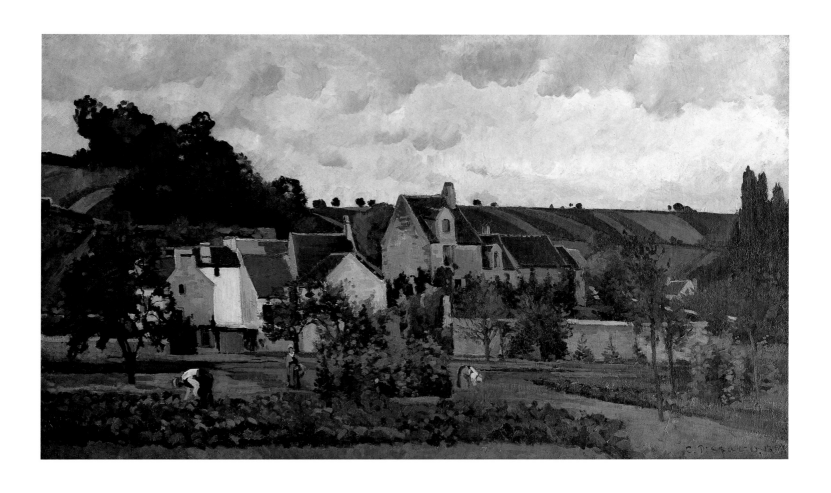

40.

L'Hermitage at Pontoise, 1867

Oil on canvas

35⅞ × 59⅛ inches (91.1 × 150.2 cm)

Wallraf-Richartz-Museum, Cologne

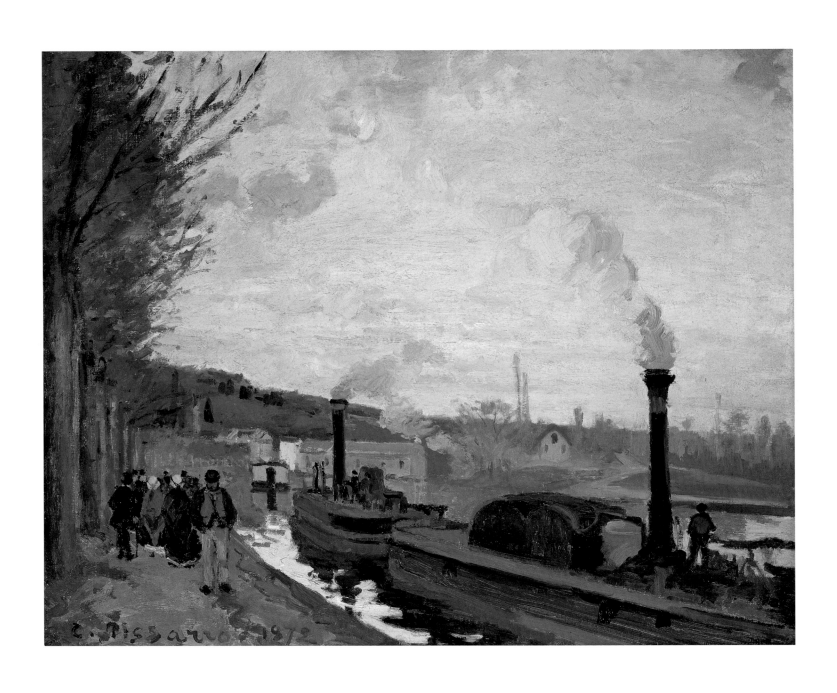

41.

The Seine at Port Marly, 1872

Oil on canvas

18⅛ × 22 inches (46 × 55.9 cm)

Staatsgalerie Stuttgart

Camille Pissarro

Port Marly is on the banks of the river Seine, approximately fifteen miles to the west of Paris near Bougival. On the hillsides above are situated St. Germain-en-Laye, Marly-le-Roi, and Louveciennes. All these places are associated historically with the *ancien régime,* but equally with the early years of Impressionism, since their proximity to Paris offered ample opportunities for the pursuit of leisure, which the Impressionist painters portrayed.[1] Pissarro first moved to Louveciennes in 1869, but he left a year later at the outbreak of the Franco-Prussian War, which was followed by the Commune. Returning from exile in London during the summer of 1871, Pissarro reestablished himself in a Louveciennes ravaged by war and remained there for nine months, during which he painted many canvases of the area, including this one.

The style of *The Seine at Port Marly* is comparable to that used by Monet and Renoir in their 1869 depictions of La Grenouillère, the floating restaurant moored opposite Bougival, which are regarded as the touchstone of the Impressionist style.[2] Pissarro's juxtaposition of bright patches of color used for the steamers, the tonal nuances in the sky, and the variety of brushstrokes applied throughout reveal a confidence and freedom in his adoption of Impressionist technique that he, too, had been perfecting since the end of the 1860s.[3] The stylistic similarities shared among Monet, Renoir, Pissarro, and Sisley when depicting the sites west of Paris did not extend as far as the subject matter. On many occasions, as in the present painting, Pissarro draws back from the scene and concentrates on the context. Both *The Seine at Marly* of 1871[4] and *The Seine at Port Marly,* which show the same stretch of river looking in opposite directions, "explore tensions between leisure and labour."[5] Thus, the commercial activities of steamers and barges are contrasted with the more leisurely pursuits of the figures strolling on the banks. Even within these groups, social observations are made in the contrast between bourgeois figures and artisans. Such an erosion of hierarchies—pictorial and sociological—is highly characteristic of these early Impressionist pictures.

Another tension exists in the pairing of *The Seine at Marly* of 1871 and *The Seine at Port Marly.* Where the former looks eastward toward the comparative modernity of Bougival, in the latter the famous Machine de Marly is evident. This was the pumping station, first built in the eighteenth century to supply water to the grounds of Louis XIV's chateaux at Marly and Versailles on the heights above. Rebuilt by Napoleon III in 1855–59, the Machine was one of the major engineering feats of nineteenth-century France, comprising six iron wheels, twelve forcing pumps, and a steam-driven pumping house. It was frequently painted by Sisley.[6]

The first owner of *The Seine at Port Marly* was Dr. Paul Gachet (1828–1909), who lived at Auvers-sur-Oise and was also a great supporter of Cézanne. It was acquired by the Staatsgalerie Stuttgart in 1965.

Christopher Lloyd

Camille Pissarro

Between 1864 and 1876, Pissarro made several visits to the farm at Montfoucault belonging to his painter friend Ludovic Piette (1826–1878). Piette and Pissarro had first met as art students in Paris in the 1850s. In 1870, during the Franco-Prussian War, the friendship was given practical expression when the Pissarro family, forced to abandon their home in Louveciennes, which was in the thick of the hostilities, took refuge at Montfoucault for several months.

In the autumn of 1874, following the first Impressionist exhibition and a summer spent painting in Pontoise, Pissarro decided to return to Montfoucault for a concerted spell of work. He told the critic Théodore Duret of his intentions: "I'm departing for my friend Piette's place; I won't be back before January. I'm going there to study the figures and animals of the true countryside."[1] Duret encouraged him in this bucolic, Milletesque vein, curious to know whether Pissarro was populating his landscapes with "two- and four-legged beasts?"[2]

In *Farm at Montfoucault,* the beasts are all two-legged. We see a stooping peasant woman gathering firewood, and another figure is just discernible beyond her. A gaggle of geese advances up the sunken track, framed by répoussoir trees to the left and right whose boughs interlock above the farm buildings. Compared to some of his Pontoise views, the painting is a dense, somewhat claustrophobic composition, with minimal sky, its dominant blue-gray tonality established by the slate gray of the roofs.

Working in the rural region of the Mayenne was the nearest Pissarro came to painting in Brittany, the region so favored in the following decade by his pupil Gauguin. The group of eighteen landscapes he produced there that year faithfully records the traditional character of the Montfoucault locality and working life of the farm. It would be wrong, however, to identify Pissarro too closely with the peasants he painted. Piette himself came from a family of "notables," having inherited the farm and outbuildings at Montfoucault in the late 1850s.

Although Pissarro showed *Farm at Montfoucault* at the second Impressionist exhibition, held in 1876 at Durand-Ruel's gallery, where Armand Silvestre commented on Pissarro's group of paintings and praised his "blues of a charming finesse," *Farm at Montfoucault* seems not to have left Pissarro's studio until 1891.[3] He then parted with it to a dealer, M. Martin (not to be confused with Père Martin, who had died in October that year, to whom Pissarro had sold work intermittently in the past).[4] He asked Martin the relatively high price of 2,000 francs for it, indicating a determination to capitalize on the greater demand for his earlier work (which Martin had specifically requested) in view of the trouble he was experiencing selling his recent divisionist canvases. In another letter written the same day to the critic Octave Mirbeau, Pissarro suggests that looking back on "old things" such as *Farm at Montfoucault* had made him ruefully aware of shortcomings in his more recent painting.[5] In 1915 the Musée d'Art et d'Histoire in Geneva acquired the painting from the Bernheim-Jeune firm for the sum of 12,500 Swiss francs, of which 5,000 were contributed by the Société des Amis du Musée.[6]

Belinda Thomson

42.

Farm at Montfoucault, 1874

Oil on canvas
23⅝ × 28⅞ inches (60 × 73.3 cm)
Collection des Musées d'Art et d'Histoire
de la Ville de Genève

Camille Pissarro

The Pissarro family spent the summer months of 1874 in Montfoucault, returning to their home at Pontoise in the autumn, and leaving again for Montfoucault on 20 October, where they spent the winter. This view of the kitchen garden behind the little house where the artist lived on the quai de Pothuis was painted in October, as is clear from the subdued colors. The palette is relieved only by the odd touches of bright green on the picket fence and vegetation in the foreground, and from the blue on the clothing of the men and women at work in the garden and of the roofs on the farm buildings. The kitchen garden had provided both Pissarro and Cézanne with subject matter for several years. In springtime the fruit trees, covered in blossoms, became the focal point of their paintings, while in autumn, as here, the more mundane produce of the ground provided inspiration.

This choice of subject was not to everyone's taste, as Jules Castagnary wrote: "He has a deplorable predilection for market-gardens and does not hesitate to paint cabbage or any other domestic vegetable. But these errors of logic or vulgarities of taste do not alter his beautiful qualities of execution."[1]

This painting is a quiet and subtle celebration of autumn, painted using delicate, uniform brushstrokes. The women gathering apples recall the burgeoning of summer, while the cabbages in the foreground foretell winter. In the distance a man hoes over the ground in preparation for spring. In a year when Pissarro's only daughter Jeanne (Minette) had died and his son Félix had been born, these reminders of the transience of life may have seemed particularly poignant. The subject of women gathering apples was one in which Pissarro seems to have delighted. Several spontaneous studies as well as finished paintings show his interest in the theme. It remained with Pissarro into the 1880s, when he enlarged the figures, making them the focal point of several pictures painted using pointillist methods, and for at least one painting on ceramic around 1884–85.

This work was one of many Impressionist paintings that once belonged to the famous operatic baritone Jean-Baptiste Faure, one of the earliest collectors of Impressionist art, who had bought most of his collection from Durand-Ruel. Faure sold many of the paintings he owned but held on to those by Pissarro and Sisley. Four years after Faure's death in 1915, Durand-Ruel sold the remainder of the collection, including this painting. It was subsequently owned by the Glasgow art dealer Alexander Reid, who sold it, before 1926, to the Glasgow-based engineer Sir John R. Richmond. Richmond gave five of his paintings to the Art Gallery of his hometown of Glasgow, whose cultural and artistic life he had consistently championed. After his death his paintings passed to his niece, Mrs. Isabel M. Traill. A resident of Edinburgh, she decided that the National Gallery of Scotland was the most suitable home for the remainder of such an important collection of Impressionist paintings. Consequently, Mrs. Traill presented this painting, along with some twenty others—almost all of which were the work of the Impressionists, including Monet and Sisley—to the National Gallery of Scotland in 1979.

Jennifer Melville

43.

Kitchen Gardens at L'Hermitage, Pontoise, 1874

Oil on canvas
21¼ × 25⅝ inches (54 × 61.5 cm)
National Gallery of Scotland, Edinburgh

44·

Garden at Valhermeil, 1880

Oil on canvas
21¼ × 25¾ inches (54 × 65.4 cm)
Národní Galerie, Prague

Camille Pissarro

When he painted this rural landscape in 1880, Pissarro was still living at Pontoise, finding abundant motifs in its market gardens and outlying villages, such as Valhermeil. The cottages of Valhermeil are just visible where the landscape meets the horizon, which is placed three-quarters of the way up the composition. Pissarro appears to have adopted a typically undramatic viewpoint here, from the edge of an orchard, incorporating a scrappy fence, path, and patch of what could be cabbages in the foreground. The scene is animated by a woman with a heavy basket or bucket making her way toward us and a cow to center left. Although the small, choppy, and dense brushstrokes give an overall harmony to the painting, Pissarro differentiates the varied colors and textures of vegetation and uses the horizontal bands of road and bushes (probably indicating the course of a stream) to articulate the composition.

In this painting and another similar composition of the same date and size, *Setting Sun at Valhermeil, near Pontoise* (1880), Pissarro, like Monet in his various series, sought to capture a single scene under different weather and light conditions.[1] Here the sky is partially overcast and the light from the sun overhead relatively muted, whereas in the evening version he depicts the foreground trees casting long shadows diagonally across the field to the left. Pissarro must have stationed himself only a few paces apart to paint the two views, as the grouping of three trees occurs in both versions. Interestingly, where the woman is placed in this painting a sapling occurs in the other, indicating that despite their seeming naturalism, these paintings were carefully constructed with a degree of artifice. Indeed, Pissarro probably turned to his sketchbook drawings to find suitable figures, rather than waiting for a figure to happen along.

Garden at Valhermeil does not appear to have been exhibited until 1892, when it was included in a one-man show at Durand-Ruel's gallery. This marked an important moment of reconciliation with his first dealer, for during the later 1880s—when Pissarro's preoccupation with pictorial unity led him to flirt briefly with Seurat's divisionism—their dealings had become somewhat strained, particularly when Pissarro had taken his work to Theo van Gogh. The critics responded variously: George Lecomte, in the preface to the catalogue, praised the courage and open-mindedness of an established artist exploring fresh techniques. Others complained of a certain monotony in his choice of motif: "His ideal hardly transports him beyond the vegetable patch. To beauty spots he prefers nondescript corners and golden shafts of sunlight strike him more than rhythms and linearities."[2]

Listed as belonging to Madame Pissarro in 1892, the painting does not appear to have passed through Durand-Ruel's hands again and was probably still with the family at the artist's death.[3] In 1923, following an important exhibition of French art in Prague, it was acquired by the Národní Galerie from the dealer Paul Rosenberg. This was the period when the gallery's forward-looking director, Dr. Vincenc Kramar, was doing much to develop a modern art collection worthy of the capital of the newly formed Czechoslovakia.[4]

Belinda Thomson

Camille Pissarro

Félix-Camille Pissarro, known as Titi, was the third son of Camille and Julie Pissarro. Using the pseudonym Jean Roch, he became a painter, engraver, and caricaturist of considerable ability. However, he never had the chance to develop his talent fully, dying of tuberculosis at the age of twenty-three. Félix was seven years old when this portrait was painted.[1] The little boy's solemn expression and the three-quarters-profile view lend him a sensitive and slightly vulnerable air that recalls Pissarro's portrait of his daughter Minette, painted in 1873, the year before her death at the age of nine (*Portrait of Minette Seated, Holding a Fan,* Ashmolean Museum, Oxford).[2]

At the beginning of the 1880s, Pissarro was seeking to move away from his early Impressionist style—in which forms were dissolved and fragmented by light—and impose a greater clarity on his compositions. One way in which this clarity emerged was in a new prominence given to the human figure, both in landscape and portraits. The setting of the figure against a patterned wallpaper background is a device often used by Cézanne, with whom Pissarro had worked closely throughout the 1870s. Not only the composition but also the technique of building up the surface with small, dense, evenly distributed brushstrokes reveals the lessons he had learned from Cézanne. The touch throughout is vigorous, animating the whole surface of the canvas and endowing the background of apple-green wallpaper with almost as much presence as the figure.

Portrait of Félix Pissarro was included in an important exhibition that marked the opening of the galleries of modern foreign art at the Tate Gallery, held from June to October 1926, an exhibition that finally put the seal of institutional approval on Impressionist and Post-Impressionist painting in Britain. It remained in the collection of Pissarro's eldest son, Lucien (1863–1944), who settled permanently in England in the early 1880s and had a strong influence on securing the acceptance of Impressionism in England. Most of the paintings by his father in Lucien's collection were donated to the Ashmolean Museum, Oxford, by his widow Esther and daughter Orovida, beginning in 1950. The present work was bequeathed to the National Gallery, London, in 1944 and transferred to the Tate in 1950.

Ann Dumas

45.

Portrait of Félix Pissarro, 1881

Oil on canvas
21¼ × 18⅛ inches (54 × 46 cm)
Tate Gallery, London; bequest of
Lucien Pissarro, the artist's son, 1944

Camille Pissarro

Manet, Monet, and Renoir all painted scenes of Paris in the 1860s and 1870s, when they embraced modern urban life as an exciting new subject. But Pissarro, who till the end of his life remained primarily a painter of rural life, turned to the subject fairly late in his career, when he painted an extensive series of Parisian views in the late 1890s, perhaps as part of a personal reappraisal of Impressionism (see also cat. 47). In mid-December, Pissarro installed himself in a room in the Grand Hôtel du Louvre high above the Place du Théâtre Français, and wrote to his son Lucien, "I am delighted to paint these Paris streets that people have come to call ugly but which are so silvery, so luminous and alive. . . . This is completely modern." [1]

Avenue de l'Opéra: Sunshine, Winter Morning is one of a number of panoramic views of the avenue de l'Opéra in Paris, including the Place du Théâtre Français in the right foreground.[2] Inspired partly by Monet's series paintings, Pissarro conceived of these pictures as an interrelated group, working on them simultaneously as he recorded the light effects at different times of day. In this painting he has captured the sharp light of a crisp, winter morning with the hurrying pedestrians and criss-crossing vehicles rendered in the most abbreviated pictorial shorthand of quick dabs and dashes of paint. While the hotel window provided a sort of automatic perspective frame within which to situate and organize this complex activity, a pinprick hole in the canvas of the Reims painting at the vanishing point suggests that Pissarro also relied on the traditional method of stretching threads across the canvas to establish the perspective.[3]

The Paris views had great critical success when they were exhibited together at Durand-Ruel's gallery in 1898. After the exhibition, the dealer bought this picture from Pissarro for 2,000 francs and in 1902 sold it to the distinguished Reims collector Henri Vasnier (see cat. 36). In 1907, Vasnier's bequest sent the work to the Musée des Beaux-Arts, Reims.

Ann Dumas

46.

Avenue de l'Opéra: Sunshine,
Winter Morning, 1898

Oil on canvas
28¾ × 36⅛ inches (73 × 91.8 cm)
Musée des Beaux-Arts, Reims

47.
Le Pont-Neuf, 1902

Oil on canvas
21⅝ × 18¼ inches (54.9 × 46.4 cm)
Szépművészeti Múzeum, Budapest

Camille Pissarro

In the 1890s, Pissarro began to render architectural ensembles of Paris in coherent series, mostly painted from the windows of a hotel room or apartment that he rented for this purpose. His worsening eye condition also forced him into the shade of his room. In a letter to his son Lucien dated 16 March 1900, he wrote that he had found an apartment at 28, place Dauphine from the windows of which he could enjoy the panorama of a picturesque part of Paris.[1] From the upper-story window of the apartment on Île de la Cité, he often depicted the famous stone bridge of Paris, the Pont-Neuf. He made two series of the sight, six in 1901 and four landscapes in 1902, all from the same vantage point.[2] Pissarro made the work in the Szépművészeti Múzeum in 1902, so it belongs to the second cycle. It is, however, closer in composition to some pieces of the 1901 series. This kind of focusing and construction seems to have provided Pissarro with the greatest potential.

Apart from some minor alteration of details and weather changes, the static elements do not seem to change. The carefully selected bird's-eye view allowed Pissarro to show the houses over the river frontally, and the architectonic block of the bridge, with its broad passageway and piers crossing the foreground askance, assumes increased emphasis. The bustle of the crowd contrasts to the solid masses of the bridge and the buildings, but the painting technique dissolves even the structural masses of the buildings.

Despite his advanced age, Pissarro painted his series of townscapes with renewed zeal. The Budapest picture, painted in the year before his death, is also replete with color and animation, though early that year he complained to his son that the slightest weather change would cause eye inflammation.[3] After a brief detour toward divisionism, he returned to a freer manner of painting in his last years.

The Nemzeti Szalon in Budapest, founded earlier by artists dissatisfied with the official art policy of Hungary, opened a new building in 1907. In its first year, it organized a series of three major exhibitions of French Impressionist and Post-Impressionist masters. Upon the recommendation of the National Art Council, which had the last word upon matters of purchase for the Szépművészeti Múzeum, the Ministry of Religion and Culture authorized the museum to launch talks for the purchase of five of the works shown in the second exhibition, which opened on 15 June. Durand-Ruel owned three of the selected works—including Pissarro's *Le Pont-Neuf.*[4] The price of 3,500 francs for the *Le Pont-Neuf* seems moderate compared to the 60,000 for a Daubigny or 15,000 for a Sisley. Eventually, the museum acquired the three pictures for a total of 60,000 francs. A few years earlier, only months after this painting was completed and shortly before he died, Pissarro made the following revealing remark about the influential art dealer: "Durand-Ruel and Bernheim had refused to take my pictures at the prices I proposed, and since a new dealer who had come to see me wanted to buy some of my paintings I seized my chance and sold the whole batch for a good sum. What motivated me especially was that here was an opportunity to escape from Durand-Ruel, who not only had a monopoly of my work by which he profited, but even forced his prices on me under the pretext that my works couldn't be sold."[5]

Ferenc Tóth

Boulevard in Paris, ca. 1888

Tempera on cardboard
19⅞ × 26⅜ inches (50.5 × 67 cm)
Göteborgs Konstmuseum

Jean-François Raffaëlli

Buildings and trees flank the spacious roadway in a lively play of restless shadows and bright patches of sunlight caught during an agreeable spring afternoon. A gentleman on horseback moves briskly toward us, his little dog racing ahead, casting a glance over its shoulder to check on its master. In the middle distance, a *fiacre* progresses at a steady pace. Strollers move in and out under the awnings of shops and cafés, or wander in the cool shade of the trees across the street. The carriage on the far left, cut off by the edge of the picture, displays Impressionist conventions of pictorial composition. The boulevard has been identified as the avenue Marigny, which crosses the Champs-Élysées not far from the Place de la Concorde.[1] The scene is as convincing and characteristic a depiction of the Parisian ambiance, in the popular sense, as one could wish.

Raffaëlli's group of bustling city views, painted in the late 1880s and 1890s, is astonishing in the context of his earlier works, which had made him famous and even controversial. Until 1876, he had painted mostly landscapes and fashionable figure pieces. He then became motivated by contemporary literature on the appalling social conditions of the underclass in the increasingly harsh industrial environment and it became the central theme of his work, especially in the late 1870s and the 1880s. Raffaëlli painted, drew, and etched French low-life—vagabonds, rag pickers, and the generally dispossessed—not as colorful characters but as tragic figures painted with a deep sense of their individual dignity and with an analytical feeling for their character and spirit.

This compassionate involvement with contemporary life was a fundamental motivation for the strong realist movement, which had dominated French art since the middle of the nineteenth century. When Degas induced the Impressionist painters to accept Raffaëlli as a participant in their exhibitions of 1880 and 1881, it was not without stiff resistance on their part, as he was thought to be too conservative. Raffaëlli showed more than thirty works in each of these exhibitions. The third time, however, in 1882, brought disagreements to a head. Raffaëlli's pictures were thought to have diluted the Impressionist characteristics as well as their level of quality. Raffaëlli was not admitted and Degas withdrew his own work in protest. Ironically, Raffaëlli was treated better by the critics than were the Impressionist stalwarts.

The grandson of an Italian who had moved to Lyons, Raffaëlli was born in Paris in 1850.[2] Without any formal instruction, he had a work accepted by the Salon at age twenty. It encouraged him to enroll as a student at the École des Beaux-Arts in Gérôme's class, but he left after just three months because his fellow students were "coarse and vulgar" and because there was "never a discussion about art . . . never a lofty idea."[3] He showed his work in the Salons before and after his inclusion by the Impressionists.

The painting *Boulevard in Paris* was acquired in Paris in 1889 by the Göteborg collectors Pontus Fürstenberg and his wife, Göthilda. They were accumulating a comprehensive collection of Scandinavian art at that time, and in 1902 bequeathed their works of art to the Göteborgs Konstmuseum.

Gudmund Vigtel

Pierre-Auguste Renoir

Woman with a Parasol in a Garden was produced during Renoir's "pure" Impressionist phase. It was probably completed during the summer after the first Impressionist exhibition in 1874, when Renoir was visiting his friend Charles Le Coeur and his family at their country estate in Fontenay-aux-Roses.[1] It depicts a garden in the full bloom of summer, a colorful riot of flowers and grasses, hedges and trees. The particular character of this landscape, the defining contours of earth and vegetation, are of little interest to Renoir. He abandons conventional pictorial structure in favor of an arrangement of contrasting and complimentary colors with a variety of energetically interwoven strokes. The dense dabs of bold color in the lower right—juxtaposed against the softer hues and more regulated and integrated strokes of the upper background—constitute the painting's essential composition. The painting operates first and foremost on the surface of the canvas, creating a richly sensual, textural point of contact between the painter and the viewer. Renoir's artistic mission, like that of Monet (alongside whom Renoir frequently painted during these years), was to reproduce a unified, vibrant impression of a singular shimmering moment rather than specific forms and details of nature.

Both Renoir and Monet grappled with the subject of the figure within a landscape. Eventually, however, the figure would disappear from Monet's vision, while Renoir would increasingly focus on the human form, building his career around portraits, nudes, and other figure studies. Even in *Woman with a Parasol,* though the figure is almost overwhelmed by the frenzy of colored strokes that lap up around her, she stands securely at the center of the composition, her dark dress contrasting with the white umbrella.

This painting was originally purchased by Renoir's Paris dealer, Durand-Ruel, passing on to New York through the purchase of Sam Salz, then to Mrs. Byron C. Foy, and to Paul Rosenberg, New York. The work then moved to London through the Lefevre Gallery. On 1 July 1974, it was purchased by Baron Hans Heinrich Thyssen-Bornemisza at Christie's, London (lot no. 14), becoming part of the renowned Thyssen-Bornemisza collection in Lugano, Switzerland. The founder of the collection, Hans's father Heinrich, distrusted "modern" art and concentrated instead on old masters. Hans overcame his father's influence (not without difficulty), and in the early 1960s purchased several Impressionist works at the Marlborough Gallery in London, including Renoir's *Wheatfield* of 1879 and van Gogh's *The Porters* of 1888.[2] Though Swiss collectors had initially been rather reluctant to invest in Impressionist works, with the postwar economic boom of the 1940s and 1950s this area of the art market, and the market in general, became very lively. (It is possible that Hans was inspired by the 1964 exhibition of Impressionist and Post-Impressionist works from Swiss private collections at the Palais de Beaulieu, Lausanne, which revealed the extent to which the Swiss had become interested in this work.) By the mid-1980s, the modern masters collection had grown to more than 800 works, far exceeding the spatial limitations of Villa Favorita, the family home in Lugano.[3] The collection thus went on a world tour, arriving in Spain in 1988. In 1993 the Spanish government acquired the collection, and the majority of it resides at the Palacio Villahermosa, Madrid.

Mary Morton

49.

Woman with a Parasol in a Garden, ca. 1874

Oil on canvas
21½ × 25⅝ inches (54.6 × 65.1 cm)
Fundación Colección Thyssen-Bornemisza, Madrid

Pierre-Auguste Renoir

Renoir was born into modest circumstances in Limoges but grew up in Paris. His family were tradespeople, his father a tailor and his mother a dressmaker. Discovering his artistic vocation through his early training as a porcelain painter, Renoir attended Gleyre's studio from 1862 to 1864 at the École des Beaux-Arts, where he befriended Fantin-Latour, Monet, Sisley, and Bazille. Renoir's early work emulated the artists of an older generation, such as Courbet, as well as the masters whom he had studied in the Louvre. His main interest was in figure painting, and he abandoned the ambitious allegorical nudes with which he had tried to make his name at the Salon in the 1860s in order to concentrate on portraiture. He was also caught up in the Impressionist impulse to capture the everyday life of modern Paris, which led to his unequaled achievement in such large-scale paintings as *Dancing at the Moulin de la Galette,* 1876 (fig. 7, p. 22). At first he relied on the goodwill of friends to pose for him, but by the later 1870s (thanks to the patronage of the publisher Georges Charpentier and his wife), he was beginning to make a name for himself and build up a clientèle.[1]

The Conversation, an intimate study on a modest scale, represents Renoir working in his most fluent Impressionist manner. In this animated exchange between two attractive young people, the woman is holding forth while her male companion listens. In another painting of the same scale and using the same two models (also entitled *The Conversation,* private collection, Paris), Renoir shows the situation in reverse, with the man seen from behind and the woman full face. We can assume he painted these works as a pair.

The Conversation has been dated to 1878, not only on stylistic grounds but also because of the identity of the models. The studious-looking young man was posed by Renoir's close friend and fellow painter, Samuel Frédéric Cordey (1854–1911).[2] In 1877 Cordey contributed four paintings to the Impressionists' group exhibition and in 1881 accompanied Renoir on a painting trip to Algiers. He appears in several other paintings of around this date. The young woman in the feathered hat has been identified as Margot (Marguerite Legrand), one of Renoir's favorite models between 1875 and 1879. It was a considerable blow to Renoir when this lively and pretty Montmartroise died of typhoid fever in early 1879, despite the best efforts of Renoir's doctor friends—Paul Gachet and Georges de Bellio—to save her.

Little is known about the early history of this painting. It was not shown at the Impressionist exhibition of 1879, since that was the year in which Renoir returned to exhibiting at the Salon, scoring a notable success with his *Madame Charpentier and Her Children,* 1878 (fig. 2, p. 30, The Metropolitan Museum of Art, New York). It apparently remained in the stock of Durand-Ruel until 1918. At this date, the necessary funds were raised to acquire it for the Nationalmuseum in Stockholm, with the assistance of Conrad Pineus and G. A. Kyhlberger. One of Europe's oldest art museums, the Nationalmuseum had been admitting Impressionist works since 1896, when it received the donation of Manet's *Young Boy Peeling a Pear* from the Swedish artist Anders Zorn (fig. 3, p. 93). In 1913 it acquired Renoir's *La Grisette,* 1875, and in 1926, soon after acquiring *The Conversation,* the Friends of the Museum went on to buy one of the artist's most important early group subjects, the Courbetesque *Mother Anthony's Tavern,* 1866.[3]

Belinda Thomson

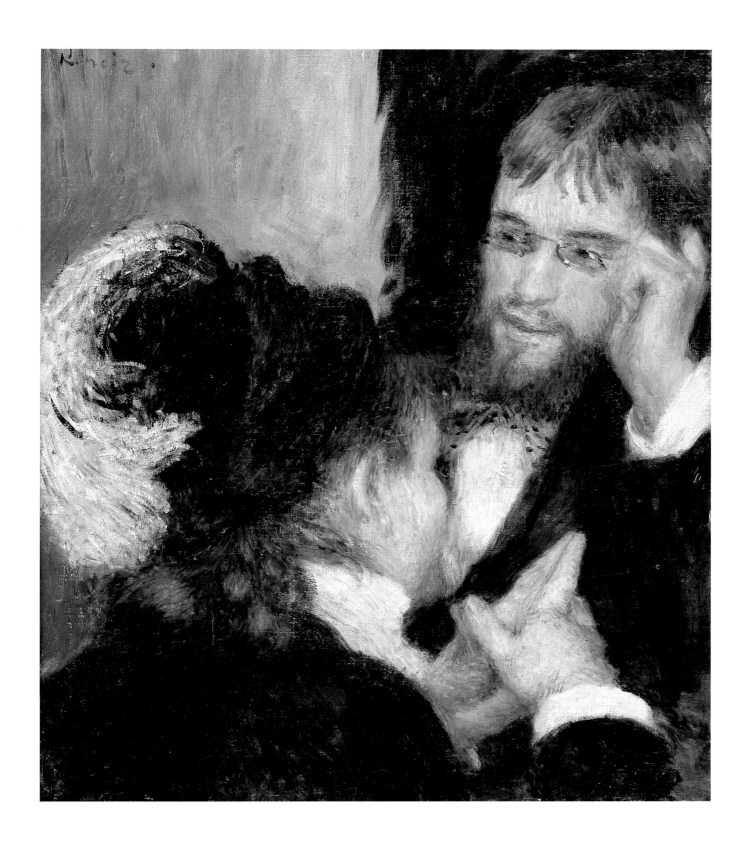

50.

The Conversation, 1878

Oil on canvas
17¾ × 15 inches (45.1 × 38.1 cm)
Nationalmuseum, Stockholm

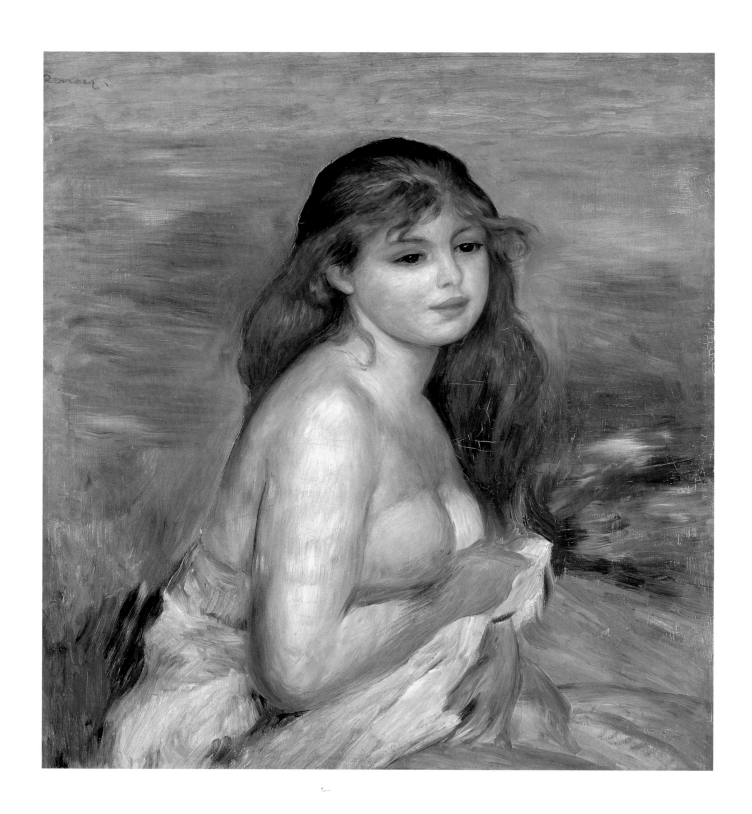

51.

Bathing Woman, ca. 1883

Oil on canvas

23⅝ × 21¼ inches (60 × 54 cm)

Nasjonalgalleriet, Oslo

Pierre-Auguste Renoir

Bathing women or female nudes in a landscape setting are a recurring theme in Renoir's imagery. In 1881–82 Renoir visited Italy, and his encounter with the work of Raphael had an immediate impact on his own work. This painting from Oslo dates from shortly after the trip, at a time when Renoir was eager that his art should be seen as in line with the classical tradition and opposed to the extreme tendencies within the Impressionist movement, especially those represented by Georges Seurat. Renoir's paint handling points back to his Impressionistic period, and at the same time forward to a firmer figure style. *Bathing Woman* is undated, but was once assumed to have been painted ca. 1885–86 and seen in the context of his work leading to the large multi-figure painting *The Bathers,* also known as *The Great Bathers* (Philadelphia Museum of Art) of 1887. However, the Nasjonalgalleriet's picture was most probably painted a few years earlier, about 1883. It should be considered in relation to his 1881 *Blond Bather* (The Sterling and Francine Clark Art Institute, Williamstown, Massachusetts) and to *Seated Bather* (Fogg Art Museum, Cambridge, Massachusetts), which has been dated to 1883–84. The model for those two paintings is clearly the same as for this one—Aline Charigot, Renoir's model and mistress, whom he married in 1890.

Bathing Woman reveals something of Renoir's working method.[1] The canvas is made up of a larger piece, on which the whole figure is positioned, and a smaller piece, a horizontal strip along the upper edge that bears the signature. This raises a question: whether Renoir himself considered the picture an unfinished study, whether it was only later transformed into a finished, signed painting. Technical examination indicates that the upper strip was added during the process of painting. There is nothing to suggest that the picture was finished piece by piece. The Nasjonalgalleriet's *Bathing Woman* must therefore be considered a significant work among those Renoir produced at the beginning of the 1880s.

In 1916, the Nasjonalgalleriet received the promise of a large sum of money from Tryggve Sagen, a young shipowner and enthusiastic collector of art, to be spent on acquiring French modern art.[2] Six pictures were bought in the following two years, among them *Bathing Woman* and Degas's *Woman and Dog* (cat. 14). Most of the pictures were purchased from the exhibition *French Art,* which opened at the Nasjonalgalleriet in the autumn of 1914. Due to the outbreak of the First World War, the exhibition lasted for several years, as returning the works by sea was too great a risk to take.[3] *Bathing Woman* was then owned by Galerie Levesque, Paris, and had previously been exhibited in St. Petersburg in 1912, at the Exposition Centennale.

Norway remained neutral during the First World War, and shipowners and corn traders amassed large fortunes. Notable private collections of French art were formed, and some found their way into public collections. The Nasjonalgalleriet is a national museum that has had very limited funds for the purchase of art. A friends' association, Nasjonalgalleriets Venner, was founded in 1917; its objective was to present the museum with original, foreign works of art, both early and modern, and the proviso was made that these gifts were inalienable.[4] Tryggve Sagen was one of the founding members.

Marit Lange

Pierre-Auguste Renoir

During the summers of 1885 and 1886, Renoir was staying in La Roche-Guyon, a village on the Seine between Paris and Rouen, a few miles upstream from Monet's home at Giverny. Cézanne, Hortense Fiquet, and their son Paul stayed with the Renoirs during the first of these two sojourns, from June to August 1885. Renoir himself left La Roche-Guyon to visit the Bérards in Wargemont, but returned to La Roche-Guyon in August. Consequently, it is very likely that this painting was executed during August 1885 or August 1886 (since their stay lasted only one month that year) as is suggested by the impression of sultry heat created by Renoir's hot range of colors. The time Renoir spent with Cézanne in La Roche-Guyon was critical for his development, as it was then that he developed his version of Cézanne's "constructivist stroke"—that is, the application of a series of evenly weighted, parallel brushstrokes. Nowhere is this new technique more clearly illustrated than in this painting. Here the strokes run diagonally from upper right to lower left through the sky, clouds, and distant hills, and down to the roofs of the cottages. Only in the left foreground do shorter, less mannered strokes counteract this rhythmic flow, breaking up the surface pattern with brushstrokes running in the other direction and thick touches of impasto.

The mid-1880s was a period of change and uncertainty for Renoir, as is reflected in two letters he wrote to his dealer Durand-Ruel at the time. In one he seems confident and composed, assuring Durand-Ruel that he had set his bungling behind him, but asking the dealer not to visit him.[1] To Bérard, however, his artistic insecurities become clear and he admits to having stalled the dealer because he had not resolved anything, writing: "I want to find what I am looking for before I deliver myself."[2]

No details are known of the painting's early history. It was in the collection of Raphael Gerard and subsequently that of Émile Roche. *La Roche-Guyon* was accepted by H.M. Treasury from the Trustees of the Green Marriage Trust in lieu of death duties. In October 1973, the city of Aberdeen entered into a loan agreement with the Treasury under which this painting was to be lent to Aberdeen for a period of fifty years. In January 1975, this loan was changed to an outright gift. Aberdeen was chosen in preference to other galleries because of the large geographical area covered by the city, its remoteness from other collections of Impressionist art throughout Britain, and its own small but significant holding of works by the Impressionists.

Jennifer Melville

52.

La Roche-Guyon, 1885–86

Oil on canvas
19¾ × 23½ inches (50.2 × 59.7 cm)
Aberdeen Art Gallery and Museums

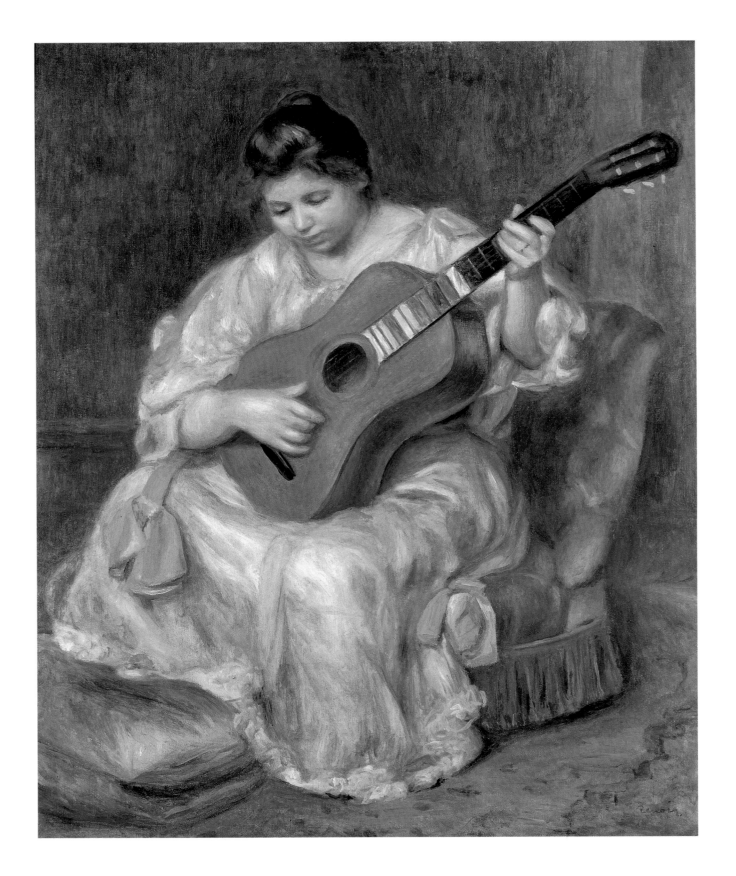

53.
Woman Playing a Guitar, 1896–97
Oil on canvas
31⅞ × 25⅝ inches (81 × 65.1 cm)
Musée des Beaux-Arts, Lyon

Pierre-Auguste Renoir

Woman Playing a Guitar is one of a series of paintings of women and men playing the guitar that Renoir painted in the late 1890s. The appeal of musical performers as a subject can be connected to Renoir's lifelong love of eighteenth-century French painting—to the lutenists whose music enchants the spellbound listeners in Watteau's or Fragonard's *fête-champêtres*—as well as to his great admiration at this time for Corot's figure subjects, especially women playing musical instruments.[1] The guitarists are the successors of the young women playing the piano, a theme that had preoccupied Renoir a few years earlier. But whereas these young musicians are located in the specific context of the bourgeois drawing room in late nineteenth-century Paris, the paintings of guitarists suggest no reference to a particular time or place; they are costume pieces in which the figures are usually attired in vaguely Spanish dress. In the Lyon painting, for example, the pink ribbons on the girl's sleeves may be intended to suggest a Spanish note. It has been proposed that Renoir's interest in guitar players was triggered by the celebrated Spanish dancer "La Belle Otéro," whose performances at the Folies-Bergère were said to capture the essence of Spanish seductiveness.[2]

These musical figures represent a turning point in Renoir's career, away from contemporary Paris toward the timeless world and monumental figure compositions that came to dominate his late work. The young woman's rounded and quietly contained form, echoed by the curved and sensuous shapes of the guitar, the cushion, and the upholstered chair, is offset by the strong verticals in the wall decoration. The palette throughout is delicate yet rich: yellow in the cushion and the background wall, the pink ribbons and pinkish-brown chair, and soft yellow, grays, and slate-blues that play across the white of the dress. The colors are applied in diluted layers that indicate, as does the portrait of Misia Sert (cat. 54), Renoir's enthusiasm at this time for the technique of Titian and Rubens.

Woman Playing a Guitar was acquired from Renoir in 1901 by the Musée des Beaux-Arts, Lyon, for 4,000 francs, with Durand-Ruel acting as intermediary. Although Renoir's contemporary work was much sought after by private collectors at this time, it was a bold and early purchase for a museum. The minutes of the museum's commission held to deliberate the acquisition reveal some initial doubts, but eventually the mayor reassured the detractors: "The painting is one whose subject and technique will not shock those who are not yet accustomed to the productions of the new school. And the price is extremely modest."[3]

Ann Dumas

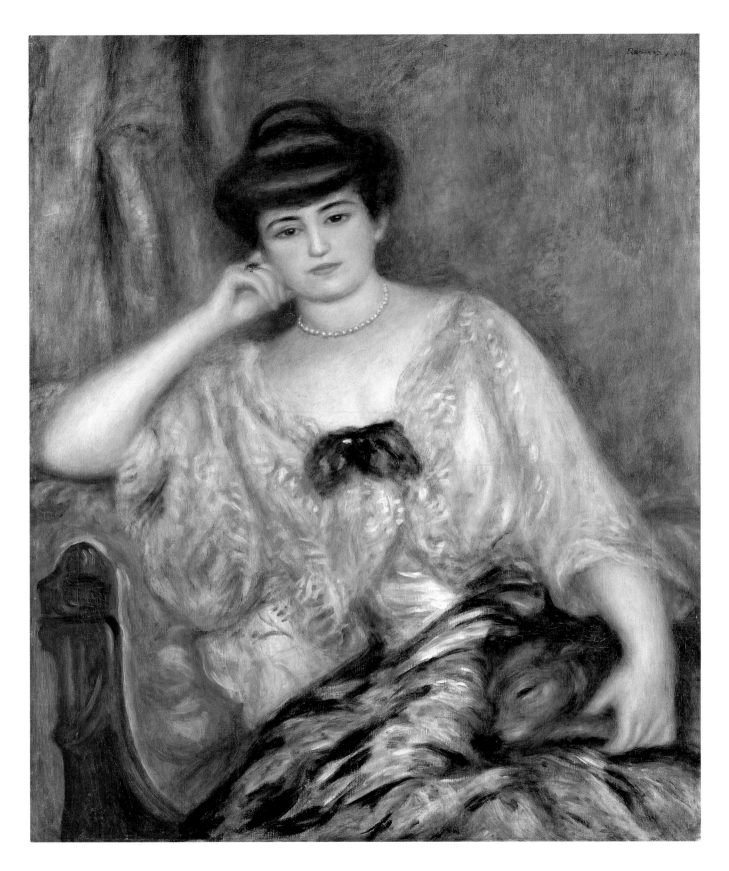

54·

Misia Sert, 1904

Oil on canvas

36¼ × 28¾ inches (92.1 × 73 cm)

The National Gallery, London

Pierre-Auguste Renoir

Misia Godebska (1872–1950) was born in St. Petersburg. Her father was a successful sculptor and her Belgian mother was the daughter of a famous cellist. Misia herself was a gifted pianist. She spent her childhood in Brussels with a wealthy grandmother. She settled in Paris in 1891 and studied the piano with Gabriel Fauré. Her marriage in 1893 to Thadée Natanson, a director of the important literary and artistic journal *La Revue blanche,* established her as a prominent figure in the Parisian art world. Her lively personality and musical talent attracted many leading avant-garde writers and painters. She was a friend of Mallarmé and Gide and was reputedly one of the models for the music-loving Madame Verdurin in Proust's *Remembrance of Things Past.* She was painted by Vuillard, Bonnard, and Toulouse-Lautrec. An active patron of the arts, she commissioned works from Vuillard and Bonnard and was one of the first supporters of Diaghilev's Ballet Russes. In 1903 she divorced Natanson for the wealthy financier and newspaper tycoon Alfred Edwards, publisher of *Le Matin.* In 1920 she married the Spanish mural painter José Maria Sert.

In her memoirs, *Misia par Misia,* she recalled that Renoir had painted seven or eight portraits of her, each of which required her to sit for three days a week for a month. But this account, written late in her life, may be an exaggeration. Only two other portraits of her by Renoir are known.[1] This portrait was commissioned the year after Misia began her liaison with Edwards, when she was thirty. She would marry him the following year. She sat for Renoir in her opulent apartment on the rue de Rivoli overlooking the Tuileries Gardens, and her relaxed yet commanding presence exudes the gracious confidence of a woman of the world, the mistress of one of the wealthiest men in Paris. As Misia later commented: "This was probably the time of my life when I had everything a woman could wish for. There was really nothing more I could want."[2] The fact that she chose Renoir to paint her portrait affirms his status as a society portraitist at the time, but is also evidence of the regard in which a younger, more avant-garde generation of collectors continued to hold Renoir and his late style, in particular.

Soft salmon pinks and creams in the silky bodice overlaid with transparent lace and in the loose, diaphanous sleeves are picked up again in the luminous skin tones. The palette and the fluid technique, especially in the boldly patterned skirt and the soft fur of the little dog, are perfectly attuned to the sensuous femininity of the sitter and confirm Renoir's long-standing love of a rococo ideal of woman presented by the French eighteenth-century painters Boucher and Fragonard. But, equally, the warm color and suave handling of paint applied in thin, transparent layers attest to his admiration, in the latter part of his career, for Titian and Rubens. He told the dealer Ambroise Vollard, "One day, in the Louvre, I noticed that Rubens had achieved more sense of values with a simple scumble *(frottis)* than I had been able to with all my thick layers of paint."[3]

After remaining in Misia's possession for four decades, the painting became part of the Walter P. Chrysler collection, then in 1959 was sold through Sotheby's to a private collector. A year later, the portrait was acquired by the National Gallery.

Ann Dumas

55.

Seated Girl, ca. 1909

Oil on canvas
25¾ × 21¾ inches (65.4 × 55.2 cm)
Musée d'Orsay, Paris; bequest of
Count Isaac de Camondo, 1911

Pierre-Auguste Renoir

This charming late study of a seated girl, who has been identified as Hélène Bellon (1890–1959), was painted at Renoir's new studio at Les Collettes in the south of France.[1] With her open, apple-cheeked face and buxom figure, amplified by a loose-fitting blouse, the model conforms closely to Renoir's voluptuous ideal of female beauty, a type associated particularly with his children's nurse, Gabrielle Renard. Drawn south for health reasons, Renoir had bought a plot of land above Cagnes in 1907, apparently in order to save an ancient olive grove from destruction. There he had a new house built and was able to continue working to the end of his life, despite the crippling rheumatoid arthritis that deformed his hands. He received visitors from Paris, but only occasionally returned to the capital. Hélène Bellon was probably one of the numerous servants employed at different times by the family.

Despite the apparent informality and naturalness of the pose, Renoir made a large study for the painting using the traditional technique of sanguine heightened with white chalk.[2] Such preparatory drawing had clear associations with the great draughtsmen of the Renaissance and seventeenth century, who increasingly occupied Renoir's thoughts toward the end of his career.

Ironically, this painting was sold to Count Isaac de Camondo, a collector who suspected Renoir of lacking a sense of tradition. Camondo had begun his career as a collector by following family tradition and buying eighteenth-century furniture, which he housed in his sumptuous Garnier-designed residence on the avenue des Champs-Elysées. He also collected Japanese art, but from the 1890s on he concentrated on assembling a modern collection, which he housed in the rue Glück. Planning to leave it to the Louvre (see cat. 31), he was increasingly concerned that it be a comprehensive collection. As he had neglected Renoir, for whose work he felt a certain antipathy, by 1910 he was asking dealers to look out for suitable examples. Ambroise Vollard gives an amusing account of Camondo's strictures about Renoir, just before he bought this and two other equally "wild" late works from Durand-Ruel in 1910.[3] But it was already too late to build a representative Renoir collection, and Camondo died in 1911.

The terms of his bequest stipulated that the collection be kept together for fifty years. Accordingly, rooms in the Louvre were specially designated to take the Camondo collection, which was inaugurated in June 1914. A French artist would not normally expect to see his work enter the Louvre during his lifetime, but a change in the statutes was introduced to allow it. For such a high number of works (fourteen by Monet, nineteen by Degas, and three by Renoir) to enter the national collections was an exceptional honor for the artists concerned. In 1947, the Impressionist pictures from the Camondo collection moved to the Musée du Jeu de Paume in the Tuileries Gardens, and in 1986 were transferred to their present home, the Musée d'Orsay.

Belinda Thomson

56.

Monsieur and Madame Bernheim de Villers, 1910

Oil on canvas
31⅞ × 25¾ inches (81 × 65.4 cm)
Musée d'Orsay, Paris; gift of Mr. and Mrs. Bernheim
de Villers, 1951

Pierre-Auguste Renoir

Renoir had already painted various members of the Bernheim-Jeune family when he made this affectionate portrait of Monsieur and Madame Gaston Bernheim de Villers in 1910. Close in date to *Seated Girl* (cat. 55), and similarly painted at Les Collettes, this work was commissioned by the successful and wealthy Paris art dealer and his elegant wife. Despite the contrast with the earlier painting in terms of social class, which Renoir signals in the elaborate accoutrements and elegant rococo sofa, this painting deploys a similar palette of warm reds and dark blues, heightened by the whites of Madame Bernheim's corsage, pearls, and hat trimming, and by her husband's starched white shirt. Clearly the couple posed for the painter in their smart city attire, whose incongruity in the rural Mediterranean setting shows up markedly in a sequence of somewhat hazy contemporary photographs taken to record their visit.[1] The portrait was already complete by March when it was admired by the painter Maurice Denis, who called on the artist while cycling to Italy along the Riviera.[2]

The brothers Josse (1870–1941) and Gaston (1870–1953) Bernheim-Jeune married two sisters, the beautiful Mathilde and Suzanne Adler, in 1901. Sons of Alexandre Bernheim, a picture dealer in the rue Laffitte, the brothers had played an active role in the Paris art market since the turn of the century. Their move to a new gallery on the boulevard de la Madeleine and rue Richepance signaled a westward shift in the location of the Paris art trade. They quickly made it one of the most stylish galleries for the exhibition of modern art. Specializing in the work of second-generation Impressionists—artists such as Bonnard, Vuillard, and Signac— whom they promoted as the natural heirs to the Impressionist tradition, they became redoubtable rivals to Durand-Ruel, whose tastes remained somewhat *retardataire*. It undoubtedly irked Durand-Ruel, Renoir's dealer of long standing, that a newcomer like Gaston Bernheim-Jeune should be made chevalier of the Legion of Honor as early as 1906, when Durand-Ruel had to wait until 1920, a delay he put down to his unfashionable ultraconservative political and religious views. The Bernheim-Jeunes already had a sizable collection of Renoir's work hanging in their Paris apartment on the boulevard Henri-Martin when this portrait was painted. However, the paintings of Bonnard, Vuillard, and Matisse would decorate their summer residence in Villers-sur-Mer—hence the aristocratic-sounding "de Villers" that Gaston Bernheim appended to his name, partly to distinguish his commercial role from his work as a painter, about which he was evidently self-effacing.[3]

This painting began as a portrait of Suzanne Bernheim de Villers. At some point during the sittings, Renoir asked Gaston to sit with his wife, achieving the addition so skillfully, Gaston observed, that it in no way upset the balance of an already established composition.[4] Two years earlier, Bonnard had painted a somewhat playful portrait of the Bernheim-Jeune brothers and their wives in a box at the Opéra (*La Loge,* 1908, private collection), which cut off the top of Gaston's head. Was it perhaps as a compensatory gesture that Renoir painted him in on this occasion?

In 1951, to mark the fiftieth anniversary of their marriage, the couple donated the portrait to the Musée du Jeu de Paume. In 1986, the work passed to the Musée d'Orsay.

Belinda Thomson

Alfred Sisley

Sisley was born in Paris to English parents and lived in France throughout his life. On two occasions he took steps to have himself naturalized as a French citizen, but never completed the paperwork. He put off marrying his lifelong companion, Eugénie Lescouezec, until 1897, by which time they were both in failing health.

Sisley grew up in easy circumstances. His father ran a thriving luxury goods business, but suffered reversals in fortune as a result of the Franco-Prussian War. Initially he seems not to have hindered his son from pursuing an artistic career, and in the early 1860s, when studying under Gleyre, Sisley received financial support. However, his liaison with the model and florist Eugénie, which produced a son in 1867 and a daughter in 1869, seems to have prompted Sisley's father to cut off this allowance.[1] Thereafter, despite the appreciation of his work by a select group, Sisley would always struggle to make a living.

View of Montmartre from the Cité des Fleurs, Les Batignolles is one of Sisley's earliest known landscapes, sober and carefully composed, in a style reminiscent of early Corot, who was one of Sisley's mentors. Its site had strong personal associations with Eugénie, for 27 Cité des Fleurs was her address between 1867 and 1873, and presumably his address as well when he was in the capital. Sisley's viewpoint gives an unusual, somewhat bleak view of the hill of Montmartre and captures a fragile moment in its history. Within a matter of years, that open foreground area with its grass and struggling, leafless saplings would be engulfed in the remorseless outward growth of Paris. In size and degree of finish, the painting has the look of a Salon submission, but it seems not to have been shown. It could have been one of the canvases Sisley had rejected by the jury in 1869. Reinforcing this theory is the similarity, in choice of motif and planar organization of structural elements, between this and Pissarro's ambitious landscapes of Pontoise, such as *L'Hermitage* (1868, Národní Galerie, Prague) or *L'Hermitage at Pontoise* (1867, Wallraf-Richartz-Museum, Cologne, cat. 40), one of which was almost certainly shown at the 1868 Salon.[2]

Little is known about Sisley's movements at this early date, and he stated that he lost much of his early work in the Franco-Prussian War. For this reason it would be intriguing to know when this painting was purchased by Joseph-Auguste Rousselin. A fellow pupil in Gleyre's studio, Rousselin made his Salon début in 1863 and specialized in portraits, horses, and genre subjects.[3] He was a cousin of the painter Jules Le Coeur, a close friend of Renoir's, and on the fringes of the group of future Impressionist painters trying to establish their careers in the 1860s. It would be nice to think that Rousselin stepped in in 1869, at Sisley's hour of need, to buy *View of Montmartre from the Cité des Fleurs* as a gesture of solidarity. A Rousselin, surely the same man, is mentioned in a cryptic way by Degas in a letter of 1884–85 to Henri Rouart, and implicitly dismissed as an artist who has been *bouguereauté,* that is, lured into the academic trap of slick finish.[4]

By 1901 Rousselin had moved to the fashionable tourist center of Grenoble. In a letter dated 9 May to the mayor of Grenoble, M. Jules Bernard, the conservator of the Musée de Grenoble, which already boasted one of the most notable art collections in provincial France, announced Rousselin's gift of the Sisley.[5] Was this generosity intended as a tribute to an old friend, recently deceased and now consecrated as museum-worthy (Sisley's *Flood at Port Marly* had sold the previous year for 43,000 francs, as Rousselin would surely have known), or was it a final severing of his ties with his erstwhile Impressionist colleagues?

Belinda Thomson

57.

View of Montmartre from the Cité des Fleurs,
Les Batignolles, 1869

Oil on canvas
27½ × 46⅛ inches (69.9 × 117.2 cm)
Musée de Grenoble

It is summer on the banks of the river Thames at Hampton Court. The sun is breaking through the clouds, and warm, shimmering light is flooding over the river, its softly rising banks, and the houses. People are strolling under the British naval flag, which flutters gaily in the breeze. They sit on the river's gentle slopes or ready one of the boats lying on the sandy shore waiting to be taken out. No one notices the two racing sculls as they move into the picture from under the bridge.

Alfred Sisley

Hampton Court lies southwest of London, easily reachable by train. It was a favorite place for Londoners to go on outings. Alfred Sisley came here in July 1874, six weeks after the first Paris group exhibition at the photographer Nadar's gallery. It was this event that led to Sisley and his friends being derisively dubbed the "Impressionists." One of their most loyal supporters, the famous baritone Jean-Baptiste Faure, had—in the princely tradition—invited the impoverished Sisley to accompany him when he went to sing in London. The painter, however, quickly fled to the idyllic Hampton Court, where he remained until the beginning of October. Sisley set up his easel on the terrace of the Castle Inn, where he probably also stayed. From there, on the southern bank of the Thames, he began to paint not only the summer bustle near the bridge but, moving his easel a few yards to the right, also the *Boat Race at Hampton Court* (Bührle Collection, Zurich). He went under the bridge to record its construction in a picture called *Under the Bridge at Hampton Court* (Kunstmuseum, Winterthur). Our painting lies topographically somewhere between this strictly axial painting and the light and air study of the *Boat Race*. The bridge on the left-hand side is Sisley's tribute to work and human endeavor, while the right half of the painting exults in the pleasure and beauty of nature.

Five of the sixteen paintings Sisley did at Hampton Court belonged in the end to his patron Faure. *The Bridge at Hampton Court* was not among them, although—or perhaps because—Faure owned a painting from 1872, the *Bridge at Villeneuve-la-Garenne* (The Metropolitan Museum of Art, New York), which bears a striking resemblance in composition to this work, though its colors are brighter. Our painting came into the collection of another early patron of the Impressionists, the brandy merchant, journalist, and author Théodore Duret. Duret's book *Histoire des peintres impressionnistes,* which appeared in 1906 but was based on a brochure from 1878, became a standard work on this school of painting. On 19 March 1894, Duret, who had fallen on hard times, auctioned a number of his Impressionist paintings in Georges Petit's gallery in Paris, an act many painters held against him because they suspected him of speculation. *The Bridge at Hampton Court* was sold for 1,350 francs, and at the beginning of the twentieth century it came into private German hands in Elberfeld (today a part of Wuppertal). From there the picture went to Cologne, first as part of a collection belonging to the industrialist Otto Wolff (1881–1940), who made his name as a book collector more than as an art collector. It was then owned by Mrs. Frangenheim, and in 1956 was acquired by the Kunstverein für die Rheinlande und Westfalen, based in Dusseldorf.

Stefan Pucks

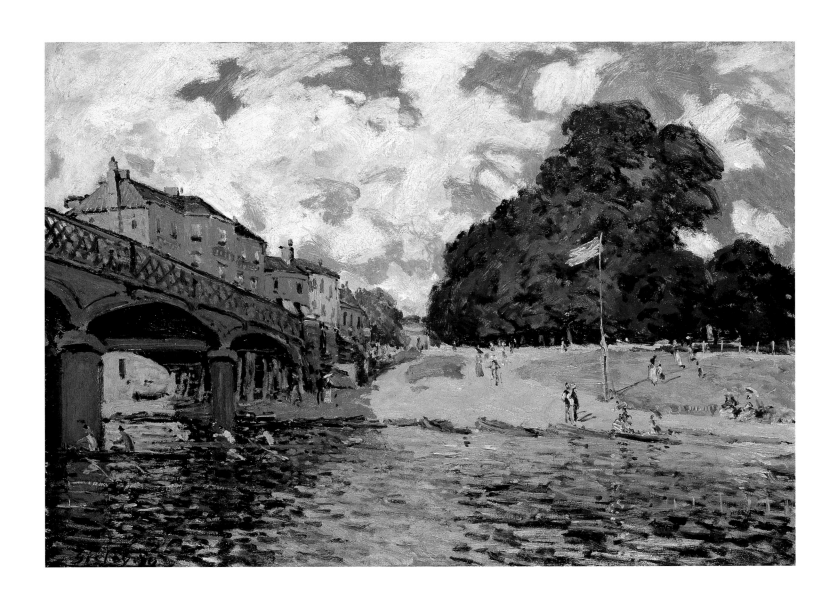

58.

The Bridge at Hampton Court, 1874

Oil on canvas
17⅞ × 24 inches (45.4 × 61 cm)
Wallraf–Richartz–Museum, Cologne

In 1880 financial hardship forced Sisley to leave Sèvres, on the outskirts of Paris, and move further out to the area around Moret-sur-Loing, to the southeast of the Forest of Fontainebleau. The scene depicted here is a footpath along the left bank of the Seine, just below its confluence with the Loing, at a site known as the Little Meadows. Wooded pathways along riverbanks are a subject that Sisley seems to have particularly favored in his work of the late 1870s and early 1880s.

Alfred Sisley

Sisley's canvas is a completely characteristic Impressionist painting, treating the effect of weather and light in an unpretentious scene. The color and handling give the canvas a great freshness. Sisley captures the sharp light that brings out vivid greens in the grass, the range of intense blues throughout the sky and river, and the white highlights in the gusting clouds and building on the distant bank. The small, blue-clad female figure in the foreground focuses the scene but remains incidental to the larger sense of burgeoning nature on a bright, breezy day in early spring. Sisley's brisk and mobile touch defines the foreground grass with assertive, broken dabs while a longer, curving stroke is employed for the branches with their newly emerging foliage.

The painting was bought at an early, unknown date by the pioneer New York collector of Impressionist paintings Erwin Davis; in April 1899 it was acquired by Durand-Ruel's New York gallery. By 1931, the painting was in London at the Arthur Tooth and Sons gallery. Five years later, it was purchased by the National Gallery, London, with funds raised from public subscription to honor the memory of the renowned English critic Roger Fry (1866–1934), who played such an important role in fostering a taste for modern art in England in the early years of this century. The choice of a work by Sisley at first seems surprising, since Fry, a champion of Cézanne, whose works he admired for their formalist structure, was a harsh critic of what he saw as the formlessness of Impressionism. The funds raised were evidently insufficient to buy a Cézanne.[1] It seems, though, that the choice of a Sisley was not so unsuitable as a tribute to Fry because, as Fry had explained: "[Sisley] surpassed the others no less in the significance of his design, in his infallible instinct for spacing and proportion. His designs have, to a high degree, that pictorial architecture which Monet's so conspicuously lack."[2] The painting was transferred to the Tate Gallery in 1953.

Ann Dumas

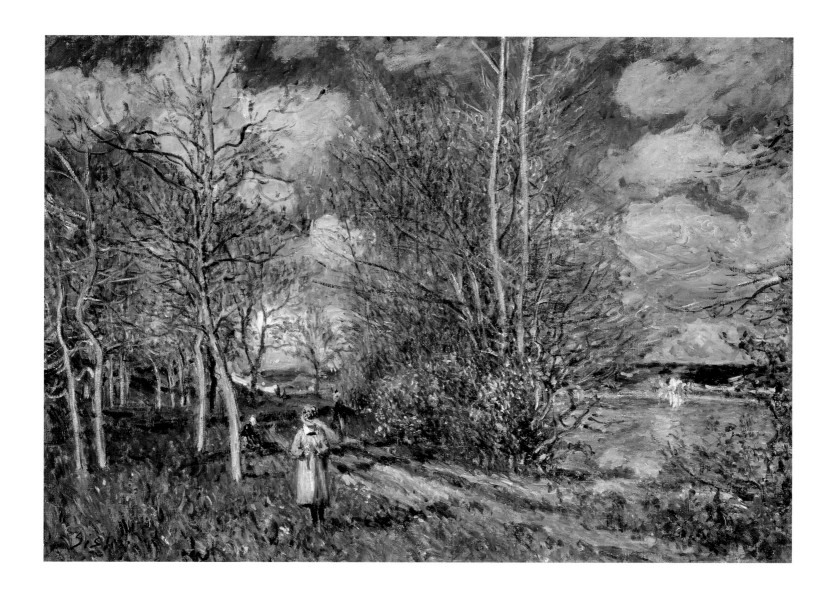

59.

The Little Meadows in Spring, 1880

Oil on canvas
21¼ × 28¾ inches (54 × 73 cm)
Tate Gallery, London; presented by a body of
subscribers in memory of Roger Fry, 1936

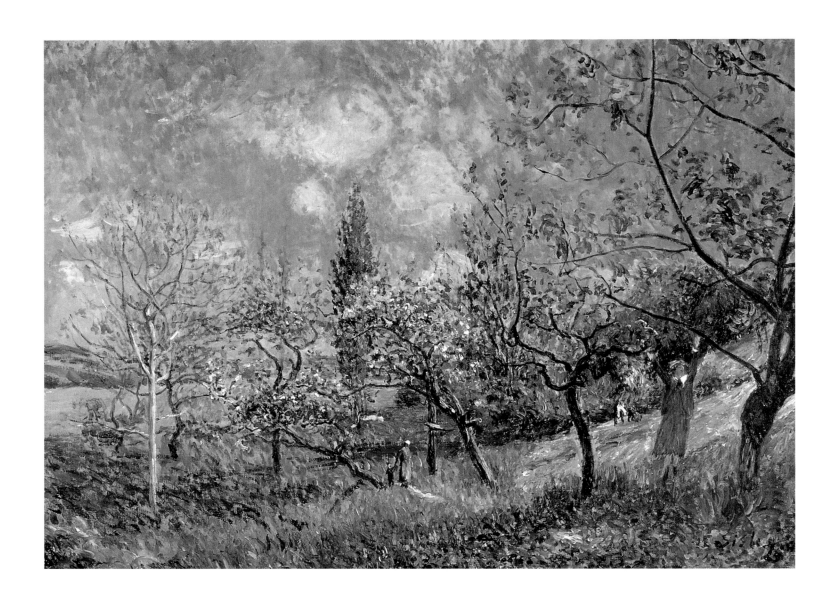

60.

A Meadow in Springtime at By, 1881

Oil on canvas
21¼ × 28⅜ inches (54 × 72.1 cm)
Museum Boijmans Van Beuningen, Rotterdam

Having explored motifs around Louveciennes, Marly-le-Roi, and Sèvres to the west of Paris during the 1870s, Sisley moved south of the city to the *départment* of Seine-et-Marne and lived in villages such as Veneux-Nadon and Les Sablons before finally settling in the medieval town of Moret-sur-Loing. To a certain extent this move represented a return to the Barbizon area where Sisley had begun to paint during the 1860s. Now, however, he concentrated on the barge port of Saint-Mammès at the confluence of the rivers Seine and Loing before immersing himself in the varied motifs presented by Moret-sur-Loing itself. While living at Veneux-Nadon in 1880–82, the artist painted a number of canvases of the paths, woods, and meadows extending along the river Seine at By, near Thoméry and Roches-Courtaut.

Alfred Sisley

As with the work of several other of the Impressionists at this time, these years mark a transitional stage in Sisley's development. By focusing on different subjects, he succeeded at the same time in extending the range of his style, as with *The Little Meadows in Spring,* 1880 (cat. 59)[1] and *The Banks of the Seine at By,* 1881 (The Sterling and Francine Clark Art Institute, Williamstown, Massachusetts).[2] In color and facture, these canvases resemble paintings by Monet from this time. Sisley now lays greater emphasis on creating a recession by brushstrokes and atmosphere than by linear perspective. He told Adolphe Tavernier, "I am in favour of a variation of surface within the same picture. . . . Because when the sun lets certain parts of a landscape appear soft, it lifts others into sharp relief. These effects of light, which have an almost material expression in nature, must be rendered in material fashion on the canvas."[3] The treatment of the sky, too, played a significant role within the composition since "not only does it give the picture depth through its successive planes . . . but through its form, and through its relations with the whole effect or with the composition of the picture it gives movement."[4] This emphasis on skies was widely acknowledged. For example, Camille Mauclair wrote: "He is the painter of great blue rivers curving towards the horizon; of blossoming orchards; of bright hills with red-roofed hamlets scattered about; he is, beyond all, the painter of French skies which he presents with admirable vivacity and facility."[5]

A Meadow in Springtime at By reveals Sisley's ability to integrate the varying forms within a landscape, including the figures who are almost camouflaged among the branches and foliage. This is partly achieved by the ebullience of the brushwork knitting different parts of the composition together, but also by the color. During the 1880s, Sisley's palette began to show greater contrasts, and the canvases painted at By are a confection of green, blue, red, purple, yellow, and white. This sophistication led in turn to the views of Saint-Mammès in the mid-1880s, where an awareness of neo-Impressionism is demonstrated, and culminates in the series of the church of Notre-Dame at Moret-sur-Loing, a series that inevitably invites comparison with Monet's paintings of Rouen Cathedral and is by no means diminished by it.[6]

According to Daulte, *A Meadow in Springtime at By* was bought by Durand-Ruel from the artist on 5 May 1881, and was sold by the dealer on 10 July 1934 to Madame de la Chapelle (Paris) before being acquired by D. G. Van Beuningen.[7] The Van Beuningen collection included another work by Sisley, *The Provencher Watermill at Moret* of 1883.[8]

Christopher Lloyd

Alfred Sisley

The subject is an unassuming landscape on a sunny autumn morning. This gentle view of fields and trees with a few modest houses in the distance and a peasant walking along a road was probably painted in the region of Moret-sur-Loing where Sisley lived from around 1880. The painting is characteristic of Sisley's Impressionist manner, with thickly painted, finely tuned brushstrokes that register the varied textures of trees, field, and sky, while the palette ranging from russet to purple-reds in the foliage and tree trunks offsets the bluish tonalities in the figure, road, pale sky, and distant horizon.

The painting is of great importance in the history of Impressionism's reception because it was the first Impressionist picture to be acquired by the French State. It was bought in February 1888 directly from the artist rather than from the Salon, which, as John House has pointed out, was very unusual for this time.[1] This was probably due, at least in part, to the intervention of Jules Castagnary, a critic and long-standing supporter of the Impressionists, who was briefly Director of Fine Arts during this period. It is not clear why the State chose this picture, but to official eyes Sisley was perhaps less outrageous than his colleagues. It may also have been part of a charitable policy on the part of the State to help out artists in financial difficulties. Sisley, however, was not pleased when the painting was transferred to the small town of Agen in southwestern France, commenting that "a canvas exhibited in such conditions is as good as lost."[2]

Ann Dumas

61.

September Morning, ca. 1887

Oil on canvas
21⅞ × 28⅞ inches (55.5 × 73.4 cm)
Musée des Beaux-Arts, Agen

62.

The Church of Moret, Evening, 1894

Oil on canvas
39⅜ × 31⅞ inches (100 × 81 cm)
Musée du Petit Palais, Paris

Alfred Sisley

In November 1889, Sisley settled permanently in the little town of Moret-sur-Loing to the southwest of the Forest of Fontainebleau, the area where he had spent much of his time since 1880, living a reclusive life rather cut off from the artistic world in Paris. From the garden of his house he could see the great Gothic church of Notre-Dame with its magnificent flying buttresses: it appears frequently in the background of his many views of the town. In 1893 Sisley began a series of twelve paintings of the church from the same viewpoint as it appeared at different times of day and seasons of the year. It is more than likely that he was inspired in this undertaking by Monet's series of thirty paintings of Rouen Cathedral, which were exhibited at Durand-Ruel's gallery two years later in 1895. But while in Monet's series the architectural detail of the cathedral is absorbed into atmospheric effects, Sisley shows a much greater interest in depicting the structural character of the building, without losing himself in descriptive details. Whereas Monet focuses on the façade, Sisley adopts a three-quarters view that includes part of the nave of the church and gives an idea of the massiveness of the whole structure. In the Petit Palais version, the building's dramatic presence is further enhanced by the very close viewpoint that virtually suppresses the foreground space. Sisley employs a thickly impastoed, dry, creamy-colored paint that perfectly renders the appearance of the stone in the soft, warm light of evening. His acute sense of the subtle effects of light playing over stone recalls the example of Corot, his early mentor and teacher.

Four of Sisley's canvases of the church at Moret were exhibited at the Salon in Paris in April 1894. The present work was acquired from the Salon of 1896 by the city of Paris. Three more versions were included in the one-man exhibition devoted to Sisley at the Galerie Georges Petit in 1897. Throughout his life, Sisley, a gentle and diffident man, struggled with lack of recognition and poverty, but within one year of his death in 1899, his works began to command high prices.

Ann Dumas

Barges from Berry on the Loing Canal in Spring depicts one of Sisley's favorite motifs, which he painted repeatedly and in all seasons in the last decade of his career. At Moret, where he had been established since 1880, the Loing canal runs side by side with the river of that name, and is distinguishable by its straighter course and bor-

Alfred Sisley

ders of poplars. Sisley's composition is remarkably simple, made up of a series of horizontal bands differentiated by technique as much as by color. Beyond the roughly treated pinkish towpath in the foreground, he has used broad flat brushstrokes of olive to indicate reflections in the limpid water; a fussier, drier stroke is used for the roofs of Moret disappearing into the blue horizon and for the wintry trees just fuzzed with new foliage. "It is at Moret," Sisley wrote in 1892 to Adolphe Tavernier, his friend and first biographer, "in this thickly wooded countryside with its tall poplars, the waters of the river Loing here, so beautiful, so translucent, so changeable; at Moret my art has undoubtedly developed most; especially in the last 3 years."[1]

Sisley's *Barges from Berry* changed hands frequently in the 1900s, a telling index of the rapid rise in the market values of the artist's work after his death.[2] In 1897 Sisley's major one-man exhibition, organized by the dealer Georges Petit, had been a disaster in terms of sales. Yet by May 1899, only three months after the artist's death from throat cancer, it was a different story. Petit auctioned thirty-three of the paintings remaining in his studio, together with donated canvases by fellow Impressionists, in aid of the artist's children. Monet rallied the support of Sisley's peers and friends to ensure a favorable outcome. *Barges from Berry* was bought by Tavernier. Less than a year later, eleven paintings from his important collection of Sisleys went under the hammer and *Barges from Berry* sold for 5,550 francs to the Marquise Arconati-Visconti, one of three works she bought. It was not with her long. The Bernheim-Jeune gallery sold it to the Prince de Wagram, one of the most voracious buyers of Impressionist pictures before the First World War. *Barges from Berry* moved, on or before de Wagram's death in action in 1918, to its final home. That same year its presence is noted in the checklist of Wilhelm and Henny Hansen's collection.[3] Hansen (1868–1936), who had made a fortune in the insurance business, began collecting French art on a major scale in 1916. His collection was to be splendidly housed in its own specially designed picture gallery at Ordrupgaard, the new house he was having built in a residential suburb of Copenhagen. After it was completed in 1919, the Hansens opened their collection to the public on one day a week. At the death of Henny Hansen in 1951, Ordrupgaard was bequeathed to the Danish State and reopened as a public museum in 1953.

Belinda Thomson

63.

Barges from Berry on the Loing Canal
in Spring, 1896

Oil on canvas
21¼ × 25⅝ inches (54 × 65.1 cm)
Ordrupgaard, Copenhagen

Vincent van Gogh

When van Gogh moved from Brussels to Paris in February 1886 to live with his brother Theo, he knew very little about Impressionism. It was through Theo, a manager of a Parisian art firm, that he was introduced to such artists as Gauguin, Toulouse-Lautrec, Sisley, Signac, and Degas. His immersion into the style occurred after the eighth and final exhibition, when most Impressionist painters had reached their maturity and were exploring new avenues of expression.

Van Gogh painted self-portraits from 1885 until his death in 1890. He was most prolific during his Paris years, 1886–88, during which he painted twenty-two portraits, including this one. Unlike most Impressionists, van Gogh was interested in the individuality and the emotion of the human face.

Through his self-portraits we can see van Gogh's technique and image of himself alter dramatically. In his early years, he painted heavy forms with dark colors. Once he adopted Impressionism, however, his color palette lightened, and his brushstrokes became shorter and looser. He alternated between images of himself as a peasant, wearing straw hats and work clothes, and as a wealthy Parisian intellectual, wearing felt hats and fine, embroidered suits.[1] The early Paris self-portraits show a vigorous, happy man. He was living with his brother, with whom he was very close, and had met a group of artists that he admired. As the years passed, the late nights, lack of money, and lack of interest in his work exhausted him, and his later self-portraits reflected his growing disillusionment and ill health.

Self-Portrait with a Straw Hat has proven difficult to date. Although it was originally attributed to van Gogh's time in Arles, it is now thought to have been painted during the summer of 1887. Van Gogh wears the traditional yellow straw hat of a laborer and a yellow workcoat with a vivid, red trim around the collar. His thick beard is painted in clear, short brushstrokes. The strong, dark accents around his right eye and along the bridge of his nose, as well as the shadows along his cheekbones, accentuate the gauntness of his face and hint at van Gogh's declining health during his last unhappy months in Paris. Although his suffering is more noticeable in other self-portraits, the three-quarters profile and his direct, sorrowful gaze show a man fighting inner demons. The contrast between the deep blue of van Gogh's right eye and the light green of the left intensify his gaze.

Van Gogh was emotionally and financially dependent upon Theo. When the artist died on 29 July 1890, Theo became the sole heir to van Gogh's estate. When Theo died in 1891, this painting, along with the rest of van Gogh's estate, was passed to Theo's wife, Johanna van Gogh Bonger, who was in Amsterdam. Although she sold many of the paintings, she steadfastly refused to sell the self-portraits.[2] Upon her death in 1925, her son Vincent Willem van Gogh of Laren inherited the estate. While promoting his uncle's fame, Vincent Willem refused to sell van Gogh's works and in 1930 loaned the collection to the Stedlijk Museum in Amsterdam for permanent display. The resulting scarcity in the market caused prices for van Gogh's works to soar, and the collection eventually became too valuable for Vincent Willem to retain. In order to preserve the collection, the van Gogh family and the government of the Netherlands created the Vincent van Gogh Foundation in 1960. In 1973, the collection moved to the Van Gogh Museum, where it is housed today.[3]

Ann W. Grove

64.

Self-Portrait with a Straw Hat, 1887

Oil on pasteboard
16 × 12¾ inches (40.6 × 32.4 cm)
Van Gogh Museum (Vincent
van Gogh Foundation), Amsterdam

Vincent van Gogh

Van Gogh came late to his vocation as a painter, after struggling to find his way in other fields—art dealing, teaching, the ministry—each of which, in different ways, influenced his artistic career, which lasted only a decade.

In 1886, van Gogh came to Paris, where his brother Theo was working as a dealer for Boussard and Valadon. Already well versed in the realist traditions of his native Dutch school and an admirer of the social realist strand within Victorian art and literature, van Gogh was keen to absorb lessons in color from the French artists. Having seen what the Impressionists and their followers were doing, he lightened his palette and began to explore color complementaries, but he was never truly absorbed into the Impressionist movement. Japanese art, with its bold designs and flat contrasts of color, was an equally strong influence on his later development.

By early 1888, van Gogh felt the need to put Paris and the confusion of new ideas it represented behind him. His first year in Arles was an intensely productive period. One of the fruits of working in a smaller community was the chance to develop the theme of portraiture, which he held to be the most significant branch of art. He claimed, when working on the portraits of the Roulin family, that the practice of portraiture consoled him "up to a certain point for not being a doctor."[1]

Armand Roulin (1871–1945) was the eldest son of the postman Joseph Roulin, van Gogh's neighbor in Arles, who first posed for his portrait in August 1888, wearing his uniform (cat. 66). In the late autumn, van Gogh embarked on a project to paint the whole family, including Madame Roulin, their new baby Marcelle, and the two older sons, Camille and Armand, in a series of head-and-shoulders portraits. Two similar portraits of Armand were done in November, when the lad was seventeen and apprenticed to a blacksmith in a nearby town. Just as the father's head was set against a flat, smoothly painted yellow background, Armand was set against jade green, and the eleven-year-old Camille against red and orange. Hung together, they would have made a striking impact. Of the two, it was *Portrait of Armand Roulin, Full-Face* (de la Faille, no. 492) that the family chose to keep, although they sold it to Vollard in 1895.

Thanks to the extensive research of Walter Feilchenfeldt, we now have a full and extremely telling picture of the early provenance of this version of *Portrait of Armand Roulin*.[2] Following the artist's death in 1890 and the death of his brother Theo in 1891, the portrait, together with the bulk of van Gogh's output, came into the hands of Johanna van Gogh Bonger, Theo's widow. In the years leading up to the First World War, she allowed a steady flow of these paintings to be exhibited and then sold in Germany through the Berlin dealer Paul Cassirer. Between 1905–1906, this portrait was seen in exhibitions in Amsterdam, Hamburg, Dresden, Berlin, and Vienna. Cassirer exhibited it again in Berlin in 1908, and then it passed to Bernheim-Jeune in Paris. In 1910 M. Goldschmidt of Frankfurt sold it to the Wallraf-Richartz-Museum in Cologne. This, however, was not the end of the story. It fell afoul of Hitler's policy to rid German museums of "degenerate art." The subject—a sullen adolescent—was perhaps more susceptible to such rejection than the other van Gogh owned by Cologne, the *Langlois Bridge*, 1888 (de la Faille, no. 570), which was spared. The painting again found itself on the market and was finally acquired in 1939 for 70,000 Dutch guilders by D. G. Van Beuningen, with whose collection it entered the Museum Boijmans Van Beuningen in 1958.[3]

Belinda Thomson

65.

Portrait of Armand Roulin, 1888

Oil on canvas
25⅝ × 21¼ inches (65.1 × 54 cm)
Museum Boijmans Van Beuningen, Rotterdam

Vincent van Gogh

This version of the monumental portrait of the postman Roulin, seated in a cane chair, is the sixth of nine images of this subject.[1] Van Gogh often explored alternatives to his compositions and would paint replicas or make drawings of works, which he would send to his brother Theo, his sister, or friends with whom he exchanged pictures from time to time. This painting of Roulin is not as imposing as the first version, done five months earlier, but it shows a marked advance toward modernism. There is an emphasis on boldly brushed color contrasts of the complementaries: the intense blue of the coat against the sunny yellow in the flat background. The face is much less specific in its characterization than in the earlier portrait, which is marked by a sympathetic interpretation of a seemingly guileless personality. Here the features are vague, the eyes are unfocused, and the dense beard is formed by an abstract pattern of heavy gray and green brushstrokes. Van Gogh seems to be distancing the presentation from the specific realities and the Impressionist treatment in much of his earlier works. The Roulin portraits fit in with van Gogh's program of depicting various working-class types. He had been inspired by his fellow countryman Frans Hals, whose portraits of Dutch burghers seemed to him a convincing representation of the Dutch people.[2]

It was van Gogh's habitual urge to change scenery that drove him to move from Paris to Arles after just two years. There is no doubt that the transfer to a different environment sparked a renewed enthusiasm and inspiration when he saw the Provençal gardens and fruit orchards in the splendor of spring. He worked furiously to capture the southern atmosphere, producing an amazingly large body of work.[3]

As he matured, van Gogh's paintings moved from the staccato neo-Impressionist brushwork he employed in Paris toward the heavier, linear strokes and even stronger colors in his landscapes and especially in his self-portraits. Buildings, interiors, bridges, and marine scenes were among his subjects, often drawn in pencil or pen with singularly rich and moving effects. Windblown wheat fields and agitated trees became predominant and increasingly bold, with the use of saturated color contrasts and furiously moving strokes in heavy impasto conveying a sense of dangerously charged energy.

Van Gogh was in Arles for only one year during this period of feverish creativity. Intervals of mental imbalance forced him to enter an asylum near Saint-Rémy in April 1889. In spite of recurring attacks, he was able to continue his work with undiminished force. Pictures selected by Theo were shown in exhibitions in Paris and Brussels.[4] A year later he insisted on leaving Saint-Rémy and put himself in the care of Dr. Paul Gachet in Auvers-sur-Oise. Gachet, an amateur painter, proved to be an empathetic influence and van Gogh was able to continue his work, moving about freely and even visiting his brother in Paris. In the end, however, he despaired of recovering his mental health and shot himself at the end of July 1890.[5]

This painting was first owned by M. Fabre of the hamlet of Gasparets, then sold through Galerie Druet to Dr. Keller in Paris. In May 1915, Georg Reinhart of Winterthur purchased the painting through Druet. Reinhart was a major collector of European and Asiatic art. Forty years later, Reinhart's heirs donated the work to the Kunstmuseum in Winterthur.

Gudmund Vigtel

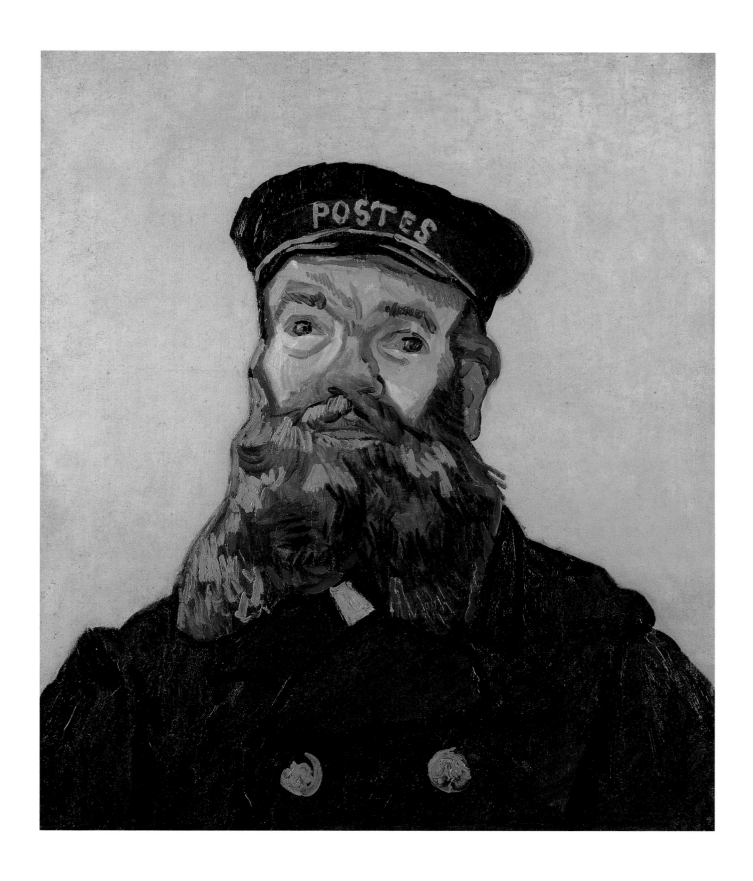

66.

Portrait of Joseph Roulin, 1888

Oil on canvas
25⅝ × 21¼ inches (65.1 × 54 cm)
Kunstmuseum, Winterthur

Federico Zandomeneghi

In Bed is a painting that links two Italians, the Venetian painter Federico Zandomeneghi and the Florentine art critic Diego Martelli (1839–1896). Between them they did much to build bridges between the most advanced groups of artists then active in Italy and France. Zandomeneghi belonged briefly to the Florentine-based group the Macchiaioli before moving to Paris in 1874. Although he had planned to stay scarcely more than a fortnight, he settled in France, dying there just two months after his close friend Degas. The two artists were drawn together from the outset by a mutual commitment to the project of painting modern life. Zandomeneghi deliberately steered clear of the route to popular success pursued by his fellow Italians Giovanni Boldini and Giuseppe de Nittis, identifying instead with the Impressionists. He exhibited with them for the first time at their fourth exhibition in 1879.

Diego Martelli, who had joined Zandomeneghi in Paris the previous year, wrote enthusiastic reviews of this show for the benefit of his readers back home, warmly praising Zandomeneghi's innovative work. He was keen to encourage artistic cross-fertilization, an attitude embodied in his decision to sit for his portrait to both Degas and Zandomeneghi at this time.[1]

Zandomeneghi did not put *In Bed* into the 1879 Impressionist show, but instead sent it back to Florence for the annual Promotrice in April 1879, where it was shown to resounding abuse from the Florentine critics: "Too much realism, too little aesthetic [quality]," wrote one.[2] At the same exhibition, two Pontoise landscapes, which Martelli had persuaded Pissarro to send to Florence and which he encouraged his Italian artist friends to study, met with total incomprehension.[3] Neither Zandomeneghi's painting nor Pissarro's found buyers. They were subsequently acquired by Martelli himself.

Daring in its informality and simplicity, *In Bed* can be seen as an example of the kind of art Martelli wished to promote. Its intimate yet comparatively chaste subject, a young woman asleep in bed, was based on a delicate study executed two years earlier. It clearly appealed to Martelli more than *Rolla,* the *succès de scandale* of 1878, in which the academically trained Henri Gervex, pupil of Cabanel and friend of Degas, had also depicted a woman asleep in bed in a modern interior. The difference was that in *Rolla* the woman is voluptuous and provocatively naked and a man is present. Rejected from the Salon on grounds of impropriety, *Rolla* was shown instead at a private dealer's shop where, over a three-month period, it attracted considerable attention from the critics. Martelli argued that despite his steamy subject matter (in fact, a poem by Alfred de Musset), Gervex had produced an "icy cold" picture reminiscent of Cabanel.[4] In contrast, Zandomeneghi's naturalism seems taken straight from life, creating an effect of warm intimacy.

In 1886, *In Bed* does seem to have been exhibited in Paris at the eighth and final Impressionist exhibition. Alongside Degas's famous "Suite of nudes" in pastel, Zandomeneghi showed twelve untitled works—four paintings and eight pastels. The critic Félix Fénéon, who generally approved of Zandomeneghi's submission, gave a cryptic description of one of these, which seems to be *In Bed:* "flat out on pillows, her hands joined above her hair, the sinuosity of her dorsal curves against a wall-hanging slashed with greens, reds and yellows."[5]

Diego Martelli died in 1896 without heirs, and *In Bed* was bequeathed, with the rest of his important collection, to the Galleria d'Arte Moderna in Florence.[6]

Belinda Thomson

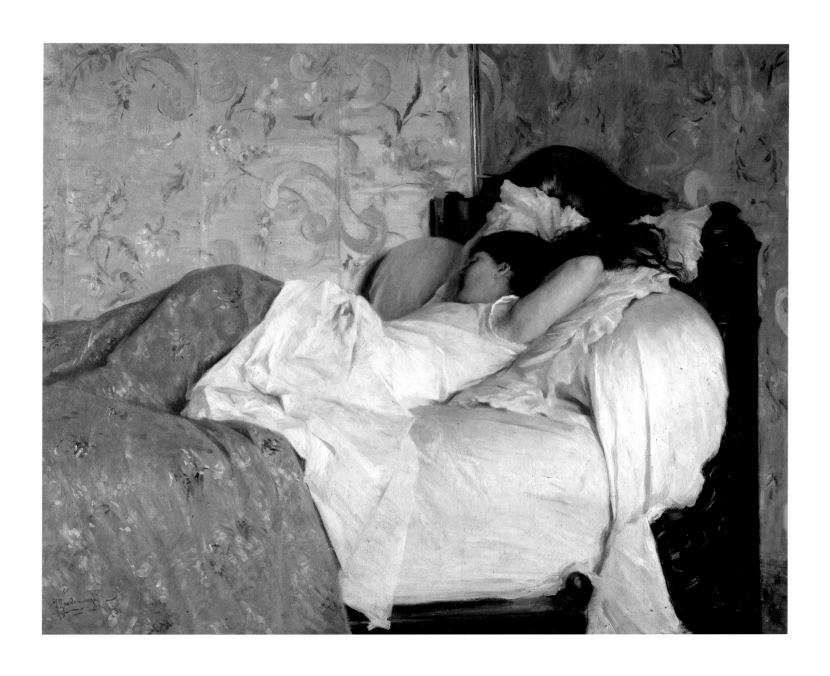

67.

In Bed, 1878

Oil on canvas
23⅞ × 28⅞ inches (60.6 × 73.3 cm)
Galleria d'Arte Moderna, Florence

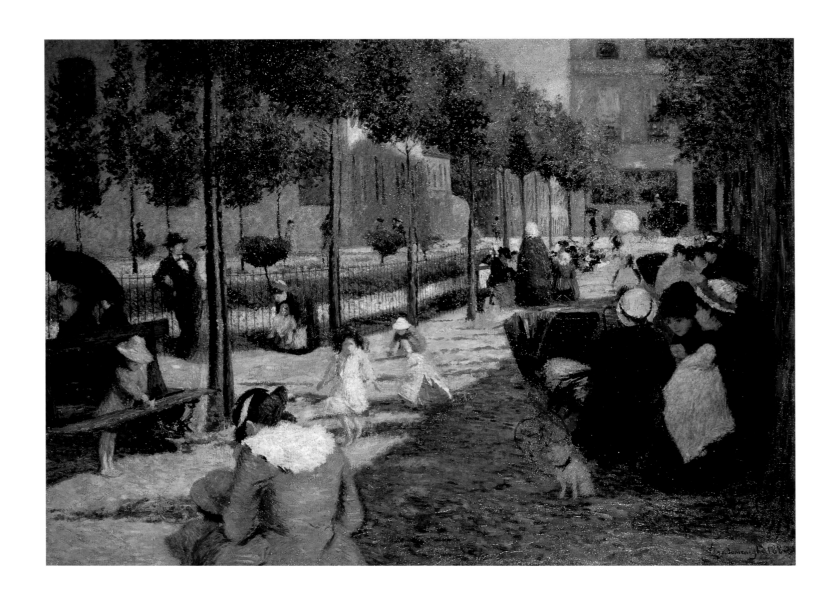

68.

Place d'Anvers, Paris, 1880

Oil on canvas
40⅛ × 53½ inches (104.5 × 135.9 cm)
Galleria d'Arte Moderna Ricci Oddi, Piacenza

Federico Zandomeneghi

Shown at the sixth Salon des Indépendants in Paris in 1881, this painting is a fine example of Italian Impressionism.[1] It depicts the animated life of the square facing the painter's house in Montmartre on a sunny day that has drawn mothers and nursemaids to the gardens. The artist uses a distinctive diagonal perspective, emphasizing figures in the foreground and picking up the elongated form of the square, trees, and flowerbeds. Subjected to the light, the forms lose their definite edges and contours, except in the shadowed area to the right, where a better-defined group of women cluster. Zandomeneghi employs short brushstrokes, a technique probably borrowed from his friend Pissarro.

Zandomeneghi had come to Paris in 1874 to see the annual Salon and never left. He was skeptical of Impressionism at first, but by 1879 onward he was in the movement. He may have been influenced by the Italian critic Diego Martelli, a friend who had come to Paris in 1878.

We do not know much about the wanderings of the painting after 1881. It passed through the gallery of Durand-Ruel in 1911 to be shown at the International Exhibition in Rome celebrating fifty years of Italian unity. Two other works by Zandomeneghi were exhibited at the same time, *Morning (Il mattino)* and *In the Restaurant (In trattoria)*. It seems likely that on the occasion of the Rome exhibit the painting was acquired by Angelo Sommaruga, a Roman publisher. Shown in Milan in 1922 by the Galleria Pesaro, one of the most important galleries in the city, the work did not attract favorable notice. The same year, the painting, along with *Girl with White Collar (Ragazza dal collaretto bianco)*, was purchased for 15,000 lire by a collector from Piacenza, Giuseppe Ricci Oddi (1868–1937). He had begun collecting paintings, sculptures, and graphics from the Romantic period to the beginning of the twentieth century, with the creation of a museum of modern art as his aim. The project was realized in 1924 when Ricci Oddi donated over four hundred works to the city of Piacenza. The works were displayed in a gallery (built by Ricci Oddi and bearing his name) that opened in 1931.

Place d'Anvers, Paris finally received critical praise in Roberto Longhi's introduction to the Italian translation of *The History of Impressionism* by John Rewald: "The particular care of the form calibrated within the Impressionistic vibrations seems to almost anticipate certain thoughts of the Divisionism of Seurat."[2] From that time on, the painting has been frequently borrowed for exhibitions, including the twenty-sixth Biennale of Venice, and the Washington, D.C., and San Francisco exhibition *The New Painting: Impressionism 1874–1886,* in 1986.

Stefano Fugazza

Notes to the Catalogue

CAT. I

1. Charles Baudelaire, "Salon de 1859," in *Écrits sur l'art* II (Paris, 1971), p. 74.

2. A wine merchant of Bordeaux, Théophile Bascle was also a painter and friend of Jongkind. His collection included eight Boudins. See Robert Schmit, *Eugène Boudin 1824–1893* I (Paris, 1973), nos. 958 and xlvi.

3. *Tavaszi kiállítás: Gauguin, Cézanne* (Spring Exhibition: Gauguin, Cézanne), May 1907. Cat. no. 3 (Old Harbor).

4. Albert Caro to Gábor Térey, Szépművészeti Múzeum Archives. 1907/1010, 1173.

CAT. 2

1. Boudin to L. Boudin, 27 April 1893; quoted in Laurent Manoeuver, *Eugène Boudin: Dessins* (Paris, 1992), p. 208.

CAT. 4

1. Although Geffroy, in his introductory essay to the Bracquemond exhibition held at the Galerie Bernheim-Jeune in 1919, said the panel was sent to the Philadelphia Museum of Art, the drawings have not been located. See Jean-Paul Bouillon in *The Crisis of Impressionism,* exh. cat. (Ann Arbor, Mich., 1979), p. 61, n. 5, which publishes old photographs of the drawings and the panel.

2. Gustave Geffroy, "Histoire de l'Impressionisme," 3rd ser., chapter XI in *La Vie artistique* (Paris, 1894), p. 268.

CAT. 5

1. See, for example, Julia Sagraves, *"The Pont de l'Europe"* and *"The Pont de l'Europe (Study),"* in Anne Distel et al., *Gustave Caillebotte: Urban Impressionist,* exh. cat. (Paris, Chicago, New York, 1995), pp. 102–105.

2. Émile Zola, "Une exposition: Les peintres impressionistes" (1877), in *Écrits sur l'art,* ed. Jean-Pierre Leduc-Adine (Paris, 1991), p. 359.

CAT. 6

1. J.-K. Huysmans, "L'Exposition des Indépendants en 1880," *L'Art moderne* (Paris, 1883), pp. 96–97.

2. Due to a large inheritance, Caillebotte was a millionaire by the age of thirty. See Anne Distel, *Impressionism: The First Collectors* (New York, 1990), p. 252.

3. Ibid., pp. 252–256.

4. Paris, Archives du Louvre, 1869, p. 8; cited in Anne Distel et al., *Gustave Caillebotte: Urban Impressionist,* exh. cat. (Paris, Chicago, New York, 1995), p. 366.

CAT. 7

1. J.-K. Huysmans, quoted in Tamar Garb, "Gender and Representation," *Modernity and Modernism—French Painting in the Nineteenth Century* (New Haven, 1993), p. 267.

2. Arnaud D'Hauterives in *Les Femmes Impressionistes,* exh. cat. (Musée Marmottan, Paris, 1993).

CAT. 8

1. Guillaume Apollinaire, reviewing Mary Cassatt's exhibition at the Durand-Ruel gallery, *Paris-Journal,* 10 June 1914; reprinted in *Apollinaire on Art* (London, 1972), p. 404.

2. *Chicago Inter-Ocean,* 13 November 1904; quoted in Frederick A. Sweet, *Miss Mary Cassatt* (Norman, Oklahoma, 1966), p. 167.

3. Ibid., p. 147.

4. I am grateful to Caroline Durand-Ruel Godfroy for this information.

CAT. 9

1. Hans Platte, "Zu einem Bild von Armand Guillaumin," *Museum und Kunst, Beiträge für Alfred Hentzen,* ed. Hans Werner Grohn and Wolf Stubbe (Hamburg, 1970), p. 165.

2. John Rewald, Walter Feilchenfeldt, and Jayne Warman, *The Paintings of Paul Cézanne* (New York, 1996), 1:200.

3. Cézanne to his niece Paulette Conil, 1 September 1902. John Rewald, ed., *Paul Cézanne, Briefe* (Zurich, 1995), p. 273.

4. Ambroise Vollard, *Paul Cézanne* (Munich, 1921), p. 128.

5. Gustav Schiefler, *Eine Hamburgische Kulturgeschichte 1890–1920* (Hamburg, 1985), p. 134. Behrens owned two other pictures by Cézanne, *Portrait of the Artist* (ca. 1877) and *The Winding Road* (1879–82).

CAT. 10

1. Anne Distel, *Impressionism: The First Collectors* (New York, 1990), p. 125.

2. The highest price paid for a Cézanne was 6,200 francs for *The House of the Hanged Man, Auvers* by Durand-Ruel for Count Isaac de Camondo. But 10,500 francs was the price paid for the small version of Renoir's *Dancing at the Moulin de la Galette*. See ibid., p. 129.

3. Ten works by Cézanne had been included in the enormous exhibition at the Grafton Galleries organized by Durand-Ruel in 1905. In 1910 a substantial group of paintings by Cézanne was largely greeted with hostility when displayed at the Grafton Galleries in the Post-Impressionist exhibition organized by the distinguished critic and great champion of Cézanne, Roger Fry. When the National Gallery bought the core of its modern French collections from the Degas sale in 1918, the director, Sir Charles Holmes, could not accept a work by Cézanne, *Apples* (Fitzwilliam Museum, Cambridge), so it was bought instead by the famous economist John Maynard Keynes.

4. Courtauld to Kenneth Clark, director of the National Gallery, 15 February 1934, National Gallery Archives, London; cited in John House, *Impressionism for England: Samuel Courtauld as Patron and Collector*, exh. cat. (Courtauld Institute Galleries, London, 1994), p. 21.

CAT. 11

1. Mary Louise Krumrine, *Paul Cézanne, Die Badenden,* exh. cat. (Kunstmuseum Basel, 1989), p. 246. She analyzes Cézanne's complete repertoire of bathing figures.

2. For more about Fåhræus, see *Svenskt biografiskt Lexikon,* vol. 16 (Fich-Gehlin) (Stockholm, 1964–66), pp. 680–681.

3. For more about Halvorsen, see *Hvem er Hvem?,* 11th ed. (Oslo, 1973), p. 205, and 12th ed. (Oslo, 1979), p. 722. According to John Rewald, Halvorsen's watercolors consisted of twenty-four landscapes and two still lifes. See Rewald, *Paul Cézanne: The Watercolors* (London, 1983).

4. For more about Moltzau, see *Hvem er Hvem?,* 12th ed. (Oslo, 1979), pp. 441–442, and 13th ed. (Oslo, 1984), p. 623. For more about his art collection, see *From Cézanne to Picasso—The Moltzau Collection,* exh. cat. (Tate Gallery, London, 1958).

CAT. 12

1. In the classic passage in the letter to Joachim Gasquet of 26 September 1897, Cézanne writes, "Art is a harmony which runs parallel to nature." See John Rewald, ed., *Paul Cézanne, Briefe* (Zurich, 1995), p. 243.

2. Pissarro to Émile Bernard, 26 May 1904. Ibid., p. 283.

3. Verena Tafel, "Paul Cassirer als Vermittler Deutscher Impressionistischer Malerei in Berlin. Zum Stand der Forschung," *Zeitschrift des Deutschen Vereins für Kunstwissenschaft* 42 (1988): 40.

CAT. 13

1. See Henri Loyrette in *Degas,* exh. cat. (Paris, 1988), p. 102.

2. Theodore Reff, *The Notebooks of Edgar Degas* (Oxford, 1976), notebook 18, p. 161.

3. Durand-Ruel archives, stock no. 2755.

CAT. 14

1. Julius Meier-Graefe, *Degas* (1920), plate 86, dates it as late as ca. 1890. P. A. Lemoisne, *Degas et son oeuvre* II (1946), no. 390, dates it to 1875–80, which seems more plausible.

2. In 1916 Sagen promised the Nasjonalgalleriet the sum of 60,000 Norwegian crowns for the purchase of French art. Five paintings were bought in 1917 and 1918, all from the then-current *French Art* exhibition. In 1918 Cézanne's *Seated Man* was bought from the same exhibition and presented to the Nasjonalgalleriet by the recently founded friends' association, Nasjonalgalleriets Venner.

3. The Nasjonalgalleriet's director, Jens Thiis, kept very incomplete journals, and the minutes of proceedings for the years 1905–20 are lacking in the museum's archives. He was a headstrong gentleman, not overly concerned about formalities.

CAT. 15

1. It was performed 758 times, with the last performance in 1893. See Michael Pantazzi in *Degas,* exh. cat. (Paris, 1988), p. 172.

2. Theodore Reff, *The Notebooks of Edgar Degas* (Oxford, 1976), notebook 24, p. 119.

3. Albert Hecht and his brother were traders in exotic colonial goods, wood, and ivory. Albert stopped buying paintings in 1886. Before his death three years later, he made a donation to the fund that Monet organized to give Manet's *Olympia* to the nation. For information on the Hechts, see Anne Distel, *Impressionism: The First Collectors* (New York, 1990), pp. 70–71.

4. Ibid., pp. 75–93.

5. Degas had agreed to paint four large paintings for Faure in return for Faure's paying 1,500 francs and buying back from Durand-Ruel six paintings that Degas was dissatisfied with and wanted to repossess, including the earlier version of *Robert le Diable* from 1871.

6. Durand-Ruel Stock Book, 20 February 1881, no. 3057.

7. This was through his friendship with Degas's friend Alphonse Legros (1837–1911), a French academic artist based in London.

8. Douglas Cooper, *The Courtauld Collection* (London, 1954), p. 67.

CAT. 17

1. See Colin Thomson, *Pictures for Scotland: The National Gallery of Scotland and Its Collection* (Edinburgh, 1972), p. 92–93.

CAT. 18

1. Robert Chipperfield bequest. Southampton City Art Gallery Archives.

CAT. 19

1. On Gauguin's art collecting, see Merete Bodelsen, "Gauguin's Cézannes," *The Burlington Magazine* 104 (May 1962): 204–211, and "Gauguin, the Collector," *The Burlington Magazine* 112 (September 1970): 590–615.
2. Gauguin to Schuffenecker, June 1888; quoted in Bodelsen, "Gauguin's Cézannes," 1962, p. 208. The work in question was most likely Cézanne's *Fruit Bowl, Glass, and Apples* (private collection), which Gauguin was finally forced to part with in 1898. Regarding this painting and the details of its sale, see Bodelsen, "Gauguin, the Collector," 1970, p. 606; and Claire Fréches-Thory, "Portrait of a Woman, with Still Life by Cézanne," in *The Art of Paul Gauguin* (Washington, D.C., 1988), pp. 192–193.
3. The other four works by Cézanne include *Nude Woman, Zola's House, Path with Trees,* and *Mountains, L'Estaque.* According to Bodelsen, Gauguin may also have owned an additional work by Cézanne, *The Harvest.* See Bodelsen, "Gauguin, the Collector," 1970, pp. 605–606.
4. John Rewald, *Gauguin* (New York, 1938), p. 8.
5. Richard Shiff, *Cézanne and the End of Impressionism: A Study of the Theory, Technique, and Critical Evaluation of Modern Art* (Chicago and London, 1984), p. 163.
6. The critic Camille Mauclair once noted the presence of "a very real affinity" between Gauguin, Cézanne, and Renoir. See Camille Mauclair, *The French Impressionists* (London, 1903), p. 198.
7. Richard Shiff has pointed out that Renoir and Cézanne were in close contact with one another during 1882, and that Renoir may have inspired Cézanne's practice of modeling with bright, contrasting colors. See Shiff, *Cézanne,* 1984, p. 300, n. 23. Kermit S. Champa has identified a related pattern of assimilation between the two artists, noting that during the early 1880s, Renoir admired and was able to learn from Cézanne's technique for achieving a low-relief pictorial surface. See Kermit Swiler Champa, *Studies in Early Impressionism* (New Haven, 1973), p. 37. I am indebted to Champa for helping me to discern Renoir's influence in Gauguin's painting.
8. This painting is no. 26 in the Impressionist exhibition catalogue (1882), which is reproduced in *The New Painting: Impressionism 1874–1886* (San Francisco, 1986), p. 394.
9. Georges Wildenstein, *Gauguin I: Catalogue raisonné* (Paris, 1964), no. 65. Significantly, Wildenstein dates this work to 1881. It is one of two of Gauguin's paintings from his Impressionist period now represented at Rennes, the other being Gauguin's *Vase of Flowers by the Window,* 1881 (G. Wildenstein, *Gauguin I,*

no. 63), which was also shown at the seventh Impressionist exhibition.

CAT. 21

1. Victor Merlhès maintains in *Correspondance de Paul Gauguin 1873–1888* (Paris, 1984), p. 68, n. 149, p. 398, that it has only been assumed, never proven, that the portrait of Mette was shown at the Autumn Exhibition. The same applies to *Basket with Flowers.* Yet according to Gauguin, the pictures were all painted in Rouen, all dated 1884, and were dispatched from Rouen to Kristiania in August of that year. This—and their provenance from Herman Thaulow's collection (later Horst)— make it more than likely that *Portrait of Mette Gauguin* was among the pictures exhibited at the Autumn Exhibition in October 1884.
2. See ibid., letters covering the period 1885–86. More accessible is David Sweetman, *Paul Gauguin: A Complete Life* (1996), pp. 110, 112, 122.

CAT. 22

1. Richard Brettell et al., *The Art of Paul Gauguin,* exh. cat. (Washington, 1988), p. 11.
2. Gauguin to Mette Gauguin, July 1886. Victor Merlhés, ed., *Correspondance de Paul Gauguin* (Paris, 1984), no. 110.
3. Pierre Leprohon, *Paul Gauguin* (Paris, 1975), p. 95; cited in Judy Le Paul and Charles Guy Le Paul, *Gauguin and the Impressionists at Pont-Aven* (New York, 1987), p. 80. Gauguin's elongated brushstrokes, which contrasted severely with neo-Impressionist pointillism, was a source of derision from the critics.
4. Charles Chassé, *Gauguin sans legendes* (Paris, 1965); cited in John House, *Landscapes of France: Impressionism and Its Rivals,* exh. cat. (London, 1995), p. 280.
5. The "primitive" characteristics that attracted artists and writers to Brittany were for the most part an illusion. As discussed by David Sweetwater, many of the region's ancient customs were, by midcentury, on the verge of dying out. The increasing number of artists and tourists visiting the region, however, made it economically wise for the locals to maintain an antiquated appearance. As a result, local costume became a sort of uniform and festivals verged on performance. Furthermore, the peasants established standardized rates for posing. David Sweetwater, *Gauguin: A Complete Life* (London, 1995), pp. 135–137.
6. House, *Landscapes of France,* 1995, p. 280.
7. Ibid.
8. René Huyghe, *Le Carnet de Paul Gauguin* (Paris, 1952), p. 222.
9. Brettell, *Gauguin,* 1988, p. 52.
10. Marla Prather and Charles F. Stuckey, eds., *Gauguin: A Retrospective* (New York, 1987), p. 299.

CAT. 23

1. It was also possible for Gauguin to live inexpensively at Pont-Aven. See Gauguin's letters to his wife Mette, dated June, July, and

September 1886, reproduced in *Paul Gauguin: Letters to His Wife and Friends*, ed. Maurice Malingue (Cleveland, 1949), pp. 68–71.

2. Mark Roskill has discussed Gauguin's "transformation" of Monet's marine subject matter in *Van Gogh, Gauguin and the Impressionist Circle* (Greenwich, Conn., 1970), p. 43. Gauguin would have seen several examples of Monet's rocky seascapes of Grainval and Fécamp at the seventh Impressionist exhibition of 1882. It also seems likely that Monet's images of the cliffs and sea at Étretat would have made an impression on Gauguin, who could have seen these paintings at Georges Petit's gallery during the spring of 1886 before leaving for Pont-Aven. See Joel Isaacson, "The Painters Called Impressionists," in *The New Painting: Impressionism 1874–1886* (San Francisco, 1986), pp. 385–386, 394.

3. Henri Delavallée, quoted in John Rewald, *Gauguin* (New York, 1938), p. 12.

4. Georges Wildenstein, *Gauguin I: Catalogue raisonné* (Paris, 1964), no. 205.

CAT. 25

1. Pissarro to Antoine Guillemet, 3 September 1872; quoted in John Rewald, *The History of Impressionism* (New York, 1973), p. 292.

2. Paul Tucker, "The First Impressionist Exhibition in Context," in *The New Painting: Impressionism 1874–1886* (San Francisco, 1986), p. 120, no. 66.

3. Illustrated in Georges Serret and Dominique Fabiani, *Armand Guillaumin: Catalogue raisonné de l'oeuvre peint* (Paris, 1971), nos. 17, 18, 25.

4. Tucker, "First Impressionist Exhibition," 1986, p. 110; and Robert L. Herbert, *Impressionism: Art, Leisure, and Parisian Society* (New Haven and London, 1988), p. 220.

5. Serret-Fabiani, *Guillaumin*, 1971, no. 25.

6. Rainer Budde, *Bildwelten des Impressionismus: Meisterwerke aus der Sammlung des Petit Palais in Genf* (Leipzig, 1994), p. 56.

CAT. 26

1. See the preface in Christophe Duvivier, *Armand Guillaumin: Les années impressionnistes*, exh. cat. (Pontoise, Aulnay-sous-Bois, 1991), n.p.

2. Richard Thomson compares *Quai de Bercy* with Signac's *Coal Crane, Clichy* (1884, Glasgow Art Gallery and Museums) in "Seurat's Choices," *Seurat and the Bathers*, exh. cat. (National Gallery, London, 1997), pp. 114–115.

3. See letter from 22 October 1889. *The Letters of Vincent van Gogh*, vol. 3 (London, 1958), T 19, p. 554.

4. Gauguin to his wife Mette, 8 December 1892. Maurice Malingue, ed., *Lettres de Gauguin à sa femme et à ses amis* (Paris, 1946), p. 237.

5. The collection is mentioned in *Bulletin de la vie artistique* (1 June 1924): 246.

6. Hanne Finsen, *The Ordrupgaard Collection* (Copenhagen, 1982), n.p. I am grateful to Andrea Rygg Karberg of the Ordrupgaard Collection for details concerning this work's acquisition.

CAT. 27

1. Martha Ward, "The Eight Exhibition 1886—The Rhetoric of Independence and Innovation," *The New Painting: Impressionism 1874–1886* (San Francisco, 1986), p. 429.

2. Georges Serret and Dominique Fabiani, *Armand Guillaumin: Catalogue raisonné de l'oeuvre peint* (Paris, 1971), p. 68. Serret and Fabiani illustrate this painting with a cropped photograph and give it an impossible title *(Gelée blanche),* incorrect measurements, and ascribe it formerly to the collection of Bernheim-Jeune.

CAT. 28

1. Françoise Cachin et al., *Manet: 1832–1883* (New York, 1983), pp. 465–470.

CAT. 29

1. Our painting is a replica of a similar picture about the same size, but in portrait format (now in the National Gallery of Victoria in Melbourne). Both pictures are based on a series of six studies. See Denis Rouart and Daniel Wildenstein, *Édouard Manet: Catalogue raisonné I,* (Geneva, 1975), nos. 400–405.

2. Angelika Wesenberg in *Manet bis van Gogh—Hugo von Tschudi und der Kampf um die Moderne,* exh. cat. (Munich, 1996), cat. no. 21. Wesenberg also refers to Hokusai's color woodcut.

3. This was one of the biggest and most beautiful art collections in Germany around 1900. See Barbara Paul, "Drei Sammlungen französischer impressionistischer Kunst im kaiserlichen Berlin–Bernstein, Liebermann, Arnhold," *Zeitschrift des Deutschen Vereins für Kunstwissenschaft* 42 (1988): 11–30, no. 3.

4. On Carl and Louis Hagen, see Rudolf Martin, *Jahrbuch des Vermögens und Einkommens der Millionäre in Preußen 1912,* part II (Berlin, 1911), pp. 350–351, 516.

CAT. 30

1. Daniel Wildenstein, *Monet: Vie et oeuvre,* vol. 1 (1974), no. 71.

2. Paul Mantz, "Salon de 1865," *Gazette des Beaux-Arts* (18 July 1865): 26.

3. Wildenstein, *Monet,* 1974, no. 71.

CAT. 31

1. The comparison is made in Paul Hayes Tucker, *Monet at Argenteuil* (New Haven and London, 1982), p. 101. Tucker entitles Monet's painting *Sunday at Argenteuil.*

2. *Hommage à Claude Monet,* exh. cat. (Paris, 1980), cat. no. 35, pp. 121–122.

3. Price comparisons for Monet sales are given in E. Bénézit, *Dictionnaire critique et documentaire des peintres, sculpteurs, dessinateurs et graveurs* (Paris, 1976), p. 482.

CAT. 32

1. Statistic given in Karl Baedeker, *Paris and Its Environs,* 7th ed. (London, 1881), p. 350.
2. Merete Bodelsen, "Early Impressionist Sales 1874–94," *The Burlington Magazine* (June 1968): 331–348.
3. For this information I am grateful to Francine Dawans, Conservatrice at the Musée d'Art moderne et d'Art contemporain, Liège.

CAT. 33

1. Daniel Wildenstein, *Claude Monet: Biographie et catalogue raisonné,* vol. 1 (Lausanne, 1974), no. 521, *Vétheuil, les pruniers en fleurs* (73.5 × 94 cm), and no. 519, *Les Pruniers en fleurs* (65 × 54 cm).
2. Cat. no. 3: *Les Pruniers en fleurs.* See ibid., p. 112.
3. On the displayed works and the circumstances of exhibition, see Annette Dixon, "The Marketing of Monet: The Exhibition at *La Vie Moderne,*" in *Monet at Vétheuil: The Turning Point,* exh. cat. (Ann Arbor, Mich., 1998).
4. Hôtel Drouot, Paris, 1910, no. 74.

CAT. 34

1. Daniel Wildenstein, *Monet, or the Triumph of Impressionism,* vol. 1 (Cologne, 1996), pp. 160–163.
2. From Caillebotte's first will, dated 3 November 1876; quoted by Anne Distel in the introduction to *Gustave Caillebotte: Urban Impressionist,* exh. cat. (Paris, Chicago, New York, 1995), p. 19.

CAT. 35

1. For a discussion of this aspect of Monet's cliff paintings, see Robert L. Herbert, *Monet and the Normandy Coast* (New Haven, 1994).
2. Daniel Wildenstein, *Claude Monet: Biographie et catalogue raisonné,* vol. 1 (Lausanne, 1974), p. 118.

CAT. 36

1. Monet to Alice Hoschedé, 14 September 1886. Daniel Wildenstein, *Claude Monet: Biographie et catalogue raisonné,* vol. 2 (Lausanne, 1979), no. 686.
2. Ibid., nos. 1108 and 1109.
3. G. G. [Gustave Geffroy], "Salon de 1887—Hors du Salon: Claude Monet," *La Justice* (25 May and 2 June 1887); cited in Paul Hayes Tucker, *Claude Monet: Life and Art* (New Haven and London, 1995), p. 131.
4. D. Wildenstein, *Monet,* vol. 3, 1979, no. 1220. The other Impressionist works he bought were two of Pissarro's late city views, *Avenue de l'Opéra* (see cat. 46) and *Le Louvre,* bought from the Galerie Bernheim-Jeune in 1902, and a tiny painting by Renoir, *La Lecture du rôle,* bought from the Humbert sale in 1902.
5. Archives of the Musée des Beaux-Arts, Reims.

CAT. 37

1. Kermit Swiler Champa, "Monet and Bazille: A Complicated Codependence," in *Monet and Bazille: A Collaboration* (Atlanta, 1998), p. 76.
2. Paul Hayes Tucker, *Claude Monet: Life and Art* (New Haven and London, 1995), pp. 209–212.

CAT. 38

1. In 1878 Duret published *The Impressionist Painters,* a brief but highly intelligent account of the movement. For a record of Duret's collecting, see Anne Distel, *Impressionism: The First Collectors* (New York, 1990), pp. 57–68.
2. He went on to form another, smaller collection of avant-garde artists such as van Gogh, Gauguin, and Toulouse-Lautrec.

CAT. 39

1. Paul de Charry, "Le Salon de 1880: Preface, les Impressionistes," *Le Pays,* 10 April 1880.
2. A. E. [Arthur d'Echerac]. "L'Exposition des impressionistes," *La Justice,* 5 April 1880.
3. Memorandum from Lord Redesdale, Trustee of the National Gallery, to the National Gallery Board of Trustees, 14 February 1913, on the proposed loan of Sir Hugh Lane's collection of modern continental pictures to the National Gallery. National Gallery Archives.

CAT. 40

1. For a full account, see Richard Brettell, *Pissarro and Pontoise: The Painter in a Landscape* (New Haven and London, 1990). The railway line had reached St. Ouen l'Aumône in 1846, but the bridge across the river Oise to the main port of Pontoise was only built in 1863.
2. Ibid., pp. 99–117, 145–150.
3. For a more wide-ranging discussion, see Gary Tinterow, "The Realist Landscape," in Gary Tinterow and Henri Loyrette, *Origins of Impressionism,* exh. cat. (The Metropolitan Museum of Art, New York, 1994), pp. 55–93, esp. pp. 86–93, and cat. nos. 158–161.
4. Pissarro's early use of the palette knife is discussed by Christopher Campbell, "Pissarro and the Palette Knife: Two Pictures from 1867," *Apollo* 136 (November 1992): 311–314.
5. For the French text, see Jean-Paul Bouillon, ed., *Émile Zola: Le bon combat de Courbet aux impressionnistes* (Paris, 1974), p. 108.
6. Christopher Lloyd, "Paul Cézanne, Pupil of Pissarro: An Artistic Friendship," *Apollo* 136 (November 1992): 284–290, with further references.
7. See Brian Kennedy, *Alfred Chester Beatty and Ireland 1950–1968: A Study in Cultural Politics* (Dublin, 1988).

CAT. 41

1. This is a wide-ranging topic examined in depth by Robert Herbert, *Impressionism: Art, Leisure and Parisian Society* (New Haven and London, 1988).

244 CATALOGUE

2. On these pictures, see Gary Tinterow, "The Impressionist Landscape," in Gary Tinterow and Henri Loyrette, *Origins of Impressionism,* exh. cat. (The Metropolitan Museum of Art, New York, 1994), pp. 252–263 and cat. nos. 146–147 and 177–178, respectively.

3. See Richard Brettell, "Pissarro in Louveciennes: An Inscription and Three Paintings," *Apollo* 136 (November 1992): 315–319.

4. Ludovic Rodo Pissarro and Lionello Venturi, *Camille Pissarro: Son art, son oeuvre* (Paris, 1939), no. 122, which was in recent years in the Peto collection and is now in a private collection in Switzerland. It is reproduced in color with the painting catalogued here by Richard Thomson, *Camille Pissarro: Impressionism, Landscape and Rural Labour,* exh. cat. (London, 1990), figs. 20 and 21, respectively.

5. Thomson, *Pissarro,* 1990, p. 24.

6. Sisley's finest painting is undoubtedly that in the Ny Carlsberg Glyptotek, Copenhagen, for which see Mary Anne Stevens, ed., *Alfred Sisley,* exh. cat. (London, Paris, Baltimore, 1992), cat. no. 20.

CAT. 42

1. Pissarro to Duret, 20 October 1874. Janine Bailly-Herzberg, ed., *Correspondance de Camille Pissarro,* vol. 1, 1865–1885 (Paris, 1980), p. 95; cited in Richard Thomson, *Camille Pissarro: Impressionism, Landscape and Rural Labour* (London, 1990), p. 40.

2. Duret to Pissarro, 14 December 1874. Ibid., p. 41.

3. Armand Silvestre in *L'Opinion nationale* (2 April 1876); quoted in Ruth Berson, *The New Painting: Impressionism 1874–1886,* documentation, vol. 1, reviews (Fine Arts Museums of San Francisco, 1996), p. 109.

4. This transaction is described in letter 708 from Camille Pissarro to his son Lucien, dated 18 November 1891. Janine Bailly-Herzberg, ed., *Correspondance de Camille Pissarro,* vol. 3, 1895–1898 (Paris, 1988), p. 143. Bailly-Herzberg suggests that the buyer in question was Charles Martin of the dealers Martin et Camentron, based at 32, rue Rodier. Ibid., p. 144, n. 1.

5. Letter 710 to Mirbeau, 18 November 1891, reads: "When I see an old thing of mine again that I'd lost from view, I become very indulgent, I look at it as though it were someone else's work, I discover qualities in it and am heart-broken not to have been able to continue working so well." Ibid., p. 146.

6. I should like to thank Isabelle Menoud of the Musée d'Art et d'Histoire, Geneva, for this information.

CAT. 43

1. *Le Siècle* (29 April 1874). This is Jules Castagny's famous review of the first Impressionist exhibition, in which he tried to explain and define the new movement.

CAT. 44

1. Included in the *Sale of Impressionist Paintings from the Estate of Ralph Friedman,* Christie's, New York, 11 November 1992.

2. Kalophile l'Ermite writing for the symbolist journal *L'Ermitage,* vol. 4 (February 1892): 117–118.

3. I am grateful to Caroline Durand-Ruel Godfroy for this information.

4. The building of the collection is described by Jirí Kotalik in *Monet to Picasso: A Hundred Masterpieces from the National Gallery in Prague,* exh. cat. (Palazzo Pitti, Florence, 1982).

CAT. 45

1. There are several other portraits of Félix by his father. See Ludovic Rodo Pissarro and Lionello Venturi, *Camille Pissarro: Son art, son oeuvre* (Paris, 1939), nos. 1553, 620, and 828, as well as some drawings. See Richard Brettell and Christopher Lloyd, *Catalogue of Drawings by Camille Pissarro in the Ashmolean Museum* (Oxford and New York, 1980), p. 156.

2. Pissarro-Venturi, *Pissarro,* 1939, no. 232.

CAT. 46

1. Pissarro to Lucien Pissarro, Paris, 15 December 1897. See Janine Bailly-Herzberg, *Correspondance de Camille Pissarro,* vol. 4, 1895–98 (Paris, 1986–91), pp. 417–418.

2. *Avenue de l'Opéra, Place du Théâtre Français: Misty Weather* (private collection, New York); *Avenue de l'Opéra, Place du Théâtre Français: Foggy Weather* (Dallas Museum of Art); *Avenue de l'Opéra, Place du Théâtre Français: Rain Effect* (private collection); *Avenue de l'Opéra, Place du Théâtre Français: Rain Effect* (The Minneapolis Institute of Art); *Avenue de l'Opéra, Place du Théâtre Français: Snow Effect* (private collection); *Avenue de l'Opéra, Place du Théâtre Français: Snow Effect* (Pushkin State Museum of Fine Arts); *Avenue de l'Opéra, Place du Théâtre Français: Morning Sunshine* (private collection); *Avenue de l'Opéra, Place du Théâtre Français: Sun Effect* (National Museum of Belgrade); *Avenue de l'Opéra, Place du Théâtre Français: Afternoon Sun in Winter* (private collection); *Place du Théâtre Français* (Los Angeles County Museum of Art).

3. See Kathleen Adler, "Camille Pissarro: City and Country in the 1890s," in *Studies on Camille Pissarro,* ed. Christopher Lloyd (London and New York, 1986), p. 104.

CAT. 47

1. Pissarro to Lucien Pissarro, Paris, 16 March 1900. John Rewald, ed., *Camille Pissarro: Letters to His Son Lucien* (New York, 1943), p. 340.

2. Ludovic Rodo Pissarro and Lionello Venturi, *Camille Pissarro: Son art, son oeuvre,* vols. 1 and 2. (Paris, 1939), nos. 1176–1181 and 1210–1213. The picture in Budapest *(Le Pont-Neuf, 2e série)* is no. 1211.

3. Pissarro to Lucien Pissarro, Paris, January 4, 1902. Rewald, *Camille Pissarro,* 1972, p. 348.

4. On the details of the purchase, see "Collecting for the Nation and Not Only for the Nation: Impressionism in Hungary, 1907–1918," by Judit Geskó in this volume.

5. Pissarro to Lucien Pissarro, Paris, 24 January 1903. Rewald, *Camille Pissarro,* 1972, p. 354.

CAT. 48

1. Arsène Alexandre, *Jean François Raffaëlli* (Paris, 1909), p. 232.

2. Barbara Schinman Fields, "Jean François Raffaëlli (1850–1924), The Naturalist Artist" (Ph.D. diss., Columbia University, 1979), p. 25.

3. John Rewald, *The History of Impressionism* (New York, 1973), p. 73.

CAT. 49

1. A painting of a more defined location is entitled *Garden at Fontenay,* currently in the Reinhart Collection, Winterthur. See Barbara Ehrlich White, *Renoir: His Life, Art and Letters* (New York, 1984), p. 51.

2. Hans Heinrich Thyssen-Bornemisza, introduction to *Impressionismo e Postimpressionismo: Collezione Thyssen-Bornemisza* (Lugano, 1990).

3. José Alvarez Lopera, introduction to *Modern Masters: Thyssen-Bornemisza Museum* (Madrid, 1992).

CAT. 50

1. Colin B. Bailey, "Portrait of the Artist as a Portrait Painter," in *Renoir's Portraits,* exh. cat. (New Haven and London, 1997).

2. See Anne Distel, *Les Collectionneurs des Impressionnistes* (Paris, 1989), p. 215.

3. O. Granath, *Guide to the Nationalmuseum, Stockholm* (Stockholm, 1995). I am grateful to Sabrina Norlander, associate curator at the Nationalmuseum, for detailed information regarding these acquisitions.

CAT. 51

1. Leif Einar Plahter, head of the Nasjonalgalleriet's conservation department, carried out a fresh examination of the picture in connection with the present exhibition. His purpose was to try to discover whether the parts were painted at different times.

2. Sigurd Willoch, *Nasjonalgalleriet gjennem hundre år* (Oslo, 1937), p. 160.

3. The exhibition was first shown in Copenhagen, at Statens Museum for Kunst. Part of it was sent to Norway at the outbreak of the war, and in 1917 was shown in Stockholm, at the Nationalmuseum.

4. Sigurd Willoch, *Nasjonalgalleriets Venner* (Oslo, 1967), p. 7 ff. The Nasjonalgalleriet's purchases may not be sold later, so the friends' association was adopting the institution's approved rules.

CAT. 52

1. Lionello Venturi, *Les Archives de l'impressionisme* (Paris, 1939), vol. I, pp. 130–131.

2. Paris, 16 February 1979 (lot 74) letter of 17 August 1885, there misdated to August 1886, when Renoir was at Saint-Briac.

CAT. 53

1. Julie Manet, the daughter of Manet's brother Eugène and Berthe Morisot, wrote that Renoir was very taken with the Corot figures in the distinguished collection of Henri Rouart, Degas's great friend. J. Manet, *Journal (1893–1899)* (Paris, 1979), p. 150.

2. Jeanne Baudot, *Renoir: Ses amis, ses modèles* (Paris, 1949), p. 70; cited in *Renoir,* exh. cat. (Paris, London, Boston, 1985), p. 265.

3. Minutes of the meeting of the Commission Administrative des Musées, 19 March 1901. Archives of Musée des Beaux-Arts, Lyon.

CAT. 54

1. Misia Sert, *Misia par Misia* (Paris, 1952), p. 106. One portrait is in the Barnes Foundation, Merion, Pennsylvania, and one was formerly in the collection of Ralph M. Coe, Cleveland, Ohio, according to Martin Davies (revised by Cecil Gould), *French School: Early 19th Century Impressionists, Post-Impressionists, etc.* (London, 1970), p. 122, no. 6306.

2. Sert, *Misia,* 1952, pp. 109–110.

3. Ambroise Vollard, *En Écoutant Cézanne, Degas, Renoir* (Paris, 1938), p. 210.

CAT. 55

1. Hélène Bellon later became Madame Garrache and then Madame Forestieri. See Musée d'Orsay, *Catalogue sommaire illustré des peintures,* vol. 2 (Paris, 1990), R.F. 2018, p. 392.

2. *Girl Seated on a Chair,* sanguine, white chalk, and charcoal, 35⅜ × 27½ inches, Musée du Louvre (fonds du Musée d'Orsay), Paris, R.F. 12 832. See *Sanguines du XIXᵉ siècle* (Dossiers du Musée d'Orsay, 1994), pp. 71, 105. In 1915, shortly after the Camondo bequest opened, the drawing was acquired from Vollard for the Cabinet des Dessins for the sum of 100 francs. See Anne Distel, "Renoir's Collectors," *Renoir,* exh. cat. (London, Paris, Boston, 1985), p. 28, n. 76.

3. Ambroise Vollard, *Renoir: An Intimate Record* (1925; reprint, 1990), pp. 89–91.

CAT. 56

1. Jean and Henry Dauberville, *La Bataille de l'Impressionnisme* (Paris, 1967).

2. Maurice Denis, *Journal,* vol. II (Paris, 1957), p. 118.

3. Félix Fénéon, "Vingt ans de peinture 1906–1926," in *Oeuvres plus que complètes,* ed. J. Halperin (Geneva, 1970), p. I: 330–331.

4. Gaston Bernheim's account is given in *Renoir's Portraits,* exh. cat. (New Haven and London, 1997), p. 334, n. 1, p. 335.

CAT. 57

1. See Richard Shone, *Sisley* (London, 1992), pp. 39–49.

2. The similarities are noted by Gary Tinterow in *The Origins of Impressionism,* exh. cat. (The Metropolitan Museum of Art, New York, 1995), cat. no. 188, pp. 462–463.

3. E. Bénézit, *Dictionnaire critique et documentaire des peintres, sculpteurs, dessinateurs et graveurs* (Paris, 1976).

4. "Bouguereau, you will see, will yet end up by lifting him into his nacelle like Rousselin. . . ." M. Guérin, ed., *Degas Letters,* trans. Marguerite Kay (Oxford, 1947), p. 100.

5. I am grateful to Christophe Terpent of the Musée de Grenoble for this detail.

CAT. 59

1. See John House, *Landscapes of France: Impressionism and Its Rivals,* exh. cat. (London, 1995), p. 254.

2. Roger Fry, *Characteristics of French Art* (London, 1932), 129; cited in House, op. cit.

CAT. 60

1. François Daulte, *Alfred Sisley: Catalogue raisonné de l'oeuvre peint* (Lausanne, 1959), no. 391. Also see Mary Anne Stevens, ed., *Alfred Sisley,* exh. cat. (London, Paris, Baltimore, 1992), cat. no. 47.

2. Daulte, *Sisley,* 1959, no. 392. Also see Stevens, *Sisley,* 1992, cat. no. 48.

3. Quoted in Robert Goldwater and M. Treves, eds., *Artists on Art from the XIV to the XX Century* (London, 1947), pp. 308–310.

4. Ibid.

5. Camille Mauclair, *The French Impressionists* (London, 1912), pp. 138–140.

6. Examples are included in Stevens, *Sisley,* 1992, cat. nos. 56–58.

7. Daulte, *Sisley,* 1959, no. 427.

8. Exhibited in *Alfred Sisley* (1992–93); see Stevens, *Sisley,* 1992, cat. no. 55.

CAT. 61

1. John House, *Landscapes of France: Impressionism and Its Rivals,* exh. cat. (London, 1995), p. 282.

2. P. Angrand, "Sur deux lettres inédites de Sisley," *Chronique des Arts* (July–Sept. 1971); cited in House, op. cit.

CAT. 63

1. Sisley to Tavernier, 19 January 1892; quoted in Richard Shone, *Sisley* (London, 1992), pp. 216–217.

2. François Daulte, *Alfred Sisley: Catalogue raisonné* (Lausanne, 1959) gives details of this painting's provenance and an interesting analysis of its market value.

3. I am grateful to Andrea Rygg Karberg of Ordrupgaard for this information.

CAT. 64

1. See *Van Gogh Self-Portraits,* exh. cat. (London, 1960).

2. Roland Dorn, *Vincent van Gogh and the Modern Movement, 1890–1914,* exh. cat. (Essen and Amsterdam, 1990), p. 87.

3. See Johan van Gogh, "The history of the collection," in Evert van Uitert and Michael Hoyle, eds., *The Rijksmuseum Vincent van Gogh* (Amsterdam, 1987), pp. 1–8. Special thanks to Monique Hageman, archivist, Van Gogh Museum, Amsterdam, for this information and for her assistance.

CAT. 65

1. Vincent to Theo van Gogh, November or December 1888. *The Letters of Vincent van Gogh,* vol. 3 (London, 1958), LT 560, p. 101.

2. Walter Feilchenfeldt, *Vincent van Gogh and Paul Cassirer, Berlin: The Reception of van Gogh in Germany from 1901 to 1914,* Cahier Vincent 2 (Zwolle and Amsterdam, 1988), p. 100.

3. I am grateful for this information to Jacqueline Rapmund, assistant curator of modern art at the Museum Boijmans Van Beuningen.

CAT. 66

1. Evert van Uitert, Louis van Tilborgh, and Sjraar van Heugten, *Vincent van Gogh: Paintings* (New York, 1990), p. 137.

2. Ibid., pp. 136, 138.

3. Jan Hulsker, *The New Complete van Gogh* (Amsterdam and Philadelphia, 1996), pp. 308, 310–311, 313.

4. Ibid., pp. 418, 421.

5. Ibid., pp. 478, 480.

CAT. 67

1. Both portraits (Degas, *Portrait of Diego Martelli,* 1879, National Gallery of Scotland, Edinburgh; and Zandomeneghi, *Portrait of Diego Martelli,* 1879, Galleria d'Arte Moderna, Florence) are listed in the catalogue of the fourth Impressionist exhibition.

2. *Firenze artistica,* no. 13, 1 February 1879, p. 2.

3. See Norma Broude, *The Macchiaioli* (The J. Paul Getty Trust, 1987), pp. 272–275.

4. "Note di soggiorno a Parigi," *Gazzetta d'Italia,* 5 May 1878; reprinted in Diego Martelli, *Les Impressionnistes et l'art moderne,* ed. Francesca Errico (Paris, 1979), pp. 76–77.

5. Félix Fénéon, "Les Impressionnistes," *La Vogue* (13–20 June 1886): 261–275; reprinted in Ruth Berson, *The New Painting, Impressionism 1874–1886,* documentation, vol. 1, reviews (Fine Arts Museums of San Francisco, 1996), p. 442.

6. I am grateful to Dr. Carlo Sisi, director of the Galleria d'Arte Moderna, Florence, for details regarding this painting's history.

CAT. 68

1. The critic J.-K. Huysmans was not impressed, calling the work "only ordinary." Huysmans, "L'Exposition des Indépendants en 1881," in *L'Art moderne* (1883) (Paris, 1975), p. 252.

2. Roberto Longhi, "L'impressionismo e il gusto degli italiani," in John Rewald, *Storia dell'impressionismo* (Firenze, 1949); reprinted in Idem, *Scritti sull'Otto e Novecento: 1925–1966* (Firenze, 1984), p. 10.

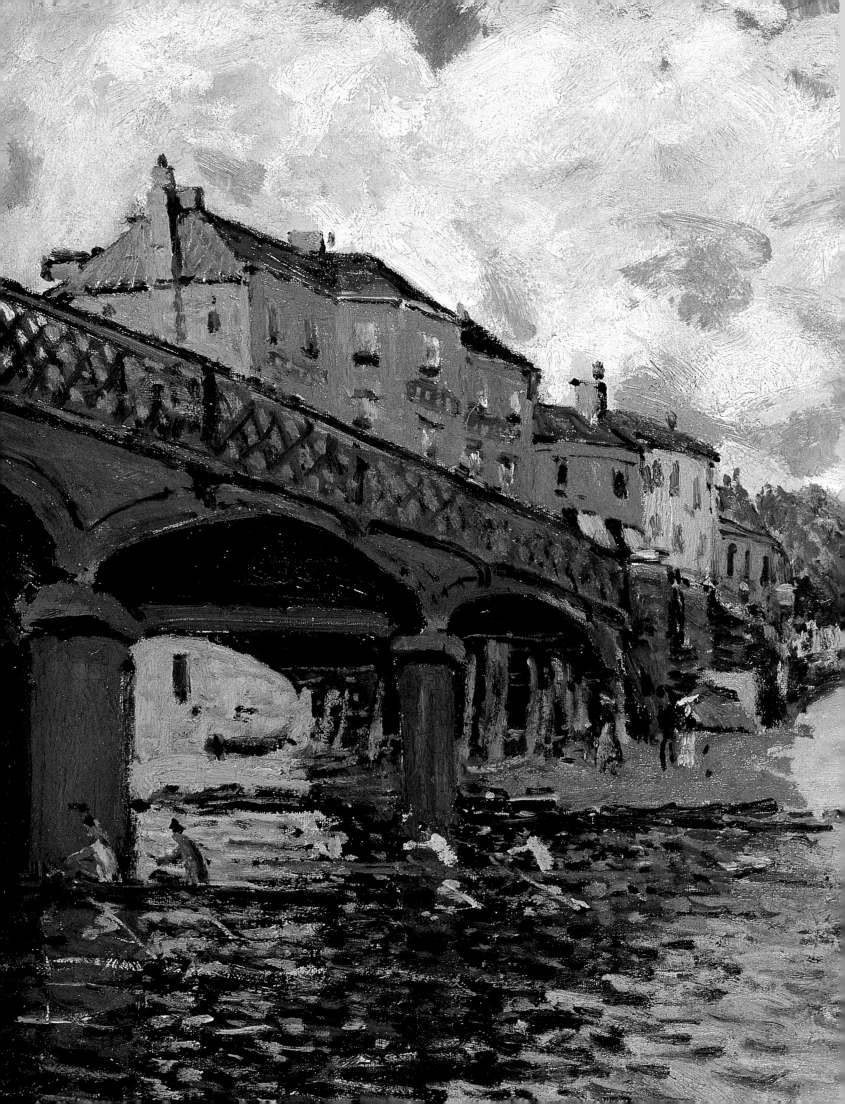

A Chronology of the Primary Events in the Early History of Collecting Impressionist Art in England, France, Germany, Hungary, Scandinavia, Scotland, and Switzerland

ROBERT MCD. PARKER

This chronology discloses recent documentation and consolidates much of the new material from the contributing authors and scholars of this catalogue, providing a selective overview of the major European sales, purchases, acquisitions, and exhibitions that contributed to the success of Impressionism as an art movement. The chronology starts with the First Impressionist Exhibition in 1874 and ends in 1927 at the death of the last Impressionist exhibitor—Armand Guillaumin.

Because this is one of the first scholarly exhibitions to treat the history of the collecting and acquisition of Impressionist works by European museums, it is important to note that the lists of works presented have been selected for the purposes of comparison and are far from exhaustive. It is hoped that this exhibition will generate additional interest and studies of the collecting and acquisition habits of institutions in these and other European countries not included in this catalogue. Thus, the main objective of this chronology is to provide a synthesis of the initial European acquisitions of Impressionist paintings and other related art events without overweighing the text with comprehensive provenance histories available elsewhere.

The entries of this chronology have been organized geographically so as both to emphasize the important event of each year and help the reader focus on the general movement of Impressionism from country to country. In most cases, the cities where these events occurred are noted; however, unless otherwise specified, Paris is generally accepted as the site of origin.

The life dates of Impressionist collectors, dealers, donors, and other lesser-known individuals have been gathered from authoritative sources and included here wherever possible.

In general, the titles of works are consistent with those noted in the major catalogues raisonnés for each of the Impressionist artists. Exact references to individual paintings, including present locations, have been given to aid the reader and ensure proper identification.

Several authors and scholars were helpful in providing additional information. In particular, I wish to thank Frances Fowle, Judit Geskó, Lukas Gloor, Caroline Durand-Ruel Godfroy, Monique Nonne, and Stefan Pucks.

1874 **First Impressionist Exhibition** is held in Nadar's studio at 35, boulevard des Capucines.

Thirty participants and 165 works are listed in the catalogue, including Degas (10 works), Monet (12), Morisot (9), Renoir (7), and Sisley (5). Art critic Louis Leroy reviews the first group exhibition and refers to the artists as the "Impressionists" after one of the Monet works shown: *Impression, Sunrise,* 1872 (Wildenstein, no. 263, Musée Marmottan, Paris). Although the majority of the more than 50 articles that appear in the Parisian journals and newspapers are critical, writers such as Armand Silvestre and Ernest Chesneau recognize the potential of the new-style painting. Lenders to the exhibition include collectors Dr. Paul Gachet and French baritone Jean-Baptiste Faure, dealer Paul Durand-Ruel, and artist Manet, who loans a painting by Morisot. The exhibition runs from 15 April until 15 May and is attended by approximately 3,500 visitors.

In France, under the direction of Philippe de Chennevières (1820–1899), the administration of French museums is reorganized and a national inventory system for artworks is initiated.

In London, art dealer Paul Durand-Ruel (1831–1922) exhibits Impressionist works of Manet, Monet, Pissarro, and Sisley.

1875 The Impressionist artists organize an auction of 73 works at the Hôtel Drouot on 24 March. The sale is a financial disaster; the average price for works is 144 francs.

Pissarro and other Impressionist artists form an association, L'Union.

Parisian collector Victor Chocquet (1821–1891) buys a work by Cézanne from the artist supplier and dealer Julien Tanguy (1825–1893) and meets Renoir, who paints Chocquet's portrait.

In his London gallery, Durand-Ruel holds the last of a series of exhibitions of the Société des Artistes Français, including some Impressionists; the gallery on New Bond Street then closes.

1876 **Second Impressionist Exhibition** is held at 11, rue Le Peletier. The 19 participants include Caillebotte, who shows with the Impressionists for the first time. Degas exhibits 24 works, including *Portraits in a New Orleans Cotton Office,* 1873 (Lemoisne, no. 320, Musée des Beaux-Arts, Pau), which attracts favorable attention. As in the case of the First Impressionist Exhibition, many paintings are loaned by French collectors such as Faure (9 Monets) and Chocquet (6 Renoirs and works by Monet and Pissarro). The catalogue lists 248 works.

In London, dealer Emile Deschamps organizes the *Twelfth Exhibition of Pictures by Modern French Artists* in his gallery at 168 New Bond Street. Captain Henry Hill (1812–1892) of Brighton buys several dance paintings. Having acquired at least seven Degas works by 1876, Hill is noted as having "the finest collection of work by Degas in Europe."

At an annual provincial exhibition at the Musée des Beaux-Arts in Pau, Degas, Manet, Morisot, Pissarro, and Renoir show the works that were so controversial in Paris.

While working as a banker in Paris, Gauguin invests 15,000 francs in works by Cézanne, Guillaumin, Manet, Monet, and others.

Cézanne introduces Chocquet to Monet.

Stéphane Mallarmé (1842–1898) writes a favorable article on Manet and the Impressionists for *Art Monthly Review* in London. Critic Edmond Duranty (1833–1880) publishes *La Nouvelle peinture,* which presents Impressionism as a natural outgrowth of realism.

1877 **Third Impressionist Exhibition** is held at 6, rue Le Peletier. Among the 18 participants, Degas, Pissarro, and Renoir each exhibit 22 works. Renoir's *Dancing at the Moulin de la Galette,* 1876 (Daulte, no. 209, Musée d'Orsay, Paris), and Caillebotte's *Paris Street on a Rainy Day,* 1877 (Berhaut, no. 57, The Art Institute of Chicago), are among the works. Of the many loans from private collectors, Ernest Hoschedé (1837–1891) is noted in the catalogue as having contributed eleven Monets; Georges de Bellio (1835–1894) three Monets and three Sisleys; and Georges Charpentier (1846–1905) two Renoirs and two Sisleys.

French art critic Georges Rivière (1855–1943) publishes the first issue of a weekly art journal entitled *L'Impressionniste,* in which he tries to explain the approach of the Impressionist artists.

Forty-five paintings are sold at a second auction at the Hôtel Drouot (28 May), organized by Renoir; the average price per work is 169 francs.

The Café de la Nouvelle-Athènes becomes a gathering place for the Impressionist artists.

1878 **First museum acquisition of an Impressionist work in France.** The Musée des Beaux-Arts in Pau acquires Degas's *Portraits in a New Orleans Cotton Office,* 1873; the painting is purchased with income from the bequest of lawyer Emile Noulibos (1833–1875), who left his fortune to the city of Pau for the acquisition of works by contemporary artists.

The Impressionist works in the collection of baritone Jean-Baptiste Faure (1830–1914) are dispersed at an auction at the Hôtel Drouot on 29 April. Among many important paintings sold are an impressive number by Manet.

Art critic Théodore Duret (1838–1927) publishes *Les Peintres impressionnistes,* a study of the art movement and its painters: Monet, Sisley, Pissarro, Renoir, and Morisot.

Bankruptcy forces Ernest Hoschedé to sell the remainder of his collection at the Hôtel Drouot on 5–6 June; it is here that Georges de Bellio pays 210 francs for Monet's famous *Impression, Sunrise,* 1872, for which Hoschedé had paid 800 francs four years earlier. Twelve Monets from this sale enter Chocquet's collection.

Exposition Universelle (World's Fair) is held in Paris at the Palais de Trocadéro. No Impressionist works are included in the art section.

1879 **Fourth Impressionist Exhibition** is held at 28, avenue de l'Opéra. The 15 participants include Cassatt (25 works) and Gauguin (38), who show for the first time. Cézanne, Renoir, and Sisley do not exhibit. Collectors de Bellio, Emmanuel Chabrier, Duret, and Eugène Murer, dealer Durand-Ruel, and artist Caillebotte loan most of the 29 entries for Monet, who did not wish to participate. A total of 15,400 visitors are recorded. The catalogue lists 246 works.

Publisher Georges Charpentier founds La Vie Moderne, a magazine and art gallery intended to promote Impressionism.

Renoir's *Madame Charpentier and Her Children,* 1878 (Daulte, no. 289, The Metropolitan Museum of Art, New York), is praised at the Salon of 1879. Manet exhibits *In the Conservatory,* 1879 (Rouart-Wildenstein, no. 289, Nationalgalerie, Berlin), which he asks the State to buy; four years later, collector Faure purchases it.

Renoir has a one-man show at Charpentier's La Vie Moderne.

Émile Zola (1840–1902) criticizes the Impressionists in the Russian periodical *Viestnik Europi,* and the article is reprinted in *Le Figaro.*

1880 **Fifth Impressionist Exhibition** is held at 10, rue des Pyramides, with 18 participants. One of the paintings by Morisot—*Summer, Young Woman Near a Window,* 1878 (Bataille-Wildenstein, no. 75)—would be given to the Musée Fabre in Montpellier in 1907. Cézanne, Monet, Renoir, and Sisley do not participate. The catalogue lists 232 works.

Subsequent defenders of Impressionism, writers J.-K. Huysmans (1848–1907) and Armand Silvestre (1837–1901), criticize the Impressionists in their articles. Huysmans shows an appreciation of Pissarro's work and will later be among the first to recognize the talents of Cassatt and Cézanne.

Dealer Georges Petit (1856–1920) buys his first Monet.

Manet has an exhibition of pastels at La Vie Moderne. Monet also has a show there, from which no works are sold.

Italian painter and critic Diego Martelli (1838–1896) publishes a pamphlet of his lecture on Impressionism given to the Circolo Filologico in Livorno the previous year.

1881 **Sixth Impressionist Exhibition** is held at 35, boulevard des Capucines, and includes 13 participants. Although the works presented by Pissarro (28) and Raffaëlli (34) dominate the exhibition, the critics respond most favorably to the submissions by Degas, Cassatt, and Morisot. Paul Bérard, Georges de Bellio, and Ernest May continue to lend works from their growing collections, as do artists Gauguin, Degas, Cassatt, and Rouart, who have been collecting works by their fellow Impressionists. The catalogue lists 170 works; this is the smallest of the eight original Impressionist exhibitions.

In Brussels, the art magazine *L'Art Moderne* is founded.

Sisley exhibits 14 paintings in a one-man show at La Vie Moderne.

Manet's *Portrait of Eugène Pertuiset,* 1881 (Rouart-Wildenstein, no. 365, Museo de Arte São Paulo), is awarded a second-class medal at the official Salon.

Dealers such as Durand-Ruel begin to amass important collections of the Impressionist artists they represent. Correspondence between dealers and artists will later prove vital in helping to catalogue the artists' works and will contribute fundamentally to the creation and abundance of modern catalogues raisonnés for nineteenth-century French artists.

The French State abandons control of the Salon to a jury of artists called the Société des Artistes Français. In 1890, the group will split again, forming the Société Internationale des Beaux-Arts.

1882 **Seventh Impressionist Exhibition** is held at the Durand-Ruel gallery at 251, rue Saint-Honoré. The exhibition has nine participants, approximately 210 works, and nearly 1,900 visitors. Renoir's *Luncheon of the Boating Party,* 1880–81 (Daulte, no. 379, The Phillips Collection, Washington, D.C.), is one of the most noteworthy paintings. Of the eight original exhibitions, the Seventh Impressionist Exhibition has the fewest participants.

Carl Bernstein (1842–1894), a Berlin law professor, and his wife, Felicie (1852–1908), are the first collectors to bring Impressionist paintings to Germany, including Manet's *The Folkestone Boat, Boulogne,* 1869 (Rouart-Wildenstein, no. 147, formerly in the collections of Hoschedé and Charles Ephrussi and later sold to Hugo von Tschudi; now Philadelphia Museum of Art), and Monet's *Summertime, Poppy Field,* 1875 (Wildenstein, no. 377).

In London, Durand-Ruel holds an exhibition at White's Gallery at 13 King Street, which includes works by Cassatt, Degas, Monet, Renoir, and Sisley.

In Tours, Durand-Ruel organizes an exhibition of the Société des Amis des Arts de Touraine, where works by Monet, Pissarro, Renoir, and Sisley are shown.

Georges Petit opens a sumptuous gallery similar to the Grosvenor Gallery in London. He and society painter Giuseppe de Nittis create the Société Internationale des Beaux-Arts in hopes of inviting twelve painters from different countries to show annually. This is the first Exposition Internationale organized by Petit. Later, these exhibitions become annual sensations, luring the Impressionists into competition with other galleries and dealers, especially Durand-Ruel.

At the official Salon, Manet's *Bar at the Folies-Bergère,* 1881–82 (Rouart-Wildenstein, no. 388, Courtauld Institute Galleries, London), is one of the most admired paintings.

1883 Berlin gallery owner Fritz Gurlitt (1854–1893) exhibits paintings from the Bernstein collection along with 23 Impressionist paintings belonging to Durand-Ruel. This first exhibition of Impressionist works in Germany is not favorably received.

In London, Durand-Ruel organizes an Impressionist exhibition of 48 works at the Dowdeswell's Galleries that receives considerable attention from the critics.

British critic Frederick Wedmore (1844–1921) writes an article on "The Impressionists" in the *Fortnightly Review,* now considered the first important piece devoted entirely to these artists to be published in English.

Durand-Ruel organizes a series of one-man shows for Monet (in March), Renoir (in April), Pissarro (in May), and Sisley (in June) at the gallery at 9, boulevard de la Madeleine.

J.-K. Huysmans publishes a collection of articles on the Salons and the Impressionists entitled *L'Art moderne.*

Eva Gonzalès (1849–1883) dies.

Édouard Manet (1832–1883) dies.

1884 In Brussels, a group of artists called Les Vingt (Les XX) forms for the purpose of organizing annual exhibitions devoted to progressive Belgian and international artists. Lawyer, journalist, and art critic Octave Maus (1856–1919) is founder of the avant-garde artists' organization.

In London at the Dudley Gallery, Durand-Ruel holds an exhibition of Impressionist works.

In Italy, art critic Diego Martelli praises Manet's work in an article for the periodical *Fieramosca.*

In Oslo, Gauguin sends eight paintings to the *Kunstudstillingen* exhibition.

In Rouen, Eugène Murer (1845–1906) holds an exhibition of Impressionist works from his collection. Impressionist works are also shown in an exhibition organized by the city of Rouen.

The atelier sale of Manet's works is held at the Hôtel Drouot on 4–5 February. A total of 159 works are sold for 116,637 francs. Important Impressionist collectors such as de Bellio, Caillebotte, Chabrier, and Faure attend, but the French museums are noticeably absent.

Theo van Gogh, Vincent's brother, buys his first artwork—a Pissarro landscape that he resells for 150 francs, making a 25-franc profit.

The Groupe des Artistes Indépendants forms with the intention of holding exhibitions without juries or awards. This same year, because of internal differences, the group disbands and re-forms as the Société des Artistes Indépendants, whose first exhibition in December includes Seurat and Signac.

Critic and novelist Octave Mirbeau (1848–1917) praises Renoir in an article for *La France.*

Anarchist and critic Félix Fénéon (1861–1944) founds *La Revue indépendante.*

1885 In Copenhagen, Gauguin has an unsuccessful six-day exhibition at the Society of the Friends of Art. Later this year, he shows in Nantes at the Palais du Cours Saint-André.

In Brussels, Monet participates in an exhibition organized by Les Vingt.

In London at the Dowdeswell's Galleries on New Bond Street, Durand-Ruel organizes an exhibition of eight works. In Brussels, he exhibits them in his room at the Hôtel du Grand Miroir, his first exhibition in Brussels since January 1875.

Eighty-five works by Gonzalès are shown at a retrospective exhibition at La Vie Moderne.

Critic Théodore Duret publishes *Critique d'avant-garde,* a collection of his writings and reviews.

Monet shows ten paintings at Petit's fourth annual Exposition Internationale.

At the official Salon, the 1,243 accepted works are seen by more than 238,000 visitors.

Finances permitting, Impressionist painters such as Monet, Pissarro, and Renoir dine monthly with friends and critics at the Café Riche.

1886 **Eighth Impressionist Exhibition** is held at 1, rue Laffitte. There are 17 participants, including Signac and Seurat, who show for the first time with the Impressionists. Of the 246 exhibited

works, Seurat's *Sunday Afternoon on the Île-de-la-Grande-Jatte,* ca. 1884–86 (The Art Institute of Chicago), arouses interest because of its size and novelty.

In Brussels, an exhibition organized by Les Vingt shows works by Monet, Renoir, and Redon.

In Britain, the New English Art Club is formed by artists who oppose the doctrines of the Royal Academy and favor French painting's emphasis on form rather than subject or content.

In New York, Durand-Ruel organizes the exhibition *Works in Oil and Pastel by the Impressionists of Paris* at the American Art Galleries, where more than 300 works are exhibited.

Félix Fénéon publishes *Les Impressionnistes en 1886* and notes the change from "naturalistic" Impressionism to the "scientific" Impressionism as represented in the works of Seurat and Signac. He later becomes a correspondent for *L'Art moderne.*

Zola publishes the novel *L'Oeuvre.* Cézanne and the deceased Manet seem to have been used as models for the central character. The book suggests the failure of Impressionism and offends those close to the Impressionist painters.

Monet and Renoir participate at Petit's fifth annual Exposition Internationale.

The Société des Artistes Indépendants organizes its second exhibition and shows works by Pissarro, Seurat, and Signac.

1887 Durand-Ruel tries unsuccessfully to assemble another group Impressionist exhibition, but Monet opposes the idea.

As director of the Parisian branch of the gallery Boussod and Valadon, Theo van Gogh buys 14 paintings from Monet; he resells more than half within the same year. At the Café Tambourin, he organizes an exhibition of Japanese prints.

The sixth annual Exposition Internationale at the Galerie Georges Petit includes works by Monet, Pissarro, Renoir, and Sisley.

At the Union Centrale des Arts Décoratifs, a major exhibition of Japanese art is held.

1888 **First purchase of an Impressionist work by the French government**. The Ministry of Fine Arts purchases Sisley's *September Morning,* ca. 1887 (cat. 61, Daulte, no. 692), for 1,000 francs and sends it to the Musée des Beaux-Arts in Agen; the artist, who had hoped to see it hang in the Musée du Luxembourg in Paris, is dismayed.

In Copenhagen, an exhibition of French art includes works by Manet, Monet, and Sisley.

At the Glasgow International Exhibition, Degas's *Le Foyer de la danse à l'Opéra de la rue Le Peletier,* 1872 (Lemoisne, no. 298, Musée d'Orsay, Paris), is the first work by the artist to be seen in Scotland. Later in the collections of Henri Vever and Count Isaac de Camondo, it is bequeathed to the Louvre in 1911.

In England, popular British artist William Powell Frith claims in an article in *The Magazine of Art* that Impressionism has "tainted" the art of his country.

Works by Renoir, Pissarro, and Sisley are shown at the gallery of Durand-Ruel in Paris.

At the Montmartre gallery of Boussod and Valadon, Theo van Gogh presents an exhibition of 10 Antibes seascapes by Monet.

The gallery of Siegfried Bing (1838–1905) holds an exhibition of Japanese prints.

Important works by Manet from the Eugène Pertuiset collection are sold at the Hôtel Drouot on 6 June.

1889 In Brussels, works by Gauguin, Monet, Pissarro, and Signac are shown at the annual exhibition of Les Vingt.

At the London branch of Boussod and Valadon, director David Croal Thomson exhibits 20 works by Monet that are surprisingly well received by the British press.

Paintings from the Henry Hill collection are auctioned at Christie's in London on 25 May.

A History of French Painting, one of the first studies of modern French art in English, is published by Mrs. C. H. Stranahan.

After having worked in Paris at Boussod and Valadon, Glasgow dealer Alexander Reid returns to Scotland to promote French art and opens his own gallery, La Société des Beaux-Arts, Glasgow.

In Copenhagen, the Society of the Friends of Art presents an exhibition entitled *Scandinavian and French Impressionists,* which includes Cassatt, Cézanne, Degas, Gauguin, Guillaumin, Pissarro, and Sisley. Gauguin loans four works by Cézanne from his personal collection.

In an interview with Hugues Le Roux for a *Gil Blas* article (3 March), Monet distances himself from the Impressionist painters.

At the Exposition Universelle in Paris, the *Centennial Exhibition of French Art* organized by Antonin Proust (1832–1905) includes the Impressionists.

Gauguin organizes an exhibition of Impressionist and Synthetist artists at the Café Volpini.

Works by Monet and Rodin are shown at Galerie Georges Petit. The exhibition includes 145 paintings by Monet and constitutes the artist's first real retrospective.

1890 **First museum acquisition of an Impressionist work in Scandinavia**. Monet's *Rainy Weather*, 1886 (Wildenstein, no. 1044), is acquired by the Nasjonalgalleriet, Oslo—the first Impressionist painting to enter a Scandinavian museum.

In Brussels, the seventh exhibition of Les Vingt is held. Octave Maus encourages Cézanne to participate.

Impressionism begins to inspire German artists such as Max Liebermann (1847–1935), Fritz von Uhde, Gotthardt Kuehl, Christian Rohlfs, and Lesser Ury.

Scotland's first Impressionist exhibition is held at the T & R Annan Gallery in Glasgow.

The gallery of Boussod and Valadon in Paris holds an exhibition of 25 works by Pissarro.

The École des Beaux-Arts exhibits Japanese woodblock prints.

At the Galerie Georges Petit, Impressionist works from the collection of Ernest May (1845–1925) are sold on 4 June. Among the paintings from this sale are: the Musée d'Orsay's "May Triptych," dated 1872, of Monet's *Pleasure Boats* (Wildenstein, no. 229), Pissarro's *Entry to the Village of Voisins* (Pissarro-Venturi, no. 141), and Sisley's *Île-de-Saint-Denis* (Daulte, no. 47); Degas's *Repetition of the Ballet on Stage* (Lemoisne no. 498, The Metropolitan Museum of Art, New York); and Degas's *Danseuses à leur toilette, examen de danse* (Lemoisne, no. 576, Denver Art Museum), which had been exhibited at the Fifth Impressionist Exhibition in 1880.

In France, Monet organizes a subscription for the purchase of Manet's *Olympia* (Rouart-Wildenstein, no. 69, Musée d'Orsay, Paris), which is bought and donated to the nation. The painting enters the Musée du Luxembourg in 1890 and the Musée du Louvre in 1907.

Vincent van Gogh (1853–1890) dies.

1891 In Brussels, Les Vingt show Impressionist works at their eighth annual exhibition.

An Impressionist exhibition is held in Munich.

In London, works by Degas, Monet, Pissarro, and Sisley are on view at Mr. Collier's Rooms on Old Bond Street and at the annual exhibition of the New English Art Club.

In Paris, paintings by Gauguin are sold at the Hôtel Drouot on 23 February. Proceeds from this auction permit Gauguin to leave for Tahiti.

Durand-Ruel shows Monet's Haystacks series. The exhibition is enormously successful, and all works are sold within three days of the opening.

Durand-Ruel holds an exhibition of recent works by Renoir.

Sisley exhibits at Galerie Georges Petit.

The Galerie Le Barc de Boutteville holds the first in a series of exhibitions of Impressionist and Symbolist art.

1892 **First commission of an Impressionist work by the French State**. The French government commissions a Renoir, *Young Girls at a Piano* (Musée d'Orsay, Paris), for the Musée du Luxembourg.

Berlin artist and collector Max Liebermann purchases Degas's *The Repose* (Lemoisne, no. 1142) from Durand-Ruel.

T. G. Arthur (1857–1907), a Glasgow textile merchant, is the first Scottish collector to buy an Impressionist work, purchasing Degas's *At the Milliner's*, 1882 (Lemoisne, no. 682, The Metropolitan Museum of Art, New York), from the gallery of Alexander Reid (Glasgow and London) for 800 pounds.

Arthur Kay, a business partner of T. G. Arthur, purchases two works by Degas from an exhibition at Reid's gallery in Glasgow: *The Absinthe Drinker* (Lemoisne, no. 393, formerly in the collections of Captain Henry Hill, then of Arthur Kay, and finally of Count Isaac de Camondo, who bequeathed the work to the Musée du Louvre in 1911, now Musée d'Orsay, Paris) and *Dancers in the Rehearsal Room with a Double Bass* (Lemoisne, no. 905, The Metropolitan Museum of Art, New York).

In London, Durand-Ruel rents a gallery at 13 King Street for an Impressionist exhibition.

The gallery of Boussod and Valadon purchases its first painting by Renoir.

In Paris, Durand-Ruel holds a retrospective of Pissarro with 75 works.

Monet's Poplars series is exhibited at Durand-Ruel; 15 of the 23 paintings from this series are presented.

Forty works by Renoir are exhibited at the gallery of Durand-Ruel.

Armand Silvestre publishes *Au Pays des souvenirs*, an autobiographical account of the early days of Impressionism and the artists and their friends who frequented the Café Guerbois.

1893 In London, at an exhibition of paintings and sculpture by British and foreign artists at the Grafton Galleries, Arthur Kay's painting by Degas, *The Absinthe Drinker,* scandalizes British artists such as Sir W. Richard and Walter Crane. In an article in *The Spectator,* D. S. MacColl defends the work, as does Irish-born writer and critic George Moore (1852–1933).

The New English Art Club in London exhibits works by Degas, Monet, and Morisot.

In Copenhagen, at least 51 works by Gauguin and 29 works of various media are presented at the *Frie Udstilling* (Free Exhibition) of modern art.

Dealer Ambroise Vollard (1866–1939) opens an art gallery on the rue Laffitte.

In Paris, the gallery of Boussod and Valadon shows works by Sisley.

Durand-Ruel exhibits 41 works by Pissarro. A few months later, at the instigation of Degas, the gallery holds its first exhibition of works by Gauguin.

1894 In Brussels, the recently dissolved Les Vingt is replaced by a new artists' group, La Libre Esthétique, which holds its first exhibition. Morisot, Pissarro, Renoir, and Sisley participate.

Due to financial difficulties, Théodore Duret, journalist and avid supporter of the Impressionists, auctions most of his collection at Galerie Georges Petit on 9 March. From this sale, the Musée du Luxembourg buys Morisot's *Young Woman Dressed for the Ball,* 1879 (cat. 38, Bataille-Wildenstein, no. 81, formerly in the collection of the painter de Nittis, who had purchased the work at the Fifth Impressionist Exhibition in 1880 [no. 120], later bought by Duret and sold as no. 30 at his sale, now Musée d'Orsay, Paris). Monet's *The White Turkeys,* 1877 (Wildenstein, no. 416, shown at the Third Impressionist Exhibition in 1877 as no. 101; now Musée d'Orsay, Paris), attracts the highest bid and sells for 12,000 francs.

Works from the collection of Julien Tanguy are sold at auction at the Hôtel Drouot by Madame Veuve Tanguy on 1–2 June. Père Tanguy sold paints and art supplies and was a friend to many of the Impressionist painters. His collection is rich in works by Cézanne and van Gogh.

Gustave Caillebotte (1848–1894) dies. He bequeaths his collection of Impressionist paintings to the French nation, but there is opposition from the academic artists who are officials at the Salon and from various bureaucrats. In 1896, the government finally agrees to accept 38 of the 57 works; in 1904 and again in 1908, the Caillebotte descendants try in vain to give the remainder of the collection to the French State. In 1928, 34 years after the initial bequest, the French government expresses an interest in accepting the remaining paintings, but is unsuccessful.

1895 *Pan* (1895–1900), one of the first German magazines devoted to modern art, is co-founded by Julius Meier-Graefe (1867–1935), renowned art critic and dealer.

In Dresden, the gallery Theodor Lichtenberg Nachfolger exhibits five paintings by Pissarro.

The Kunstverein in the Hamburger Kunsthalle holds an Impressionist exhibition.

The History of Modern Painting, by German critic Richard Muther (1860–1909), is translated into English after having been published in German two years earlier; the book contains a favorable chapter on Impressionism.

The Venice Biennale, one of an increasing number of international exhibitions, is first held.

In Paris, a sale of works by Gauguin is held at the Hôtel Drouot on 18 February.

Monet exhibits 50 paintings at Durand-Ruel, including the Rouen Cathedral series. François Depeaux becomes the first private collector to acquire a painting from this series: *Portal of the Rouen Cathedral, Overcast,* 1894 (Wildenstein, no. 1345, Musée des Beaux-Arts, Rouen).

Dealer Ambroise Vollard mounts exhibitions of works by Manet, van Gogh, and Cézanne in his gallery on rue Laffitte. The November–December exhibition, devoted to Cézanne, presents approximately 150 of the artist's paintings on a rotating basis and affirms Vollard's reputation as a dealer of avant-garde art.

Berthe Morisot (1841–1895) dies in March.

1896 **First museum acquisition of an Impressionist work in Germany.** Purchased from Durand-Ruel for the Nationalgalerie Berlin with funds from various German collectors, Manet's *In the Conservatory,* 1879 (Rouart-Wildenstein, no. 289, formerly in the Faure collection), becomes the first museum purchase handled by Durand-Ruel in Europe. Under the direction of Hugo von Tschudi (1851–1911), works such as Monet's *View of Vétheuil,* 1880 (Wildenstein, no. 609, from Durand-Ruel), and Degas's *The Conversation,* ca. 1882 (Lemoisne, no. 774, formerly in the collection of Théodore Duret, Paris), figure among the 16 Impressionist works acquired by the Nationalgalerie and shown at its exhibition of new acquisitions in December.

Collectors in Berlin buy works from Durand-Ruel: Eduard Arnhold (1849–1925) purchases Monet's *Low Tide at Pourville,* 1882 (Wildenstein, no. 776), and German critic Harry Graf Kessler (1868–1937) buys Renoir's *Apple Seller,* 1890 (Daulte, no. 585, The Cleveland Museum of Art). Kessler will be instrumental in bringing Impressionism to Germany by introducing German critics such as Meier-Graefe and artists such as Max Liebermann to French collectors and dealers.

The Hamburger Kunsthalle acquires Monet's *Pears and Grapes,* 1880 (Wildenstein, no. 631, from Durand-Ruel), under the direction of Alfred Lichtwark (1852–1914).

The art periodicals *Jugend* and *Simplicissimus* are founded in Munich.

The Nemzeti Szalon (National Salon) is founded in Budapest.

Manet's *Young Boy Peeling a Pear,* 1868 (Rouart-Wildenstein, no. 130, formerly in the Faure collection), a gift from Swedish portrait painter Anders Zorn (1860–1920), is the first Impressionist painting to enter the Nationalmuseum, Stockholm.

In Rouen, Eugène Murer shows works by Guillaumin, Monet, Pissarro, Renoir, and Sisley at his Hôtel du Dauphin et d'Espagne. The exhibition catalogue is entitled *Magnifique collection d'impressionnistes dont 30 toiles du grand artiste Renoir.*

The Impressionists organize a retrospective at the gallery of Durand-Ruel in memory of Morisot.

The collection of composer Emmanuel Chabrier (1841–1894) is sold at the Hôtel Drouot on 26 March. Among the 26 modern paintings featured in the sales catalogue are Manet's *Bar at the Folies-Bergère,* 1881–82 (Rouart-Wildenstein, no. 388, Courtauld Institute Galleries, London), and Monet's *Rue Saint-Denis, Celebration of 30 June 1878* (Wildenstein, no. 470, Musée des Beaux-Arts, Rouen). Durand-Ruel purchases numerous works.

Pissarro and Renoir have one-man exhibitions at Durand-Ruel.

1897 Works by Monet, Pissarro, and Gauguin are presented at the Art and Industry exhibition in Stockholm.

The Caillebotte bequest is exhibited in an extension of the Musée du Luxembourg.

Monet exhibits at the second Venice Biennale.

Impressionist landscapes enter the collections of the Nationalgalerie Berlin: Sisley's *First Snow at Louveciennes,* 1870–71 (Daulte, no. 18), Pissarro's *House at L'Hermitage, Pontoise,* 1873 (Pissarro-Venturi, no. 226), and Cézanne's *Mill on the Couleuvre at Pontoise,* 1881 (Venturi, no. 324, Rewald, no. 483, formerly in the collection of Julien Tanguy, Paris).

In Germany, dealer Hermann Pächter (1839–1902) organizes an exhibition of works by Monet.

At the Kaiserhof Hotel in Berlin, art critic and collector Julius Elias (1861–1927) shows an exhibition of Impressionist paintings owned by Durand-Ruel.

The collection of jeweler Henri Vever (1854–1942) is sold at the Galerie Georges Petit on 1–2 February. The sale includes many works by the Barbizon School artists, but among the Impressionist paintings were eight Monets, two Pissarros, four Renoirs, and eighteen Sisleys, primarily depicting scenes from Moret and Saint-Mammès.

A large retrospective of 146 paintings and six pastels by Sisley is held at the Galerie Georges Petit.

The Caillebotte bequest is exhibited in an extension of the Musée du Luxembourg.

1898 Durand-Ruel sells his first Impressionist painting to Moscow collector Sergei Shchukin (1854–1936), who buys Monet's *Lilacs in the Sun,* 1873 (Wildenstein, no. 204, Pushkin Museum of Fine Arts); it is the first Impressionist painting to reach Russia. Shchukin's collection of modern paintings would number more than 250 when he died.

In Berlin, cousins Paul and Bruno Cassirer open a gallery to promote French modernists in Germany. Paul Cassirer is instrumental in the creation of the Max Linde collection in Lübeck and the Julius Stern and Mendelssohn collections in Berlin.

The Berlin Secession movement is founded under the presidency of artist Max Liebermann. In later years, the Secession exhibitions would help to establish Berlin as an important center for contemporary art.

German critic Harry Graf Kessler amasses an impressive modern art collection that includes a van Gogh, a Cézanne, a Renoir, a Vuillard, two Bonnards, a Denis, and one of Seurat's masterpieces, *Les Poseuses* (The Barnes Foundation, Merion, Pennsylvania).

In London, the Guildhall Art Gallery holds an exhibition of works by Degas, Monet, Pissarro, and Renoir.

At the Prince's Skating Rink in London, an Exhibition of International Art, organized by American artist James A. McNeill Whistler (1834–1903), includes Impressionist painters.

The Musée Fabre in Montpellier receives Bazille's *The Heron,* 1867 (Daulte, no. 35), as a gift from the artist's mother.

At the Société Internationale des Beaux-Arts, Sisley exhibits five scenes from his 1897 visit to Britain.

Durand-Ruel organizes an Impressionist show and shortly thereafter exhibits recent works by Pissarro, along with other works by Monet, Renoir, and Sisley.

The Galerie Georges Petit holds a successful exhibition of Monet's work.

Eugène Boudin (1824–1898) dies.

1899 In Frankfurt, Sisley's *Bank of the Seine in Autumn,* 1876 (Daulte, no. 223), enters the collection of the Städelsches Kunstinstitut und Städtische Galerie.

The Ernst Arnold gallery in Dresden organizes an Impressionist exhibition, helping to establish Dresden's reputation as the first German city to hold regular exhibitions of modern French art.

In London, exhibitions featuring the Impressionists are held at the New Gallery and the Grafton Galleries.

In Paris, the collection of Victor Desfossés (1836–1899) is dispersed at auction on 26 April. Of the 98 modern paintings, there are four Monets, three Pissarros, and a Sisley.

Following the death of Alfred Sisley (1839–1899), the artist's works are displayed at the Galerie Georges Petit on 29 January. An auction at the gallery on 1 May yields a total of 115,640 francs.

More than 250 paintings from the collection of Count Armand Doria (1824–1896), including many works by Corot and by Impressionist artists such as Guillaumin, Lépine, Pissarro, and Renoir, are auctioned at the Galerie Georges Petit on 4–5 May.

The collection of Victor Chocquet is sold on 1, 3, and 4 July at the Galerie Georges Petit by his wife. Artists such as Degas and Henri Rouart and collectors such as Auguste Pellerin, Étienne Moreau-Nélaton, and Count Isaac de Camondo (through Durand-Ruel) make purchases from the collection of more than 30 Cézannes, 10 Monets, 10 Renoirs, and others.

1900 In Le Havre, the contents of Boudin's studio (approximately 200 works) are given by the artist's brother, Louis, to the city museum to add to its renowned Boudin collection .

Renoir gives two paintings, *Jean Renoir as a Child* and *Portrait of a Young Girl,* to his native city of Limoges for the Musée National Adrien Dubouché.

Works by Pissarro and Renoir are shown in the Berlin Secession exhibition. The Secession exhibition in Munich also includes their works, as well as those by Degas and Monet.

The first Cézanne exhibition in Germany is held at the Cassirer gallery in Berlin.

Dresden collector Oscar Schmitz (1861–1933) acquires his first Impressionist work: Monet's *Towpath at Lavacourt,* 1878 (Wildenstein, no. 496, from Eugène Murer).

The gallery of Bernheim-Jeune in Paris holds an exhibition of works by Renoir; most of the 68 paintings are sold.

Important works by Sisley from the collection of art critic Adolphe Tavernier are dispersed on 6 March at the Galerie Georges Petit. Count Isaac de Camondo buys Sisley's *Flood at Port Marly* (Daulte, no. 240), which would enter the Louvre in his large bequest in 1911. Today this and other Impressionist paintings he bequeathed are in the Musée d'Orsay.

At the Exposition Universelle, a Centenary Exhibition of French Art includes the Impressionists and helps to secure their reputations internationally. The Impressionist works are shown in two rooms organized by French art critic and collector Roger Marx (1859–1913). Upon seeing the exhibition, another critic remarks that thanks to the exquisite presentation, "the history of the movement writes itself."

Eugène Blot's collection of works by Cézanne, Monet, Morisot, Renoir, and Sisley is sold at the Hôtel Drouot on 10 May.

Durand-Ruel exhibits 12 paintings by Monet of his garden in Giverny.

1901 **First museum acquisition of an Impressionist work in Britain**. The Victoria and Albert Museum in London acquires Degas's *The Ballet Scene from Meyerbeer's Opera "Robert le Diable,"* 1876 (cat. 15, Lemoisne, no. 391, formerly in the Faure collection), as a bequest of Constantine Ionides (1833–1900).

At the Hanover Gallery in London, Durand-Ruel shows 37 paintings by Monet, Pissarro, Renoir, and Sisley. The International Society of Artists in London also exhibit their works.

At the Glasgow International Exhibition, eight Impressionist works are shown.

Karl Ernst Osthaus (1874–1921) buys Renoir's *Lise,* 1867 (Daulte, no. 29, formerly in the collection of Théodore Duret, Paris), from the gallery of Paul Cassirer in Berlin.

Dresden collector Oscar Schmitz buys his second Monet, *The Saint-Lazare Train Station,* 1877 (Wildenstein, no. 441), from Lazare Weiller.

In the Berlin Secession exhibition, five paintings by van Gogh are shown; this is the first exhibition of the artist's works in Germany.

A major Impressionist exhibition is held at the gallery of Paul Cassirer in Berlin.

As a friend and fellow painter, Joseph-Auguste Rousselin (1848–1916) gives Sisley's *View of Montmartre from the Cité des Fleurs, Les Batignolles,* 1869 (cat. 57, Daulte, no. 12), to the Musée de Grenoble.

In Lyon, the Musée des Beaux-Arts purchases Renoir's *Woman Playing a Guitar,* 1896–97 (cat. 53), from Durand-Ruel.

In Paris, Durand-Ruel exhibits 42 works by Pissarro.

Headmaster and collector Abbé Paul-Octave Gaugain (1850–1904), a regular client of Durand-Ruel, sells all his Impressionist paintings to the dealer.

1902 In Essen, banker's son and collector Karl Ernst Osthaus opens the Museum Folkwang.

In Germany, Bruno Cassirer (1872–1941), cousin of Paul Cassirer, publishes *Kunst und Künstler,* a magazine that defends the Impressionists until it ceases publication in 1933.

British artist and critic D. S. MacColl publishes *Nineteenth Century Art,* a study of modern French art.

In Lyon, the Musée des Beaux-Arts buys two Monets from Durand-Ruel: *Étretat, Turbulent Sea,* 1883 (Wildenstein, no. 821), and *Springtime,* 1882 (Wildenstein, no. 586).

The collection of Jules Strauss, rich in works by Sisley, is auctioned on 3 May. The Musée des Beaux-Arts in Lyon purchases two works: Manet's *Portrait of Mademoiselle Gauthier-Lathuille* (Rouart-Wildenstein, no. 326, no. 36 of Strauss sale) and Sisley's *Landscape with Winding Path,* 1870 (Daulte, no. 218, no. 58 of Strauss sale). The sales catalogue lists 71 paintings.

Duret publishes a book about Manet and his work.

1903 **First museum acquisition of an Impressionist work in Austria**. In Vienna, Julius Meier-Graefe organizes the first large Impressionist retrospective to be held in a German-speaking country. The Osterreichische Galerie Belvedere makes its first Impressionist acquisition with the purchase of Monet's *The Cook, Monsieur Paul,* 1882 (Wildenstein, no. 744 as *Portrait of Paul Antoine Graff*).

One year after its inauguration, the Kunsthalle Bremen begins collecting Impressionist works with a Degas pastel given by publisher and patron Alfred Walter Heymel.

Van Gogh's *Street in Auvers-sur-Oise,* ca. 1890 (de la Faille, no. 802, as *Road at Auvers*), is acquired by the Ateneum in Finland; it is unclear how this early Finnish acquisition of Impressionist art occurred.

Camille Mauclair's book *French Impressionists* is translated from French into English.

Paul Gauguin (1848–1903) dies in April in the Marquesas Islands.

The Salon d'Automne opens its first exhibition and begins to present major artists' retrospectives in conjunction with its regular exhibits. The inaugural exhibit presents Gauguin's works in a memorial to the artist.

Camille Pissarro (1830–1903) dies.

1904 Russian collector Sergei Shchukin trades Monet's *The Thames, Waterloo Bridge,* 1903 (Wildenstein, no. 1565, Denver Art Museum), for Monet's *Houses of Parliament, Seagulls,* 1904 (Wildenstein, no. 1613, Pushkin Museum of Fine Arts, Moscow). This is the last transaction between Shchukin and the Durand-Ruel gallery, from which he had purchased a total of 14 paintings since 1898.

In Berlin, collector Eduard Arnhold purchases Manet's *A Corner in the Garden at Bellevue,* 1880 (Rouart-Wildenstein, no. 347, formerly in the Pertuiset collection, Paris), and a version of Monet's *La Grenouillière,* 1869 (Wildenstein, no. 136).

Cassirer exhibits works by Degas, Manet, and Monet in his Berlin gallery.

Carl Montag, a painter from Winterthur, settles in Paris and begins to promote Impressionism to Swiss friends and collectors.

In Britain, Wynford Dewhurst publishes *Impressionist Painting.*

In Dublin at the Royal Hibernian Academy, works by Monet and Renoir are presented in an exhibition called *Pictures Presented to the City of Dublin to Form the Nucleus of a Gallery of Modern Art.*

In Brussels, La Libre Esthétique holds an Impressionist exhibition.

The city of Le Havre buys two Pissarro paintings for the Musée des Beaux-Arts: *Outer Harbor at Le Havre, Southampton Quay* (Pissarro-Venturi, no. 1315) and *Outer Harbor at Le Havre, Pilot's Bay* (Pissarro-Venturi, no. 1310).

In Durand-Ruel's gallery in Paris, Monet shows 37 paintings of the Thames River in London.

The gallery of Paul Rosenberg exhibits 51 paintings by Sisley.

French manufacturer Auguste Pellerin (1852–1929) begins buying paintings by Cézanne, of which he will acquire more than 100 in the next 25 years. Pellerin's collection of Impressionist works will be valued at 80 million francs when he dies.

1905 The first Manet to enter a provincial French museum, *Autumn,* 1881 (Rouart-Wildenstein, no. 393), is bequeathed to the city of Nancy by the artist's friend and model Méry Laurent.

Pissarro's *The Red House at L'Hermitage, Pontoise,* 1876 (Pissarro-Venturi, no. 347), is purchased by Hungarian painter and collector Ferenc Hatvany (1881–1958) while he is studying art in Paris.

At the Grafton Galleries in London, Durand-Ruel organizes the largest exhibition of Impressionist works ever seen in Britain, marking the apogee of Impressionism as an art movement. He presents 315 paintings, of which 196 are from his personal collection.

Sir Hugh Lane (1875–1915) purchases several paintings from Durand-Ruel—Pissarro's *View at Louveciennes* (Pissarro-Venturi, no. 85), Monet's *The Thames, Waterloo Bridge, Overcast,* 1900 (Wildenstein, no. 1556), and Monet's *Lavacourt, Sun and Snow,* 1881 (Wildenstein, no. 511, entitled *Effet de neige, Vétheuil,* 1881, in the Durand-Ruel archives)—establishing himself as the first major collector of Impressionism in Britain. Upon Lane's death, these works would belong to both the National Gallery of London and the Hugh Lane Municipal Gallery of Modern Art in Dublin.

In Paris, important works by Renoir from the collection of diplomat and businessman Paul Bérard (1823–1905) are sold at the Galerie Georges Petit on 8–9 May. The sales catalogue lists 36 paintings and nine works on paper.

1906 In Paris and London, Durand-Ruel exhibits paintings and watercolors by Manet that Faure wishes to sell. The works are also shown at the Cassirer gallery in Berlin.

Manet's *Music in the Tuileries Gardens* (Rouart-Wildenstein, no. 51, formerly in the Faure collection, Paris; now National Gallery, London) is acquired by the Irish collector Sir Hugh Lane through an exchange and purchase arrangement with Durand-Ruel.

The Kunsthalle Bremen acquires Monet's *Camille* (Wildenstein, no. 65) from Cassirer in Berlin.

The Budapest Szépművészeti Múzeum opens to display art from the former Hungarian National Museum and the National Gallery, which had been founded in 1870 to house the collection of the Esterházy princes.

Pál Majovsky (1871–1935) begins his collection with the idea that it would later be incorporated into the Budapest Szépművészeti Múzeum.

In Paris, the dealers Bernheim-Jeune open a new gallery at 15, rue Richepance.

Étienne Moreau-Nélaton (1859–1927) gives more than 100 paintings (including important Impressionist works) and a collection of drawings and watercolors (approximately 3,000 sheets and 100 sketchbooks) to the Musée du Louvre. One of Manet's masterpieces, *Déjeuner sur l'herbe,* 1863 (Rouart-Wildenstein, no. 67, formerly in the Faure collection, Paris), is among the works of this gift now housed in the Musée d'Orsay, Paris.

At the Salon d'Automne, a retrospective of Gauguin's works is held.

Paul Cézanne (1839–1906) dies.

1907 **First museum acquisitions of Impressionist works in Hungary**. In Budapest, the Nemzeti Szalon (National Salon) mounts an exhibition in May–June: *Spring exhibition, Gauguin, Cézanne [et al.].* Gábor Térey (1864–1927) purchases works for the Szépművészeti Múzeum from this exhibition, including Boudin's *Panoramic View of Portrieux,* 1874 (cat. 1, Schmit, no. 958), Gauguin's *Garden under Snow,* 1879 (Wildenstein, no. 27, shown at the Fifth Impressionist Exhibition in 1880), Pissarro's *Le Pont-Neuf,* 1902 (cat. 47, Pissarro-Venturi, no. 1211), and Sisley's *Banks of the Loing River, Autumn Effect* (Daulte, no. 420). In December, the Nemzeti Szalon in Budapest holds the second exhibition related to the Impressionists: *Great Modern French Artists.*

Mr. and Mrs. Julius Schmits give Sisley's *The Canal of the Loing,* 1884 (Daulte, no. 527), to the city museum of Wuppertal-Elberfeld; this is the first of their gifts of modern French paintings.

Friedrich Deneken (1857–1927) acquires Monet's *London's Parliament at Sunset,* 1900–01 (Wildenstein, no. 1602), for the Kaiser Wilhelm Museum in Krefeld, which had opened in 1897 as a center for German art and crafts.

More than a decade after the Hamburger Kunsthalle's first Impressionist acquisition, a second enters their collection: Manet's *Portrait of Henri Rochefort,* 1881 (cat. 29, Rouart-Wildenstein, no. 366, formerly in the Faure collection, Paris).

In Oslo, the Nasjonalgalleriet buys two paintings by Gauguin from private Norwegian collectors: *Portrait of Mette Gauguin, the Artist's Wife,* 1884 (cat. 21, Wildenstein, no. 95), and *Basket with Flowers,* 1884 (Wildenstein, no. 134).

Irish collector Sir Hugh Lane purchases one of Renoir's masterpieces, *The Umbrellas* (Daulte, no. 298, National Gallery, London), from Durand-Ruel.

The Manchester City Art Gallery holds an exhibition of modern French paintings.

In Reims, Henri Vasnier (1832–1907) bequeaths Impressionist works to the museum.

In Montpellier, Morisot's family gives *Summer, Young Woman Near a Window,* 1878 (Bataille-Wildenstein, no. 75), to the Musée Fabre.

The collection of publisher Georges Charpentier (1846–1905) is sold at the Hôtel Drouot on 11 April. The sales catalogue notes 27 paintings and 53 works on paper.

In the same year that Cubist paintings are first exhibited in Paris, the entry of Renoir's *Madame Charpentier and Her Children,* 1878 (Daulte, no. 289, purchased from the Georges Charpentier sale as no. 21), into the collection of The Metropolitan Museum of Art, New York, and the hanging

of Manet's *Olympia,* 1863 (Rouart-Wildenstein, no. 69, Musée d'Orsay, Paris), in the Louvre mark the recognition of Impressionism as an art movement of historical merit.

In May, major Impressionist works from the Moreau-Nélaton collection are exhibited in the Musée des Arts Décoratifs.

1908 Emperor Wilhelm II of Germany removes director Hugo von Tschudi from the Nationalgalerie Berlin. Among the ten Impressionist paintings that Tschudi purchased through Durand-Ruel between 1896 and 1907 are Cézanne's *Mill on the Couleuvre at Pontoise* (Venturi, no. 324, Rewald, no. 483, formerly in the collection of Julien Tanguy, Paris), Sisley's *Early Snows* (Daulte, no. 18), and Monet's *Saint-Germain l'Auxerrois, Paris,* 1867 (Wildenstein, no. 84).

The Musée du Petit Palais in Paris receives Manet's 1868 portrait of Théodore Duret.

In Switzerland, the first exhibition of French Impressionist paintings is held at the Künstlerhaus in Zurich. The first Impressionist paintings enter private Swiss collections. Fritz Meyer-Fierz (1847–1917) purchases van Gogh's *Vase with Five Sunflowers* (de la Faille, no. 459), *Landscape with Plowman* (de la Faille, no. 625), *The White House at Night* (de la Faille, no. 766), and *Levert's Daughter with Orange* (de la Faille, no. 785). Hans Schüler (1869–1920) buys van Gogh's *Thatched Sandstone Cottages at Chaponval,* 1890 (de la Faille, no. 780), which he bequeaths to the Kunsthaus Zurich in 1920.

Swiss collectors Sidney (1865–1941) and Jenny (1871–1968) Brown-Sulzer purchase several Cézannes from Ambroise Vollard. These works and others from their collection would be housed at Langmatt, their estate in Baden, which would open to the public in 1990.

Julius Meier-Graefe's *Modern Art* is translated from German into English.

Gauguin's *Landscape with Pig and Horse,* 1903 (Wildenstein, no. 637), is bought by the painter Magnus Enckell for the Ateneum in Helsinki.

With the assistance of Hugh Blaker, the Davies sisters from Cardiff, Wales, begin 20 years of acquiring Impressionist paintings.

1909 In Germany, the Kunsthalle Mannheim gains international notoriety by acquiring Manet's *The Execution of Maximilian,* 1867 (Rouart-Wildenstein, no. 127). Encouraged by director Fritz Wichert (1878–1951), nine residents of Mannheim purchase the painting for the museum. Three other versions of this painting exist: Museum of Fine Arts, Boston; Ny Carlsberg Glyptotek, Copenhagen; and The National Gallery, London.

The Kunsthalle Bremen acquires Manet's *Zacharie Astruc* (Rouart-Wildenstein, no. 92) from Cassirer in Berlin.

For the Gemäldegalerie in Dresden, director Karl Woermann buys Monet's *The Seine at Lavacourt,* 1879 (Wildenstein, no. 495, from Durand-Ruel).

French businessman François Depeaux (1853–1920), who at one point had acquired as many as 50 works by Sisley, gives numerous paintings, including three important works by Monet and nine by Sisley, to the Musée des Beaux-Arts, Rouen. Monet's *Rue Saint-Denis, Celebration of 30 June 1878* (Wildenstein, no. 470, cited as the masterpiece of the Fourth Impressionist Exhibition in 1879 as no. 154) is part of this gift. At an earlier sale in Paris in 1906 (31 May–1 June), Depeaux had dispersed much of his collection, including Impressionist works; the sales catalogue listed 216 modern paintings. After his death, the catalogue for a sale in Paris (30 June 1921) will list 74 paintings.

Dr. Paul Gachet (1828–1909), friend and supporter of Impressionists such as Cézanne, Monet, Pissarro, Renoir, and van Gogh, dies. In a series of donations ending in 1954, his collection is given to the French museums and is now in the Musée d'Orsay.

In Moscow, the Shchukin collection of modern paintings opens to the public.

1910 Durand-Ruel sells seven paintings to Irish collector Sir Hugh Lane, including Monet's *Springtime* (Wildenstein, no. 273), Pissarro's *The Forest* (Pissarro-Venturi, no. 91), and Sisley's *Shoreline near Veneux,* 1882 (Daulte, no. 410).

In London, critic Roger Fry (1866–1934) organizes *Manet and the Post-Impressionists,* in which he defends Manet's role as a precursor to the Post-Impressionist movement. This is the first of two important exhibitions of contemporary art he would present at the Grafton Galleries.

In Lyon, the Musée des Beaux-Arts purchases Degas's *Café-concert at the Ambassadeurs,* ca. 1876–77 (Lemoisne, no. 405), from Bernheim-Jeune.

In Frankfurt, the Städelsches Kunstinstitut und Städtische Galerie buys from Durand-Ruel: Monet's *The Luncheon* (Wildenstein, no. 132), Renoir's *The Luncheon* (Daulte, no. 288), and Renoir's *Girl Reading* (Daulte, no. 333).

Monet's *Vétheuil,* 1900–02 (Wildenstein, no. 1641, given by Julius Schmits) enters the collection in Wuppertal-Elberfeld.

In Leipzig, the city museum acquires Pissarro's *La Place du Théâtre Français,* 1898 (Pissarro-Venturi, no. 1028).

Works from the Kunsthalle in Berlin are shown in Budapest at the *International Impressionist Exhibition* in April–May.

Hungarian collector Ferenc Hatvany purchases Manet's *Suicide,* 1877 (Rouart-Wildenstein, no. 258, formerly in the collection of Auguste Pellerin).

Two years after becoming director of the Nasjonalgalleriet in Oslo, Jens Thiis purchases a van Gogh self-portrait (de la Faille, no. 528, formerly in the collection of Auguste Pellerin, Paris) and a Cézanne still life (Venturi, no. 593, Rewald, no. 663, formerly in the collection of the Prince de Wagram, Paris); he will buy Impressionist paintings for the museum until 1919.

The Brown-Sulzer collection in Switzerland acquires Sisley's *Church at Moret, Rainy Morning,* 1893 (Daulte, no. 821).

1911 Count Isaac de Camondo (1851–1911) bequeaths his collection of more than 800 artworks to the French museums. This extraordinary bequest of 62 "modern" paintings includes important Impressionist works now in the Musée d'Orsay, such as Cézanne's *La Maison du pendu à Auvers-sur-Oise,* 1873 (Venturi, no. 133, Rewald, no. 202, in the First Impressionist Exhibition in 1874 as no. 42, formerly in the collections of Count Armand Doria and Victor Chocquet), and Degas's *The Absinthe Drinker* (Lemoisne, no. 393).

The collection of Marczell de Nêmes (1866–1930) is exhibited at the Szépművészeti Múzeum in Budapest. Pál Majovsky attempts to buy works from the collection for the city of Budapest but fails, and the works are dispersed in Paris in 1913.

In Berlin, landscape painter Carl Vinnen publishes an article criticizing the invasion of modern French works into the German art market. Paul Cassirer responds with a two-part essay entitled "Kunst und Kunsthandel," in the art journal *Pan.*

The Kunsthalle Bremen acquires van Gogh's *Poppy Field,* 1889–90 (de la Faille, no. 581, formerly in the collection of the Prince de Wagram), from the gallery of Paul Cassirer in Berlin.

After the death of Hugo von Tschudi, the twelve Impressionist works ("Tschudi-Spende") bought on his advice by German donors are finally displayed at the Neue Pinakothek in Munich. Among them are two important paintings from 1874: Manet's *Monet Painting in His Studio* (Rouart-Wildenstein, no. 219) and Monet's *The Bridge at Argenteuil* (Wildenstein, no. 313, from Auguste Pellerin). The most expensive French painting to enter a German museum to date, Manet's *Luncheon in the Studio,* 1868–69 (Rouart-Wildenstein, no. 135, formerly in the collection of Auguste Pellerin, Paris), had also been bought under Tschudi's guidance and was finally shown.

In Mannheim, lawyer Theodor Alt writes a protest pamphlet entitled "The Devaluation of German Art by the Followers of Impressionism."

Near Stockholm, Swedish art critic and collector Klas Fåhræus builds a gallery in his home to display Swedish art and works by such artists as Courbet, Monet, Renoir, Gauguin, van Gogh, and Cézanne.

At the initiation of Finnish painter Magnus Enckell, the Ateneum in Helsinki acquires Cézanne's *The Viaduct of L'Estaque* (Venturi, no. 402, Rewald, no. 439, from Ambroise Vollard) from the 1910–11 exhibition arranged by Roger Fry at the Grafton Galleries in London.

The city of Le Havre buys three works by Monet, including *The Water Lilies,* 1904 (Wildenstein, no. 1664), for the Musée des Beaux-Arts.

Swiss collector Georg Reinhart buys his first Impressionist painting, Renoir's *Bathers* (Daulte, no. 528, formerly in collection of the Prince de Wagram), from Durand-Ruel.

1912 **First museum acquisition of an Impressionist work in Switzerland.** Three Basel artists (Paul and Carl Burckhardt and Hermann Meyer) encourage private art patrons and the city of Basel to purchase Pissarro's *L'Hermitage, Pontoise,* 1878 (Pissarro-Venturi, no. 447), for the Kunstmuseum; this is the first Impressionist painting to enter a Swiss museum.

In Russia, works by Manet, Monet, and Renoir are exhibited at the *Centennial Exhibition of French Art* in St. Petersburg.

Paintings owned by Hungarian collector Ferenc Hatvany are shown at the galleries of Cassirer in Berlin and Bernheim-Jeune in Paris.

For the Szépművészeti Múzeum in Budapest, director Gábor Térey and curator Simon Meller (1875–1949) purchase an important Monet, *Plum Trees in Blossom,* 1879 (cat. 33, Wildenstein, no. 520), from the Galerie Arnot in Vienna.

Monet's *Three Fishing Boats,* 1886 (Wildenstein, no. 1029, Szépművészeti Múzeum, Budapest), is purchased by Hungarian collector Mór Herzog.

Cézanne's *L'Hermitage at Pontoise,* ca. 1881 (Venturi, no. 176, Rewald, no. 484, formerly in the collection of Auguste Pellerin), is donated to the city museum in Wuppertal-Elberfeld by Mr. and Mrs. Julius Schmits.

In Mannheim, an Impressionism exhibition features Cézanne, Degas, Manet, Monet, and Renoir.

The Hamburger Kunsthalle buys Renoir's *Riding in the Bois de Boulogne,* 1873 (Daulte, no. 94), from Berlin art dealer Paul Cassirer, who had acquired it from the 9–11 December sale of Henri Rouart (no. 269) at the Galerie Manzi-Joyant.

Durand-Ruel gives Renoir's *Head of a Man, Soft Hat (Mr. Bernard)* (Daulte, no. 342) to the Neue Pinakothek in Munich to display in the room dedicated in memory of Hugo von Tschudi.

Georg Reinhart purchases additional works for his art collection in Switzerland, including Cézanne's *Chestnut Trees at Jas de Bouffan* (Venturi, no. 478, Rewald, no. 521), Gauguin's *Apples and Jug,* 1888 (Wildenstein, no. 287), and Degas's *Woman with Red Hair* (Lemoisne, no. 528).

In London at the Grafton Galleries, the Second Post-Impressionist Exhibition is held; Roger Fry organizes the French Group.

Among Jean Dollfus's collection of Romantic and Realist paintings auctioned at the Galerie Georges Petit (2 March), are six Renoirs, two Sisleys, and one Pissarro.

At the Galerie Manzi-Joyant in Paris, Degas's *Dancers at the Barre,* 1876–77 (Lemoisne, no. 408, The Metropolitan Museum of Art, New York), is auctioned at the sale of more than 900 paintings and drawings from the collection of Henri Rouart on 9–11 December. The painting sells for more than 475,000 francs, attaining a record price for a work by a living artist.

1913 The Armory Show in New York, a major exhibition of modern art from European dealers and American collectors, includes Impressionists and is seen by approximately 87,000 visitors.

Sir Hugh Lane offers, without success, to lend 39 paintings to the National Gallery in London.

From the Grosvenor Gallery in London, the Davies sisters acquire Renoir's *The Parisian,* 1874 (Daulte, no. 102, sold from the Henri Rouart collection on 9–11 December 1912, but acquired later by the Davies sisters, now National Museum of Wales, Cardiff)—one of the most outstanding Impressionist paintings in Britain at the time.

In Glasgow, dealer W. B. Patterson organizes an exhibition of nineteenth-century French art.

In Budapest, the Ernst Museum holds three important exhibitions related to Impressionism: *French Impressionists* (Manet and Lipót Herman's collected works), *The Collection of Dr. Zsigmond Sonnenfeld,* and *Great Nineteenth-Century French Masters,* from which the Budapest Szépművészeti Múzeum purchases an important painting by Gauguin, *Black Pigs,* 1891 (Wildenstein, no. 446).

The Nationalmuseum Stockholm receives two paintings by Degas and one by Sisley as a gift from the Friends of the Nationalmuseum, founded in 1911 by Crown Prince Gustaf Adolf.

In Frankfurt, the Städelsches Kunstinstitut und Städtische Galerie buys Degas's *Orchestra Musicians,* 1874–76 (Lemoisne, no. 295), from Durand-Ruel.

The Kunsthalle Mannheim purchases Sisley's *A Street in Marly,* 1876 (Daulte, no. 199), from Durand-Ruel.

In Paris at the gallery of Manzi-Joyant, Hungarian collectors Hór Herzog and Ferenc Hatvany buy important Impressionist works at the 18 June sale of the Marczell de Nêmes collection from Budapest. From 1910 to 1912, the Nêmes collection had been exhibited in Budapest, Munich, and Düsseldorf. An additional 46 paintings would be auctioned at the second sale of the Nêmes collection in Paris on 21 November 1918.

1914 In Paris, the Prince de Wagram (Alexander Berthier, 1883–1917) begins to disperse his collection, and in April he sells 16 Renoirs to Durand-Ruel.

In Budapest, Elek Petrovics (1873–1949) becomes director of the Szépművészeti Múzeum.

Swiss collector Hans Schüler purchases two Cézannes: *Rocks in the Forest* (Venturi, no. 674, Rewald, no. 776) and *Landscape in Provence* (Venturi, no. 839, Rewald, watercolor no. 115).

In Copenhagen, a large exhibition of nineteenth-century French masters is held at the Royal Museum of Fine Arts in May–June. Durand-Ruel loans 26 paintings, including one of the four versions of Manet's *Execution of Maximilian* and *The Absinthe Drinker,* 1859 (Rouart-Wildenstein, no. 19, formerly in the collection of Jean-Baptiste Faure, Paris). Among other paintings housed today in the Ny Carlsberg Glyptotek that were shown and purchased from this exhibition are the following works, formerly in the collection of the Prince de Wagram: Monet's *Shadows on the Sea at Pourville,* 1882 (Wildenstein, no. 792), Sisley's *The Waterworks at Marly,* 1873 (Daulte, no. 67), Sisley's *The Fields or The Furrows,* 1873 (Daulte, no. 65), and Sisley's *The Flood,* 1872 (Daulte, no. 21, formerly in the collection of François Depeaux and then the Prince de Wagram).

1915 The Swedish painter Richard Bergh (1858–1919) is appointed director of the Nationalmuseum Stockholm.

In Geneva, the Musée d'Art et d'Histoire acquires Pissarro's *Farm at Montfoucault,* 1874 (cat. 42, Pissarro-Venturi, no. 274).

Sir Hugh Lane, a passenger on the *Lusitania,* is killed when the ship is sunk by a German submarine. His collection is currently shared between the National Gallery of London and the Hugh Lane Municipal Gallery of Modern Art in Dublin through a policy of loans.

1916 For the Szépművészeti Múzeum in Budapest, Simon Meller purchases Monet's *Entrance of the Port at Trouville,* 1870 (Wildenstein, no. 154, in Fourth Impressionist Exhibition as no. 147). It was purchased from Paul Cassirer, who had bought it earlier that year at the auction of the Julius Stern collection on 19–22 May.

Through the Berlin art dealer and architect Kurt Walter Bachstitz, Elek Petrovics, director of the Szépművészeti Múzeum, Budapest, exchanges Sisley's *Banks of the Loing River, Autumn Effect* (Daulte, no. 420), which the museum had purchased in 1907, for Manet's *Portrait of Baudelaire's Mistress,* 1862 (Rouart-Wildenstein, no. 48).

Manet's last masterpiece, *Bar at the Folies-Bergère,* 1881–82 (Rouart-Wildenstein, no. 388, formerly in the collections of Emmanuel Chabrier and Auguste Pellerin, and originally exhibited at the Salon of 1882), enters the Hatvany collection in Hungary. It is now in the Courtauld Institute Galleries in London.

Danish collector Wilhelm Hansen (1868–1936) buys works by Sisley, Pissarro, Monet, and Renoir.

The Reinharts, a family of wealthy merchants, contribute substantially to the construction of the new Kunstmuseum in Switzerland. Later in the year, the museum organizes an exhibition of 196 works by French Impressionist and Nabis artists; one-quarter of the paintings are loaned by local Swiss collectors and another quarter are sold to new collectors. This exhibition establishes Winterthur's reputation as the most important center of French painting in Switzerland.

The Winterthur Kunstmuseum purchases three paintings from Durand-Ruel: two Renoirs and Sisley's *Bend in the Loing River* (Daulte, no. 811).

In London, the Tate Gallery acquires Degas's *Carlo Pellegrini* (Lemoisne, no. 407, offered by Sir Joseph Duveen).

Marie Bracquemond (1841–1916) dies.

1917 British artist Walter Sickert (1860–1942) writes a memoir on Degas in *The Burlington Magazine.*

At the Tate Gallery in London, an exhibition of the collection of Sir Hugh Lane inspires British industrialist Samuel Courtauld (1876–1947), who admires Impressionist paintings such as Renoir's *The Umbrellas* (Daulte, no. 298, which Lane had acquired from Durand-Ruel in 1907), Manet's *Music in the Tuileries Gardens* (Rouart-Wildenstein, no. 51, which Lane had purchased from Durand-Ruel in 1906), and Degas's *Beach at Trouville* (Lemoisne, no. 405, which Lane had bought from the Henri Rouart sale, 9–11 December 1912, no. 178). All these works are now in the National Gallery, London.

Ferenc Hatvany donates Cézanne's *The Cupboard,* 1877–79 (Venturi, no. 208, Rewald, no. 338, formerly in the Marczell de Nêmes collection), to the Szépművészeti Múzeum in Budapest; it is one of six extraordinary Cézannes from the 1913 sale of the Nêmes collection in Paris.

Under the directorship of Helge Jacobsen, the Ny Carlsberg Glyptotek in Copenhagen receives important donations from the Ny Carlsberg Foundation, including paintings originally bought at the exhibition of French art held at the Royal Museum of Fine Arts in Copenhagen in 1914.

As director of the Göteborgs Konstmuseum in Sweden, Axel L. Romdahl buys Renoir's *Girl in Spanish Jacket,* van Gogh's *Olive Grove, Saint-Rémy* (de la Faille, no. 586, as *Olive Yard: Orange Sky,* acquired in 1917 from Bernheim-Jeune, Paris), and Bonnard's *The Hunting Party.*

In Switzerland, Rudolf Staechelin (1881–1946) makes his first purchases of works by Impressionists, including Gauguin's *Nafea Faa Ipoipo (When Do You Marry)?* (Wildenstein, no. 454) and Cézanne's *House of Dr. Gachet in Auvers* (Venturi, no. 146, Rewald, no. 194, formerly in the collection of Georges de Bellio). Much of Staechelin's collection (approximately 40 paintings) would enter the Kunstmuseum in Basel in 1947 but would later be removed.

Edgar Degas (1834–1917) dies.

Federico Zandomeneghi (1841–1917) dies.

1918 As a gift for the Budapest's Szépművészeti Múzeum, Ferenc Hatvany purchases Pissarro's *La Varenne de St. Hilaire, Seen from Champigny,* ca. 1863 (Pissarro-Venturi, no. 31), from the Paul Cassirer gallery in Berlin.

Wilhelm Hansen, the first Scandinavian collector to concentrate on French art, opens his estate and museum, Ordrupgaard, to the public once a week. His collection is considered by some to be the most substantial representation of French art outside Paris.

During the bombardments of the First World War, several thousand works from the collection and studio of Degas are auctioned. The artist's collection, which would be dispersed in three sales, includes Old Masters as well as important Impressionist paintings, such as Gauguin's *La Belle Angèle (Madame Angèle Satre),* 1889 (Musée d'Orsay, Paris), Manet's *Execution of Maximilian,* 1867 (The National Gallery, London), and Sisley's *The Factory During the Flood,* 1873 (Ordrupgaard, Copenhagen). Degas's own oeuvre is auctioned in 1918 and 1919 at the Galerie Georges Petit in five separate sales.

1919 The Berlin Kunsthalle holds an exhibition of the artworks placed under public ownership.

The French museums receive works from the collection of Étienne Moreau-Nélaton.

In Oslo, the Nasjonalgalleriet acquires Monet's *Springtime at the Île-de-la-Grand-Jatte* (Wildenstein, no. 459, from Paul Rosenberg in Paris).

Pierre-Auguste Renoir (1841–1919) dies.

1920 In Glasgow, an important exhibition of 171 Impressionist works is shown at Alexander Reid's gallery; Scottish collectors Leonard Gow (1859–1936), William McInnes (1868–1944), and William Burrell (1861–1958) purchase works.

In Copenhagen, an exhibition of nineteenth-century French art includes works by Degas.

As a bequest of Swiss collector Hans Schüler, the Kunsthaus Zurich receives van Gogh's *Thatched Sandstone Cottages at Chaponval,* 1890 (de la Faille, no. 780, purchased at the 1908 exhibition of French painting in Winterthur), and Renoir's *Seated Nude* and *Trees in a Garden.*

1921 In London, the Tate Gallery refuses to borrow two Cézanne paintings—*Midday at L'Estaque,* ca. 1879 (Venturi, no. 490, Rewald, no. 391), and *Still Life with a Teapot,* ca. 1902–06 (Venturi, no. 734, Rewald, no. 934)—offered by the Davies sisters.

The French Ministry of Fine Arts decides that Monet's *Water Lilies,* a series of twelve canvases inspired by his garden in Giverny, is to be installed in the Orangerie. The artist would continue to alter the installation until his death in 1926.

In Berlin, paintings, watercolors, and drawings by Cézanne are loaned to the gallery of Paul Cassirer for the first major Cézanne exhibition in Germany; Julius Meier-Graefe writes the introduction to the catalogue.

1922 In London at the Burlington Fine Arts Club exhibition *Pictures, Drawings, and Sculptures of the French School of the Last Hundred Years,* British textile manufacturer Samuel Courtauld discovers the work of Cézanne loaned by the Davies sisters, particularly *Mountains in Provence,* ca. 1879 (Venturi, no. 490, Rewald, no. 391, formerly owned by Julien Tanguy, then Gauguin, then Vuillard, then the dealers Vollard and Bernheim-Jeune, before being purchased by Gwendoline E. Davies, now in the National Museum of Wales, Cardiff). In September, Courtauld begins his collection of modern French art. One of his initial purchases is Renoir's *Woman at Her Toilette,* ca. 1918, which now hangs in the Courtauld Institute Galleries.

Danish collector Wilhelm Hansen offers his collection for sale because of financial difficulties. The Danish State declines his proposition, but foreign collectors such as Oskar Reinhart from Winterthur, Albert Barnes from Philadelphia, and Japanese industrialist Kojiro Matsukata acquire works. Helge Jacobsen, director of the Ny Carlsberg Glyptotek, buys at least 19 Impressionist paintings by Degas, Manet, and Renoir, including Degas's *Dancers Practicing in the Foyer* (Lemoisne, no. 924) and *Dancers in Red Skirts* (Lemoisne, no. 783, formerly in the collections of Théodore Duret and Georges Viau).

In Copenhagen, the Royal Museum of Fine Arts and the Ny Carlsberg Glyptotek exchange works; the Ny Carlsberg Glyptotek receives the Royal Museum's Impressionist and Post-Impressionist works in exchange for its collection of Old Masters.

The Kunstmuseum in Winterthur, Switzerland, receives van Gogh's *Summer Evening,* 1888 (de la Faille, no. 465), as a gift of collector Emil Hahnloser.

In Brussels, an exhibition of Impressionist masters is held at the Musées Royaux des Beaux-Arts de Belgique.

1923 In Britain, Alexander Reid organizes an exhibition of Impressionist art that travels to Agnew's gallery in London and Manchester and to his own gallery in Glasgow. Important purchases were made by collectors Samuel Courtauld, William Burrell, and Mr. and Mrs. R. A. Workman, who bought Gauguin's *Tropical Vegetation, Martinique,* 1887 (Wildenstein, no. 232, as *Tropical Vegetation,* now National Gallery of Scotland, Edinburgh).

In London, collector and industrialist Samuel Courtauld gives 50,000 pounds to the British government to encourage the purchase of French Impressionist and Post-Impressionist paintings. Disbursed by the Courtauld Trustees, this money is used for such acquisitions as Degas's *Young Spartans,* 1860, and *Mademoiselle La La at the Cirque Fernando,* 1879; Manet's *The Waitress,* 1879; Seurat's *Bathers at Asnières,* 1883–84; and van Gogh's *Sunflowers,* 1888, and *Cornfield with Cypresses,* 1889. These important works are now in The National Gallery, London.

Monet's *Village Street in Vétheuil, Winter* (Wildenstein, no. 510) is given to the Göteborgs Konstmuseum in Sweden by collector Gustaf Werner.

1924 In Scandinavia, ten years of active acquisitions come to an end. With the exception of the Ny Carlsberg Glyptotek, the majority of Scandinavian collections of Impressionist art were created between 1914 and 1924.

The Hamburger Kunsthalle acquires Manet's *Nana,* 1877 (Rouart-Wildenstein, no. 259, formerly in the collection of Auguste Pellerin, Paris).

Jean-François Raffaëlli (1850–1924) dies.

1925 **First museum acquisitions of Impressionist works in Scotland**. The National Gallery of Scotland in Edinburgh buys Monet's *Poplars on the Epte,* ca. 1891 (Wildenstein, no. 1310, from Alexander Reid), and Gauguin's *Vision after the Sermon,* 1888 (Wildenstein, no. 245, from Sir Michael Sadler).

In London, Samuel Courtauld buys, from Percy Moore Turner, Renoir's *The Box (La Loge),* 1874 (Daulte, no. 116). The work, one of the artist's masterpieces, had been exhibited at the First Impressionist Exhibition in 1874 (no. 142).

In Paris, the collection of Maurice Gangnat (1856–1924), including 150 works by Renoir, is auctioned at the Hôtel Drouot on 24–25 June. Renoir's *Gabrielle with a Rose,* 1911 (Musée d'Orsay, Paris), is given by the collector's son, Philippe Gangnat, to the Louvre.

1926 The Friends of the Nationalmuseum in Stockholm purchase a Courbet, Renoir's *The Inn of Mère Antony,* 1866 (Daulte, no. 20), a Monet, and a Cézanne from the Klas Fåhræus collection for the Nationalmuseum.

The Thielska Galleriet, built in 1904 to house Ernest Thiel's collection of contemporary Swedish and French artists, opens to the public as a museum, after having been purchased by the Swedish State in 1924.

The Kunstmuseum in Basel buys Renoir's *Young Girl Lying on the Grass* in memory of Friedrich Rintelen, director of the museum from 1925 to 1926.

In London, Manet's masterpiece, *Bar at the Folies-Bergère,* 1881–82, is purchased by Samuel Courtauld. The celebrated painting from the Salon of 1882—having resided in the famous collections of Emmanuel Chabrier and Auguste Pellerin in Paris and Ferenc Hatvany in Budapest—finds its final home. In accordance with Courtauld's wishes, the painting remains today in the collections of the Courtauld Institute Galleries, which he founded in 1931 as a center for the study of art history.

Mary Cassatt (1844–1926) dies.

Claude Monet (1840–1926) dies.

1927 In Glasgow, Alexander Reid's son McNeill organizes an exhibition entitled *A Century of French Painting* at the MacLellan Galleries.

The Independent Gallery in London presents an exhibition of 20 paintings by Sisley.

Collector Étienne Moreau-Nélaton, having already donated works in 1906, 1907, and 1909, bequeaths his remaining artworks to the French museums.

Jean-Baptiste Armand Guillaumin (1841–1927), the last Impressionist painter to have participated in the Impressionist exhibitions held from 1874 to 1886, dies. His works had been exhibited at six of the initial eight Impressionist exhibitions.

Selected Bibliography

Bailly-Herzberg, Janine, ed. *Correspondance de Camille Pissarro.* 5 vols. Paris: Presses universitaires de France, 1980–1991.

Bataille, M.-L., and Georges Wildenstein. *Berthe Morisot: Catalogue des peintures, pastels et aquarelles.* Paris: Les Beaux-Arts, 1961.

Berhaut, Marie. *Caillebotte, sa vie et son oeuvre: Catalogue raisonné des peintures et pastels.* Paris: La Bibliothèque des arts, 1977.

Berson, Ruth, ed. *The New Painting.* San Francisco: Fine Arts Museums; distributed by University of Washington Press, 1996.

Brades, Susan Feleger, and Michael Raeburn. *Renoir.* Exh. cat., London: Arts Council of Great Britain, 1985.

Brayer, Yves. *Jean-Louis Forain, 1852–1931.* Exh. cat., Paris: Musée Marmottan, 1978.

Breeskin, Adelyn Dohme. *Mary Cassatt: A Catalogue Raisonné of the Oils, Pastels, Watercolors, and Drawings.* Washington: Smithsonian Institution Press, 1970.

Cachin, Françoise, et al. *Cézanne.* Exh. cat., New York: Harry N. Abrams in association with the Philadelphia Museum of Art, 1996.

Cooper, Douglas. *The Courtauld Collection: A Catalogue and Introduction.* London: Athlone Press, 1954.

Daulte, François. *Alfred Sisley: Catalogue raisonné de l'oeuvre peint.* Lausanne: Durand-Ruel, 1959.
———. *Auguste Renoir: Catalogue raisonné de l'oeuvre peint.* Lausanne: Durand-Ruel, 1971.

Dawson, Barbara. "Hugh Lane and the Origins of the Collection," in *Images and Insights.* Exh. cat., Dublin: Hugh Lane Municipal Gallery of Modern Art, 1993; pp. 13–31.

Dini, Francesca. *Federico Zandomeneghi: La Vita e le opere.* Firenze: Edizioni Il Torchio, 1989.

Distel, Anne. *Impressionism: The First Collectors.* New York: Harry N. Abrams, 1990.
———, et al. *Gustave Caillebotte: Urban Impressionist.* Paris: Réunion des Musées Nationaux: Musée d'Orsay; Chicago: Art Institute of Chicago; in association with Abbeville Press, New York, 1995.

Doran, P., ed. *Conversations avec Cézanne.* Paris: Collection Macula, 1978.

Faille, J.-B. de la. *The Works of Vincent van Gogh: His Paintings and Drawings.* Amsterdam: Meulenhoff International, 1970.

Flint, Kate, ed. *Impressionists in England: The Critical Reception.* London and Boston: Routledge & Kegan Paul, 1984.

Galeries Nationales du Grand Palais (France)/Réunion des Musées Nationaux. *De Corot aux Impressionnistes, Donations Moreau-Nélaton: Galeries Nationaux du Grand Palais.* Exh. cat., Paris: Bibliothèque Nationale; Réunion des Musées Nationaux, 1991.

Geelhaar, Christian. *Kunstmuseum Basel: The History of the Paintings Collection and a Selection of 250 Masterworks.* Basel: Verien der Freunde des Kunstmuseum Basel; Zurich: Eidolon, 1992.

Geskó, Judit. "Die Entstehung von Pál Majovszkys Sammlung französischer Zeichnungen des 19. Jahrhunderts. Ein Konservativer für die Modernen," in Judit Geskó and Josef Helfenstein, eds. *Zeichnen ist Sehen: Meisterwerke von Ingres bis Cézanne aus dem Museum der Bildenden Künste Budapest und aus schweizer Sammlungen.* Exh. cat., Ostfildern-Ruit bei Stuttgart: Verlag Gerd Hatje, 1996.

Gloor, Lukas. *Von Böcklin zu Cézanne, die Rezeption des französischen Impressionismus in der deutschen Schweiz.* Berne and New York: P. Lang, 1986.

Gordon, Donald E. *Modern Art Exhibitions 1900–1916.* Munich: Prestel, 1974.

Herbert, Robert. *Impressionism: Art, Leisure and Parisian Society.* New Haven and London: Yale University Press, 1988.

Hollenzollern, Johan Georg, Prinz von and Peter-Klaus Schuster. *Manet bis van Gogh: Hugo von Tschudi und der Kampf um die Moderne.* Exh. cat., Munich and New York: Prestel, 1996.

House, John. *Impressionism for England: Samuel Courtauld as Patron and Collector.* Exh. cat., London: Courtauld Institute Galleries, 1994.
———. *Landscapes of France: Impressionism and Its Rivals.* Exh. cat., London: Hayward Gallery, 1995.

Institut Suisse pour l'Étude de l'Art (Swiss Institute for Art Research), ed. *L'Art de collectionneur: Collections d'art en Suisse depuis 1848.* Zurich, 1998.

Isaacson, Joel, and Jean-Paul Boullon. *The Crisis of Impressionism*. Exh. cat., Ann Arbor: University of Michigan Museum of Art, 1979.

Jensen, Robert. *Marketing Modernism in Fin-de-Siècle Europe*. Princeton, New Jersey: Princeton University Press, 1994.

Kendall, Richard. *Degas Beyond Impressionism*. Exh. cat., London: National Gallery Publications; Chicago: Art Institute of Chicago; distributed by Yale University Press, 1996.

Kern, Josef. *Impressionismus im Wilhelminischen Deutschland—Studien zur Kunst—und Kulturgeschichte des Kaiserreichs*. Würzburg: Konighausen & Neumann, 1989.

Kosinsky, Dorothy, Joachim Pissarro, and Mary Anne Stevens. *From Manet to Gauguin: Masterpieces from Swiss Private Collections*. Exh. cat., London: Royal Academy of Arts in association with Ludion Press, Ghent, 1995.

Lemoisne, Paul-André. *Degas et son oeuvre*. New York: Garland Publications, 1984.

Macleod, Dianne Sachko. *Art and the Victorian Middle Class*. Cambridge and New York: Cambridge University Press, 1996.

Marosi, Erno, ed. *Die ungarische Kunstgeschichte und die Wiener Schule, 1846–1930*. Exh. cat., Budapest: Statischer Verlag, 1983.

Moffett, Charles S. *The New Painting: Impressionism, 1874–1886*. Exh. cat., San Francisco: The Fine Arts Museums, 1986.

Munk, Jens Peter. *Catalogue, French Impressionism, Ny Carlsberg Glyptotek*. Copenhagen: Ny Carlsberg Glyptotek, 1993.

Oeuvres de Marie Bracquemond, 1841–1916. Exh. cat., Paris: Bernheim-Jeune, 1919.

Pissarro, Ludovic R., and Lionello Venturi. *Camille Pissarro: Son art, son oeuvre*. Paris: P. Rosenberg, 1939.

Rewald, John. *The History of Impressionism*. New York: The Museum of Modern Art, 1973.

———, ed. *Camille Pissarro: Letters to His Son Lucien*. 4th ed. London: Routledge & Kegan Paul, 1980.

———, Walter Feilchenfeldt, and Jayne Warman. *The Paintings of Paul Cézanne: A Catalogue Raisonné I–II*. New York: Harry N. Abrams; London: Thames & Hudson, 1996.

Rouart, Denis, and Daniel Wildenstein. *Édouard Manet: Catalogue raisonné*. 2 vols. Lausanne and Paris: La Bibliothèque des arts, 1975.

Sainsaulieu, Marie-Caroline. *Eva Gonzalès, 1849–1883: Étude critique et catalogue raisonné*. Paris: La Bibliothèque des arts, 1990.

Schmit, Robert. *Eugène Boudin, 1824–1878*. Paris: Galerie Schmit, 1973.

Serret, Georges, and Dominique Fabiani. *Armand Guillaumin: Catalogue raisonné de l'oeuvre peint*. Paris: Mayer, 1971.

Société Anonyme de Artistes, Peintres, Sculpteurs, et Graveurs. *Impressionist Group Exhibitions*. New York: Garland Publications, 1981.

Stevens, Mary Anne. *Alfred Sisley*. Exh. cat., London: Royal Academy of Arts, 1992.

Vaisse, Pierre. *La Troisième République et les peintres*. Paris: Flammarion, 1995.

Venturi, Lionello. *Cézanne: Son art, son oeuvre*. Paris, 1936.

———. *Les archives de l'impressionnisme*. 2 vols. Paris and New York: Durand-Ruel, 1939.

White, Harrison C., and Cynthia A. White. *Canvases and Careers: Institutional Change in the French Painting World*. New York: Wiley, 1965.

Wildenstein, Daniel. *Claude Monet: Biographie et catalogue raisonné*. Lausanne and Paris: La Bibliothèque des arts, 1974–1991.

Wildenstein, Georges. *Gauguin*. Paris: Les Beaux-Arts, 1964.

Notes on Contributors

Marcia Brennan is a visiting professor at the College of the Holy Cross in Worchester, Massachusetts.

David A. Brenneman is Frances B. Bunzl Family Curator of European Art at the High Museum of Art.

Görel Cavalli-Björkman is Chief Curator and Head of Research at the Nationalmuseum in Stockholm, Sweden.

Ann Dumas is Guest Curator of *Impressionism: Paintings Collected by European Museums,* and resides in London.

Stefano Fugazza is Director of the Galleria d'Arte Moderna Ricci Oddi in Piacenza, Italy.

Judit Geskó is Curator of Modern Prints and Drawings at the Szépművészeti Múzeum in Budapest, Hungary.

Lukas Gloor is Deputy Director of Pro Patria, a Swiss cultural foundation based in Zurich, and resides in Zofingen, Switzerland.

Caroline Durand-Ruel Godfroy is an archival specialist of the Durand-Ruel gallery in Paris.

Ann W. Grove is Assistant to the Deputy Director and Chief Curator at the High Museum of Art.

Joni Haller is a Graduate Intern at the High Museum of Art from the University of Southern California, Los Angeles.

Marit Lange is Chief Curator, Department of Paintings and Sculpture, at the Nasjonalgalleriet in Oslo, Norway.

Christopher Lloyd is Surveyor of The Queen's Pictures at The Royal Collection Trust in London.

Jennifer Melville is Keeper of Fine Art at the Aberdeen Art Gallery and Museums in Aberdeen, Scotland.

Mary Morton is Assistant Curator of European Art at the Museum of Fine Arts, Houston.

Monique Nonne is Head of Documentary Studies at the Musée d'Orsay in Paris.

Robert McD. Parker is a researcher in Paris who specializes in nineteenth- and twentieth-century French art.

Stefan Pucks is an art historian in Berlin.

Michael E. Shapiro is Deputy Director and Chief Curator at the High Museum of Art, and Managing Curator of *Impressionism: Paintings Collected by European Museums.*

Phaedra Siebert is Curatorial Assistant, Department of European Art, at the High Museum of Art.

Belinda Thomson is an independent art historian specializing in French art, and resides in Edinburgh, Scotland.

Ferenc Tóth is Chief Curator, Collection of Modern Art, at the Szépművészeti Múzeum in Budapest, Hungary.

Olga Uhrová is Curator, Collection of Modern and Contemporary Art, at the Národní Galerie in Prague, Czech Republic.

Gudmund Vigtel is Director Emeritus of the High Museum of Art.

Index

Photo Credits

Unless otherwise noted, reproductions of works in the exhibition are by the permission of the lenders.

© Photo RMN: 18

© Photo Routhier—Document Archives Durand-Ruel: 20

© RMN–H. Lewandowski: 22, 67

Photographie Musée de Grenoble: 25

Documents Archives Durand-Ruel, Droits Reservés: 29, 34, 36

© 1992 The Metropolitan Museum of Art: 30

Staatliche Museen zu Berlin—Preußischer Kulturbesitz, Nationalgalerie—Klaus Göken, 1992: 31; Jörg P. Anders: 54; 57

Co Elke Walford, Hamburg: 32

Artothek—Blauel/Gnamm: 33

Départment des estampes et de la photographie, Bibliothèque Nationale de France: 40, 41, 42, 43

Giraudon: 42

Photographie Publicitaire—Jean Christophe Poumeyrol: 44

RMN–Jean: 48

© Photothèque des Musée de la Ville de Paris: 49

Kunstbibliothek, Berlin: 55

Dezernat Deutsche Fotothek: 56

Rudolf Dührkoop, Hamburg, 1899: 58

Bildarchiv Foto Marburg: 60

Rheinisches Bildarchiv Köln: 61

Wilhelm Weimer, Darmstadt, 1900: 62

Marianne Feilchenfeldt, Zurich: 63

National Gallery Picture Library, London: 66, 72

National Museums & Galleries of Wales: 67, 72, 73

Courtauld Institute Galleries: 70

Country Life Picture Gallery, London: 71

© Ashmolean Museum, Oxford: 74

Szépművészeti Múzeum, Budapest: 79, 80, 81, 83, 84

BTM Kiscelli Múzeum, Budapest: 83

Magyar Nemzeti Galéria, Budapest: 86

© Ole Woldbye: 92

© Foto Nationalmuseum, Stockholm: 93

© 1997 Nasjonalgalleriet, J. Lathion: 94

The Central Art Archive/Hannu Aaltonen: 96

Swiss Institute for Art Research, Zurich: 97, 98, 99, 100